Lucienne Peiry

Art
Brut

The Origins of
Outsider Art

Translated by
JAMES FRANK

Lucienne Peiry

Art Brut

The Origins of Outsider Art

Flammarion

This work was originally presented as a doctoral thesis at the University of Lausanne in 1996 with the title *De la clandestinité à la consécration. Histoire de la collection de l'Art Brut, 1945-1996.*

Published with the support of the Collection de l'Art Brut, Lausanne, and Pro Helvetia, the Arts Council of Switzerland

CONTENTS

PREFACE by Michel Thévoz 7

FOREWORD 9

Chapter 1 11
THE OTHER AND THE ELSEWHERE

Chapter 2 35
THE FIRST ART BRUT VENTURE

Chapter 3 105
NEW YORK AND VENCE

Chapter 4 125
THE REBIRTH OF THE COMPAGNIE DE L'ART BRUT

Chapter 5 177
AN ANTIMUSEUM

Chapter 6 225
AFFINITIES AND INFLUENCES

CONCLUSION 262

APPENDICES 265
Notes 265
Biographies 283
Bibliography 303
Index 314

For Alice Guillet

ACKNOWLEDGMENTS

I could not have completed this book without the help of many people. I would particularly like to thank Michel Thévoz and the late Geneviève Roulin, the former Curator and the Assistant Curator of the Collection de l'Art Brut in Lausanne, Switzerland.

Many people who have been connected with the Art Brut adventure have provided me with their testimonies: I want to express my gratitude to the late Slavko Kopac, Curator of the collections in Paris; Armande de Trentinian, Director of the Fondation Jean Dubuffet; Jacques Dauchez, President du Conseil Consultatif de la Collection de l'Art Brut; Doctors Jacqueline Porret-Forel, Alfred Bader, the late Gaston Ferdière, and Pierre Maunoury; also to Jacques Berne, Pierre Bettencourt, Roger Cardinal, Ignacio Carles-Tolrà, Laurent Danchin, the late Robert Dauchez, Philippe Dereux, the late Robert Doisneau, Michèle Edelmann, Jean-Paul Ledeur, the late François Mathey, Jean-Christophe de Tavel, and Jacqueline Voulet. I have also been warmly received and assisted by various people at the Fondation Jean Dubuffet in Paris, the Bibiliothèque Littéraire Jacques Doucet in Paris, the Centre de Recherches sur les Lettres Romandes in Lausanne, the Musée d'Ethnographie in Geneva, the Ossorio Foundation in Southampton, NY, and by Caroline Bourbonnais, Pierre Chave, Anne Ferdière, Regina Irman, Madeleine Lommel, and Rolf Röthlisberger.

This study owes much to the warm and friendly support of Jean-Pierre Amann, Stéphanie Bédat, Catherine Raemi-Berthod, Claudia Carl, Viviane Courbat, Nicolas Crispini, Mario del Curto, Anne-Hélène Darbellay, Anne-Lise Delacrétaz, Nicole Gaillard, Esther González Martínez, Marilou and Jean-Pierre Herren, Pierre-André Lienhard, Daniel Maggetti, Véronique Mauron, François Menoud, Félix Rodriguez, François Rossel, Laurent Schweizer, Christine Sylvestre, Madeleine Teuscher, Else and Hans Tillmanns, Gilles Weber, Bernard Wyder, Anic Zanzi, as well as the whole museum staff. I want to express my thanks in particular to Roland Tillmanns, Léo, and Victor, whose presence, attention, and support have been invaluable.

This book has enjoyed the support of the Collection de l'Art Brut, the Fondation pour le Progrès de l'Homme, the Fonds National pour la Recherche Scientifique, the municipal department of cultural affairs at Lausanne, the University of Lausanne and the Fondation du Quatre Cent Cinquantième Anniversaire, the Société Académique Vaudoise, of the "Jeunes chercheurs" scholarship sponsored by Burrus S.A., and of Radio Suisse Romande. Finally, I must also thank the gallery owners and collectors who have graciously given me their permission to reproduce these documents, and Stéphane Cancelli and Bluette Schmid-Freymond for their help and support.

The publisher would like to thank Lucienne Peiry for her help with the translation of her original text, and Stéphane Cancelli and the Collection de l'Art Brut for their invaluable aid in the publication of this new edition.

PREFACE

In the *Les Bâtisseurs d'Empire* (The Empire Builders), Boris Vian portrayed a symptomatic case of negative hallucination: a monstrous, mute being, the "schmürz," is born and grows up in the apartment of a bourgeois family, who nonetheless deliberately ignore it and continue to go about their lives as if it were not there. Art Brut is a sort of schmürz that appeared unexpectedly at the forefront of the art scene, but about which established artists wished to know nothing, beyond the fact that it was a subject of fashionable controversy. Twentieth-century artists made sure they acknowledged their debt to African and Oceanic arts. Why, then, did they choose to remain silent about this kind of domestic, pathological exoticism, which was revealed to them in all its particulars in the illustrated works of Marcel Réja in 1907 and Hans Prinzhorn in 1922? André Breton, receptive as he was to all forms of delirium, was nevertheless committed to maintaining a specific category for the "art of madmen" that guaranteed artistic discrimination; for this reason, he broke with Dubuffet. How long would it have taken otherwise for the names of Adolf Wölfli, Augustin Lesage, or Aloïse even to be mentioned in twentieth-century art history? Even Malraux, one of the first to crack open the doors of the "museum without walls" for them, contented himself with the name tag "anonymous" and the condescending caption "drawing of a madman" for the works of Aloïse, Otto Stuss, and Guillaume Pujolle.

When all is said and done, the first event to have placed the works of avant-garde artists and those produced in asylums on the same level was, paradoxically, the "Entartete Kunst" (Degenerate Art) exhibition in 1937, instigated by Joseph Goebbels, Minister of Propaganda during the Third Reich. The infamous amalgam of works by artists such as Kirchner, Nolde, Kokoschka, Chagall, and Kandinsky, and those of the mentally ill collected by Dr. Prinzhorn at Heidelberg's psychiatric hospital, was clearly an attempt to convince the public of the corruptness of "Judeo-Bolshevik" art. Over time, it

has become clear that Goebbels, possessed of some sort of negative intuition and racist allergy, nonetheless put together a genuine anthology of innovative art. But has the appreciation of Art Brut today been totally reversed? Curators of American museums, who have attempted with some difficulty to reconstruct this exhibition—as a defense of modern art this time around—have been careful to exclude Prinzhorn's collection, no matter how easily included, as if these works still retained their ability to corrupt the entire show. By leaving Karl Brendel, Paul Goesch, and Franz Pohl in their psychiatric ghetto, these curators seem ironically to have adopted the same point of view as Goebbels.

In contrast to art historians, who continue to remain silent, the sociologist Pierre Bourdieu deserves some credit for taking Art Brut into consideration. In his *Les Règles de l'art* (The Rules of Art), he devotes a brief commentary to it (page 342), albeit characteristic of the resistance and the rationalism that greets any form of expression foreign to the socio-cultural milieu of intellectuals. The gist of what he has to say is that Art Brut, characterized by its lack of cultivation, depends on the very thing—culture—from which it has purportedly been set free. Art Brut owes its very existence to an eminently cultural viewpoint; its effect is a projection, a fiction attributable to an absolute misinterpretation. But isn't it the case that Bourdieu builds for this verdict of exclusion a foregone conclusion; isn't it itself tautological? If one adhered to the requirement of non-contradiction—surprising for a Marxist thinker—one should then challenge Marxism itself, since it is a theory conceived within a bourgeois setting, or psychoanalysis, whose inventor was never psychoanalyzed, or Nietzsche's thought, established on the basis that "one word is already a prejudgment." Formal logic never betrays its incongruity more than when it is applied to art. The proof of the pudding, Engels would say, is in the eating; the proof of Art Brut is seeing it, proof too that contradiction is contained

within the principle of symbolic creation. Bourdieu seems, from an ethical or political standpoint, to be condemning the hereditary transmission of cultural capital; in fact, he attacks above all those who dare to go against the law of artistic production or those "rules of art" to which he has linked his name; he drifts, so to speak, from Marxism to narcissistic Leninism.

It must be noted that, far from having created Art Brut, established culture—the only one that Bourdieu takes into consideration—has done its best to contain Art Brut in its original place underground. The inventor of Art Brut is an atypical artist, a traitor to his profession, an intellectual keen on a lack of cultivation, a professor of the inconsequential, a double agent, an ingenious smuggler operating along the borders of culture, as Marx did along those of the bourgeois ideology, or as Freud did in regard to consciousness, or as Nietzsche with those of verbal codes. Incidentally, Dubuffet's aim was not at all to establish Art Brut or to belatedly make a little space for it in the pantheon of the visual arts, or even to rectify an injustice. His objective was to challenge the tribunal of artistic taste, the one that determines art history and its hierarchies, and the same one that today—more despotically than ever—makes and breaks the reputations of artists. To pride oneself on the interest it aroused in the imaginary museum of contemporary art, with its little pontiffs and commercial centers, would have been to boast about having the Mafia's approval.

Would it have been better to retreat further into the secrecy that was so favorable to it when it first emerged, in order to save it from all communicative, ideological, and commercial compromise? The history that you are about to read shows that Dubuffet did just the opposite and led it from confidentiality to publicity—that is to say from, the basement of the Galerie Drouin to the major exhibition in the Musée des Arts Décoratifs in Paris in 1967, and finally to Art Brut's own museum.

Does this mean that the model of the pantheon, at first challenged, has resurfaced in a more modest form? In truth, only one road leads to Rome, that of compromise; confidentiality and publicity occupy opposite poles within Art Brut. Dubuffet's motive for opening up the collections stemmed from his desire to do battle with Culture, rather than to create an open field. As to the recurring suspicion, which the opening of these collections gave rise to, of "appropriation" by Culture, one would have to be blinded by devotion to museums or art publishing to credit these organizations with the transcendent power of cultural consecration or integration. How could these artists, who actually make fun of their notoriety, the commercial value of their works, and the opinions of experts—and who for this same reason produce intensely communicative works—avoid calling into question a system of promotion that regulates its valuation precisely according to these three parameters? Putting Art Brut into a museum does not mean the appropriation of Art Brut by culture, but rather the creation of crisis within the museum, through an incongruity that is given full resonance by the crisis in contemporary art. It is an act of defiance to endow the only "poor art" worthy of the name with its own museum, directed according to the rules of art (whether Pierre Bourdieu agrees or not), as well as with a historical exegesis and meticulous documentation equal to that of other fields. How could we deprive ourselves of the pleasure of introducing a schmürz into the palaces of culture?

Michel Thévoz

FOREWORD

From 1945, the year of its secret emergence and definition, up until the end of the twentieth century, when it became established, Art Brut occupied an essential place in contemporary artistic and social history. In order to understand the importance of its present role in the decentering of cultural and esthetic values, one needs to examine its history, which teems with milestones and important events. The chronology of Art Brut clarifies its meaning and its subversive power.

The complex history of the Art Brut collection has up until now been the object of little research. Outside of the rigorous studies of Roger Cardinal, Michel Thévoz, Laurent Danchin, and John Maizels, it has been reduced to a few dates or a few facts drawn from essays or articles in encyclopedias. Although the subject has generated some thought-provoking insights, the groundwork is far from being finished. I became familiar with these types of investigations through research carried out for my thesis on the Italian Art Brut creator Giovanni Battista Podestà. I have traveled far and wide in search of people who have participated in the Art Brut venture: the curator of the first collections (Slavko Kopac); doctors who have contributed works and information (Jacqueline Porret-Forel, Gaston Ferdière, Alfred Bader); collaborators and prospectors (Michèle Edelmann, Jean-Paul Ledeur); a photographer (Robert Doisneau); "clandestine" visitors (François Mathey, Pierre Bettencourt); creators (Ignacio Carles-Tolrà, Philippe Dereux); and the close friends of Jean Dubuffet (Armande de Trentinian, Jacques Berne, Robert and Jacques Dauchez). By providing me with their accounts, the protagonists of this story permitted me to penetrate retrospectively into the universe of Art Brut. Their words formed my first archives, which proved indispensable material for my research. To these have been added the precious documents preserved by the Compagnie de l'Art Brut, and those held by various other institutions. My travels have regularly taken me back to the Collection de l'Art Brut in Lausanne, Switzerland, a privileged place of study, with its works of art and files within arm's reach. Most of my project was carried out here.

As my prospecting proved fruitful, my initial project—with the prodding of Michel Thévoz—turned into an analysis with a far greater scope than was intended, although it has remained a historical study. Many aspects of Art Brut are handled in an innovative fashion. Because Art Brut is being investigated for the first time, some choices and biases have arisen. In addition, most of the events in this adventure belong to the recent past. This fact inevitably resulted in a foreshortened historical perspective, that was, however, richer in observations on the current situation in art.

I could not have seen this project through if Art Brut had not aroused in me a kind of emotional and intellectual excitement. Jean Dubuffet's esthetic and philosophical propositions have modified my vision of art. His keen intuition with respect to these marginal works, his sharp eye, and his inexhaustible energy have left a deep impression on me. All the same, I do not entirely subscribe to Dubuffet's more extreme theories; certain theoretical points—such as the rejection of "cultural" creation and the virginity of Art Brut creators—were advanced in a particular context and no longer possess the same dissident value. Yet two generations after its emergence, Art Brut has retained all of its relevance. Even today, it cannot be ignored because of the disturbing, independent power displayed by its creators. Such was the existential and artistic fracture, and such were the imaginations of Wölfli, Aloïse, and Müller, that their encounter with the Other and the Elsewhere retains its radical force. Their symbolic universe plunges us into the heart of an intense and stimulating poetics of the strange.

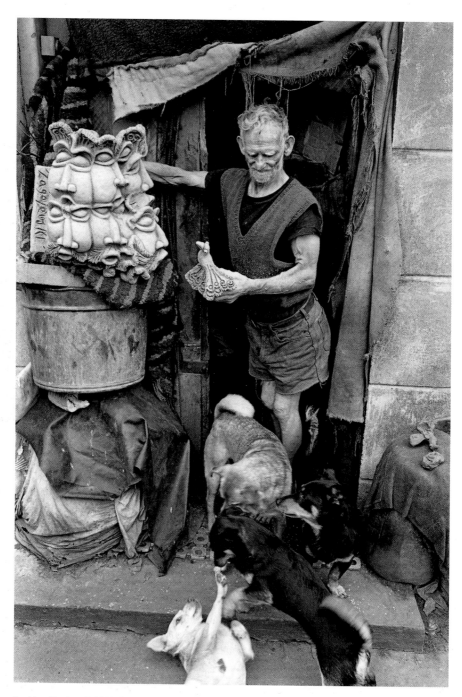

Stanislaw Zagajewski, 1995. Photograph by Mario del Curto.

THE OTHER AND THE ELSEWHERE

THE ADVENT OF ART BRUT

Jean Dubuffet was conducting an investigation in the literal sense when he began prospecting for marginal works of art during the summer of 1945; he was searching for a true, anonymous type of art, which was still nameless and for which he had not yet come up with a definition. Dubuffet coined the term Art Brut during his trip through Switzerland and France. The term appeared in July of that year.[1] The investigation and the discovery therefore preceded the theory, and Dubuffet let himself be guided by his private convictions. The project seemed to be an impossible venture; the term originated from an initial phase that was imprecise and purely intuitive.

Nevertheless, Dubuffet outlined his first approach upon his return from Switzerland: "Drawings, paintings, all works of art emanating from obscure personalities, maniacs; arising from spontaneous impulses, animated by fantasy, even delirium; and strangers to the beaten track of catalogued art."[2] Then he clarified his subject: "Artistic works such as paintings, drawings, statues, and statuettes, various objects of all sorts, owing nothing (or as little as possible) to the imitation of art that one can see in museums, salons, and galleries; but that on the contrary appeal to humanity's first origins and the most spontaneous and personal invention; works which the artist has entirely derived (invention and manner of expression) from his own sources, from his own impulses and humors, without regard for the rules, without regard for current convention."[3] Although this definition already contains the essential elements of the concept of Art Brut, it is still very general, and does not proffer the various components of an artistic theory. These would only be presented and developed over the following years, in the light of discoveries and studies carried out by this prospector, collector, and exegete of Art Brut. Dubuffet's enterprise initially proved to be controversial and difficult to support. The adventure of

Jean Dubuffet, 1943. Fondation Jean Dubuffet, Paris.

Art Brut offered a real challenge. Thus the sociologist Pierre Bourdieu directly attacked the notion of Art Brut, which he perceived as "a sort of 'natural art' which only exists as such by an 'arbitrary' decree of the most refined." According to him, these works "only appear as such to an 'eye' produced . . . by the field of art, one invested with the history of this field."[4]

However, the specificity of the works, as well as that of the people who produced them, proves the existence of Art Brut. Self-trained, marginal, each creator develops a new thematic, iconographic, stylistic, and technical syntax, that bears witness to an obvious inventiveness and independence. Each one of them works in solitude, secrecy, and anonymity, filling the pages of private journals. The artist has no particular audience in mind and has no aspiration

for public recognition. The artist is unaware that he operates in the domain of artistic creation: his work is developed outside any institutionalized framework. Art Brut thus embraces a composite whole, within which each corpus corresponds to a particular esthetic. Thus these creators cannot be compared to members of a movement or an artistic trend, united in a collective action by common positions and claims. Art Brut is an ideological phenomenon.

Incapable, by definition, of revealing its existence, Art Brut demanded the presence of a third party in order to be discovered: only an individual possessing comprehensive knowledge of the art world was capable of assessing the break with official culture to which its works testified. The revelation was made by a very cultivated man, who discovered how to identify and appreciate both their remarkable quality and their own brand of dissidence. Jean Dubuffet's campaign consisted in naming, gathering, exhibiting, and formulating the specificity of this marginal, clandestine form of creation. He played the role of an esthetic catalyst. Art Brut arises, then, as a double heresy from the point of view of art history: the first use of the term in 1945 preceded both the emergence of the concept and the development of a definition, and the concept was preceded by the work it defined. This double anachronism is intrinsically linked to a particular conception of Art Brut. It constitutes the first sign of a fracture in Western culture.

FORERUNNERS

A genealogical study of Art Brut is necessarily hypothetical because so little remains from the past: no artistic accounts have been preserved, no examples of Art Brut from before the late nineteenth century have survived. On the other hand, the mosaic of separate esthetics which makes up Art Brut hinders historical analysis of iconographic and iconological aspects, as well as formal and stylistic ones. The researcher is reduced to conjecture and presumption. Any genealogy of Art Brut is necessarily uncertain.

Throughout history, idiosyncratic artists have developed ways of expressing themselves outside the official rules. Bomarzo's fantastic gardens, Bosch's dreamlike scenes, Arcimboldo's monstrous heads, or even Goya's works of disturbing delirium

stand out because of an audacity and inventiveness beyond the familiar; the panorama of potential predecessors to Art Brut is vast. Focusing on the twentieth century, a more relevant approach, makes it possible to illuminate various significant currents, whose development can be linked to the advent and history of Art Brut. As far back as the nineteenth century, however, several small marginal movements can be included as forerunners. Around 1800, the Barbus circle, a group of young painters from the studio of Jacques Louis David, rejected academia and made themselves conspicuous by adopting a marginal lifestyle and eccentric look. In the same dissident spirit in 1882, the group of Incohérents led by Jules Lévy burst onto the scene in an unusual way by presenting "an exhibition of drawings executed by people who do not know how to draw." Their slogan was "Death to principles!"[5] The lack of artistic talent that they advocated and their refusal to discuss their work suggested a spirit of insouciance and provocation.

But the emergence of the notion of Art Brut is connected more precisely to the artistic revolution

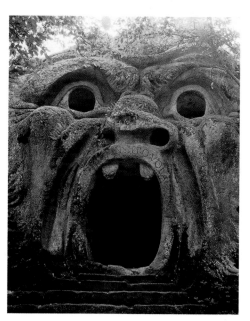

The fantastic gardens of the Villa Orsini at Bomarzo, near Viterbo, c. 1550.

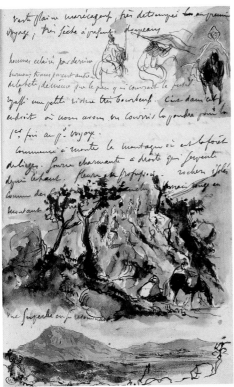

From Eugène Delacroix's journal of his voyage to Morocco, 1832. Watercolor. Musée du Louvre, Paris.

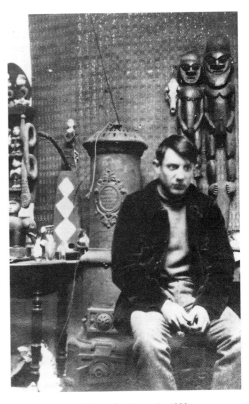

Pablo Picasso in his Bateau-Lavoir studio, 1908. Photograph by Gelett Burgess.

at the beginning of the twentieth century. The interest in primitivism, which can be traced back as far as the sixteenth century and the myth of the "noble savage," spread throughout Europe around 1900, and completely transformed intellectual and esthetic thinking. Artists felt a need to free themselves from their tradition and were searching for new values and landmarks, resulting in a kaleidoscopic quest for otherness: Delacroix left for the East in search of an ideal of savageness and refinement, Gauguin fell in love with the splendor of the South Seas, Picasso was fascinated by strange tribal works, and Kandinsky marveled at the engravings of folk artists. Exoticism, the primitive, and folklore each proved in varying degrees to be fruitful endeavors for a return to liberating sources. Some artists turned to different poles of otherness or to the regenerative virtues of children's art, spiritualist art,

and works from asylums. These crazes have an important place in the history of Art Brut.

CHILDREN'S SCRIBBLES AND SMEARS

"Take one of those school kids who sketch what are already lively, expressive little men in the margins of their exercise books and make him go to art school so he can refine his abilities; soon, as he makes progress in drawing, the new little men he carefully draws on a white piece of paper will have lost, compared to those he had sketched haphazardly in the margins of his exercise book, the expression, the life, and the vivacity of movement or intention that were noticeable before, while at the same time they will have become infinitely superior in their careful, imitative fidelity."[6] Two generations before the first studies of children's art,

Rodolphe Töpffer cast his discerning eye over the works of "school kids." In his *Réflexions et menus propos d'un peintre genevois* (Reflections and Small Talk of a Painter from Geneva), published in 1848, he devotes a number of chapters to these drawings and from the outset recognizes an exemplary value in these graphic inventions: it is "the first, true birth of art, since, in these little men at least, art already exists in its entirety, albeit in embryonic form."[7] Töpffer's ideas were daring for his time, and one in particular makes him a forerunner: the child, protected from all artistic study or training, delivers a virgin drawing freed from the imitative will, without slavishly trying to copy his model. On the contrary, his hand as it draws is guided solely by the intention of thought—the idea.[8]

At the beginning of the twentieth century, many avant-garde painters also became interested in the works of children.[9] They regarded them as an innocent form of expression, where original, authentic forces of creation were at work. For this reason, Ernst Ludwig Kirchner chose to present his mature works beside his first drawings, while Paul Klee, when putting together his own catalogue raisonné, included around twenty works done during his childhood. This type of composition became a fertile source; collections were begun, such as the one assembled in 1908 in Munich by the Expressionist artist Gabriele Münter, who drew inspiration from them. Four years later, Wassily Kandinsky and Franz Marc made forays into this collection and reproduced a number of children's drawings in the famous *Der Blaue Reiter* almanac, along with their works and the works of artists such as Picasso and Braque. This volume also contained pieces of folk art, tribal works, and naïve paintings. All of these works of art were placed on the same level, not within any qualitative hierarchy. By elevating marginal creations—including those of children—to the ranks of art, by bestowing on them authentic esthetic status, they were introducing a radically new value in the culture. The capacity to see the world through the eyes of children, wrote Kandinsky, permits the youthful drawer to discover "the inner sound of an object . . . There is an unconscious power in children that expresses itself here and places the work of children on the same level as (and often much higher than!) the work of adults . . .

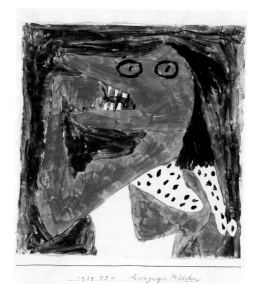

Paul Klee, *Famished Young Girl*, 1939.
Tempera paint on paper, 10 1/2 × 8 1/2 ins (26.9 × 21.3 cm).
Private collection, Switzerland.

The artist who for his whole lifetime resembles the child . . . can often succeed in reaching the inner sound of things more easily than others."[10] Members of various groups—the Munich circle, the Fauves, and Die Brücke—attempted this style of expression and adopted its simplification of form, use of bright colors, absence of nuance and relief, and the distortion of perspective.[11]

One major figure stood out at this same time: Paul Klee. He was undoubtedly the artist who, right from the beginning of his career, displayed the most active interest in the drawings of children. Like some of his contemporaries, he wished to recapture uncultured, spontaneous artistry: "I want to be like a newborn, knowing nothing of Europe, ignorant of the poets and fashions, almost a primitive,"[12] he declared at the age of twenty-three. According to Klee, the development of a new world arises from the exploration of repressed feelings: "For these are the primitive beginnings in art, such as one usually finds in ethnographic collections or at home in one's nursery. Do not laugh, reader! Children also have artistic ability, and there is wisdom in their

14

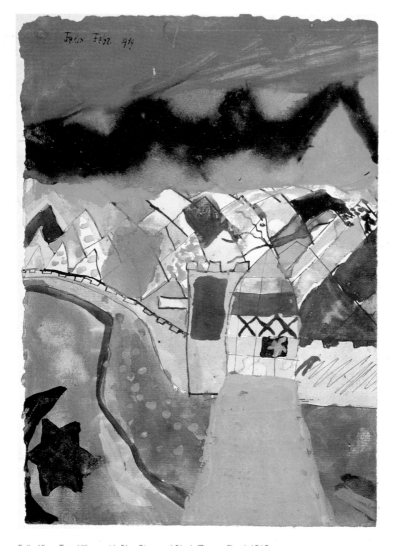

Felix Klee, *Tent Village with Blue River and Black Zigzag Cloud*, 1919.
Watercolor on paper, 9 1/4 x 6 1/2 ins (23.7 x 16.8 cm). Private collection, Switzerland.

having it! The more helpless they are, the more instructive are the examples they furnish us; and they must be preserved free of corruption from an early age. Parallel phenomena are provided by the works of the mentally diseased; neither childish behavior nor madness are insulting words here, as they commonly are. All this is to be taken very seriously, more seriously than all the public galleries, when it comes to reforming today's art."[13]

Paul Klee consulted several scientific studies devoted to these works, which at the time were of great interest to many intellectuals: in fact, ethnologists, doctors, and historians established numerous connections between the drawings of children, the works of tribal peoples, and those of the mentally ill. Sketched out in the nineteenth century, this theory

contained an underlying idea that these three groups possessed similar perceptions and minds; humankind would evolve psychologically and culturally, beginning with the most elemental stage wherein children, primitive peoples, and the insane would be ranked together.[14] Klee was opposed to this evolutionary concept, as well as pedagogical studies concerning children's artwork, and he inverted critical assessments that the specialists assigned to the differing phases of children's expression from the initial, schematic stage, regarded as "negative," to the accomplished, mimetic stage regarded as "positive."[15] The work that precedes study and apprenticeship was precisely the sort that the artist cultivated because it seemed to him the richest and most inventive. It radiates a conceptual abstraction and artistic spontaneity still devoid of any influence, of any "corruption"; here the power of expression in drawing attains its height. Klee was sure of detecting in it a source of liberating inspiration.

The natural processes implemented by young children—the linear style, repetition of motifs, anatomical distortions—are taken up and exploited by the artist in a deliberate move—a paradoxical venture, to say the least, since it summons up artlessness through contemplation. Even if he was conscious of the method's ambiguity, Paul Klee saw it as providing access to esthetic and spiritual fulfillment: "Their lordships the critics often say my pictures are like children's scribbles and smears. That's fine! The pictures my little Felix painted are better than mine, which all too often have trickled through the brain."[16]

MEDIUMISTIC CREATORS

"In January 1912, powerful Spirits came and revealed themselves to me, ordering me to draw and paint, something which I had never done before. Having never seen a tube of paint, consider my surprise upon this new revelation: 'But,' said I, 'I know nothing about painting.' 'Do not worry about insignificant details,' was their response. 'We are the ones working through your hands.' I then received, while writing, the colors of paint and types of brushes I needed and I began to paint under the influence of planetary artists, as soon as I would get back from the mine, completely worn out from

Augustin Lesage, *Untitled*, 1923. Oil on canvas, 6 ft 11 1/2 ins × 4 ft 8 3/4 ins (212 × 144 cm). Musée d'Art Moderne, Villeneuve-d'Ascq.

work."[17] These words belong to Augustin Lesage, a miner from the Pas-de-Calais region in northern France, who became a mediumistic painter in 1925.

Spiritualism appeared abruptly and emphatically in the middle of the nineteenth century. New ideas and theoretical practices were enjoying an unprecedented boom, particularly in the newly industrialized regions of England, Belgium, and northern France. The reasons for its development are connected to the growth of the proletariat and the rural exodus, two major socioeconomic events of the time which were part of the industrial revolution's turmoil. At odds with their origins and their ancestory, the members of the working class were feeling the need to renew clandestinely their ties to their predecessors.[18] Allan Kardec, founder of the spiritualist doctrine, published his theories in 1857 in *Le Livre des Esprits* (The Book of Spirits), and created *La Revue spirite* (The Spiritualist Review) in Paris a

Comte de Tromelin, *The Fairy*, c. 1903.
Black pencil on gray paper, 12 1/2 × 10 ins (32 × 25 cm).
Collection de l'Art Brut, Lausanne.

a hundred times to the same point."[20] Other mediumistic creators worked "differently, in a roundabout way, in no particular order,"[21] or utilized a nondescript structure similar to a séance table—in this way, the Comte de Tromelin shaded his sheet of paper so as to make out against this background the details which he revealed with the use of a pencil. Victor Hugo also consulted spirits with the aid of séance tables. During his exile on Jersey, between 1853 and 1855, he "entered into contact" with Aristophanes, Jesus Christ, Mohammed, Molière, and Galileo, who guided his drawing on hundreds of sheets of paper, filling several albums' worth of drawings. Furthermore, his graphic and pictorial creations which were not the product of spiritualism were produced using a technique close to automatism. Hugo experimented with ink blots, prints, foldings, scratchings, and tearings, and experimented

Victor Hugo, blot and fold embellished with pen, undated.
Ink, 8 × 5 1/2 ins (20 × 14 cm).
Bibliothèque Nationale de France, Paris.

year later.[19] More and more séances were held, the number of followers grew, stories abounded, works and reviews were widely circulated. The phenomenon stirred up considerable interest throughout Europe and in the United States.

During a séance, the medium, a sensitive, receptive individual, would free himself of all conscious will in order to "welcome" what was referred to as the message from the invisible spirit. He put himself at the disposition of the Other—the deceased—and of the Elsewhere—the kingdom of the dead—and established a link with the mysterious presence from beyond the grave. This practice at times triggered a scriptural, pictorial, or graphic explosion: Victorien Sardou's hand was "guided by a supernatural force, [which] made his burin follow a highly erratic path . . . passing without stopping and with an unimaginable rapidity from one end of the plank to the other without losing contact, returning

Hélène Smith, *Ultramartian Landscape*, 1900. Watercolor, India ink, lead pencil, and egg wash, 11 1/2 × 12 ins (29 × 30.1 cm). Olivier Flournoy Collection, Geneva.

with unusual methods such as beard feathers from birds, scraps of paper, burned matches, or coffee grounds, letting his mind attain a state of reverie conducive to hallucinations. These diverse artistic processes share similarities with the characteristic techniques of many creators of Art Brut.

Doctors were interested in the products of spiritualism at the end of the nineteenth century, a time when studies concerning hysteria, somnambulism, and experimentation with hypnosis were flourishing.[22] Pierre Janet, among others, attached great importance to the experiences of mediums in his work devoted to the actions of the subconscious, *L'Automatisme psychologique*.[23] Although most psychologists discounted the direct intervention of the deceased, they carefully examined cases of productive trances. In their opinion, a spiritualist had to be considered as a split personality; the subject gave free rein to his subconscious, to his "lower psyche,"

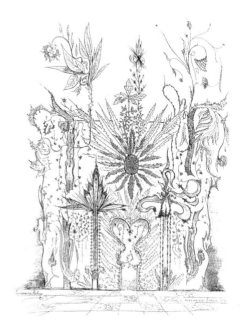

Victorien Sardou, *Palissy*, c. 1860. Etching, 19 × 16 ins (48 × 40.5 cm). Collection de l'Art Brut (Collection Neuve Invention), Lausanne.

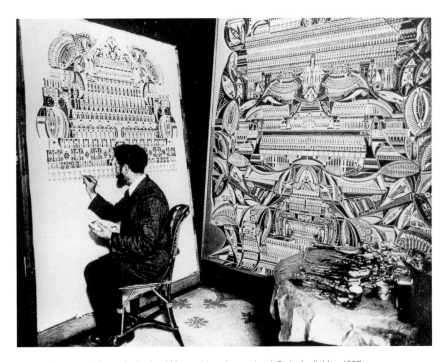

Augustin Lesage painting at the Institut Métapsychique International, Paris. April–May, 1927.

though his inhibitions made him attribute the message to supernatural powers. Spiritualist drawings, paintings, and accounts were thus considered invaluable tools for exploring the unconscious. This was how Dr. Théodore Flournoy described his patient Hélène Smith's pictorial and linguistic creations, which were widely circulated.[24] The first attempts at formal analysis appeared; a new corpus was recognized in 1900.

The experiment conducted by Eugène Osty at the end of the 1920s reflected this craze. The doctor invited Auguste Lesage, one of the major figures in spiritualist art, to do a few paintings at the Institut Métapsychique International in Paris so that he "could examine him while at work."[25] These "live" painting séances and the exhibition accompanying the event drew the public. Osty took detailed notes of the various methods Lesage used and collected the reactions of the visitors—ethnologists, art historians, and artists. In 1928, he published an important article on this example of a spiritualist creator and on this early form of "performance" art.

The spiritualist phenomenon had already been attracting the attention of many artists for some years, André Breton in particular. If the writer "categorically refused to admit that communication existed between the living and the dead,"[26] he was still fascinated by the works of Victorien Sardou, Hélène Smith, Augustin Lesage, Victor Hugo, and Le Facteur (Ferdinand) Cheval, wrongly considered as the "uncontested master of mediumistic architecture and sculpture."[27] Breton saw in these works the enactment of creative, free acts, which were not consciously directed or guided by premeditated intent. The spiritualist practitioner was therefore considered as an instrument capable of giving rise to the expression of the individual self—the sort of self-expression already proclaimed by the romantics and embraced in an even more radical way by the Surrealists. Through spiritualism, or more precisely through its operation—interpreted as a semi-conscious, passive state conducive to the channeling of unconscious messages from the beyond—the Surrealists discovered the richness of automatism,

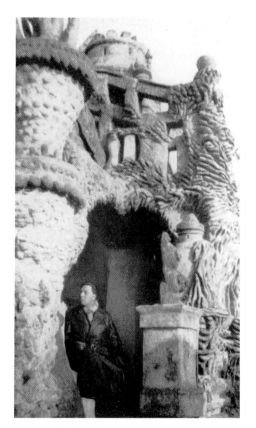

André Breton visiting Le Facteur Cheval's *Ideal Palace*, 1931.

include mediumistic paintings, drawings, embroideries, clothes, and writings by Augustin Lesage, Fleury-Joseph Crépin, Madge Gill, Jeanne Tripier, and Laure Pigeon. Their works would become part of his collection of Art Brut and would no longer be circumscribed in the category of spiritualist art.

ARTISTRY OF THE MENTALLY ILL

Walter Morgenthaler and Hans Prinzhorn published studies on the works of the insane in 1921 and 1922 respectively; both of them attributed an esthetic dimension to the works of the mentally ill.[28] They introduced a radically new attitude toward these works in an effort to transcend age-old exclusion. The two works are seminal and mark "the arrival of 'the schizophrenic artist.'"[29]

The young Swiss doctor Walter Morgenthaler was a true pioneer: assigned to the psychiatric hospital in Waldau near Bern, in 1908 he started to take an interest in his patients' creations, and systematically expanded the institution's new collection.

Adolf Wölfli, Collection de l'Art Brut, Lausanne.

which would become one of the essential ingredients of their creative ferment. Otherness became a muse. The state of a medium was perceived as a poetic foreshadowing of automatic writing.

André Breton recognized the esthetic value of mediumistic works; he consulted various spiritualist and medical reviews and chose to publish several reproductions in the review *Minotaure*, accompanying them with a long article. Once again, it was artists who showed the real value of these neglected works, even if the latter continued to be classified in a specific artistic category. In other respects, the Surrealists made use of these works, which nourished their quest for the primitive. This recognition was insidiously combined with a form of appropriation.

Spiritualist creations became an overriding preoccupation for Dubuffet, whose collection would

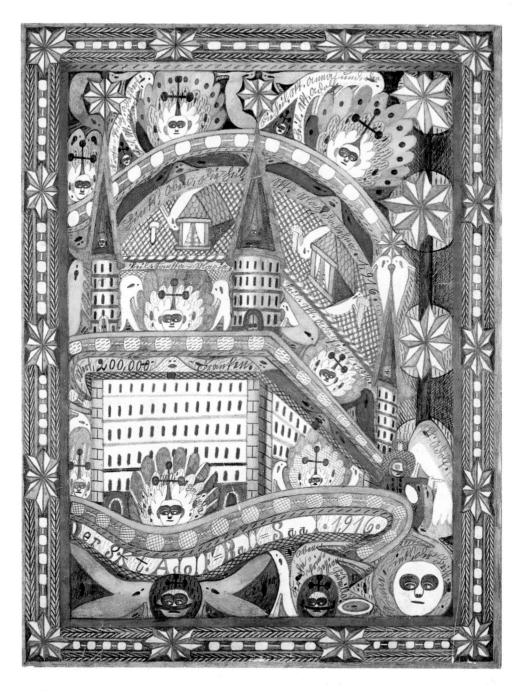

Adolf Wölfli, *The Ballroom of Saint Adolf*, 1916. Colored pencil, 24 1/2 × 19 ins (62.5 × 48 cm).
Collection de l'Art Brut, Lausanne.

Walter Morgenthaler.
Universitäre Psychiatrische Dienste, Bern.

Hans Prinzhorn.
Prinzhorn Collection, Heidelberg.

He fell in love with the graphic, scriptural, and musical works of Adolf Wölfli. Rather than focusing his attention on the pathological traits of Wölfli's works, Dr. Morgenthaler set out first to do a formal study, in an attempt to determine Wölfli's artistic style. He studied the spatial and rhythmic organization of Wölfli's compositions, attempted to define the connections between word and image, and identified all the iconographical motifs that enliven this encyclopedic work. His awareness of contemporary trends in art facilitated this kind of analysis. The title of his work—*Ein Geisteskranker als Künstler* (A Mentally Ill Person as Artist, published in English as *Madness and Art: The Life and Works of Adolf Wölfli*)—announced the revolutionary character of his approach: the categorizing of a "madman's" work as art. Furthermore, he unveiled the identity of his patient and published his photograph. "Departing from the psychiatric practice of using a pseudonym, Dr. Morgenthaler wanted to signal that for him the artist mattered as much to him as the insane patient."[30] His work is above all an artistic monograph, and differs sharply from a psychiatric study.[31]

The following year, Hans Prinzhorn's book—*Bildnerei der Geisteskranken* (The Artistry of the Mentally Ill)—had a thunderous effect. Appointed to the psychiatric clinic in Heidelberg in 1919, the young German doctor was assigned to study the institution's collection of drawings and paintings. He decided first to enlarge the corpus, then sent letters to several colleagues, traveled from asylum to asylum in a number of European countries, and based his research on more than five thousand works by the mentally ill—he collected in particular Karl Brendel's famous chewed bread and wooden sculptures, as well as Peter Moog's watercolors of biblical scenes.[32] Following Morgenthaler's example, Prinzhorn was guided by his personal interest in painting and sculpture; he recognized the ability of the mentally ill to draw from "the depths of their interior life, their visions, their ideas, and the phantasmagoria of their secret intuitions."[33] His familiarity with Munich's avant-garde circles, notably the Phalanx association which included Kandinsky, Alexej von Jawlensky, and Alfred Kubin, was particularly well known, and his studies in art history predisposed him to recognize the inventiveness of

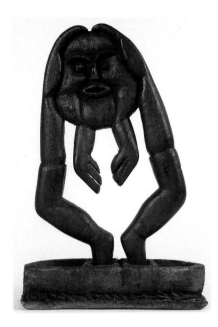

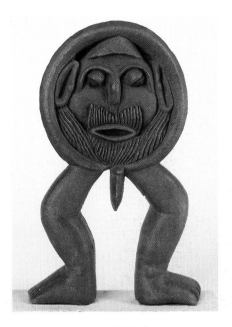

Karl Brendel, wooden sculpture, undated. Prinzhorn Collection, Heidelberg.

Karl Brendel, *Jesus*, undated. Wood, 7 1/4 ins (18.5 cm). Prinzhorn Collection, Heidelberg.

these works. According to Prinzhorn, no single trait distinguished the art of a "madman" from the work of a "normal" creator: "What is schizophrenic about this picture? We cannot be certain . . . Instead we have to make up our minds once and for all to count on a separate creative component and to look for the value of a work only within the work itself."[34] On several occasions Prinzhorn utilized his own term "creation of art,"

lending esthetic status to the production of the mentally ill.

The appearance of these two works constituted a decisive turning point in the history of the "art of the insane."[35] Although psychiatric studies into the works of the insane proliferated at the end of the nineteenth century, the majority of them maintained a strictly symptomatological viewpoint, tending to pick out signs of the illness in order to list the

Peter Moog, *Fight of the Knights of St. George and Madonna*, undated. Ink and watercolor on paper, 7 x 19 3/4 ins (18 x 50 cm). Prinzhorn Collection, Heidelberg.

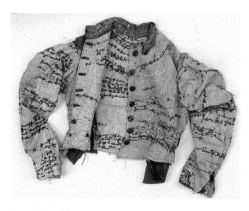

Agnès Richter, embroidered jacket, undated.
Prinzhorn Collection, Heidelberg.

specific forms and styles of each pathology and to confirm certain diagnoses. In evaluating their patients' works, doctors relied on normative criteria such as the ability to imitate, the use of perspective, getting the proportions right, coherence in representation, or sensitivity to beauty. Multiple classifications of "artistic abnormality" were formulated: "The criteria for judging the existence and degree of madness based on a drawing are expressed in a few words: strangeness, pretension, obscenity and eroticism, rapidity, incoherence (in allegories), stereotypes and scribbles; to these are added, in the case of homemade furniture for example, the absence of

sense and utility."[36] Limited to itself, the image was only permitted to reflect the illness. All consideration of an artistic order was absent from these psychiatric studies; the insane remained excluded from creation.

Progressive individuals emerged nonetheless, proclaiming the same spirit of open-mindedness as Morgenthaler and Prinzhorn. At the end of the nineteenth century, Dr. Max Simon developed an interest in work produced in asylums and devoted two brief articles to them. Though these first studies lack any formal or stylistic analysis, they did pave the way for the more systematic discussion completed by Dr. Joseph Rogues de Fursac around 1900.[37] But the first rupture occurred in 1907 with the appearance of the work *L'Art chez les fous* (The Art of Madmen) under the penname Marcel Réja.[38] The pseudonym that Paul Meunier used proved to what extent this doctor distanced himself from institutionalized psychiatry; he addressed the works without associating them with any diagnosis, recognized their emotional content, and demonstrated his sensitivity to the quality and inventiveness of some of them. His consideration of the esthetic qualities of the works of the insane bears witness to a new attitude. But this collection of publications did not cause any real stir in cultural circles; only Morganthaler's work and that of Prinzhorn in particular would be real breakthroughs and facilitate contact between the art of the asylum and contemporary art.

In the same spirit, other psychiatrists stood out

Wood sculptures. Photograph taken from *L'Art chez les fous* by Marcel Réja (Paul Meunier), 1907.

Émile Josome Hodinos. *Coins for Casting*, between 1876 and 1878. Ink on paper, 9 × 7 ins (23 × 17.8 cm). Collection de l'Art Brut, Lausanne.

for their dissident acts, arising from their independent mind-set, finding themselves marginalized by the psychiatric and academic thinking of the time. They were not only conscious of the expressive values of the art of the insane but also aware of the importance of preserving and presenting them. William A. F. Browne in Dumfries, Cesare Lombroso in Turin, Auguste Marie in Paris, Charles Ladame in Geneva, Hans Steck in Lausanne, and Gaston Ferdière in Paris then Rodez figured among the doctors who gathered together the most important works and established the first collections.[39] They collected drawings, paintings, sculptures, objects, and writings by patients, and studied these works that, thanks to them, acquired an esthetic and documentary status. Dr. Marie began his collection around 1900—one of the first in France—and assembled the works of major artists, such as those of Émile Josome Hodinos, the Comte de Tromelin, and the Voyageur Français. Five years later at the Villejuif asylum, he put together a "small museum of the insane," which was opened to doctors and the general public.[40] Marcel Réja drew from this corpus

Top: Dr. Auguste Marie in the Museum of Criminal Anthropology, Turin, c. 1905. Photograph by Georges Leyris. Bibliothèque Historique de la Ville de Paris, Paris.

Bottom: Comte de Tromelin. *Woman with Tiara*, c. 1903. Black pencil on gray paper, 12 1/2 × 9 1/2 ins (32.5 × 24 cm). Collection de l'Art Brut, Lausanne.

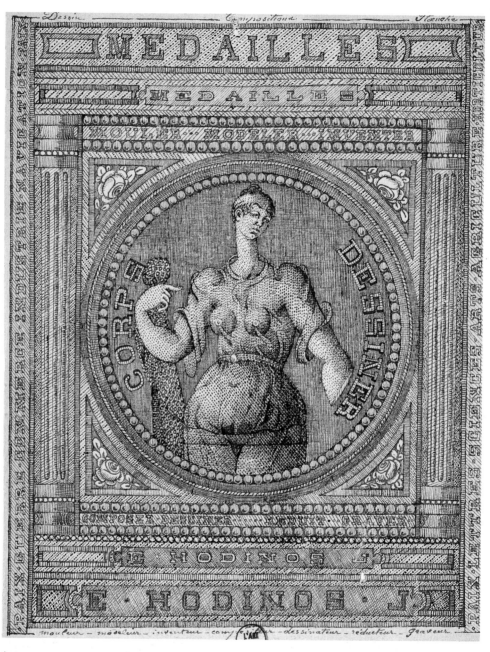

Émile Josome Hodinos, *Body Drawing*, between 1876 and 1896.
Ink on paper, 8 1/2 × 6 1/2 ins (21.4 × 16.4 cm). Collection de l'Art Brut, Lausanne.

the scientific resources needed for his famous work. Following on from Auguste Marie, Dr. Ladame set aside a small study for artwork in a wing of the Bel-Air asylum in Geneva in 1925; he displayed works he had collected over the previous ten years, as well as those done by the asylum's patients. His intentions were twofold: "To make known to the outside world this intense as well as unsuspected activity" and "to try to determine the mechanisms of this artistic work, reconnecting it to its natural place, the vast domain of art, human thought and its external manifestations."[41]

Carried along by this innovative current, many collections became the subject of temporary exhibitions, presented in conjunction with psychiatric symposia and conferences in various European

Le Voyageur Français, *The Land of Meteors*, 1902. Watercolor on paper, 24 1/2 × 18 1/2 ins (62 × 47 cm). Collection de l'Art Brut, Lausanne.

View of a room in Dr. Charles Ladame's study at the Bel-Air asylum, Geneva. Collection de l'Art Brut, Lausanne.

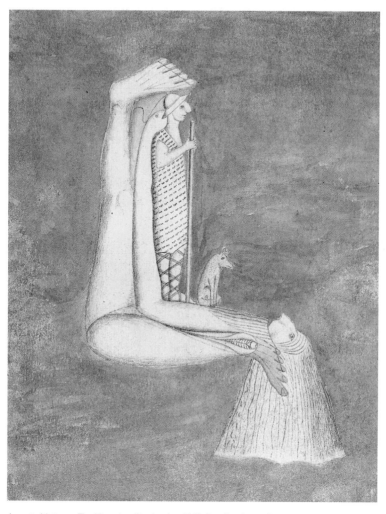

Auguste Natterer, *The Miraculous Shepherd*, c. 1919. Pencil and gouache
on cardboard with watercolor and varnish, 9 1/2 × 7 3/4 ins (24.5 × 19.5 cm).
Prinzhorn Collection, Heidelberg.

cities.[42] At the end of the 1920s, these collections
were released from their clinical setting on rare occa-
sions and were hung in museums (Gewerbemuseum,
Basel, 1929; Musée d'Art et d'Histoire, Geneva,
1930) and in galleries (Vavin gallery and Max Bine
gallery, Paris).[43] During his research, Dubuffet
discovered the collections of Marie, Ladame, and
Steck and, thanks to donations, incoporated them into
his collection of Art Brut. Once there, they would no
longer be categorized as insane asylum art.

At the same time, other marginal forms of
expression achieved real emancipation and acquired

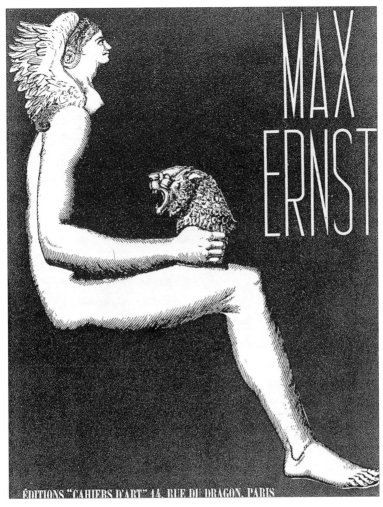

Max Ernst, *Oedipus*,
cover for a special edition of *Cahiers d'art*, 1937. Collage.

a new status: primitive and folk art. Exhibited at the beginning of the century on account of their strangeness and exoticism, collections of tribal works were now placed in museums equipped with institutional and scientific personnel. The objects of curiosity became objects of knowledge and pieces to be studied. Significantly, in 1937 the Musée d'Ethnographie du Trocadéro, founded in Paris in 1929, was renamed the Musée de l'Homme. The legitimization of insane asylum, tribal, and folk art works contributed, each in their own way, to the development of a radically new Western outlook.

Max Ernst, illustration for the *Starry Castle* by André Breton, 1936. *Frottage*. Private collection.

Oscar Dominguez, *Untitled*, 1936. Decalcomania and gouache on paper, 15 × 11 ins (38 × 28 cm). Private collection.

PAUL KLEE, DADA, AND THE SURREALISTS

Prinzhorn's work, *Bildnerei der Geisteskranken*, quickly garnered thousands of readers and was in a new edition by 1923, one year after its appearance—its success overshadowed the publication of Morgenthaler's monograph which, without passing entirely unnoticed, remained in the background.[44] If Prinzhorn's book generated great interest in clinical circles, it provoked an equally spectacular stir in avant-garde artistic circles in many European cities.

"The doctors are of the opinion that my paintings are basically the work of a sick person. You are certainly aware of Prinzhorn's excellent book *Bildnerei der Geisteskranken*. We ourselves can persuade ourselves of this! Look: there is Klee at his best! And here, and there too! Look at these religious subjects: there's a profundity and power of expression that I could never achieve. Truly sublime art. A purely spiritual vision . . . Children, the mad, and the primitives have preserved—or rediscovered—the ability

to see. And what they see, and the forms that they use are for me the most valuable of confirmations,"[45] asserted Paul Klee. As someone who had been fascinated by the work produced in insane asylums for some time, the artist visited Prinzhorn's collection before the book was published and, having lived in Bern on several occasions, he in all likelihood knew of the small museum at Waldau and Adolf Wölfli's work.[46] The publication of *Bildnerei der Geisteskranken*, a copy of which he kept in his studio, dazzled him and reinforced his interest. In these visionary and uncultured works, Klee discovered an artistic intensity and freedom in perfect accord with his own work; he was inspired by it and was influenced by many artists, one of whom was Karl Brendel. In the courses in art theory that he taught at the Bauhaus in the 1920s, Klee attached great importance to the notions of spontaneity and original creation. The works of children and the insane without a doubt played a decisive role in his teaching, as well as in his own work.[47]

In a similar vein, Max Ernst became interested in the work of the mentally ill before Prinzhorn's work appeared. As a student in Bonn before World War I, he often visited the collection at an asylum near his university. Struck by the energy of the paintings and sculptures, he sought to "recognize glimmers of genius" there and was tempted "to explore the depths of dangerous wastelands located within the confines of madness."[48] Max Ernst organized a Dada exhibition in Cologne in 1919, where, next to his works and those of other avant-garde artists, he exhibited the drawings of children, African sculptures, found objects, and works by the insane.[49] If his intent was to provoke, it was also to rehabilitate. In the same spirit, Ernst dreamed of devoting a study to asylum art, which he had been collecting for a number of years, but when *Bildnerei der Geisteskranken* appeared, he abandoned his project. He doubtless did not realize the importance of his actions and their repercussions when, on his arrival in France in 1922, he offered Prinzhorn's book to Paul Eluard. It was passed on to Jean Arp, Sophie Taueber, Jean Dubuffet, and André Breton, among others, and became the bedside book of many artists. It didn't matter that most of them did not read German; there were numerous illustrations, many of which were reproduced in color. Never before had they seen so many works of the insane so well reproduced. Prinzhorn was knowledgeable about theories of creativity and conversant with contemporary thinking. Among some five thousand works, he had perceptively chosen the most meaningful ones, and he had sensed the affinities that linked the works of the mentally ill with the "latest trends of real art," in particular "the strange expression of the soul, whose reflection is glimpsed in bizarre subjects that are translated into very naïve compositions—and then the primitive form of the act of creation, which remarkably casts light into mysterious depths."[50] The strange, inner landscapes and the original, artistic process constituted in reality the dual subject on which many artists based their quest. Their sensitivity was thus heightened by the discovery of these peculiar works. In their eyes, the mad carried within them certain elemental human truths.

The Surrealists were convinced that the unconscious harbored untapped powers capable of enriching the artistic process; they implemented a variety of methods of free creation. The first, automatic

Assemblage made by a psychotic artist. Part of André Breton's collection.

31

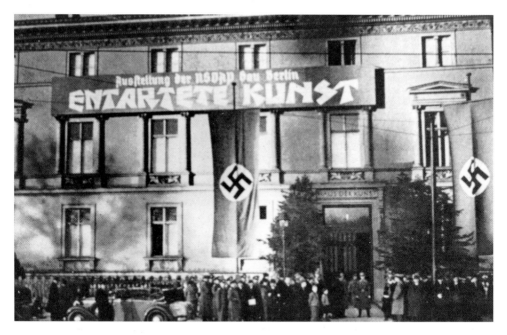

Entrance to the "Entartete Kunst" exhibition in Berlin, 1937.

writing, was pioneered in 1919 by André Breton and Philippe Soupault in *Les Champs magnétiques* (Magnetic Fields). Artists in other fields adopted similar means, such as André Masson, who completed drawings by letting his pencil glide across a sheet of paper, cultivating the accidental nature of the creative act. Max Ernst used automatism to his advantage with the invention of two techniques, collage and *frottage*, specific methods of subverting the artistic process and freeing the unconscious. With the first, he experimented with random combinations of various images; with the second, he took advantage of signs that sprung up unexpectedly. Like a spectator, Ernst witnessed the manufacture of his composition. These diverse graphic experiments, such as the use of decalcomania or exquisite corpse, provided a vast repertory that offered ways to second sight by stimulating the artists' visual effects and hallucinations. The techniques of projection and suggestion used were reminiscent of those adopted by Victor Hugo (see p. 17). These automatic practices were followed by other experiments, considered as forms of exploration, involving trances or hypnotic sleep, spiritualism or the use of drugs to lower inhibitions and lift the barriers to expression, thus encouraging the implementation of exceptional creative abilities. The purpose was to induce a sort of delirium, an undermining of reality, an opening up to the "random event" with the aim of bringing about a feverish "emancipation of the spirit."

Prinzhorn's work had arrived at just the right moment: the Surrealists were won over and strongly influenced by it.[51] Some painters and writers decided to push experimentation even further: they consulted publications, assiduously frequented asylums, visited their collections, and acquired the works of the mentally ill. The Surrealists cultivated the irrational and began to worship "divine madness": "The mad are imprisoned in pompous cells and our delicate hands inflict on them scientific torture," wrote Eluard. "Do not believe, however, that they will succumb to it. The country that they have discovered is so beautiful that nothing can turn them away from that place . . . We know only too well that it is we who are locked up when they close the doors of the asylum: the prison is all around us, freedom inside."[52] The Surrealists sought out states of mental distress so that they could better penetrate

the unconscious. Robert Desnos entered into profound trances and placed himself under hypnosis to produce delirious drawings; Breton and Eluard tried to copy madness by imitating a series of psychological pathologies, and by inciting disordered thinking, associations between ideas, absurd digressions, and chaotic verbal images. The experimentation led to the publication of *L'Immaculée Conception* (The Immaculate Conception) in 1930, with "the transcendent effect of consecrating, in an exemplarily didactic way, the free categories of thought culminating in insanity."[53]

The idolization of madness and the unconscious was such that it led some Surrealists to an astonishing degree of identification. Eluard, for example, accompanied one of his articles with graphic and literary works that were presented as the work of the mentally ill whose identity had been concealed; the publication was hailed as a contribution to the study of asylum art. In reality, the poems belonged to members of the Surrealist group and ten of the thirteen drawings had been done by Robert Desnos.[54] These artists could not have revealed any better the failure of their attempts: inducing a state of insanity and seeking to reproduce the intensity of works by "madmen" through the absence of control and proportion were utopian experiments. The art of the insane remained out of reach. The Surrealists knew it, and Breton himself admitted that only madness guaranteed "total authenticity."[55] No doubt it was for this reason that they were careful to conceal their sources—Prinzhorn's book in particular was almost never mentioned and remained a clandestine source. The creations of patients that were featured alongside their works in a few exhibitions in the 1930s were used in large part to prove their theories.[56]

The Surrealists' interest in deviant works was evident. Recognizing the inventiveness of many artists, they published and exhibited the works of spiritualists, the marginalized, and self-taught artists, such as the voodoo painter Hector Hyppolite, Le Douanier Rousseau, and the drawer Scottie Wilson. They also presented anonymous works and the famous "found objects" discovered in nature or picked up at flea markets.[57] The Surrealists were sustained by the Other and the Elsewhere, *a fortiori* madness, the image of otherness par excellence.

The works of the insane broke through the barriers of exclusion because of dissident psychiatrists and avant-garde artists. But a disastrous future loomed at the end of the 1930s: the works in the Heidelberg collection, which Prinzhorn gave so much prominence to, appeared fifteen years later in the Nazi's "Entartete Kunst" (Degenerate Art) exhibition, which began in Munich and traveled to nine other cities in Germany and Austria. In order to convince the public of the pathological elements in the paintings of such artists as Kandinsky, Nolde, Klee, Kirchner, Kokoschka, and Chagall, the organizers placed beside their paintings works by the mentally ill, seeking to bring about the "downfall of modern art for psychiatric reasons."[58]

Artwork produced by children, the spiritualists, and the insane had risen to prominence during the early part of the twentieth century. At first treated as works unworthy of consideration, they became objects of curiosity or exoticism and later manifestations of primitive creation; they served as sources of inspiration for European avant-garde artists in search of artistic purity and rawness. At the same time, heightened interest in the works went hand in hand with a sort of appropriation, at times leading to a real cultural phagocytosis. These phenomena revealed the acuteness of the intellectual and esthetic crisis that existed at this time. These works created in obscurity had shattered the art world, opening a breach at the beginning of the twentieth century through which would surge a violent subversion: Art Brut.

Aloïse, *Esmeralda*, undated. Colored pencil, 8 1/4 × 6 ins (21 × 15 cm). Collection de l'Art Brut, Lausanne.

THE FIRST ART BRUT VENTURE

"A girl belting out a song while sweeping the stairs moves me more than a complex cantata. Every man to his own taste. I love the little. I also love the embryonic, the badly made, the imperfect, the mixed up. I love best diamonds in the rough, in their rock. And with flaws."[1] The tone was set. Dubuffet's words from 1945 testify to his aim: to sweep out established artistic values. His two earlier starts in painting—the first in 1918 when he was seventeen, the second fifteen years later—did not enable him to free himself from esthetic tradition so that he could venture into genuine personal creation; his experiments were very quickly aborted. Born in Le Havre, the young man fled the confines of a bourgeois family and his authoritarian, intellectual father. In Paris, he deserted the Académie Julian where he had enrolled; he left the Latin Quarter and its "student confabs," then Montmartre and its bohemian lifestyle, where, during the 1920s, he spent a lot of time with important artists such as Suzanne Valadon, Max Jacob, and Charles-Albert Cingria.[2] Dubuffet would launch his career as an artist quite late—a few years before he embarked on his search for works of Art Brut. He was forty-one years old.

His stance at this time was anti-authoritarian. Of course, after Kandinsky's or Klee's "primitivist" quest and after the pictorial advances of Matisse, Bonnard, and Picasso—who were by now committed to a return to traditional values—Jean Dubuffet's revolution might appear incongruous, indeed anachronistic; it was as if he were struggling alone, indifferent toward art history. Furthermore, his belated remarks were not those of a rebellious young artist, but were rather a fundamental part of an esthetic of subversion to which he would remain faithful for forty years.[3]

Dubuffet violently attacked all types of pictorial creation. In a number of theoretical texts written at this time, he rebelled against official painting, which he regarded as a trivial form of expression whose sole aim was to reproduce the exactitude of

Jean Dubuffet, rue Lhomond in Paris, 1943.
Fondation Jean Dubuffet, Paris.

photographic plates and which had been reduced to the mere "execution of a trick"; learned and wise, this type of painter survived solely on his reputation. And although Dubuffet expressed respect for the inventiveness of avant-garde artists, he condemned their mania for "bringing back a serious and learned form." He recommended to Matisse, Rouault, Modigliani, and Picasso "a transfusion of healthy, robust blood from the common folks."[4] As to the naïve artists, their recourse to academic painting had the harmful effect of developing inhibitions that served as obstacles to audacity and imagination—this type of art was only a weak compromise. Dubuffet also went so far as to disapprove of folk art, shop signs, and the decoration of fairground stalls and cabarets: although in some respects these had an attractive simplicity, they were too timid, content with repeating a familiar style from which no originality could be derived.[5]

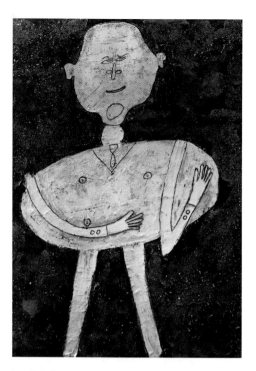

Jean Dubuffet, *White Cingria on a Dark Background*, 1947. Oil on canvas, 4 ft 9 1/2 ins × 3 ft 9 ins (146 × 114 cm). Fondation Jean Dubuffet, Paris.

Pusillanimous, painters copied each other so much that they had simply become "chameleons"— "everyone in Paris, New York, and most other capitals is doing the exact same painting."[6] Dubuffet had reasons for repudiating these works. If art had indeed reached such a degree of insipidness and corruption, this was due to its inflated value in society. The status of the artist had become sacred "when someone made the regrettable discovery that art was the most beautiful and holiest of things, and that there was good reason to bear some sort of devotion to it; and when someone got the idea of the artist as genius . . . People began speaking more and more of the artist's gifts, his vocation, his sacred mission, and other pretentious silliness. They increasingly validated this idea that art . . . is a monopoly reserved for a few rare visionaries put on this planet especially for this mission, and that common mortals have nothing to do with knowing it nor understanding it."[7]

Dubuffet was not only concerned with artists, but also with those "right-thinking" representatives in official places: historians, specialists, experts, dealers, and other lovers of art. All were condemned for the solemnity with which they surrounded the artist. But the most important battle for Dubuffet had to do with the notions of vocation and genius: "I am pretty much persuaded that in every human being there are vast reserves of mental creations and interpretations of the highest value . . . I believe these ideas, no matter how widely held, about rare men who are marked by destiny and privileged enough to have an internal world worth expressing, are entirely wrong."[8] He used as a point of reference primitive societies that, according to him, had an approach toward creative expression that was based on familiarity and complete freedom. In Africa and Oceania, paintings and sculptures were executed by any "common peasant" in the most natural way, "without bothering with ten years of study in a school of fine arts."[9] Dubuffet was here revealing his own aspiration for a harmonious existence, of the kind that he felt primitive societies had managed to conserve. This idealization also served as a tool for criticizing Western philosophical and esthetic values. In his later writings, he violently attacked these values which he contrasted in a Manichean way with those of primitive peoples.[10]

Following the example of Delacroix, Gauguin, and Klee, Dubuffet would undertake a trip to the countries of the Other and the Elsewhere. Between 1947 and 1949, he traveled to southern Algeria on a number of occasions, hoping to get back to the original roots of existence and creativity. But his attempts failed. Unlike the quests undertaken by his predecessors, Dubuffet's resulted in a disenchantment with all exoticism. In the turbulent search for a sort of *tabula rasa,* his roamings became the devastating testimony of a man whose desire for otherness was so intense as to be utopian. What little remained of this utopian vision—the part that mattered most—brought about real action and results.

LONG LIVE THE "COMMON MAN"

The idea of the "common man" is at the heart of Dubuffet's philosophical and artistic theories.[11] Although this common man was revealed *a posteriori* to be a prefiguration of the author of Art Brut,

Jean Dubuffet, *Métro*, 1943. Oil on canvas, 5 ft 3 3/4 ins × 4 ft 3 1/4 ins (162 × 130 cm). Fondation Jean Dubuffet, Paris.

he was to begin with merely a common person, the man in the street in the fullest sense of the term. Very early on, during his troubled youth, Dubuffet was utterly fascinated by this idea: the common man represented life's power and the ideal equilibrium to which he aspired. "When I used to see the young guys talking among themselves in the barbershop in Chaville, the fireman with the butcher or the mailman, I felt like they really fitted in; for them, things seemed to be a whole lot easier, their speech sounded joyful and certain, which made me envious of them; and above all else I felt that there was more life in their disjointed conversations, more surprise and invention, in short more flavor. Let's say the word: more art—yes, more art, and poetry, in the words of the young barber—in his life—in his head—than in those of any specialist on the subject."[12] Later on, after Dubuffet had decided on being an artist, he maintained his keen interest in the common man, toward members of the working class, and the banality of their everyday existence. He drew from this universe the ferment he needed to sustain his iconographic repertory, giving birth to an astonishing series of works during 1943 and 1944, including *Métro*, *Vues de Paris* (Views of Paris), and *Scènes de la ville et de la campagne* (Scenes of the City and Country). During this period, he would wander all day through the working-class neighborhoods of Paris—he even imagined writing a guide to Paris's working-class areas—and tirelessly marveled

at one of the Meccas of the common man: the Saint-Ouen flea market.[13] If André Breton was happy walking through it in search of an unusual object—walks that he described in *Nadja* in 1928—the "find" in keeping with the Surrealist esthetic, Dubuffet on the contrary would discover there a dazzling celebration: "Oh, my festival of man! Heaping multitudes of mankind over there, or flowing by, in front of the pour-through stoppers, gas lighters, all of those great gadgets—in front and also behind because here there is no difference between merchant and customer. The same face—and it's this shapeless face of the *middle-aged* man, which is how man looks most of the time . . . And I like that face. I like the clothes too. They are uniformly gray-black, dusted like the blacktop . . . the same bituminous and soiled brown colors that mankind loves because they are the colors of mankind, the color of his hair, his roads, his walls and fences, his grime. This isn't a festival of pheasants and parakeets but a festival of man."[14]

Dubuffet wanted to associate with this kind of man and make him the ideal audience for his art: "I want my paintings to amuse and interest the man in the street, when he gets out of work, not the finicky, nor the sophisticated, but the man who has no training nor particular opinions. It is the man in the street

Jean Dubuffet with Jeanne Léger's monkey, 1924.
Fondation Jean Dubuffet, Paris.

that I want to make happy. I feel I am like him, he is the one I wish to befriend, to trust, and to be able to count on, and he is the one I want to please and delight."[15] And the artist would go even further, considering these working-class representatives not only as his source of inspiration, but also as the audience most likely to understand his art.

Imagining artistic creation in a festive atmosphere and sharing it with the common man untouched by all esthetic prejudice proved to be a trap: Dubuffet quickly realized that it was a "working-class illusion."[16] Nevertheless, it didn't seem to modify his conception of creation; beginning with the postulate that "art is a pursuit open to everyone that does not require specific gifts, instruction, or prior initiation," all anyone had to do was to refuse imitation and to express oneself "in complete simplicity, for his own pleasure, and quite openly." The common man would assume the traits of the self-taught artist, capable of surpassing any artistic system, with no concern for social recognition. Dubuffet valued "those who've got guts, as they say, [and who] tend . . . to have strong personal tastes that differ from the tastes of those around them, and do the opposite in their lifestyle of what is generally done."[17] Already we can see in this statement an early formulation of the fundamental principles of Art Brut. Self-taught creation, the working class, art that is desacralized or dearistocratized would all lie at the heart of his prospecting. To these would be added other criteria: artistic autism and self-sufficiency, non-conformism and rebellion.

RAW GOLD

During his military service in 1923, Dubuffet was attached to the Office National Météorologique on the Eiffel Tower. There he made a curious discovery one day: "I had . . . to catalogue photographs of clouds and among them I found something that captured my interest. It was a notebook that came from someone living in a suburb of Paris recounting her observations of the sky and illustrated with drawings. They were not depicted as clouds, but as columns of tanks and all sorts of processions and dramatic scenes. I paid many visits to this visionary lady, whose instability turned quickly into complete dementia."[18] Dubuffet corresponded with Clémentine Ripoche for almost a year

Adolf Wölfli, *Saint Adolf's Giant Cask*, 1922. Colored pencil, 20 × 26 3/4 ins (51 × 68 cm). Collection de l'Art Brut, Lausanne.

and gathered a few of her notebooks; he carefully typed out each of her letters—texts that bear a mediumistic stamp.

The encounter with this creator and her visionary drawings marked a decisive moment: it was Dubuffet's first direct contact with this most remarkable form of art. Over the next two decades, the idea gradually evolved, developing in keeping with his anti-cultural positions up until the 1940s. By then, Dubuffet was convinced of the existence of another type of art, that he soon baptized. "I preferred 'Art Brut' instead of 'Art Obscur' [Obscure Art], because professional art does not seem to me any more visionary or lucid; rather the contrary. It would add to the confusion. It would appear as if I were pleading guilty. Why then do you write that gold in its raw state is more fake than imitation gold? I like it better as a nugget than as a watchcase. Long live fresh-drawn, warm, raw buffalo milk."[19]

The seeker for "raw gold"—now known as "Art Brut"—didn't burden himself with detailed explanations. His convictions were more intuitive than discursive. Eager to find this "raw, warm, fresh-drawn" art, Dubuffet left for Switzerland.

TRAVELS IN SWITZERLAND

It was in Switzerland in 1945 that Dubuffet began his first enquiries, formed his first friendships, and made his first discoveries. Adolf Wölfli, Aloïse, Heinrich Anton Müller, and the Prisonnier de Bâle would become major figures in Art Brut, and their works would form the core of his collections. To begin with, we should explain the mystery of why Dubuffet searched for dissident art in what is apparently the most conformist country in the world.

"Thank goodness we have our long underwear with us," Dubuffet wrote to Jean Paulhan. "Seven

39

Aloïse, *Benito Cereno*, 1947. Colored pencil, 4 ft 11 ins × 3 ft 3 1/2 ins (150 × 100 cm).
Collection de l'Art Brut, Lausanne.

degrees in Lausanne! The Swiss have on Mongolian shepherd's hats ... We go from party to party here in this country of parties: Sunday night with Auberjonois, yesterday with Mermod, today with Budry and his companion from Vienna whose birthday was yesterday too. And now we are splitting up. One of us is leaving with his ambassadors and the other is leaving with his madmen. I am catching the train to Geneva in just a moment, and René Drouin is headed to Bern. I will head to Bern Thursday, and perhaps we will meet up there. Then I am going to Basel. Maybe he'll go too. He thinks the Swiss girls are very pretty, and his orders for dessert possess a demented perversity (bananas flambé with vanilla ice cream) because there are bananas and mandarins. I am reading *Le Théâtre et son double* [Theater and Its Double] by Antonin Artaud and marvel at finding that his ideas are the same as mine."[20] Dubuffet was already familiar with Switzerland; he had stayed in Lausanne in 1923 and in 1934, and for more than twenty years he had kept in regular contact with the writer and art critic Paul Budry, as well as René Auberjonois. He doubtless met them through his friends Charles-Albert Cingria and Blaise Cendrars, who were Swiss expatriates living in Paris.[21] He was also in touch with Henry-Louis Mermod, an editor in Lausanne.[22] Moreover, after some marital problems, Dubuffet went off by himself for a month to the Alps in Valais. His view of Switzerland as a place of wild, primitive nature surely gave rise to a "generous extrapolation,"[23] especially one time when he declared that "Switzerland is a funny country. The people, in appearance, are conformists, they seem very deferential in regard to institutions and established order, but one notices among them that they keep a certain distance in respect to culture; they are more international, less the loyal subjects of an official culture."[24] It is necessary to put this image of Switzerland into the context of the 1930s and 1940s, when cultural life was marked by various impulses whose characteristics should be noted.

Between the two world wars, several exhibitions revealed to the public works that were very different from the ones they were accustomed to seeing in museums. In November 1929, Waldemar Deonna, curator of Geneva's Musée d'Art et d'Histoire, mounted an exhibition on the mediumistic works of Hélène Smith.[25] The same year, the Gewerbemuseum

Paul Budry, photograph by Germaine Martin.
François Martin Archives, Geneva.

in Basel exhibited vast collections of works by the mentally ill; in January 1930, the museum in Geneva did likewise.[26] This last exhibition was discussed in the local press and was covered by foreign newspapers in Paris, Brussels, and Cairo.[27] During the spring of 1930, the drawings of the "insane artist" Adolf Wölfli were shown at the Gewerbemuseum in Winterthur alongside the drawings of children.[28] These exhibitions were not universally popular with the public and provoked some indignation, but they testified to the courage of the curators who affirmed the esthetic qualities of mediumistic and asylum works. They stand as crucial moments in the history of Swiss art and society.

In a much more indirect way, Albert Skira played an important role. From 1933 to 1939, the publisher from Geneva published the celebrated review *Minotaure*, which involved artists, writers, poets, philosophers, critics, psychoanalysts, and ethnologists. The publication's orientation was experimental; it brought to light hidden realms of art, reproduced the drawings of the insane, mediumistic messages, African ritual objects, postcards, decalcomania, and

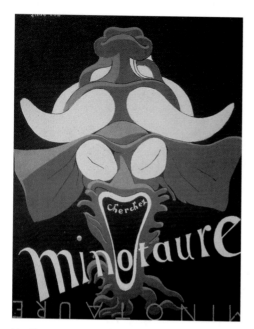

Max Ernst, cover of the journal *Minotaure*, number 11,
May 15, 1938.

graffiti. *Minotaure* devoted a number of pages to
the work of the visionary creator Louis Soutter.[29]
This review undoubtedly influenced cultural life in
Switzerland with its open-mindedness and new
ideas.[30]

During the summer of 1945, the Swiss National
Office of Tourism invited a number of French per-
sonalities to visit the country, in order to renew cul-
tural contact between the two nations. Paul Budry,
then the director of the organization's Lausanne
bureau, hosted his friend Jean Dubuffet, who was
accompanied by Jean Paulhan and Le Corbusier,
from July 5 until July 22. The trip became leg-
endary in the history of Art Brut because it marked
the beginning of the venture.

The artistic forms which Dubuffet was drawn to
were situated a million miles away from traditional
cultural models. These works were created in
remote places, springing up out of exclusion and
confinement. To begin with, Dubuffet drew on
works from psychiatric hospitals. Jean Starobinski
has offered an illuminating reading of the works
produced at this time by certain creators interned in
hospitals: "Figures molded out of breadcrumbs,
statues built out of available materials, drawings
traced on toilet paper . . . the schizophrenic artist
had to use cunning in order to gain access to the
means of his work. Obtaining them through difficult
conflict, the artist proved that artistic activity is
vital. As if, reduced by his incarceration to possess-
ing no more than his own body, the artist had sud-
denly discovered objects and surfaces that he could
treat as extensions of his body and history. Very
often for the artist, it was a way of dealing with the
'passage to chronicity,' of responding to it, and
peopling an appallingly empty space. Prolonged
hospitalization and the absence of any therapy con-
tributed to the making of artistic works, the only
outlet for the sick patient's expression once he had
discovered the possibility. Next to sick people who
would sink into catatonic sterility, a few secret flow-
ers here and there would bloom in the hands of
Wölfli, Aloyse, 'Brendel.'"[31] In fact, at the beginning
of the twentieth century, being committed was noth-
ing more than detention. Isolation or promiscuity,

Vili mask (Congo). Painted wood,
height 10 1/4 ins (26 cm). Musée de l'Homme, Paris.

42

Oskar Voll, figures, silhouettes, undated. Pencil, 24 3/4 x 15 1/4 ins (63 x 39 cm). Prinzhorn Collection, Heidelberg.

idleness and exclusion, the burden of oppression and despair engendered in some of them a lethargic state that paradoxically favored the development of the imagination. Dubuffet realized this; he kept in mind the virulence of the works reproduced in Prinzhorn's book, *Bildernei der Geisteskranken*, which Paul Budry had given him. In his own right, he imagined tracking down dissident art among domestic exiles: "The pictures in Prinzhorn's book struck me very strongly when I was young. They showed me the way and were a liberating experience. I realized that everything was permitted, everything was possible. Millions of possibilities of expression existed outside of the accepted cultural avenues."[32] Dubuffet would find this confirmed in Switzerland's asylums.

Dubuffet came up with the idea of publishing a series of journals under the title *L'Art Brut*, for which he had received approval from Gaston Gallimard before his departure. Paul Budry arranged his visit

43

Johann Knopf, *Magnificence of Hunting Lead*, undated. Pencil, pastel, gouache, and pen, 8 1/4 × 13 ins (21 × 33 cm). Prinzhorn Collection, Heidelberg.

and obtained interviews for him with some twenty individuals—curators, doctors, publishers, writers, and artists. A number of meetings proved fruitful. Jacob Wyrsch, director of the university psychiatric clinic at Waldau in Bern, together with Walter Morgenthaler, showed him the works of Heinrich Anton Müller and Adolf Wölfli.[33] Many works by patients had been carefully selected for the hospital's "little museum," which he was invited to tour. At Morgenthaler's urging, Wölfli had embellished the closets and windows of his small study with drawings. Dubuffet also had access to the establishment's attic, where the patient's encyclopedic, magisterial works were stored. The artist was speechless in front of these exceptional creations, and found his resolve even stronger than before. Furthermore, the doctors' warm welcome and the open-mindedness that they had shown toward his research persuaded him to include them in his project. They accepted immediately, subscribed to his idea, and promised to collaborate with the *L'Art Brut* series. Numerous drawings by Wölfli and Müller would be photographed and accompanied by a short monograph signed by each psychiatrist.

Upon his return to Lausanne, thanks to all the people he met, Dubuffet went from one discovery to another, not least the sumptuous ink drawings by Louis Soutter, completed in solitude at a retirement home in a remote village in Ballaigues, near Vallorbe in the Jura. Dubuffet marveled at the originality of this creator who had passed away a few years before, to almost complete indifference. He had been introduced to his work by his friend René Auberjonois. Le Corbusier, Soutter's distant cousin, had doubtless already praised his talents to him. The painter accepted Dubuffet's proposal and agreed to write an introduction to these works.[34] During this same visit, Dr. Georges de Morsier showed Dubuffet the hallu-

August Natterer, *Witch's Head*, undated. Pencil, watercolor, and pen, 10 1/4 × 13 1/2 ins (25.9 × 34.2 cm). Prinzhorn Collection, Heidelberg.

cinatory works of his patient Marguerite Burnat-Provins, who had committed to paper strange visions: faces in which the animal is combined with the human.

Dubuffet's Swiss tour took him to Geneva and the Musée d'Ethnographie, where he met its director, Eugène Pittard. There the terrifying masks from Lötschental caught his attention, as well as two watercolors completed by a patient at the Bel-Air asylum. Upon Dubuffet's departure, Pittard promised him some photographs of folk masks and also agreed to compose a text for the *L'Art Brut* series. Moreover, he proposed putting Dubuffet in contact with Charles Ladame, director of the city's psychiatric institution, who was also passionate about the art of the insane.

If his stay in Switzerland that summer in 1945 has become legendary in the history of Art Brut, it is because the visit had all the characteristics of a

Armoire painted by Adolf Wölfli, undated. Universitäre Psychiatrische Dienste, Bern.

Louis Soutter, *Alone*, undated. Black ink finger painting, 25 1/2 × 19 3/4 ins (64.9 × 50 cm). Musée Cantonal des Beaux-Arts, Lausanne.

A page from Jean Dubuffet's journal, *Trip to Switzerland*, about his first trip to Switzerland in July 1945. Collection de l'Art Brut.

Marguerite Burnat-Provins, *Anthor and the Black Bird*, 1922. Watercolor, 14 3/4 × 13 ins (37.6 × 33.2 cm). Collection de l'Art Brut (Collection Neuve Invention), Lausanne.

real rite of passage. The people that Dubuffet met were not merely members of gracious hospital staffs, they also became his friends, providing him with their invaluable knowledge and suggestions. They automatically agreed to collaborate with what was yet a precarious venture. Dubuffet's notes about this trip attest to his exuberant enthusiasm and the abundance of information he gathered.[35] The investigator had moved from intuition to conviction: "The city of Lausanne was in 1945 the point of departure for my research and the nucleus of voluntary collaborations that snowballed," he declared.[36]

After this first step, Dubuffet maintained a continuous, voluminous correspondence with his Swiss friends, and his visits to Switzerland increased. Later, he would get to know prominent doctors, such as Charles Ladame from Geneva; both shared the same views on the artistic expression of the insane. The psychiatrist opened up for him the doors of his "little museum of madness," where over the course of his career he had gathered

```
Juillet 1945

Ma visite à Mr Eugène Pittard, conservateur du Musée
d'Ethnographie de la Ville de Genève, 65 Bould Carl
Vogt à Genève .

Marguerite Lobsiger-Dellenbach
Adjointe au Directeur du Musée .

1°) Peintures de LUBACKI, indigène nègre du Congo
Belge . Mr. Pittard va en faire photographier trois
et les faire tenir pour moi à Paul Budry . Mr Pittard
fera une monographie sur cet artiste .

2°) Dessins de Berthe Urasco ( folle ) . Mr Pittard
va en faire photographier trois et les adresser à
Paul Budry .

3°) Peintures d'un indigène d'Abyssinie ( voir ARCHIVE
SUISSES D'ANTHROPOLOGIE GENERALE, Tôme V, N°1 ( 1928/
1929) Albert Kundig, Editeur, 10 Rue du Vieux Collège,
Genève )

-------------------------------------------------

Mr Pittard me conseille d'entrer en rapports avec le D
Ladame, 13 Quai Capo d'Istria à Genève ( qui doit
avoir affaire à l'Hopital de Bel-Air, asile d'aliénés)
spécialiste des dessins et peintures de fous .
Il me signale aussi Mlle Smith, le medium du Dr
Flournoy, et son livre : "Des Indes à la Planète Mars"
Et le tableau de Marcel Lenoir : "Quand je serai fou".
Et Mme Dellenbach me parle des bambous gravés de
la Nlle Calédonie que possède le R.P. O'Reilly et il
y en a aussi 27 au Musée de l'Homme .
```

Heinrich Anton Müller, *Man with Runny Nose*, 1917–22. Watercolor and chalk on wrapping paper, 29 1/2 × 17 3/4 ins (75.4 × 45 cm). Collection de l'Art Brut, Lausanne.

Masks from Lötschental (Valais) and Flums (Saint-Gall) c. 1940. Multicolored wood carvings, height approx. 15 3/4 ins (40 cm). Musée d'Ethnographie, Geneva.

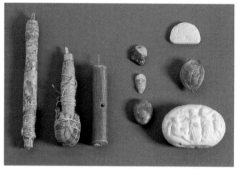

From Ladame's collection of objects made by psychiatric patients. Collection de l'Art Brut, Lausanne.

Dr. Charles Ladame, c. 1940.
Collection de l'Art Brut, Lausanne.

together the works of his patients: drawings by Joseph Heu and Berthe Ura, calligraphic works by Jean Mar and Robert Gie.[37] Other sources allowed Dubuffet to cull new works; for example, the colorful designs for Aloïse's theater were shown to him by the young Swiss doctor Jacqueline Forel. Stirred by these compositions, he paid a visit to the creator in Gimel, accompanied by the doctor and René Auberjonois. The latter would report on the strangeness of the meeting, describing how Aloïse "agreed to a meeting before her drawings, hundreds of which she executes with incredible rapidity. Her hands worried me, so elastic and agitated that I already felt seized by my jaw and strangled with pleasure. She was a young girl with gray hair, very neat, but still at the same time very fretful."[38] Later, Dubuffet's prospecting would lead him to share his passion with Professor Hans Steck, who for more than twenty years had carefully and perceptively attended to and collected his patients' works, particularly those of Aloïse.[39] Finally, Basel would play a dominant role in the history of his discoveries. The director of the Strafanstalt-Basel, a penitentiary, would show him breadcrumb statues made by Joseph Giavarini, better known as the Prisonnier de Bâle.

Jean Mar, *Round Faces*, c. 1908. Pencil and ink, 1 1/4 x 6 1/4 ins (3.5 x 15.7 cm). Collection de l'Art Brut, Lausanne.

49

Robert Gie, *Three Persons Visited by Smells*, c. 1916.
Pencil and India ink on tracing paper, 19 1/4 × 24 1/2 ins (49 × 67 cm).
Collection de l'Art Brut, Lausanne.

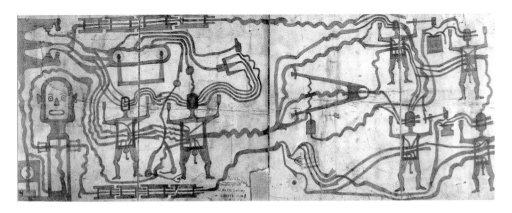

Robert Gie, *Cosmic Circulatory System of Smells*, c. 1916.
Black pencil on gray cardboard, 12 1/4 × 35 ins (31 × 89 cm).
Collection de l'Art Brut, Lausanne.

Aloïse, *Archaic Stained-Glass*, between 1925 and 1933. Black pencil and colored pencil on cardboard, 28 × 10 1/4 ins (71 × 26 cm). Collection de l'Art Brut, Lausanne.

Aloïse, March, 1963. Photograph by Henriette Grindat. Collection de l'Art Brut, Lausanne.

VISITS TO THE SOUTH OF FRANCE

Dubuffet left for the South of France in September 1945; he crossed France and met Dr. Gaston Ferdière, director of the psychiatric hospital in Rodez, and stressed the importance of this visit within the context of his research.[40] The name of Ferdière is linked to that of Antonin Artaud—who was his patient during the war—but it is also linked to the avant-garde art scene in Paris during the 1930s; at that time, Ferdière associated with many artists and was friendly with the Surrealists, particularly André Breton and Marcel Duchamp. A number of them would come by the Sainte-Anne asylum, where the doctor was then stationed, and they would discuss the art of the insane. Prinzhorn's work, *Bildnerei der Geisteskranken*, was their favorite. In those years, Gaston Ferdière, "fascinated by all that was bizarre," was gathering the works of his patients

Dr. Gaston Ferdière and Antonin Artaud at the hospital in Rodez, 1946. Gaston Ferdière Archives.

The Prisonnier de Bâle. Collection de l'Art Brut, Lausanne.

The Prisonnier de Bâle, *Chopped off Head with a Goatee*, between 1928 and 1934.
Unidentified material, height 6 1/4 ins (16 cm).
Collection de l'Art Brut, Lausanne.

and included them in his collection of "a little bit of everything," made up of various unusual objects.[41] Alerted to the interests of this doctor, Dubuffet asked him to support his project.

Ferdière kindly welcomed him and, thanks to his numerous contacts, pointed him in several directions; he advised him to begin contacting a number of psychiatrists who took an interest in the creations of their patients, among whom was Lucien Bonnafé who was caring for Auguste Forestier at the Saint-Alban-sur-Limagnole clinic in Lozère. When Dubuffet left Rodez, he not only had a notebook full of invaluable addresses, but also the memory of Guillaume Pujolle's colored ink drawings, which he had doubtless discovered in Ferdière's collection.[42] When he arrived at Saint-Alban, Dubuffet was not able to meet with Forestier, but this did not prevent him from marveling at the artist's sculptures roughly blocked out of wood and embellished with scraps of leather and fabric. Paul Eluard, a friend of Dr. Bonnafé, had sought refuge in this hospital for a few months during the winter of 1943, and while there he had admired and acquired Forestier's statues—it is clear that he must then have shown his discoveries to Tristan Tzara, Picasso, and Dora Maar, all of whom possessed a few of them. With the

The Prisonnier de Bâle, *World Station* (detail), between 1928 and 1934. Breadcrumbs, height 36 1/4 ins (92 cm). Collection de l'Art Brut, Lausanne.

publication of the *L'Art Brut* series in mind, Dubuffet had Eluard's works and those owned by Raymond Queneau photographed.

From the beginning, France proved to be particularly fertile ground; two creators whom Dubuffet associated with his adventure, Guillaume Pujolle and Auguste Forestier, were major representatives of Art Brut, and, together with Wölfli, Aloïse, and Müller, they would form the nucleus of the future collections. A considerable range of Art Brut creations were also flowering in other countries, such as Germany, Italy, England, and the nations to the east and north, where Dubuffet would have been able to find material for enriching his collection. The search was continued by letter in various European countries, as well as in Mexico and Haiti, but ultimately it came to nothing.

Auguste Forestier, *The Chosen One*, 1914. Colored pencil on paper, 12 1/2 × 9 1/4 ins (31.6 × 23.5 cm). Lucien Bonnafé Collection, on loan to the Musée d'Art Moderne, Villeneuve-d'Ascq.

JEAN DUBUFFET SPOKESMAN

"Yesterday evening Papa Gaston received me and my Art Brut (transported in two suitcases) and was in the most friendly, attentive, affable of moods, and patiently listened to my entire account (a little long and dense perhaps) and examined all of my files . . . He appeared to be very interested. We agreed that I would do a quick outline of the entire first journal [in the *L'Art Brut* series]. After all of that, I am trying to write a sort of opening declaration to come at the beginning of the first one," Dubuffet wrote to Jean Paulhan after his return.[43]

After conducting his searches from 1945 to 1947, Dubuffet decided to gather the artists and their creations into a work that would be published as a series of journals. At this time, he was not looking to acquire any works by Aloïse, Wölfli, or Forestier, but contented himself with having a large number of their drawings, sculptures, and paintings photographed for his publications. If he was not collecting, he was writing even less: the texts that he expected to bring out in monographs on Art Brut were really requests addressed to the attending

Auguste Forestier, *Untitled (Two Men Smoking)*, undated. Colored pencil on paper, 6 3/4 × 9 ins (17.3 × 22.5 cm). Lucien Bonnafé Collection, on loan to the Musée d'Art Moderne, Villeneuve-d'Ascq.

Auguste Forestier, *Winged Monster with Fish Tail*, undated. Wood sculpture, length 27 1/2 ins (70 cm). Collection de l'Art Brut, Lausanne.

Guillaume Pujolle, *Fortification. Rebirth of the Musketeers*, 1937. Pharmaceutical products on paper, 12 1/2 × 19 1/2 ins (31.6 × 49.2 cm). Lucien Bonnafé Collection, on loan to the Musée d'Art Moderne, Villeneuve-d'Ascq.

Guillaume Pujolle, *Bird*, 1937. Pharmaceutical products on paper, 11 1/2 × 9 1/4 ins (28.9 × 23.4 cm).
Lucien Bonnafé Collection, on loan to the Musée d'Art Moderne, Villeneuve-d'Ascq.

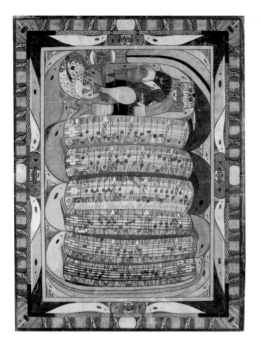

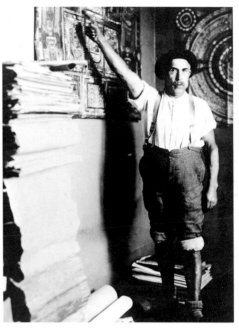

Adolf Wölfli, *Saint Adolf Bitten on the Leg by the Serpent,*
1921. Colored pencil, 26 3/4 × 20 ins (68 × 51 cm).
Collection de l'Art Brut, Lausanne.

Adolf Wölfli in his cell.
Collection de l'Art Brut, Lausanne.

doctor, to a friend, an expert on theories of creation,
or even a particular artist.

No talking, nor buying, nor writing. That is what
Dubuffet's motto seemed to be during the prehis-
tory of Art Brut; he wished instead to keep back and
play the role of spokesman and messenger for these
creators. Messenger and not discoverer: in fact,
Dubuffet did not credit himself with the discovery
of Heinrich Anton Müller's works, nor those by
Adolf Wölfli. He knew that their creations had
sparked Prinzhorn's interest more than thirty years
earlier and that for a number of decades the works
of many insane artists had caught the attention of
certain doctors as well. "The absurd idea of taking
credit as the 'discoverer' of Art Brut never occurred
to me . . . I think in the end that the true discoverers
of Wölfli's art or Aloïse's are none other than
M. Wölfli and Mme. Aloïse themselves and that the
competition among people who want to be recog-
nized as the first to have held them in high regard is
entirely pointless."[44]

ART BRUT IS NOT "INSANE ART"

Dubuffet did not limit the scope of his investiga-
tion to the field of psychiatry and stated quite
early that "these publications in question entitled
L'Art Brut are meant to be about not only the art
of the insane, but also much more generally about
works of art done by people who are strangers to
the ordinary art world, knowing little about cur-
rent works of art, or perhaps even deliberately dis-
tancing themselves from all of that."[45] Dubuffet
did not use mental illness as the basis for his
search, and Art Brut was not associated purely
with the art of the insane. From this point on,
Dubuffet began working out his own conception
of madness, which would be connected funda-
mentally to genuine creation: "Naturally, there
will also be [in the *L'Art Brut* series] the mad, but
not as the mad. Hasn't madness been passed
down to all human beings and do any works of art
exist that haven't tasted its fruit?"[46]

Dubuffet widened the scope of his prospecting
over the months that followed his first travels

Somuk, untitled, undated. Black pencil and colored ink, 9 x 8 1/4 ins (23 x 21 cm). Collection de l'Art Brut (Collection Neuve Invention), Lausanne.

Child's drawing. Gouache on paper, 9 1/2 x 12 ins (24.5 x 30.5 cm). Collection de l'Art Brut (Collection Neuve Invention), Lausanne.

Child's drawing, 1939. Gouache on paper, 10 x 12 ins (25.4 x 30.5 cm). Collection de l'Art Brut (Collection Neuve Invention), Lausanne.

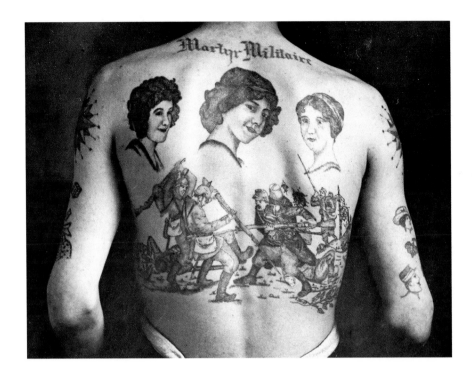

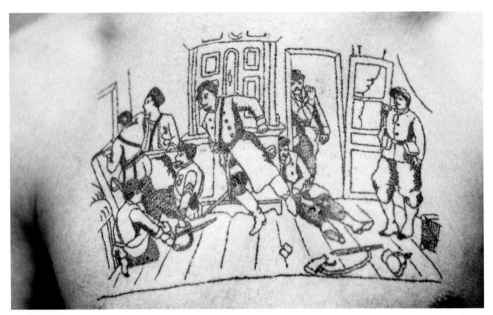

Tattoos. Iconographic documentation of the Compagnie de l'Art Brut. Collection de l'Art Brut, Lausanne.

"Sun King" graffiti, c. 1950.
Photograph by Brassaï. © Gilberte Brassaï.

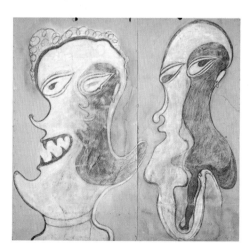

Heinrich Anton Müller, *Two Faces*, between 1917 and 1922.
Pencil and chalk, 2 ft 6 3/4 ins × 2 ft 8 3/4 ins (78 × 82 cm).
Collection de l'Art Brut, Lausanne.

because of his new contacts and exchanges of correspondence. Art Brut was not reduced to the "art of the mad"; the selection of works included in his project attests to that conviction. His vision of this dissident art became kaleidoscopic in nature—though only temporarily. In the *Situation des cahiers de "L'Art Brut"* (Situation of the "Art Brut" Series), written on October 14, 1946, and addressed to Gaston Gallimard,[47] he set out how he planned to arrange the works in sixteen short journals: beside the recently discovered works from asylums, he would place folk works—the "Barbus Müller" statues and the Lötschental masks; works from Oceania—the Melanesian paintings from Bougainville by Somuk; paintings done by self-taught artists—Trillhaase and Capderoque; drawings by children from Egypt and England; as well as the art of tatoo. His attention was also drawn to Brassaï's photographs of cave paintings and graffiti,[48] to works from the Congo and Polynesia, and even works completed by the paralyzed, to whom he planned to devote an entire journal in the series. "I am convinced that this art is more alive and passionate than any of the boring art that has been officially catalogued—even that of the avant-garde," he proclaimed.[49]

ELUSIVE AND INDEFINABLE

The diversity of these plans shows that the "outline" of Art Brut was still not clearly defined in Dubuffet's own mind; his thinking still betrayed the influences that arose from the interest in primitivism that dominated the early part of the twentieth century. His choices remain tinged by the important movements that motivated the avant-garde artists and intellectuals in Europe. All the same, the selection of works reveals a clear predilection for productions that deviate and distance themselves from traditional Western esthetic norms. It is clear that Dubuffet was the first who yielded to Art Brut's virulence and irreducibility: "I am working on the inaugural article for the *L'Art Brut* series; it is really quite painful for me. I would like it to be well done: not pedantic—not too heavy—not sententious, nor aggressive, etc., and it is all of that to some extent so I have to start over in a different vein. It has to be a little 'Art Brut.' What a job! I am sweating."[50] He finally decided to content himself with "a short

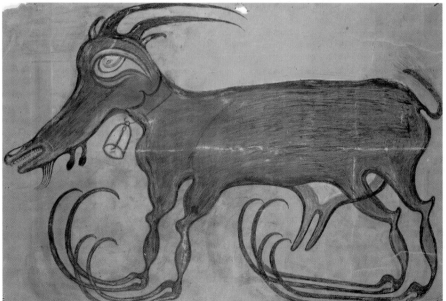

Works catalogued for iconographic documentation by the Compagnie de l'Art Brut. Location unknown.

Heinrich Anton Müller, *Goat*, between 1917 and 1922. Chalk and pencil on cardboard, 17 1/2 × 26 1/4 ins (44.5 × 66.5 cm). Kunstmuseum, Bern.

Adolf Wölfli, *The Giant Violet*, 1916. Colored pencil, 24 1/2 × 18 1/2 ins (62 × 47 cm). Collection de l'Art Brut, Lausanne.

announcement a few lines long entirely free of silly pretentions, identifying the goals of this series as simply and politely as possible since it is proper to do so in this case and all others."[51] At the end of his text, Dubuffet admits the hold Art Brut has on him and makes it understood that he was committed despite all opposition to defending it and celebrating it: "Naturally, Art Brut is very difficult to define without getting confused (I know something about that, having struggled with it for two weeks). But there is no reason for saying that something does not exist because it is elusive and indefinable."[52]

He would further specify his notion of Art Brut by definitively excluding from his proposal works derived from any tradition, namely primitive art, folk art, naïve art, and children's art.[53] Furthermore, artists who had been formally schooled, such as Marguerite Burnat-Provins and Louis Soutter,

who were initially part of the collections during Art Brut's gestation, would be kept apart. Dubuffet would concentrate on European creators and would orient his search toward the insane and the socially isolated, eccentrics and the maladjusted, the self-taught, and those who resisted or were free of culture.

OTHERNESS AT HOME

Delacroix had gone in search of otherness in Morocco, Gauguin on the islands of the South Seas, Nolde in New Guinea, and Dubuffet in the Algerian desert . . . All of them had left their country in search of the Other and the Elsewhere. In the same spirit, some painters had looked to marginal forms of artistic expression as a path to salvation. Archaism, primitivism, exoticism, folklore, childhood, and madness represented regions

of otherness; Western civilization had welcomed foreign peoples and uncivilized art. But it really amounted to the invocation of parallel institutions. This Other would linger in the domain of homology.

An extreme form of otherness existed nearby, almost at home, rising up out of the creators' belligerent energy, and this otherness was more striking than the otherness introduced by other cultures, no matter how distant. Those who had rejected social integration, whether voluntarily or not, were producing works of a radical, offensive otherness. Strange effigies painted on ordinary cardboard, a delirious bestiary out of scraps of rough-hewn wood, imaginary pieces of music, calligraphy on scraps of paper; these works defied classification. In his attempt to free himself from all influences and tradition, Dubuffet was even more receptive to Art Brut's autonomy, which had no roots or home base. These "extremists in thinking and feeling" had access to the strangeness of the Other and the Elsewhere.[54] The intensity of the adventure drew these people into the most dissident of exiles, the "inner exile."

CREATION OF THE FOYER DE L'ART BRUT

"I remember the shocking effect that exhibitions at the Foyer de l'Art Brut had on me . . . There was indeed something new there and far more exciting than most art by 'artists,'" Michel Ragon attested.[55] In the 1940s, Art Brut stood in contrast to the art being produced on the Parisian cultural scene, where abstraction was gradually making itself felt. Various exhibitions displayed the works of such pioneers as Kandinsky and Mondrian, as well as those of Jean Arp and Sophie Taeuber-Arp, and Robert and Sonia Delaunay. In 1946, the Salon des Réalités Nouvelles opened its doors, exhibiting nothing but abstract works. The painters of the new

Poster for the Foyer d'Art Brut, 1947.
Collection de l'Art Brut, Lausanne.

Aloïse, *Marie-Antoinette*, undated.
Colored pencil, 9 1/4 x 6 1/4 ins (23.3 x 16 cm).
Collection de l'Art Brut, Lausanne.

FOYER D'ART BRUT

A dater du 15 novembre 1947, une des salles du sous-sol de la GALERIE RENÉ DROUIN, 17, Place Vendôme, PARIS (Tél.: Opéra 94-00), sera affectée aux enquêtes sur l'Art Brut. Une permanence y fonctionnera, tenue par M. Michel Tapié, et ouverte à tous visiteurs. On trouvera là de quoi s'informer. On y pourra examiner des peintures, statuettes, dessins, objets et ouvrages divers. Des expositions raisonnées y seront faites périodiquement.

Juva, *Man's Head*, 1948–49. Black flint, height 8 ins (20 cm).
Collection de l'Art Brut, Lausanne.

Juva, *The Érynnie*, 1948–49. Flint, height 11 ins (28 cm).
Collection de l'Art Brut, Lausanne.

Joaquim Vicens Gironella, untitled, between 1946 and 1948.
Cork sculpture. Location unknown.

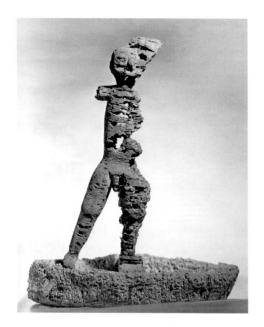

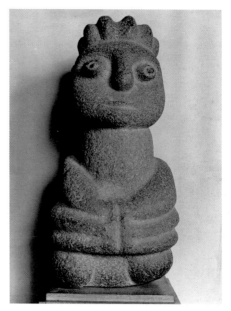

Joaquim Vicens Gironella. *Shadow of the Clever One*, undated. Cork sculpture, height 10 3/4 ins (27.5 cm). Location unknown.

Barbus Müller, sculpture. Location unknown.

The Foyer de l'Art Brut in the basement of the Galerie René Drouin, February 1948. Collection de l'Art Brut, Lausanne.

The Foyer de l'Art Brut in the basement of the Galerie René Drouin in Paris. Exhibition devoted to Jan Krizek, February 1948. Collection de l'Art Brut, Lausanne.

generation, such as Jean Bazaine, Alfred Manessier, Tal Coat, and Maurice Estève, also began working in a similar vein.

At that time, the Foyer de l'Art Brut was showing the royal and princely figures drawn by Aloïse, flints hewn by Juva, and Gironella's bas-reliefs sculpted out of cork. Given the artistic context of the period, visitors must have felt an intense visual and emotional shock on discovering such works. The Foyer's exhibitions were subversive. Dubuffet was going against the flow: "I believe that the position of my art and my views on art are as unconnected from the 'problems and tendencies of art today' as the hiker with a backpack tramping through beets and plowed fields is from the railroad network and the movements of the great express trains."[56]

Gaston Gallimard did not follow through with the publishing of the *L'Art Brut* series and broke the contract signed May 16, 1947; only the first edition devoted to "Barbus Müller" was printed, but it was never distributed. Having anticipated the editor's withdrawal, Dubuffet in the meantime sought help from the art dealer René Drouin, who agreed to

LES BARBUS MÜLLER

et autres pièces de la statuaire provinciale

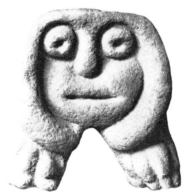

Gallimard

The Barbus Müllers. Cover of fascicule 1, Gallimard, 1947. Collection de l'Art Brut, Lausanne.

66

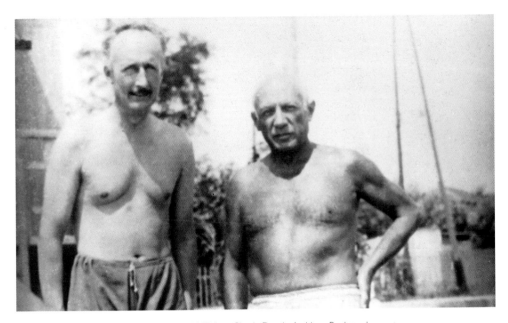

René Drouin and Pablo Picasso in Golfe-Juan, 1947. Jean-Claude Drouin Archives, Rochecorbon.

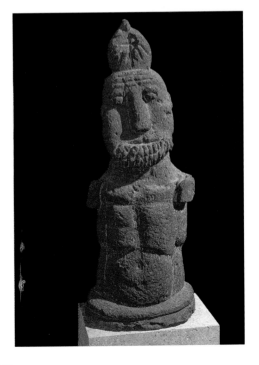

donate space in his gallery's basement to the display of Art Brut. "You would enter the basement of the gallery through a hallway entrance which opened up on Place Vendôme [at no. 17]," Jean-Claude Drouin remembered. "The set-up in the basement was rather precarious and very somber. The walls were draped in burlap. Three or four openings on the side next to the Hotel Ritz's garden brightened it up some, but, low down as they were, they were really in fact only large basement windows. I think I remember that aside from Jean Dubuffet, who was the instigator and the only significant person connected to Art Brut, some writers and personalities in the art world were interested in this movement but no more than that. The idea amused a lot of intellectuals, but, aside from Jean Dubuffet, the whole thing wasn't considered very important. I can name Jean Paulhan, Georges Limbour, Michel Tapié, André Breton (though I never saw him on the Art Brut premises) . . . The few exhibitions that took place had a limited number of visitors and, as I recall, some initiates."[57]

Barbus Müller, *The Bishop, Man with a Crown*, undated.
Lava sculpture, height 37 3/4 ins (96 cm).
Collection de l'Art Brut, Lausanne.

67

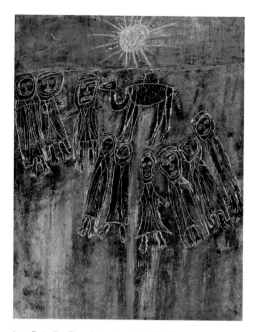

Jean Dubuffet, *They Go to Council*, 1947. Oil on canvas,
57 × 44 ins (145 × 112 cm). Fondation Jean Dubuffet, Paris.

Opened at the beginning of the war with the help of the dealer Léo Castelli, René Drouin's gallery during the 1940s mounted daring exhibitions of artists who were little known, such as Georges Rouault and Kandinsky, or totally unknown, such as Dubuffet, Jean Fautrier, Wols, and Henri Michaux. His gallery was "a crucible where H. Michaux, Paulhan, and others would get together with R. D. [René Drouin] at night to discuss projects," Jean-Claude Drouin recalls again. "I can remember, when I was living for a time in the basement, lively meetings where the critical spirit seemed to me well developed, caustic even."[58] René Drouin, who had rapidly acquired a reputation as a gallery owner with a sharp eye, played an important role in the postwar period. He became the first person to open his doors to the Art Brut venture, thanks in part to the prompting of Jean Paulhan. He had also been exhibiting Dubuffet's work since 1944, and the two had grown close. So it was in a dark, underground, north-facing space that these silent, secret, shadowy works were housed. Dubuffet named it the Foyer de l'Art Brut, with the word *foyer* suggesting the idea

of a safe haven, a sort of club or community center, where one could join with others to drink, talk, and warm up. Here he deposited the documents, photographs, and information gathered together over the course of more than two years.

The Foyer de l'Art Brut was inaugurated in November 1947 with an exhibition of the strange statues in black basalt that Dubuffet had baptized "Barbus Müller."[59] The absence of any indication of who their creator was or what their origins were shrouded the "characters" with a mysterious muteness that Dubuffet thought was appropriate for the opening show. These pieces—reproduced in the journal devoted to them—belonged to the Swiss collector Joseph-Oscar Müller, to the primitive art specialist Charles Ratton, and to the writer Henri-Pierre Roché. Dubuffet managed to get a number of friends to share his enthusiasm and they began to spend time at the Foyer. For his part, the musician and critic Michel Tapié contributed rather odd, small, cement medallions made by an innkeeper from the South of France, Henri Salingardes, a dozen of which were included in the exhibition.

From the beginning of the adventure, Dubuffet combined his own work as an artist with his exploration of Art Brut, the first often interfering with the development of the second—though he did put aside the latter in order to free some time for his own personal work. In 1947, his two trips to North Africa, to Algiers then to El Goléa, inspired him to stay in the western Sahara with the Bedouins. Fascinated by their culture, in his eyes the repository of primitive values, Dubuffet left Paris at the end of the year and spent five months in Algeria. He learned Arabic, painted, drew, and sought to integrate himself into desert life and to share in the existence of his hosts. He returned from North Africa in the spring of 1949. His Saharan experiment had cut him off from the Foyer de l'Art Brut, whose keys he had for the moment given to his friend Michel Tapié.

THE FOYER UNDER THE DIRECTION OF MICHEL TAPIÉ

"A few months ago in Paris . . . a foyer under the title 'Art Brut' was founded for the centralization and exhibition (and sale) of Art Brut paintings, sculptures, etc., and all other objects connected to a

Henri Salingardes. Collection de l'Art Brut, Lausanne.

type of art that we like [with] the hope of developing the public's appreciation of them . . . Our enterprise has met with success; many well-known individuals in the art world from Paris and foreign capitals have visited us and warmly supported our activities. We are planning to mount exhibitions in foreign countries too."[60] During the months the Foyer was under his direction, Michel Tapié was very active: he tracked down a number of leads that turned out to be very productive and discovered some remarkable creators whose works he showed in the basement of the Galerie Drouin. An article announced that "a bass player from the cabaret 'La Rose Rouge,' Michel Tapié, has become a 'prospector for Art Brut,'" mentioning the medallions of Salingardes and the pipes and tools sculpted by Xavier Parguey, a basket-maker from the valley of the Doubs.[61] Later, works by the Czech immigrant Jan Krizek sculpted out of stone recovered from demolition sites and the arabesque paintings of the Spanish

Henri Salingardes, *Profile of a Man*, between 1936 and 1943. Cement, 10 × 8 ins (25.5 × 20 cm). Collection de l'Art Brut, Lausanne.

Henri Salingardes, *Face of a Man in a Bouquet of Leaves*, between 1936 and 1943. Cement, height 13 3/4 ins (35 cm). Collection de l'Art Brut, Lausanne.

69

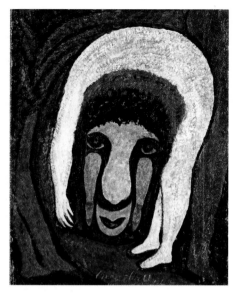

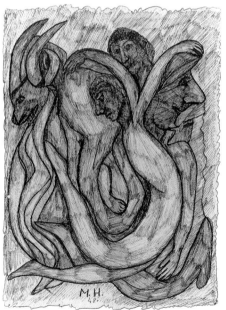

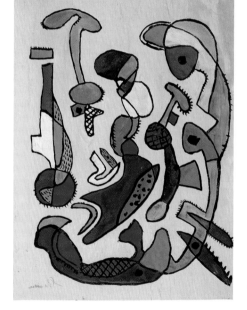

Miguel Hernandez, *Head Encircled by Nude Body*, 1947.
Oil on panel, 16 × 13 ins (41 × 33 cm).
Collection de l'Art Brut, Lausanne.

Miguel Hernandez, *Woman with Three Heads*, 1948.
India ink, 12 1/4 × 9 1/2 ins (31.5 × 24 cm).
Collection de l'Art Brut, Lausanne.

Sculptures by Krizek, booklet published by René Drouin,
Paris, 1948.

Gaston Chaissac, forms and objects, c. 1948.
Enamel paint, 25 1/2 × 19 3/4 ins (65 × 50 cm).
Collection de l'Art Brut (Collection Neuve Invention),
Lausanne.

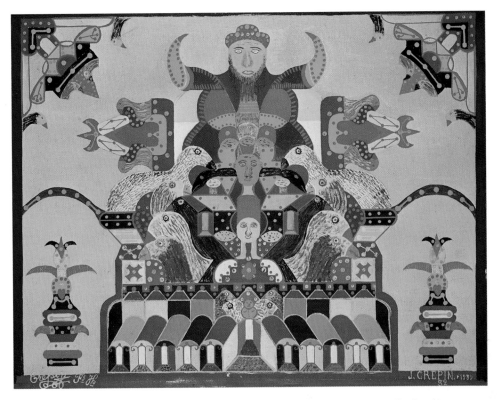

Joseph Crépin, *Composition no. 32*, 1939. Oil on canvas, 19 3/4 × 25 1/2 ins (50 × 65 cm). Collection de l'Art Brut, Lausanne.

immigrant Miguel Hernandez were exhibited in the Foyer. Aloïse's imperial figures would also be hung in this dark subterranean place. Tapié was assisted by René Drouin, who published for some of these exhibitions a small monograph illustrated with four reproductions.[62] The Foyer de l'Art Brut was very busy; its various shows were attracting artists, intellectuals, and critics, including Anatole Jakovski, Hans Hartung, and Michel Ragon. The works were borrowed from their creators and put up for sale in a space that was devoted to them; the place functioned from the start as an art gallery.[63]

Upon his return from El Goléa in the spring of 1948, Dubuffet was initially charmed with his friend's finds and "his little Foyer de l'Art Brut."[64] Later, he maintained a surprising distance: "There is only one interesting thing in the art world today and it is the small Foyer de l'Art Brut that Michel Tapié, with his assistants Robert Giraud

and Aline Gagnaire, watch over in the basement of the Galerie Drouin. Soon there will be an exhibition of extremely interesting works made out of finely carved flint by M. Juva, (a pseudonym for an old Austrian prince who specializes in prehistory and prefers to remain anonymous). I find these flints completely fascinating and it's all I think about."[65] In agreement with Michel Tapié, Dubuffet studied these works and authored the text for a pamphlet, *Les Statues de silex de M. Juva* (The Flint Statues of Monsieur Juva), to accompany the lavish exhibition that was made up of ninety-nine pieces.

During the summer, an exhibition filled the basement featuring pieces by artists whose works had already been exhibited—Aloïse, Hernandez, Salingardes, Gironella, and Krizek—together with the mediumistic works of Joseph Crépin, the statues of a Ukrainian alchemist-creator Maurice Baskine,

Gaston Chaissac, *Composition with Bright Pink Face*, 1962. 19 3/4 × 25 1/2 ins (50 × 65 cm).
Collection de l'Art Brut (Collection Neuve Invention), Lausanne.

Chaissac's works, and tree bark carvings by Pierre Giraud. This presentation offered Dubuffet the chance to take stock of the Foyer's activities: "Lots of bad stuff dubiously attributed to Art Brut are lumped in with the good stuff. Michel Tapié has too many ideas, he is too open-minded. In the end, he would let anything pass through the door."[66]

The fact that total control of the Foyer had been handed over to Michel Tapié—who had a tendency to choose eclectic things, to lack organization, and to care too much about sales—pushed Dubuffet into a corner. The Art Brut venture needed a new direction: "Michel Tapié is . . . too messy and too mad and mixed up and completely confused and it has been decided to put an end to all of the underground activities at the Galerie Drouin and to lead Art Brut back to its purer positions of no compromise and strict anti-commercialism. To do this we are putting together with some friends (Breton among them) an association (a company for research and study) and we will mount an annual exhibition and publish an annual almanac. No more Drouin, no more Tapié, no more business, and no more confusion."[67]

FOUNDING OF THE COMPAGNIE DE L'ART BRUT

Even though he seemed opposed to all forms of convention, Dubuffet nevertheless decided to give his project a legal status. "Freedom is found only within discipline. Dubuffet hoped that this idea of an Art Brut collection, which was really just an idea at this stage, would be put together according to the rules so that it would not be lost in the desert," Robert Dauchez noted. He was a notary and Dubuffet's friend and was the one who established the articles

COMPAGNIE DE L'ART BRUT

(Société non commerciale)
17, RUE DE L'UNIVERSITÉ, PARIS (7ᵉ)

•

Le but de notre association est défini par ses statuts dans les termes suivants :

" Rechercher des productions artistiques dues à des personnes obscures, et présentant un caractère spécial d'invention personnelle, de spontanéité, de liberté à l'égard des conventions et habitudes reçues. Attirer l'attention du public sur ces sortes de travaux, en développer le goût et les encourager ".

Outre le fonctionnement permanent de notre FOYER DE L'ART BRUT (17, rue de l'Université à Paris ; ouvert les mardis, mercredis, jeudis et vendredis, l'après-midi, de 14 à 18 heures) où sont réunies nos archives et collections, et où de nombreux documents seront présentés au public, notre activité se manifestera par la publication d'ouvrages et par l'organisation d'expositions à Paris et à l'étranger.

Nous désirons nous abstenir de toutes opérations présentant un caractère commercial, et les frais entraînés par l'entretien du FOYER DE L'ART BRUT et par nos recherches et activités diverses auront pour seule contrepartie les cotisations des membres de notre Compagnie.

Nous serons, en conséquence, très reconnaissants aux personnes que notre entreprise intéresse, et qui ont le désir de la seconder, de s'inscrire soit comme Membres Actifs, soit comme Adhérents.

ADHÉRENTS :

Cotisation annuelle : **1.000** fr. Accès gratuit à toutes nos manifestations ; accès permanent à nos archives et documents.

MEMBRES ACTIFS :

Cotisation annuelle de **1.000** fr. ; *droit d'entrée forfaitaire de* **10.000** fr. Seront assidûment tenus au courant de nos recherches et activités et participeront à nos délibérations.

Les versements doivent être adressés à Henri Parisot, 17, rue de l'Université, Paris (7ᵉ). Compte chèques postaux : **Paris 1274.01.**

Top: Jean Dubuffet, Édith Boissonnas, and Jean Paulhan in the amphitheater at Nîmes, 1947. Fondation Jean Dubuffet, Paris.

Above: Jean Dubuffet, *Portrait of Jean Paulhan*, 1945. India ink, 15 × 12 1/2 ins (38 × 32 cm). Fondation Jean Dubuffet, Paris.

Left: Poster for the Compagnie de l'Art Brut, 1948. Collection de l'Art Brut.

The Gallimard pavilion. Photograph by Jacques Sassier.

Charles Ratton, 1935. Archives G. Ladrière, Paris.

for the Compagnie de l'Art Brut's constitution. A partnership was founded in Paris on October 11, 1948 under the 1901 law concerning the status of associations.[68] Six members were named: André Breton, Jean Paulhan, Charles Ratton, Henri-Pierre Roché, the "too messy and too mad" Michel Tapié, and Edmond Bomsel. They were certainly not a group of youthful, light-hearted, rebellious artists: Paulhan was sixty-four years old, Breton fifty-two, and Dubuffet forty-seven. To Dubuffet's satisfaction,

they chose the name "Compagnie de l'Art Brut," a term that evoked an image of a band of folk artists from a fairground or a traveling troupe. After being engaged in a risky enterprise on his own for over three years, Dubuffet would finally have the support of some close collaborators. Moreover, the act of making the organization official and the inclusion of partners would obviously grant the adventure more stability. The Compagnie de l'Art Brut was now also authorized to received grants. "I felt it best that Art Brut's interests should not be solely associated with mine, particularly from the point of view of the collection. Freed from my presence, it would survive. Similarly, in the interests of my research, it would be beneficial to let others join the project. Art Brut is hidden, and help is needed to locate it."[69]

For this new beginning, the group of friends inaugurated a new space. After spending ten months in the basement of the Galerie Drouin, the Foyer was transferred to new surroundings that were no less remarkable: "M. Gaston Gallimard has graciously agreed to lend us the small, theater-like pavilion in his garden . . . The first thing to do will

be to whitewash the interior walls . . . and as soon as that's done we will move into this place," Dubuffet announced to Breton.[70] Paulhan had doubtless worked out this agreement in part due to his relationship with Gaston Gallimard. The year before, the latter had rejected the publication of the *L'Art Brut* series; this time he personally interceded on behalf of the project. "Behind the offices of Éditions Gallimard," Michel Seuphor recounted, "is a somewhat austere garden, without any flowers, but big enough to accommodate some tall trees that make this place, right in the heart of Paris, a relaxing oasis with everything in uniform shades of green and gray . . . At the center of this joyless garden was an elegant pavilion, freshly painted white, which barely succeeded in brightening the somberness of the garden as a whole."[71] Access to this "little antique temple," Dubuffet's name for it, was not very easy; one had to pass through the Pléiade bookstore, located in the Éditions Gallimard building, in order to enter the garden. This arrangement didn't necessarily displease Dubuffet. "I am fond of enclosed, clearly delineated places, blocking out what surrounds them, creating a universe just for the eyes, which can then easily take it all in. I find comfort in confinement."[72]

Aloïse, *Marriage of Tristan and Isolde*, undated. Colored pencil, 23 1/2 x 16 1/2 ins (59.5 x 42 cm). Collection de l'Art Brut, Lausanne.

FROM EXHIBITION TO COLLECTION

"To search for artistic works by ordinary people, which bear special qualities of unique inventiveness, spontaneity, and freedom from accepted conventions and customs. To attract the public's attention to these sorts of works, to develop an appreciation for them, and to encourage these works": these were the stated goals of the company as noted in official documents. In other respects, the text proclaimed a state of non-participation in regard to any commercial activities. Its non-profit-making status constituted a necessary rule in the eyes of its founders.

Dubuffet's uneasiness with the sale of Art Brut works echoed, in a striking way, his inability to make money from his own paintings: "I would never dare to sell a painting. That would be like selling my letters, my words, my presence: it is indefensible," he would claim in 1944.[73] Although

he disregarded this point as far as his own work was concerned, he did however remain faithful to his non-commercial principles when it came to works of Art Brut; considered as testimonies to pure creation, they were kept out of the art market. However, the works of Aloïse, Wölfli, Forestier, and others were up for sale during the 1948 exhibition in the Galerie Drouin. This operation was unique because, according to Dubuffet, its primary aim was to permit these works to be known and appreciated. For this reason, he wrote to Salingardes' son: "I suspect you must be disappointed that we didn't sell anything, but perhaps you will agree that your father's works have been placed before a great many people who are connoisseurs of art, who have examined them with great sensitivity and admiration, and that, don't you think, is the most important thing. And these works, which we possess and have found a place for in our collections, will receive in the future—

Kuevelec, engraved horn, 1843. Height 8 1/4 ins (21 cm).
Collection de l'Art Brut (Collection Neuve Invention), Lausanne.

Wilhelm Lehman, root sculpture, undated. Location unknown.

Cinema, collective work by children, c. 1950. Gouache, 5 ft 8 1/4 ins × 9 ft 7 3/4 ins (173.5 × 294 cm).
Collection de l'Art Brut (Collection Neuve Invention), Lausanne.

Jeanne Tripier, forty-three small pieces of embroidery and lace, between 1935 and 1939. Silk, cotton, wool, and colored string, various formats under glass, 23 1/2 × 29 ins (60 × 74 cm). Collection de l'Art Brut, Lausanne.

Gaston Chaissac, *Crucified Person*, c. 1948. Gouache on paper, 10 1/2 × 8 1/4 ins (27 × 21 cm). Collection de l'Art Brut (Collection Neuve Invention), Lausanne.

Adolf Wölfli, *The Map to the City of Beer Cracker*, 1917. Colored pencil, 18 1/2 × 24 1/2 ins (47 × 62 cm). Collection de l'Art Brut, Lausanne.

and no doubt for a long time—even more attention. That is what is important."[74]

This is precisely what did happen; the Compagnie's plan to create a collection would enable the works to be "handed down [subsequently] to whatever foundation it would become."[75] From the basement in the Galerie Drouin to Gallimard's pavilion, the Foyer de l'Art Brut had gone from exhibiting and selling works to the creation of an art collection, art gallery, and center for study.

The show that celebrated the founding of the Compagnie de l'Art Brut and its small pavilion was inaugurated on September 7, 1948. It brought together some forty creators and more than a hundred works. Enthusiastically prepared, the show

introduced those artists discovered by Dubuffet during his own searches (Wölfli, Aloïse, and Gironella), as well as those artists exhibited at the previous premises (Juva, Hernandez, and Salingardes). Numerous works were placed alongside one another: engraved horns by a farmer from Brittany, root sculptures by a teacher from Zurich, anonymous African drawings, tapestries, and numerous children's paintings from Paris and Cairo.

Subsequent shows attested to a change in policy with regard to the way works were exhibited; the items produced by tribal societies and children were set apart, as were works of less intensity arising from casual activity, making room for the works of the most feverishly productive artists who would

COMPAGNIE DE L'ART BRUT
17, RUE DE L'UNIVERSITÉ, PARIS

A L O Y S E

DÉCEMBRE 1948

COMPAGNIE DE L'ART BRUT
17, RUE DE L'UNIVERSITÉ, PARIS
FRANCE

HEINRICH ANTON M.

JANVIER 1949

Monograph devoted to Aloïse,
published by the Compagnie de l'Art Brut, 1948.
Collection de l'Art Brut, Lausanne.

Monograph devoted to Heinrich Anton Müller,
published by the Compagnie de l'Art Brut, 1949.
Collection de l'Art Brut, Lausanne.

Auguste Forestier, *Boat*, between 1935 and 1949.
Assemblage made out of carved wood and various
materials, height 3 ft 1 3⁄4 ins (96 cm).
Collection de l'Art Brut, Lausanne.

become the major figures of Art Brut.[76] At this time,
Gaston Chaissac was an integral part of Art Brut.
Dubuffet was very enthusiastic about his uncivilized
artistic experiments and his letters written in a raw,
inventive idiom. The works that the creator from
Vence regularly sent to the Compagnie were included
in the pavilion, even if Chaissac himself appeared at
times reluctant about his inclusion in Art Brut.[77]

Monthly exhibitions succeeded one another in a
regular rhythm, alternating between collective and
solo shows. The premises were open four afternoons
a week and the task of running it was entrusted to
the painter Slavko Kopac, a Croat émigré who
became the organization's curator responsible for
day to day operations. Seven artists—Wölfli,
Gironella, Aloïse, Jeanne Tripier, Hernandez,
Müller, and Forestier—were given individual shows.
The Art Brut pieces required special presentation
and supervision, since a number of artists used both
sides of the support. For example, the exhibition
devoted to Wölfli consisted of nearly 130 drawings
scattered about the pavilion as if one were in a study

full of curiosities.[78] The hanging of paintings one above the other went against the rules followed in museums which, since the beginning of the twentieth century, decreed that each work must be isolated on a vast neutral background.[79] While cultural institutions established a hierarchy and offered to the public only a select few "masterpieces" in the exhibition space, the Compagnie de l'Art Brut exhibited a maximum number of its works, refusing to keep certain works in reserve. Wölfli's prolixity was thus revealed to explosive effect.

Although activities were now centered more on the collection and the organization of exhibitions, Dubuffet had still not given up on his original plan to publish a series: although the association had little in the way of funds, each individual presentation was the subject of a slim volume, artisanally printed and put up for sale in the Foyer.[80] In these monographs, Dubuffet used the texts composed for the *L'Art Brut* series. Morgenthaler's study on Wölfli, Professor Wyrsch's on Müller, and Dr. Forel's analysis of Aloïse appeared and were illustrated with one or even a few reproductions; Dubuffet authored the volumes presenting Gironella and Hernandez. These short publications endeavored to supplement, albeit modestly, the exhibitions and to publicize the Art Brut creations.

Lili Dubuffet, Scottie Wilson, and Jean Dubuffet, c. 1950. Fondation Jean Dubuffet, Paris.

A SOMEWHAT SECRET PLACE

"I think a little obscurity is befitting for these works of art. Do we not want to protect the somewhat private and secret nature of our Foyer de l'Art Brut, like a small circle of intimate friends who understand these things, and shelter them from the insensitive uncouthness of gawkers and reporters."[81] According to Dubuffet's idea, works of secrecy and silence required obscurity's discretion. The Foyer's shows took place in an atmosphere of confidentiality, almost clandestinely. Moreover, the organization's right-hand man, Slavko Kopac, was described by Dubuffet as a "discreet, solitary, ferocious man lacking (fortunately) any of the know-how to succeed on the professional art scene."[82] Luckily, he had been chosen to succeed the vocal Michel Tapié. Furthermore, the Compagnie's activities contrasted with postwar excitement; at a time when everyone was celebrating the Liberation and was waving the flag, Dubuffet hunkered down in silence. In order to keep out of sight, he worked in solitude, in hiding almost, as if the existence of the association were illegal. The Foyer de l'Art Brut became a sort of center of resistance against the cultural and media powers, which Dubuffet felt were oppressive.

"Facing Parisod's boutique at the end of the garden rises an antique temple. Treasures are locked away there. Lili, my kind wife, watches over them with me every Wednesday afternoon . . . Lili takes care of feeding the stove; she gets intense heat from it. She makes some tea too, when it is time. There's a bottle of rum stored away when one wants a little something extra. You should stop by sometime."[83] Even if Dubuffet invited several acquaintances to discover these "treasures" of Art Brut in a convivial setting, the public rarely showed up. The number of visitors to the Foyer—four or five a day during the first year—diminished later because of the reduction in the number of hours it was open and because Dubuffet wished to keep the place "somewhat secret." Despite the famous visitors—Jean Cocteau, Claude Lévi-Strauss, Johannes Itten, Pierre Matisse, and several doctors, such as Walter Morgenthaler,

L'ART BRUT PRÉFÉRÉ AUX ARTS CULTURELS

LIBRAIRIE MARCEL EVRARD
7, Place de Béthune, Lille

Cinq Petits Inventeurs *de la* *Peinture*

Paul END — ALCIDE — LIBER
GASDUF — SYLVOCQ

Art Brut Preferred to the Cultural Arts, cover and page 3 (below) of the catalogue for the exhibition mounted at the Galerie René Drouin by the Compagnie de l'Art Brut in Paris, 1949. Collection de l'Art Brut, Lausanne.

Five Ordinary Inventors of Painting, booklet for the exhibition mounted at the Librairie Marcel Évrard in Lille, 1951. Collection de l'Art Brut, Lausanne.

L'art brut préféré aux arts culturels

Un qui entreprend, comme nous, de regarder les œuvres des IRRÉGULIERS, il sera conduit à prendre de l'art homologué, l'art donc des musées, galeries, salons — appelons le L'ART CULTUREL — une idée tout à fait différente de l'idée qu'on en a couramment. Cette production ne lui paraîtra plus en effet représentative de l'activité artistique générale, mais seulement de l'activité d'un clan très particulier : le clan des intellectuels de carrière.

Quel pays qui n'ait sa petite section d'art culturel, sa brigade d'intellectuels de carrière ? C'est obligé. D'une capitale à l'autre,

Jacob Wyrsch, Jacqueline Forel, and Hans Steck—the need for confidentiality at the pavilion resulted in a profound solitude. But Dubuffet was not opposed to this seeming contradiction.

When Art Brut was mentioned in the *Cahiers de la Pléiade*, edited by Jean Paulhan, Dubuffet oscillated between satisfaction and disapproval. "I thank you for doing me the honor of including in *Les Cahiers de la Pléiade* [the text on] Hernandez and the Announcement [of the Compagnie de l'Art Brut]. It seems to me that your idea to insert this little castle of Art Brut in your next journal is a very good one, and the sort of thing that might be really advantageous for our enterprise."[84] However, when the journals appeared, he deplored this publicity in a letter dated April 29, 1949: "I let Jean Paulhan put that stuff in about Art Brut because it made him happy, but I don't like seeing Art Brut mixed up with those doctors of fake art; Art Brut couldn't be more out of place in that company."[85] But a few

months later, the Compagnie committed one of its major infractions against this rule of confidentiality. A major exhibition of Art Brut ran from October until November in René Drouin's gallery on Place Vendôme; two hundred works by sixty-three creators were shown in public and put up for sale in a commercial setting. The show was a success and drew artists, writers, publishers, ethnologists, and critics, among whom were Francis Ponge, Henri Michaux, Tristan Tzara, Joan Miró, Victor Brauner, Georges Bourgeaud, Michel Seuphor, René de Solier, Claude Lévi-Strauss, André Malraux, Michel Ragnon, Arnal, and a representative of the journal *Minotaure*. Persuaded by members of the association—most likely André Breton and Jean Paulhan—Dubuffet agreed to compromise his principles of confidentiality and non-commercialism, and the exhibition took the form of a cultural event. Nonetheless, paradoxically, Dubuffet snubbed the press with his silence: "Journalists have said little about it; they find it ridiculous. The feeling is mutual. It is true that to all of their requests for interviews, access to documents, radio, and even television programs, I have replied with apathy. These things really bore me and really repel me. No matter; lots of people will come."[86]

For thirty years, Dubuffet would waver between confidentiality and disclosure, choosing the first while at the same time making some allowances. For the moment, he used this exhibition and the publicity it generated to lead an offensive against cultural institutions; in the catalogue, he penned a lampoon that had the hallmarks of a manifesto, *L'Art Brut préféré aux arts culturels* (Art Brut Preferred to the Cultural Arts).[87] Less than two years later, in January 1951, he repeated the experiment but with a show having as limited a scope as possible. It took place at the Marcel Évrard bookstore in Lille, where around fifty works by "Five ordinary inventors in painting" were shown, accompanied by a simple brochure introducing Art Brut and some of its creators. As a preview to the opening, Dubuffet gave a lecture to the school of letters, *Honneur aux valeurs sauvages* (Tribute to Uncivilized Values).[88]

CHOOSING ANONYMITY

In his 1921 monograph, Walter Morgenthaler had analyzed the work of his patient Adolf Wölfli and

Gaston Duf, *Pâûlïçhinêle gânsthêrs vitrês'-he*, 1949. Colored pencil, 27 × 20 ins (68.5 × 50.5 cm). Collection de l'Art Brut, Lausanne.

revealed his identity; in breaking with medical confidentiality, he was recognizing Wölfli as a real artist. More than twenty years later, the anonymity of the mentally ill was preserved during the small exhibition mounted by the Sainte-Anne hospital in Paris. Neither the last nor first name of the creator was placed beside the works, each of which was accompanied by a card that indicated the author's diagnosis: for example, "drawing by a schizophrenic suffering from hallucinations." The course of action followed in medical contexts was thus not simply a question of guaranteeing the patient's anonymity. The description of the psychological ailment—an integral part of a person's privacy—was openly revealed and presented as part of the nature of the work. A painting, a sculpture, or a drawing thus remained inseparable from the pathology.

Dubuffet chose a different course. He left aside the diagnosis and preserved the anonymity of creators who were living or had lived in psychiatric institutions and whose works were kept in the

Barbus Müller, head carved out of rock, undated. Location unknown.

Jan Krizek, sculpture, undated. Location unknown.

Foyer. He respected the ethic of medical confidentiality recommended by psychiatrists with whom he was in contact. In the publications and Art Brut exhibitions, the artists were designated by a simple abbreviation: Auguste Forestier was named Auguste For, and Jeanne Tripier, Jeanne Tri; for Aloïse and Heinrich Anton, the family name disappeared, while Gaston Dufour was called Gasduf. Each creator was thus identified by his first name or part of his surname, treated as an autonomous individual, and presented as the author of the artistic creation.

CRITICAL REACTIONS

The Art Brut exhibitions attracted critical attention in Paris and elsewhere.[89] When the Foyer was still located in the basement of the Galerie Drouin, journalists mentioned in a playful tone the "pleasant, occultist atmosphere" that reigned in this "cave of forty thieves, Ali Baba's treasure where piles of treasures lie . . . Art Brut."[90] Taken aback, they limited themselves to reporting, indicating their surprise at the discovery of "crude statues" named Barbus Müller, the "curiously unusual" sculptures by Krizek and "compositions with a hallucinatory symmetry" from the "zinc-plumber and medium" Crépin.[91] After the founding of the Compagnie de

l'Art Brut and the transfer of the collection to Gallimard's pavilion, the critics came in greater numbers, were more precise in their observations, and offered opinions about these creations.

Art Brut provoked in turn irritation, disquiet, puzzlement, and admiration. The liveliness of the reactions proved that the exhibitions really made postwar Parisian art circles uneasy. Jean Bouret proved to be the most acerbic when faced with what he called the "little comedy of Art Brut," and considered it a "con" and a "hoax." He condemned the works of Chaissac, Crépin, and Giraud: "All of these people really amuse us, but the annoying thing is that none of them are worthy of the title artist, painter, or sculptor."[92] Some of his colleagues adopted a mocking tone so as to denigrate these "ridiculous" works and "this salon, which in the hope of being revolutionary, exceeds the limits of politeness and humor."[93] Others censured Art Brut as "a well without a bottom, without water, and therefore without the least possibility of reflection."[94]

Alongside these critics who had nothing but contempt, others endeavored to explain their condemnation; they contested the artistic virginity of the creators, detecting in their works various elements reminiscent of medieval Russian art, pre-Columbian art, prehistoric art, or oriental paintings.[95] The most

controversial idea was the one put forth in *Art Brut préféré aux arts culturels*, which implied the— inconceivable—annihilation of art history and the representatives of its esthetic tradition. "The messengers of Art Brut commit a mistake the moment they claim that these gouaches and naïve, instinctive drawings, these crudely honed stones and roots 'obliterate' the premeditated works whose techniques and inspiration are nourished by civilized painting and sculpture."[96] Crépin, Aloïse, and Wölfli certainly attracted attention, but the importance that Dubuffet attributed to them could not be tolerated; "The Musée du Louvre and Manet's French school in our own time are still above all others the jewels in our crown."[97]

However, some journalists considered the exhibitions at the Galerie Drouin and at the little pavilion as a breath of fresh air in the cultural world. In this artificial and mercantile universe, Art Brut was capable of producing "more remarkable insights than a professional painter" and "things of more interest than many of the works of . . . 'cultural' artists"[98]; "Anton the painter, Auguste the sculptor, and Jeanne the embroiderer certainly surpass in talent, even genius, the roughly 30,000 individuals who call themselves painters in Paris."[99] If Art Brut was the revelation of a weariness with official creation, it also triggered and provoked major reexaminations among certain critics who penned a number of feature articles, namely Claudine Chonez, Patrick Waldberg, and Georges Bourgeaud. "Dubuffet at the Galerie Drouin has invited us with much finesse, in respect to Art Brut, to revise all of our esthetic values," one of them stated. "Is it art? Can it be done without skill and consciousness?" questioned another.[100] The ideas of intuition, capability, and skill were successively challenged because of the "non-conformist spirit that presides over the choosing of works."[101] However, Claudine Chonez noted the originality of these shows: "It's the first time . . . that someone has devoted a museum of sorts (discreet, certainly confidential) to the small shop owner, to the café waiter, or a postal employee like Le Facteur Cheval . . . who devotes all of his leisure time, his dreams, his life to his irrepressible creation of a selfless work."[102] Those critics who were favorable toward the exhibitions, which were judged admirable, fascinating, and exceptionally important,[103] were especially full of praise for the

Pascal-Désir Maisonneuve, head, undated. Wood and seashells. Location unknown.

Pascal-Désir Maisonneuve, *The Tartar*, between 1927 and 1928. Seashells, height 7 ins (18 cm). Collection de l'Art Brut, Lausanne.

power of invention and expression displayed by these self-taught creators. They congratulated "the sincerity, the application, and especially the blossoming of unbridled imagination—thus original power" where "the esthetic instinct artlessly manifests itself."[104] Well informed about Dubuffet's revolutionary ideas, Claudine Chonez emphasized: "The unprejudicial study of Art Brut destroys the

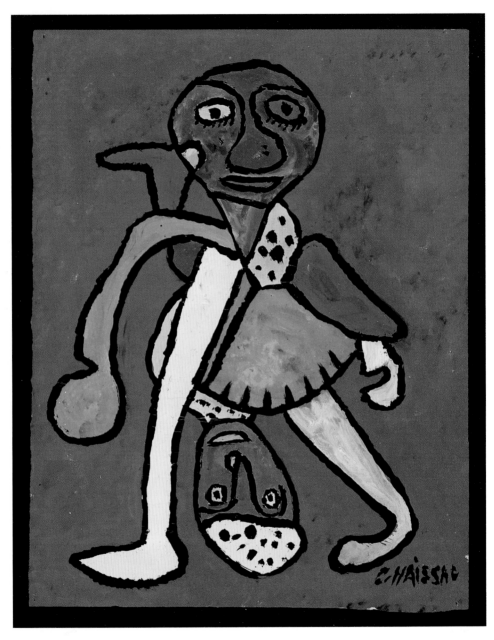

Gaston Chaissac, *Two Figures, One of Whom is Upside Down*, c. 1949.
Enamel paint on paper, 15 3/4 × 12 1/2 ins (40 × 31.5 cm).
Collection de l'Art Brut (Collection Neuve Invention), Lausanne.

idea of orthodoxy; and one clearly perceives that culture risks causing the rusting of art."[105] Henri Héraut went so far as to predict a spectacular future for Art Brut and its inventor.[106]

AN UNPUBLISHED ALMANAC

The year 1948 was one of ambitious projects and decisive choices. In addition to the founding of the Compagnie, the Foyer's first moves toward the establishment of a collection, and regularly scheduled exhibitions, the group of friends were eager to embark on a major project: the publication of an important work, entirely devoted to Art Brut. In spite of this enthusiasm, the *Almanach de l'Art Brut* would remain unpublished.[107] In the fashion of popular publications, it was to be introduced as a collection of commentaries and advice. The contents of the publication would list a number of regular columns. Monographic studies were devoted to non-professional works—Juva, Crépin, Maisonneuve, Aloïse, Wölfli, Müller, Hyppolite, Berthe Ura, and the "Swiss masks." Assembled together under the title "Petit courrier" (Brief Notes), articles would recount the marginal existence of a few creators—for example, Chaissac, Jean l'Anselme, and Robert Véreux—or discuss a popular belief or a personal philosophy. A third category, entitled "Peinturez hardi" (Paint Boldly), was to serve as a practical guide on issues of pictorial technique. Dubuffet recommended to the contributors to be completely straightforward: "We need to come up with short articles that appear to be nothing much at all, totally free of any solemnity, woven with very ordinary words and ideas, but endowed with enough power for you to capture the man."[108]

Most of the monographs were done by writers like Paulhan, Breton, and Dubuffet, who each left their stamp on the work. Breton's famous text, *L'Art des fous, la clé des champs* (Art of the Insane: The Door to Freedom), had been composed for the *Almanach de l'Art Brut*. Dubuffet was responsible for most of the other works. In content as in form, Dubuffet's writings bore the traces of his defense of the "common man." The articles under the edict "Paint Boldly" echoed his famous conviction: "Everyone is a painter." They were intended to encourage people to devote themselves to creation and to break with the idea of genius.

While planning the almanac, other ideas were grafted on to the project. Some influences are recognizable, in particular an inventive parody which consisted in renaming each day of the year with the name of a saint: Saint Abstrait, Saint Gagnerson-biftec, Sainte Mission de l'Artiste, Saint Pourcent. All of this is reminiscent of the Surrealists and their word games, as well as exquisite corpse. Other ludicrous suggestions sprouted up, but these threatened to take the project away from its initial intent: "His [Joë Bousquet's] other suggestions seem to me foreign to Art Brut. Inspiration is a very curious mechanism which tries to combine something that pleases you with all the other things that please you; it is the same mechanism with which our good Tapié rolled everything that he likes and wants to celebrate up into a little ball: Picabia, Saint Jean de la Croix, and Saint Theresa; jazz and Aline Gagnaire and Raymond Roussel."[109] Dubuffet put a stop to these spurious divergences and imposed on the volume a character that was "more massive, more elaborate, filled with reproductions. More raw, more purely and 'extremistly raw' in its contents and presentation."[110]

In the almanac *Der Blaue Reiter* (The Blue Rider) which appeared in 1912, Kandinsky and Marc had gathered together works from folk art, the avant-garde, children's drawings, and canvases by masters. With the *Almanach de l'Art Brut*, nearly forty years later, Dubuffet and his friends pushed the process even further by only selecting pieces of marginal art. Moreover, they presented the works in monographic studies without relying on any artistic theories. The works were considered as truly autonomous productions.

The layout of the almanac was finished during the fall of 1948 so bookstore sales could begin at the end of the year. It was a great relief for Dubuffet that Gaston Gallimard—who withdrew for economic reasons—handed the project over to René Bertelé. "He will be better than Gallimard because Gallimard is too expensive, too slow, and hardly enthusiastic."[111] Although the generosity of Maurice Auberjonois—who made a donation of 500,000 francs[112]—made prospects more promising for the publication, it was nevertheless abandoned by Éditions du Point du Jour for lack of funds. Publication was postponed by the association until the following year—but it would remain unpublished.

Scottie Wilson, *Crystal Gazers*, 1950–51. Colored ink, 17 × 15 1/4 ins (43 × 38.5 cm). Collection de l'Art Brut, Lausanne.

FINANCIAL RESOURCES

"On Charles Ratton's suggestion, I am working on putting out a kind of newsletter, which could be printed or mimeographed, wherein we could announce the aims and meaning of our enterprise, and the conditions for becoming a member. I will eventually have you take over these newsletters once they are ready to be sent out to people that you know."[113] Although Dubuffet wished to shield Art Brut from all publicity, the Compagnie nevertheless opted for another way of getting in touch with the public and addressed to eight hundred people a prospectus composed by the president in which the conditions for membership in the association were spelled out. Forty-eight subscriptions were received, among whom were Henri Michaux, Jules Supervielle, André Malraux, Claude Lévi-Strauss, Georges-Henri Rivière, René and Maurice Auberjonois, Jacques Berne, and Robert Dauchez.[114]

Scottie Wilson, two heads on a green background, between 1938 and 1940. Colored ink, 19 3/4 × 10 1/2 ins (50 × 27 cm). Collection de l'Art Brut, Lausanne.

The Compagnie's financial resources were derived entirely from the subscriptions of its members and the sale of rare works of art. Although the acquisition of works did not incur significant expenses (most of the works were gifts), the association was burdened with

Scottie Wilson. Collection de l'Art Brut, Lausanne.

heavy costs which quickly led to running deficits: the association had to pay expenses for its collaborators like Slavko Kopac, the move to a new location, the photographic reproduction of creations, the publication of small books, newsletters, and the purchases of a few books. Having donated a significant sum of money to pay for the move to its new location, Dubuffet would continue to provide large sums of money (somewhere around 850,000 francs) on a regular basis in a vain attempt to improve the financial health of the organization.[115]

PROSPECTING AGAIN

The difficulty of prospecting for Art Brut was one of the reasons why Dubuffet surrounded himself with allies: "Art Brut is hidden away and one needs help in finding it . . . Paulhan, Breton, and others had friends and connections. I hoped that they were going to lead to new members and the acquisition of new works."[116] At the start, the founders were caught up in the adventure and put a lot of time into the preparation of the *Almanach de l'Art Brut.* Some even joined the search for works likely to be exhibited in the Foyer.

One well-informed collector, André Breton, brought to Dubuffet's attention the existence of some remarkable artists, examples of whose work he possessed. In 1948, he was the one who introduced Dubuffet to the seashell masks done by a secondhand goods dealer from Bordeaux named Pascal-Désir Maisonneuve at the Saint-Ouen flea market. The same year he made contact with an art dealer, Mesens, so that they could exhibit the drawings of Scottie Wilson at the Art Brut pavilion. A few months later, André Breton and Benjamin Péret accompanied their friend to Neuilly-sur-Marne and visited the Ville-Évrard and Maison-Blanche hospitals, where Dubuffet had made some contacts. Finally, Breton agreed to loan from his own collection some of the works completed by the Haitian painter and priest Hyppolite, so that they could be photographed and entered into the association's archives.[117] Some of the other members sporadically contributed gifts of literary and artistic works. Departing from customary museum practice, Dubuffet refrained from mentioning the donors.

After several months, the collaborators' enthusiasm had waned. Except for the important but all too rare discoveries of art discussed earlier, Dubuffet became once more the sole prospector. Basing his searches on his previous forays, he set out on a methodical search through the psychiatric hospitals in France, Switzerland, Belgium, and Germany.[118] He kept up numerous correspondences with doctors and accompanied his letters with the brief announcement that outlined the goals of the association and the functions of the Foyer de l'Art Brut. Knowing how little interest these productions generated, he labored to make the recipient aware of "all the work that might have been done by the patients in your institution. Even those drawings that appear to be bad drawings or scribblings are of interest to us. Even tiny works of sculpture (out of breadcrumbs, for example) or stones or wood carvings; or embroidered works or tapestries" or "tracings in ink or pencil, blotches that have been reworked," "writings too, letters, poems, or short texts . . . even if they are really wild (especially in this case)."[119]

Dubuffet paid a number of personal visits during which he followed up on his inquiries. One hospital that he visited was Saint-André-lez-Lille, where he met Dr. Paul Bernard, who was receptive to the works of his patients: Gaston Duf, Paul End, Sylvain Lec, Stanislas Lib, and Alcide. In January 1949, he began corresponding with Dr. Jean Titeca in Brussels, and he tried his best to make other

Hector Hyppolite, *Ogoufer. Ogun Scrap Iron,* undated. Enamel paint on cardboard, 20 × 27 1/2 ins (51 × 70 cm). Private collection (formerly André Breton's collection).

Paul End, *Journey of No Return*, 1948. Pencil, 17 × 29 1/2 ins (43.5 × 75 cm). Collection de l'Art Brut, Lausanne.

doctors in Belgium aware of his interests. The following year he went to Germany, where he discovered the most famous collection of works by the insane in Europe, one that had become almost mythical: "This trip in the company of Werner Schenk has been from start to finish a joyous vacation and in all respects successful and for two whole days I have been able to treat myself to poking around through Dr. Prinzhorn's collection in Heidelberg, which is a place I have really wanted to visit for many years."[120]

Dubuffet traveled regularly to Switzerland and visited numerous hospitals in Geneva, Morges, Lausanne, Bern, and Basel, including its prison. The works of the incarcerated had probably been brought to his attention by Claude Lévi-Strauss, who as soon as he discovered the activities of the Foyer de l'Art Brut in 1948 had immediately applauded this initiative: "As I was saying to André Breton yesterday, your effort seems to me the only valuable one when faced with the failure of the art that people call professional, and I will be following its development with the warmest and kindest of interests."[121] The ethnologist had then proposed to

conduct a search "into criminology, tatooing, drawings and writings of prisoners, and graffiti on the walls of cells and other small works," but he never got around to this project.[122]

GIFTS, BARTERING, AND PURCHASES

If his many trips led Dubuffet down familiar paths, they also led him on new ones and allowed him to acquire hundreds of works, such as the drawings, paintings, embroideries, sculptures, and manuscripts by the self-taught (Scottie Wilson, Gironella, Hernandez), by prisoners (the Prisonnier de Bâle), by eccentric creators (Maisonneuve, Soutter, Juva), and by children and anonymous artists (the Barbus Müllers). Chaissac and Gironella regularly offered him various pieces; as compensation, the association purchased a certain number of their works. But most of the works added to the collection had been made by the insane and were donated by doctors, donations being at this time the preferred way for acquisitions.[123] Dubuffet would then send to some of the creators gifts such as paint, brushes, treats, cigarettes, and small amounts of money.

Pascal-Désir Maisonneuve, *The Eternal Adultress*, 1927–28.
Assemblage of seashells, height 16 1/2 ins (42 cm).
Collection de l'Art Brut, Lausanne.

Other works were purchased, however. Dubuffet would buy them from a secondhand goods dealer, or directly from the creator or one of his or her parents, at a small cost; in 1948, he paid forty thousand francs for a mask by Maisonneuve, five thousand francs for a painting by Hernandez, and twelve thousand francs for a group of ten medallions by Salingardes. These prices had no connection to those in the art world. At the same time Dubuffet sold a painting for twenty-nine thousand francs to his dealer.[124] Passionate about a type of art that was held in low esteem, he was thus able to avoid any real business transactions and the heavy costs which would ordinarily be incurred by collectors in the art market. For Dubuffet, Art Brut works had above all else "a spiritual, documentary value; but their commercial value is totally problematic, and at any rate is of no interest . . . They are rare, irreplaceable objects whose loss or destruction could never be compensated for by any sum of money that we could get from an insurance company."[125]

During its three-year existence from 1948 to 1951, the Compagnie de l'Art Brut added to its collections around 1,200 works produced by about one hundred creators.

Pascal-Désir Maisonneuve, *The Crown Prince*, 1927–28.
Assemblage of seashells, height 11 1/2 ins (29 cm).
Collection de l'Art Brut, Lausanne.

Pascal-Désir Maisonneuve.
Collection de l'Art Brut, Lausanne.

Louis Soutter, 1939.

Gaston Chaissac, 1952. Photograph by Robert Doisneau.

THE COMPAGNIE'S ARCHIVES

The acquisitions of works of art were accompanied by numerous biographical documents about the creators and their works, adding considerably to the association's archives. The archives also included sets of photographs, of which about a thousand were classified and catalogued in twelve albums which were available to visitors. Portraits of the artists whose works were exhibited were added to these; Robert Doisneau photographed Gaston Chaissac in Vendée and Miguel Hernandez: "I have always been drawn to Art Brut because I find that it is similar to the type of research that I do with my photography: the use of settings that are not commonly shown, views of the suburbs—Hernandez was living in Belleville, the HLMs, people who are never in the limelight and whom I had tried to find and photograph. I was searching and still am for the universe of the humble world . . . These folks are good, I really like them, and we get along well, they feel as if they have in front of them someone who, if not an accomplice, was at least on the same wavelength as them, with the same naïvety and refusal to disappear."[126]

Miguel Hernandez. Photograph by Robert Doisneau. Collection de l'Art Brut, Lausanne.

The Compagnie de l'Art Brut's library possessed numerous reference works as well. Some fifty books and studies, in addition to many manuscripts by the artists, were deposited there thanks to Dubuffet and donors. These included fundamental books devoted to the creations of the insane—those of Marcel Réja,

Walter Morgenthaler, Hans Prinzhorn, and Jean Vinchon—publications on work by children, primitive art, folk art, and art from different civilizations; two editions of the review *Minotaure*, and a spiritualist review. This heterogeneous mix is indicative of the various kinds of expression that were being explored while a definition of Art Brut was still emerging.

THE CREATOR OF ART BRUT IS NOT AN ARTIST

"True art is always where you least expect it. There where no one thinks to find it nor pronounce its name. Art detests being recognized and greeted by its name. If so, it immediately runs for its life. Art is a character passionately in love with remaining incognito. As soon as someone detects him, as soon as someone points a finger at him, then he runs away leaving in his place a laureate understudy who carries on his back a big placard where someone has written ART, whom the whole world showers with champagne, and whom lecturers lead from city to city by a ring in his nose . . . There is no danger of the real Monsieur Art donning placards. Nobody would recognize him then."[127] Dubuffet's position, reinforced by his discoveries, would from this time on be based on a Manichean esthetic philosophy that distinguished between "true art" and "false art." This opposition became one of the essential tenets on which he based his definition of Art Brut, defined as a counter-culture, a different kind of power.

According to this notion, the creators of Art Brut are distinct from established artists: they are defined as "artists" or "people" and their creations are qualified as "works." This generalized vocabulary differed with the institutional terminology, with its "masters" and "masterpieces." Dubuffet deliberately chose a semantics of dissidence. Self-taught, the creators were defined as "persons estranged from culture, and who have not been informed or influenced by it." Their ignorance of the art scene "shelters them from any distortions perpetrated by deliberate lies or mimeticism."[128] In his first published work on Art Brut in 1947, Dubuffet describes these "artists" responsible for unusual works as people "who do not follow any career, who have devoted themselves to art by chance, who execute these works in their own way and for their own

Heinrich Anton Müller, *Machine*, between 1917 and 1922 (destroyed). Collection de l'Art Brut, Lausanne.

pleasure, without any great plans for them, impelled only by the need to externalize the festivities that are taking place in their minds. Modest Art! And they are often unaware that it is called art!"[129] The lack of any training makes them ideally "devoid of any artistic culture," Dubuffet emphasized. He would soon come to realize the illusory nature of his claim and his theories later would be more nuanced. For the moment, he remained convinced that this ignorance was highly beneficial because it led each of them to invent works derived from a creative process that was wholly independent. This necessary manufacturing of the work—along thematic, iconographic, and stylistic rather than technical lines—demanded lots of hard work. For Dubuffet, Art Brut was distinct from the works of naïve painters and children. The former are "filled with respect for cultural art, and their works are

entirely influenced by classical art; their goal is to become part of the art world, borrowing the same methods and imitating them as well as they can."[130] As for the latter, they attest to a creative spontaneity and freedom: "Children outside of social norms, outside of the rules, antisocial, and alienated are precisely what an artist should be," but "they do not have the endurance or strength to be passionate . . . nor are they tenacious enough to stick to an enterprise and take it very far."[131]

The creation of Art Brut implies a return to the first principles of expression. When Hernandez painted, when Aloïse drew, when the Prisonnier de Bâle made a sculpture out of breadcrumbs, every one of them appealed "to humanity's first origins and the most spontaneous and personal invention." They implemented "natural and normal processes in their elemental and pure state for the creation of art." Their lack of skill and their "preposterous and inadmissible techniques" mattered little. What was essential revealed itself in these "little works of nothing at all, totally basic, half deformed, but which ring true." Expression achieved its maximum intensity and engendered an "externalization of the most intimate workings of their temperament, the most profound inner workings of the artist." Probing deeply into the "underlying layers" of the personality led Wölfli and Jeanne Tripier to come into contact with the most obscure zones of savagery and violence. The works of these creators "offer us burning language."[132] Rimbaud's idea of "vision" (*voyance*), taken up by the Surrealists among others, was seen by Dubuffet as the principal path to the expression of an *art brut*.

CREATION AND MADNESS, MADNESS AND CREATION

If the designation of "art of the insane" seems outdated today, during the 1930s and 1940s it provoked intense debate.[133] From 1937 until 1941, the Nazi exhibition "Entartete Kunst" (Degenerate Art) displayed side by side the works of the insane with those of modern painters in order to prove how degenerate the latter had become. On the other hand, avant-garde artists—particularly the Surrealists—magnified the powers of the unconscious, sanctifying dementia and thus the works of the mentally ill. They created a category for "divine

madness" (see page 32). In dismissing both of them, Dubuffet was opposed to any dividing up of this kind of work. "In the majority of works, there is no criterion that justifies discriminating between works that one could call sane and works that one could call sick. I truly believe that this discrimination has taken place and that it is meaningless." The theorist ignored madness in matters of artistic creation, claiming that "there is no more an art by the mad than art by dyspeptics or an art by people with bad knees."[134] The definition of Art Brut is not based on the mental state of the creator. For Dubuffet, any real artistic expression necessarily implies excitement, tension, and violence; it verges on deviance and gives rise to an "inspired delirium." Creation is an "unhealthy and pathological phenomenon."[135] Referring to the letters of Paul End, Sylvocq, and Alcide, he exclaims: "Granted this art is mad. What art isn't mad? When it isn't mad, it's not art."[136]

However, the problem was not so easily resolved. Dubuffet made no secret of the fact that most of the Art Brut works had been produced by the insane, and he explained in 1948 in the first announcement for the Compagnie "It is natural that people lacking work or pastime (and this stands for prisoners too) would be more inclined than others to seek pleasure through the means of artistic activity."[137] If confinement made the creation of an imaginary world urgent, madness opened the way to an original uncivilized state as well. This dementia that Dubuffet claimed to disregard suddenly played a role as the primary motivating force for creativity: "Madness unburdens the individual and gives him wings and vision."[138] Considered from an artistic viewpoint, alienation is "the pole where all mental creations of the highest order, all mental phenomena, and particularly artistic creation in the first place" arises from. This appraisal is not however derived from an idealistic vision of madness; Dubuffet was not foolish enough to regard everything that was produced in asylums as an expression of artistic value. "The case of a real artist is almost as rare among the insane as it is among normal people," he disclosed. Nonetheless, he considered the insane person to be an exceptional being, capable "of bursting through the crusts of habit . . . and opening up paths so that the internal voices of the uncivilized man can be expressed."[139]

Auguste Forestier, *The King*, between 1935 and 1949.
Statuette in carved wood decorated with fabric
and other materials, height 28 1/4 ins (72 cm).
Collection de l'Art Brut, Lausanne.

In 1947, during the preparation of the *L'Art Brut*
series, Dubuffet became aware of how Art Brut
might be assimilated into the art of the insane, and
he tried to prevent this equivocal categorization. He
planned to introduce the artists in an order that
adhered to a very clear principle: "I do not want to
start with my madmen. I want to start with folk art,
where madness properly speaking isn't an issue, and
I will then follow up with my madmen after-
wards."[140] He attempted to thwart all ambiguity by
devoting the first edition of his fascicles to *Les Bar-
bus Müller et autres pièces de la statuaire provin-
ciale* (The Barbus Müller Statues and Other Works
of Statuary from the Provinces); the statues would
make it clear. Dubuffet adopted the same attitude in
the exhibitions organized at Gallimard's pavilion by
alternating "reputedly mad" artists—Aloïse or
Forestier—with "reputedly sane" artists—Gironella
or Salingardes. In spite of his efforts, which
extended to his theoretical writings as well, he
only partly succeeded in avoiding this assimila-
tion.[141] Art Brut remained linked to the work pro-
duced in asylums and this misunderstanding
endures fifty years later. For this, the theorist was
partly to blame.

Dubuffet had at first been reluctant to provide a
precise definition of Art Brut. "Describing what Art
Brut is surely not my responsibility. To define a
thing—even isolating it—does much to ruin it. It
nearly kills it. There is a continuity in these things.
How can you ever define what it is? The clearer one
tries to be, the more muddled one becomes."[142] His
refusal to define any object as such has without a
doubt caused confusion and has contributed to the
association of all of Art Brut with work produced in
asylums. The initial period of research and discov-
ery seems to have been necessary for the concept of
Art Brut to ripen and take shape. However, several
intellectuals still cling today to Dubuffet's tautolog-
ical claim that "Art Brut is Art Brut, and everyone
has understood it very well."[143] In spite of the extra-
ordinary diversity of works, in his later essays
Dubuffet lucidly outlined the principles—more
philosophical than esthetic—on which Art Brut is
based. Exponents of this type of art have no formal
training or knowledge of a traditional culture; they
are capable of reinventing the creative process; they
work in anonymity and in complete independence.

André Breton's home in 1960. On the wall are Hopi dolls from his personal collection.

DUBUFFET AND BRETON: AFFINITIES AND QUARRELS

"The role that has been designed for you, as you say, in this Compagnie de l'Art Brut is yours by right, because your ideas, your moods, your impulses have certainly played a large part in guiding our thinking in all of this, and it is fitting that a place be laid for you at this table and if you no

longer wanted that place, it would remain vacant like the place of an angel, but in our hearts occupied by you."[144] Dubuffet was proud of André Breton's presence at the center of his association and considered it a privilege. In fact, his presence was more than just indirect support, as was the case with Charles Ratton and Henri-Pierre Roché. Guest of honor, Breton was a founding member who, according to

Adolf Wölfli, *Biela Villa District*, c. 1924. Colored pencil, 20 x 26 3/4 ins (51 x 68 cm). Collection de l'Art Brut, Lausanne.

Dubuffet, committed himself entirely to the Art Brut adventure. When he discovered remarkable creators and kept the best pieces for his private collection before passing them on to the Compagnie, Dubuffet thanked him for alerting him to them; but when he offered to sell to the Foyer drawings that he owned while taking a significant percentage for himself, Dubuffet turned a blind eye.[145] No matter! Breton enlarged the circle of Art Brut artists with major figures and provided invaluable support in the planning and writing of the *Almanach de l'Art Brut*.

The two men shared the same fascination for unusual works, and from the time of Breton's first visit to the Foyer they became good friends. In June 1948, Dubuffet wrote to him: "Yes, it is true that you are branded with the reputation for being despotic and intransigent and, as one says, sectarian,

a man who makes one fearful of suddenly being tossed in the category of junk, for unexpected reasons resulting from unexpected tests . . . and this reputation, I have to admit, made me fearful of meeting you . . . you are however incredibly understanding and generous and kind."[146] Thereafter, their meetings became more frequent and their correspondence proved fruitful. Dubuffet seemed to have met his alter ego: "I sense an intimate, profound agreement between us that I have only felt as strongly with a few others (let's say none)."[147] However, Dubuffet expressed an odd presentiment to his friend Paulhan: "I don't know what to think about my relationship with André Breton; it is equivocal; there are some points on which one would say that we understand each other well; others, where major and grave differences lie coiled; however, one would say that we get along well together but that's not

Scottie Wilson, *Birds of Paradise*, undated. India ink and colored pencils, 25 × 19 3/4 ins (63.5 × 50.2 cm). Collection de l'Art Brut, Lausanne.

meaning of the piece. In taking this esthetic approach, he ignored Forestier's and Wölfli's illness, Crépin's spiritualism and Maisonneuve's and Wilson's "normality." Any sort of categorization was banned. Breton, on the other hand, put madness in a particular category. Even if "the art of the insane" was associated with "the door to freedom"—according to the title of his article—it remained circumscribed within this specific category. Furthermore, the work produced in asylums was considered a natural culmination which did not originate from artistic development.[150] Breton was not concerned with craftsmanship and did not devote much attention to the pictorial and graphic qualities of the works, neglecting the formal, stylistic, and technical aspects of the compositions.[151] In looking at the works, he was guided above all by a remarkable intuition, but one which remained attached to criteria based on the works' filiations, notably with the insane and spiritualists.

The reason for the dispute appeared in a letter where the theorist of Surrealism leveled a number of accusations against the theorist of Art Brut: "The organic fusion that he [Dubuffet] claimed existed between the art of some self-taught artists and that of the mentally ill has turned out to be inconsistent, illusory. The list of exhibitions that have followed one another in succession at the 'Foyer' on rue de l'Université testify to the fact that more and more it is the art of the insane that has prevailed. Yet everyone has known for a long time that this art no longer needs to be discovered."[152] His grievance had no foundation, for two reasons. Worried about the risk that Art Brut might be identified with the art of the insane, Dubuffet had constantly been careful to alternate works by the "sick" with those by the "sane." Aside from this preventative measure, the essence of the dispute lay in the whole conception of the activities of the organization. Although Dubuffet judged important the biographical backgrounds of the authors and was never silent about the incarceration of the creators, he did not establish any direct connection between the madness of the artist and his work. A drawing by Wölfli and a painting by Hernandez were put on an equal footing outside of any category. Art Brut gathered together various types of expression under one name, one concept, and did not try to categorize them. This was precisely Dubuffet's original vision.

sure; neither is it that it will last for long. He is too self-congratulatory. At any rate there is at least one point on which we are in agreement, and that is Art Brut."[148] This intense relationship took conflicting turns and would end with a violent break. During the disbanding of the Compagnie de l'Art Brut, Dubuffet decided to dispatch the entire collection to the United States; Breton was opposed to this resolution and handed in his resignation to the president of the organization.

The central point of their disagreement was related to their notions of creative madness: Dubuffet ignored the dementia in insane creators; Breton on the other hand considered it an asset. For the former, Aloïse's work was a marvelous creation of Art Brut; for the latter, it was an extraordinary example of the art of the insane. Although Dubuffet recognized in madness a "positive, very fertile and useful value,"[149] in matters of expression he granted it limited attention, focusing more on the work in question. He perceived it visually from the viewpoint of a craftsman; Dubuffet was searching to discover the work's internal logic and decipher the symbolic

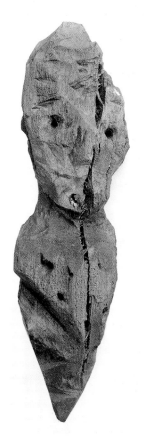

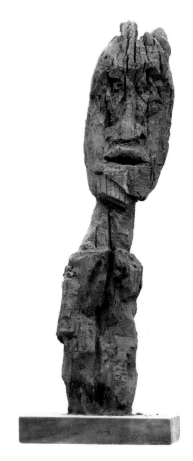

Gaston Chaissac, *The Mottled Woman*, 1948.
Charcoal, height 6 ins (15 cm).
Collection de l'Art Brut (Collection Neuve Invention),
Lausanne.

Jean Dubuffet, *Old Man*, 1954.
Charcoal, height 11 3/4 ins (30 cm).
Fondation Jean Dubuffet, Paris.

Obviously, Breton did not understand Dubuffet's thinking or did not share his opinion—perhaps he was simply unaware of it. According to Dubuffet, he intended to incorporate Art Brut into his own movement: "He [Breton] was very interested in Art Brut . . . but unfortunately, he saw it as an extension of surrealism. I am opposed to that . . . He wanted to include me and Art Brut within surrealism, within his vast network, his contacts, his influences, his enormous cultural machine. It was a disappointment to him and he was angry with me."[153] In view of the important place that the work produced in asylums occupied in Art Brut, Breton doubtless felt it was natural to incoporate it into Surrealism where these works were considered as an interesting category, being an integral part of the movement. Dubuffet's refusal profoundly altered their relationship, and Breton broke with the association and "for two years did not once pass through . . . the doors to the Foyer de l'Art Brut."[154]

The two men, each endowed with strong personalities, no longer had an opportunity to find any common ground. The exiling of the Art Brut collections right in the middle of this quarrel was very timely.

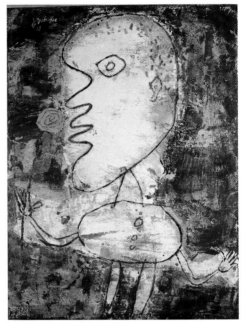

Jean Dubuffet. *The Man with the Rose*, 1949.
Tempera on jute, 3 ft 9 3/4 ins × 2 ft 11 ins (116 × 89 cm).
Fondation Jean Dubuffet, Paris.

Heinrich Anton Müller, *À ma femme. / J'envoie /
ce / ventre / depuis si lonteng / qu'elle et / Privee de moi*,
between 1917 and 1922.
Pencil, chalk, and ink on cardboard, 30 1/4 × 15 1/2 ins
(76.8 × 39 cm). Kunstmuseum, Bern.

"I HAVE BEEN INFLUENCED BY THEIR FREEDOM"

Dubuffet's works and those of Art Brut are directly connected. Undeniable similarities are apparent in his *Vieillard* (Old Man) and Gaston Chaissac's *La Dame de moire* (The Mottled Woman), in *L'Homme à la rose* (Man with the Rose) and Heinrich Anton Müller's *À ma Femme* (To My Wife), and in *Le Dépenaillé* (The Ragged One) and Maurice Baskine's *Personnage* (Figure). The painter was accused on a number of occasions of plagiarizing particular Art Brut artists, and still is today.[155]

When Dubuffet devoted himself to art in 1942, a few years before discovering the works of Aloïse,

Müller, and Hernandez, he was attempting to develop a new form of expression, disconnected from all tradition, in order to rediscover an internal, spontaneous inspiration. In order to "unlearn," he experimented with unusual techniques and materials, sought out chance or pictorial accident, and drew his inspiration from everyday life: "A torn poster, a piece of shiny sheet metal, rusted iron, a muddy path, a cap smeared with coal tar. A shop window painted pine green, a brightly colored shop sign, an inscription in chalk washed away by the rain, a color encountered in the streets and on paths, and traces, marks, smears, chance elements."[156] He attempted to rediscover simple gestures in a search for the ephemeral and improvisational: "Drawing

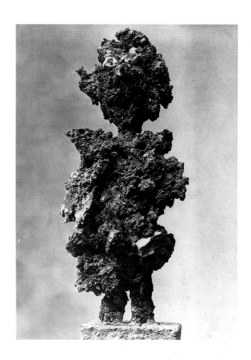

Maurice Baskine, *Figure*, undated. Location unknown.

Jean Dubuffet, *The Ragged One*, 1954. Cinders, height 28 ins (71 cm). Fondation Jean Dubuffet, Paris.

with one's finger on a fogged up windowpane or even with the point of a knife in a block of butter or even with the toe of one's shoe in the dust, that revives him [the artist], that gives him a way to invent new forms and modes of expression."[157] He was immediately delighted with the discovery of the works of Aloïse and Chaissac, not surprisingly, since they were related to his own. This revelation owed nothing to chance. During this period, Dubuffet had begun to look beyond his own experimentation and displayed a very receptive mindset that allowed him to apprehend the conceptual complexity and esthetic subtlety of Art Brut. The works of Wölfli, Hernandez, and Müller embraced preoccupations similar to his. Even though he would become the collector and exegete of the practitioners of Art Brut, he was first and foremost their accomplice. These works would confirm and reinforce his own artistic approach and are therefore more like witnesses than examples—to an expression that Picasso used in regard to African sculptures.[158] But Dubuffet nursed a

profound aversion toward the notion of influence. He advocated solitary work and individual expression. It is perhaps inevitable that some of his own works reveal a connection with certain pieces of Art Brut—in terms of the choice of material or form—but analysis reveals that they are very few in number.

On the other hand, an influence of another sort held sway over Dubuffet's artistic enterprise. "If someone asked him not which artist, an offensive term, but which craftsman in magical objects he would have liked to resemble the most, [he] would have replied: 'All that I desire is to be as good as Heinrich Anton and Jeanne la Médium.'"[159] Fascinated by these self-taught creators, Dubuffet used them as models and submitted to their influence not along esthetic lines but philosophical ones. Adopting the position of disciple, he was inspired in a brotherly way by their detachment and their audacity, by their relentlessness and the power of their inventiveness. If there be plagiarism, it is ideological.

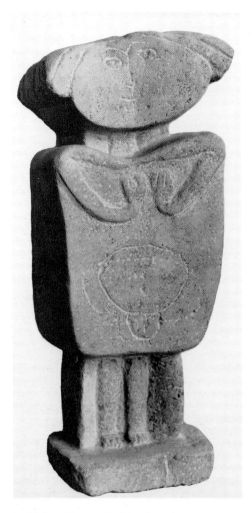

Jan Krizek, sculpture, undated. Location unknown.

would lock them up in boxes. They succeeded in giving life to what they saw themselves without caring in the least that they were the only ones to see them. I blame myself for not having as strong a will as they do. I still try all the same."[160]

If Dubuffet managed to create a body of autonomous and rebellious work, it is obviously due to the lessons in subversion he learned from the creators of Art Brut: "Other artists have identified with Leonardo da Vinci and Michelangelo; in my mind I had the names of Wölfli and Müller, etc. I have never been directly influenced by Art Brut. I have been influenced by their freedom, a freedom which has helped me a great deal. I have used them as examples."[161]

THE DISBANDING OF THE COMPANY

"Tonight, I have had a long bout of insomnia during which I had little by little decided to give my art-brutist secretary Robert Giraud the following instructions at daybreak: pack up everything in the Art Brut pavilion including the manuscripts for the almanac and place a note on a box saying that due to a serious accident I am finally saying farewell to these things and this enterprise and declare it be liquidated. But this morning these defeatist attitudes have completely left me and I have taken heart again in the work, and have returned to my typewriter once more. The wisest thing is evidently to stick with this project until next June so that it will have survived for at least one year, and then liquidate it at that time."[162] Dubuffet was far from imagining that his daydream would be realized almost exactly three years later. For the moment, the first sign of exhaustion was just simple discouragement. The Compagnie still had a lot of time in front of it, during which Dubuffet exhibited a breathtaking display of energy. Prospecting, acquisitions, exhibitions, publications: except for the limited help of a few collaborators, the organization was entirely directed through his efforts. Nevertheless, this fervor tended to decline over time. The renewal of exhibitions at the pavilion came to an end—only one exhibition, collective and permanent, was mounted—and the premises were opened to the public more and more infrequently. "We are not going to close the doors to the Foyer de l'Art Brut for good at the end of June. We are just going to

And although Dubuffet was conscious of never being able to attain such a level of artistic freedom—and although he could not be considered as an Art Brut artist—he strove tirelessly to be like its creators. The only obvious obstacle to this aspiration was the social and cultural integration of his work in the contemporary system. "It is the desire to strengthen the existence of my works that obliges me to show them," he wrote. "The heroes of Art Brut (my models) did not have this need. They would hide their works under their mattresses or

Heinrich Anton Müller, *Three Women in a Wheelbarrow*, between 1917 and 1922. Pencils, pastels, and chalk, 20 x 33 1/2 ins (51 x 85 cm). Collection de l'Art Brut, Lausanne.

shut the door a little. We will leave it half-open one afternoon a week," Dubuffet wrote to Gaston Chaissac.[163] Research had slowed down and fewer acquisitions were made. The Foyer was losing its vitality.

In September 1951, the *Communication de M. Jean Dubuffet aux membres de la "Compagnie de l'Art Brut"* (Message from M. Jean Dubuffet to the Members of the Compagnie de l'Art Brut) provides insight into some of the reasons behind the disbanding of the association. Gradually, the members lost interest in its activities and showed no desire to see it progress. Dubuffet was guiding this adventure with such dynamism and such authority that his behavior undoubtedly deterred his associates from taking an active role. The financial difficulties made the situation worse and the enterprise quickly found itself with no resources whatsoever. All the expenses were charged to Dubuffet, who confided to Jacques Berne: "I have paid out more than a million francs, and it is impossible for me to continue spending that much money."[164] Moreover, the small pavilion—which had been lent to them temporarily by Gaston Gallimard—had become too cramped to preserve and present the vast collections of works,

and moving to another location proved impossible because it was too costly. No help could have been expected from the powers that be, according to Dubuffet, since Art Brut had declared itself hostile to cultural circles. By way of a conclusion, the president invoked the endangerment of the Compagnie's collections and archives in the event of war or political turmoil in Europe.

Each one of these reasons had a powerful effect on the slowing down of the Compagnie's operations, and the feeling of abandonment that Dubuffet also felt played a pivotal role: "Nobody helps me with the work and research; I am the only one who does any work; the members do absolutely nothing; they don't even pay their dues. They are phantom members and it's a phantom organization, and I believe that it is not worth it to continue in this charade, that it is necessary to put an end to it, and disband this association."[165] Although he had been happy to neglect his own work while the Compagnie was growing and its prospects were good, his attitude changed when it started to go into decline. He distanced himself little by little from the Foyer and announced the decision to his dealer, Pierre Matisse: "I am shelving

Alfonso Ossorio, *The Mother in Pink*, 1951.
Watercolor, 32 1/4 x 24 ins (82 x 61 cm).
Collection de l'Art Brut (Collection Neuve Invention),
Lausanne.

'Art Brut'; I no longer want to allow myself to be consumed by this enterprise as I have been this past year; I want to concern myself solely with my own painting, and as for the rest, to drown in a little peaceful tranquility."[166] The discoverer, collector, and theorist of Art Brut gave way to the artist.

At the same time as he was making this new commitment, Dubuffet met the American painter Alfonso Ossorio—a meeting that would prove to be hugely important. In 1949, on the advice of Jackson Pollock, Ossorio made a trip to Paris with the goal of paying Dubuffet a visit. He was immediately fascinated with his paintings—which were very controversial at the time—as well as with the works of Art Brut. In turn, Dubuffet displayed a keen interest in Ossorio's works. The two men quickly recognized intellectual and artistic affinities. When Ossorio left France, he carried in his luggage two works, *Prospectus aux amateurs de tout genre* and *L'Art Brut préféré aux arts culturels* (Prospectus for Amateurs in All Genres; Art Brut Preferred to the Cultural Arts), as well as several canvases by

Dubuffet. Between 1950 and 1952, the two men engaged in a particularly rich correspondence, accompanied by drawings, books, technical manuals, and artists' letters.[167]

Ossorio was aware of Dubuffet's concerns; he knew of his desire to find an adequate place to house the Art Brut collections and offered him the chance to move them into his luxurious home, The Creeks, located in East Hampton on Long Island near New York City. There, Dubuffet would find the freedom he needed to compose his voluminous work devoted to Art Brut, whose publication Ossorio offered to finance. A new network for prospecting could be organized in the United States due to the increased funds and the help of effective collaboration, and the works could be shown to the American public. Dubuffet let himself be tempted by the idea of a new direction for his enterprise. In July 1951, the president called an urgent meeting of the Compagnie's administrative council, made a brief statement on the critical situation, presented the American offer, and decided in agreement with his associates to call a general meeting of the membership so they could vote on disbanding the company. Three months later, in the *Procès-verbal de l'assemblée des membres de la compagnie de l'Art Brut* (Minutes of the Meeting of the Members of the Compagnie de l'Art Brut) the proposal was ratified: "All material, the collections, and the archives of Art Brut will remain now and in the future indissolubly grouped together . . . The organization's collections and documents contributed by M. Jean Dubuffet during the establishment of the organization will be returned to his sole ownership, as well as the pieces that have been added in the meantime and which are the fruits of his own work." On October 8, 1951, the liquidation of the association was agreed to by a unanimous vote; the official disbanding would be announced on January 23, 1952.

DEPARTURE FOR NEW YORK

In mid-October 1951, Dubuffet decided to live in the United States for a while and then to return later for fairly long visits. The 1,200 works of Art Brut were inventoried by Slavko Kopac, who made up an identification sheet for each item before their voyage to New York: paintings, drawings, sculptures, high and bas-reliefs, embroideries, manuscripts,

The Creeks, Alfonso Ossorio's estate in East Hampton, N.Y.

books, and archives were carefully packed up and sent to Le Havre.

Of all the wanderings that Art Brut had known and would know, this one seemed like the most daring and unexpected. Dubuffet had only met Ossorio a few months earlier; he had never visited the United States and felt no real affinity with the continent. Once again, he was going against the flow, because "few French artists are traveling . . . at this time to New York, even fewer stay for a while to work. Jean Dubuffet was the rare exception."[168] Although a few of the exhibitions of his works in Pierre Matisse's New York gallery from 1946 to 1951 met with a certain amount of success, Dubuffet had no contacts and hardly knew anybody. Alfonso Ossorio's residence, which was supposed to be spacious, was in fact in the middle of being remodeled. Dubuffet did not have any assurances in regard to this new space. The pieces

gathered together through his care were extremely fragile—they had not been made to last—and a trip such as this one risked damaging and dispersing the entire collection. Furthermore, the passage across the Atlantic was very expensive.

Dubuffet responded to the challenge with determination, his boldness proving to be commensurate with his desire to leave. The United States appeared to him to offer a highly promising opening, and he seized the opportunity. It seemed in every way advantageous for the development of his own work; as for Art Brut, Ossorio's proposal and the support of his American friends were tempting and promised to breathe new life into the adventure. On October 16, 1951, accompanied by his wife Lili, Dubuffet boarded the *Île-de-France* in Le Havre. He was unaware that his stay would last six months and that Art Brut would be in exile for ten years in New York.

103

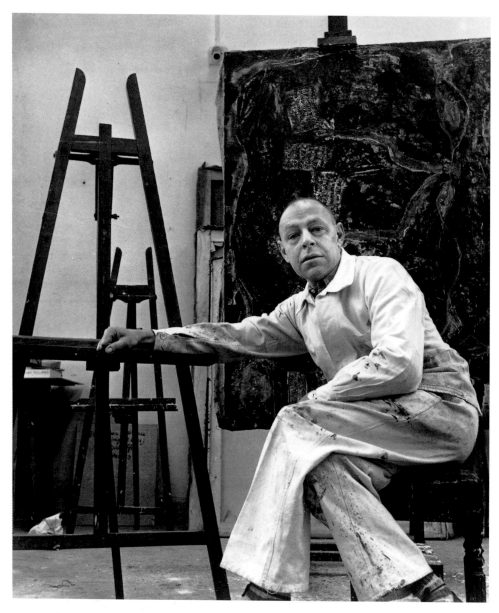

Jean Dubuffet in front of *The Speculator*, 1951. Photograph by Robert Doisneau. Fondation Jean Dubuffet, Paris.

NEW YORK AND VENCE

On October 23, 1951, after a six-day passage, Jean and Lili Dubuffet arrived in New York. Alfonso Ossorio was close to acquiring his sumptuous estate: its park-like grounds comprised close to sixty acres and abounded in exotic trees. The estate was built in 1899 facing Georgica Pond and had a spectacular view of the Atlantic. But the property was in the process of being renovated and Ossorio could not yet receive Dubuffet and his wife there. As to the works of Art Brut, they were far from being moved in. The artist was therefore limited to editing his manuscript, which he had also planned on doing. The couple moved into a small residence in Greenwich Village—where Ossorio was also living—but they fled the place almost immediately when their host tried to take Dubuffet around to the spots that artists frequented in New York: "I saw myself caught in a trap where, contrary to what was promised, long-winded esthetes trailed in one after another."[1] They moved to Manhattan and rented a loft as a studio on the "dramatic Bowery Avenue, sheltered from the rain by the subway, which passed above it . . . the place where the city's bums hung out in a state of permanent drunkeness," and where it was necessary "to keep your doors locked to be safe."[2]

The move to Ossorio's estate was delayed; the organization and the presentation of the collection had to wait. In the weeks that followed, the move was continually postponed, but it gave Dubuffet some free time to devote to his own work: "I live on the work site, locked in like a prisoner."[3] Two important exhibitions of his own work were mounted during his brief stay in America. A retrospective at the Arts Club of Chicago was held from December 1951 until January 1952. There the painter gave his famous talk, "Anticultural Positions," which he had probably prepared with the help of Marcel Duchamp, who was living in New York.[4] In February and March 1952, Pierre Matisse exhibited his work in his New York gallery.

Six months rolled by. The crates that contained the Art Brut works were still nailed shut. Dubuffet

Jean Dubuffet in Chicago, 1951.
Fondation Jean Dubuffet, Paris.

Alfonso Ossorio, 1952.
Photograph by Hans Namuth.

Views of the Art Brut collection in Alfonso Ossorio's home in East Hampton, 1952.
Photographs by Hans Namuth.

left New York at the beginning of April 1952, apparently without any regrets or bitterness: although Alfonso Ossorio—the "little storyteller," as Dubuffet called him—hadn't kept his promises, the trust the painter had in him didn't seem damaged. He delegated all the necessary powers over the Art Brut collections to him and considered Ossorio just as entitled as he was to the entire collection.

ALFONSO OSSORIO, ARTIST AND COLLECTOR

A few months after Dubuffet's departure, work on Ossorio's estate was finally completed and he moved in. Left solely in charge, the American collector gradually began to open up the crates, had the works cleaned and processed, and saw to the framing of numerous pieces. Many were hung in his private living quarters next to his own works and others by Jackson Pollock, Jean Dubuffet, Clyfford Still, Jean Fautrier, Wols, Lee Krasner, and Willem de Kooning.[5] The fact that he hung these works together proved that Ossorio considered all of them equals. Moreover, he set aside six spacious rooms on the upper floor of his home for the entire Art Brut collection. As in the Galerie Drouin basement and the Gallimard pavilion, the paintings, drawings, sculptures, and embroideries were exhibited in large numbers—hung on the wall, set on tables and bookshelves or simply put on the floor or leaned against walls. None of the works were singled out or given preferential treatment in any way, and Ossorio wasn't worried that they would compete with each other because of their proximity.

Many artists, including a number of Abstract Expressionists, came to visit: Marcel Duchamp,

Adolf Wölfli, *The Whale Karo and the Devil Sarton the 1st*, 1922. Colored pencil, 19 3/4 × 25 3/4 ins (50 × 65.5 cm). Collection de l'Art Brut, Lausanne.

Henri Matisse, Rooman, Urs, Soby, Jarris, Alfred Barr, Jr., Barnett Newman, and Jackson Pollock. Some lived on Long Island, while others, such as Karel Appel, Michel Tapié, and Jean Planque, came over from Europe.[6] Some of the reactions reported by Ossorio were negative: "It took me several dozen visitors before I realized the way in which people would react and I must say I was very curious to see the anger and fear it seemed to provoke among some of the artists here." In general, the Art Brut works did not generate much real interest on the part of visitors. Ossorio, however, took pains to guide them through the rooms, providing them with the necessary explanations. "I must confess that among the dozens of interested and curious there were few that I felt were really moved by it [the collection of Art Brut] or who understood its value and meaning." Later, he would confide: "Jackson wasn't interested . . . He didn't feel it was that serious. I don't remember Jackson showing any great enthusiasm for Art Brut. Still couldn't have cared less . . . Practically no one cared. Perhaps, Barnett Newman . . . who had a wider range of intellectual interests."[7]

The American public was far from excited about this exceptional collection, but Ossorio's attitude may have had something to do with this. The works were only put on display in his home in the spring of 1953, a year and a half after their arrival in New York, and as a way of making Art Brut known to Americans, the arrangement was hardly ideal. East Hampton was three hours by train from Manhattan and few if any in cultural circles seemed to know of the existence of this collection on his estate. When the move was finally completed, following one last shipment of pieces in February 1957, Ossorio decided to postpone the collection's official opening

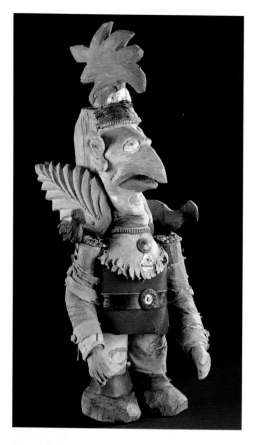

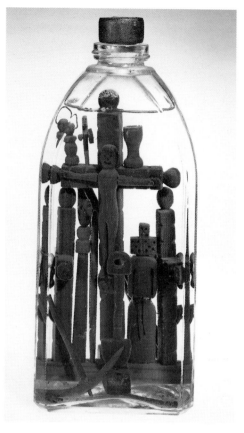

Auguste Forestier, *Person with Bird Head*, between 1935 and 1949. Assemblage in wood and various materials, height 20 3/4 ins (52.5 cm).
Collection de l'Art Brut, Lausanne.

Anonymous, *Crucifix in a Bottle*, undated.
Ossorio Foundation, Southampton.

for a few more months. Information was meted out parsimoniously. Yet, Betty Parsons and Eleanor Ward, two gallery owners from New York known for their daring and intuitive work, discovered the collection and offered to exhibit a selection of Art Brut works. Both of them reiterated their requests, but Ossorio hesitated and finally rejected their proposals. However, he wasn't under any pressure on Dubuffet's part. Although Dubuffet was skeptical about the reception Art Brut would receive on the American art scene, he wrote his friend several times expressing his confidence in him and granting complete

control over the collection. But Ossorio turned down every offer, while promising for the future a "more developed interest" in Art Brut, "its meaning clarified for the public'" an exhibition of "the whole collection," and the organization of an exhibition "under very different auspices."[8]

During Art Brut's stay in New York, its new caretaker seemed to perpetuate the secrecy that surrounded the works since their first years in Paris. Dubuffet had been reluctant to reveal these works; Ossorio dreaded a serious misunderstanding on the public's part—yet, he displayed the true spirit of a

collector, enamored with the works that surrounded him: "For myself the collection becomes more interesting and moving the more I see of it. Going through it the way I have these past weeks has made me realize more than ever how unique, and of what quality and inventiveness the collection is."[9] In addition to paintings by Pollock, Still, and Dubuffet and the works of Art Brut, Ossorio owned a vast number of objects—baroque crucifixes, Mexican votives, figurines of saints, ceremonial swords, eskimo boxes, jade and ivory sculptures, oriental rugs, fossils, horns, shells, antlers, minerals, and scrimshaw. The collection testified to the painter's curiosity; he was receptive to any type of creativity and did not care about hierarchies of genre and style. All of his possessions might be interpreted as "the collection of an artist—in exactly the same sense that dictionaries and encyclopedias are the working library of a writer. Here are tools, points of reference, stimulants, abrasives of the artist-as-collector."[10]

Ossorio proved to be more a curator than a seeker and collector of Art Brut. The experience of living with these works led him to modify his work and resort to eclectic materials and collage; he did not attempt to do any prospecting or to acquire any works as Dubuffet had hoped he would. During this entire New York period, not a single American work would be added. Indeed, it was not until the 1980s that the first American examples of Art Brut would be incorporated into the collection.

EXHIBITION IN NEW YORK

From February 20 until March 3, 1962, Maisonneuve's shell masks, Forestier's monstrous bestiary, and Tripier's mediumistic embroideries finally appeared in an exhibition at Daniel Cordier's and Michel Warren's gallery. Cordier was a passionate dealer and collector. A friend of Dubuffet's, since 1956 he had regularly exhibited the Frenchman's work in Paris, Frankfurt, and New York. In his new Madison Avenue gallery, he displayed various kinds of European art, alternating between recognized artists and marginal creators such as Henri Michaux, Dado, and Eugène Gabritchevsky—a Russian geneticist diagnosed as schizophrenic who had been committed to a psychiatric hospital for more than thirty years.[11] Art Brut fitted in perfectly with his daring selections. In the text that Alfonso

Aloïse, *Cloisonné de théâtre*, detail, 1950.
Colored pencil, 55 x 39 1/2 ins (140 x 100 cm).
Private collection, Switzerland.

Jean Dubuffet and Alfonso Ossorio in Southampton, 1970.
Ossorio Foundation Archives, Southampton.

Pascal-Désir Maisonneuve, *The Devil*, between 1927 and 1928. Assemblage in seashells, height 9 3/4 ins (25 cm). Collection de l'Art Brut, Lausanne.

Ossorio composed for the invitations, he reprised the history of the collection and briefly defined the idea of Art Brut. He concluded with these lines: "and indeed the works shown deserve study. In their clarity of commitment, their passionate involvement in the meaning of the work, their rightness and freedom of material and scale, these often small and fragile objects shame many more pretentious works of art."

The exhibition had no impact. The art world was preoccupied with new developments in Abstract Expressionism, Pop Art, and Minimalism, which had little in common with Art Brut. Furthermore, Cordier's exhibition coincided with the first retrospective of Dubuffet's work at the Museum of Modern Art. The press was more interested in the man who was considered "the most important French artist since the second [sic] World War"[12] and the Art Brut show went unnoticed. If critics commented on it at all, it was because they considered it a small exhibition connected to the one at the Museum of Modern Art. Art Brut was rightly understood as a form of expression devoid of any

Auguste Forestier, *The Little Cavalryman in the Blue Kepi*, undated. Assemblage of pieces of carved wood and various materials, height 15 1/2 ins (39.5 cm). Collection de l'Art Brut, Lausanne.

Jeanne Tripier, *Buffalo*, between 1935 and 1939. Multicolored cotton embroidery on a white background, 7 3/4 x 9 3/4 ins (19.5 x 25 cm). Collection de l'Art Brut, Lausanne.

110

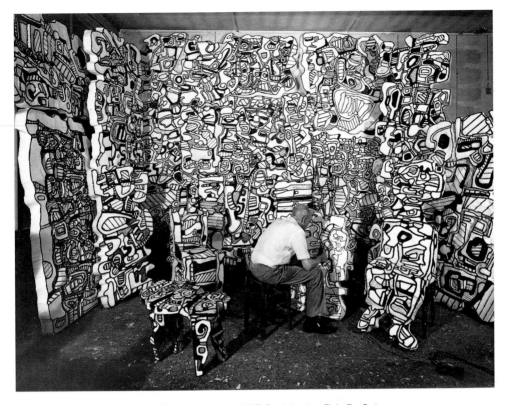

Jean Dubuffet working on a section of his *Hourloupe* series, 1967. Fondation Jean Dubuffet, Paris.

artistic culture, but it was also mistakenly viewed as the art of "children, savages and the insane," as "curious inventions," as "an assortment of eccentric, nonsensical, sentimental illustrations, fancy-work of embroidery and crocheting, oddities of carving, scrimshaw, dolls," where one sees "a touch of madness in it all." The creators of Art Brut were never named and their works were not reproduced: they were only interesting insofar as they were illuminating and helped to elucidate the French painter's work and views.[13]

Ossorio was acutely conscious of how little coverage the Art Brut exhibition received in the press—just a "simple announcement" in *The New York Times*, he said—and regarded the exhibition as a parting gift from Dubuffet. Indeed, several months later, during the summer of 1962, all of the works would be returned to France. The extended stay on Long Island had lasted eleven years. In this time, Dubuffet had put Art Brut on the back burner, although in 1959 he had started to prospect again.

KEEPING HIS DISTANCE

While the collectiuon was in America, Dubuffet remained in constant contact with Ossorio. On many occasions he inquired about the collection and, keen that all the works be conserved together, he sought to send the last few pieces still in Paris to the United States. Even though he had given up looking for new works, he did send books and documents to East Hampton so as to expand the former Compagnie's library and archives.

111

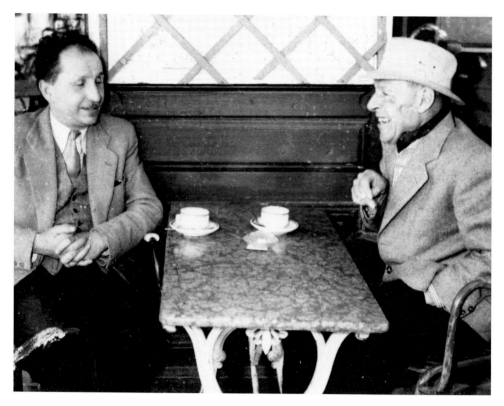

Alphonse Chave and Jean Dubuffet on the terrace at the Régence in Vence, c. 1955. Collection Pierre Chave, Vence.

However, upon his departure from New York in 1952, Dubuffet made a decision that was a disconcerting about-face: "It seems to me that it isn't necessary to put together an Art Brut association in the United States. It's understood that the collections belong in common to you and me; and besides, I believe that neither you nor I attach much importance to these issues of ownership. Nevertheless, if it is advantageous for you, from the point of view of 'Income Tax' in particular, to form an Art Brut corporation or whatever, do what you judge best and consider me in agreement beforehand."[14] Evidently, the painter was experiencing an urgent need to distance himself from Art Brut. An ocean—that he wouldn't cross for a decade—was required to separate Dubuffet's work as a collector and his work as an artist. The exile of these works freed his energies

for his own work. "I have been working on my painting practically non-stop the last three months . . . I was living like a prisoner, never even leaving the house . . . I decided to keep living like a prisoner, which suits me fine."[15] The 1950s were a key period of experimentation in his work that eventually culminated in the ambitious *Hourloupe* cycle of the 1960s.

ALPHONSE CHAVE

In early 1955, Dubuffet and his wife left Paris for Vence in the South of France because of Lili's ill health. The painter felt restricted and experienced a deep feeling of isolation: "The region is full of ridiculous villas and inhabited by obtuse and quarrelsome people whose company is hardly pleasant,

to say nothing about the palms and mimosas . . . I am terribly bored, I am as bored as Saint Anthony in his damn cave . . . I am beginning to develop a healthy dislike for this region."[16] However, his sense of gloom and alienation was mitigated by a meeting with an enthusiastic, lively man who would play a major role in reigniting Dubuffet's interest in Art Brut. "I only have one friend here," he wrote. "The good Alphonse Chave. He loves to talk and laugh. He owns a small shop that sells Bic ballpoints, notebooks for students, toys for children, and moreover, a nice gallery of paintings where there are never any customers and whose sole return is calamitous debts. I have coffee with him every day after lunch."[17]

Dubuffet was immediately charmed by Chave's fiery character and established close ties with him: "He isn't at all like a typical dealer; he is a very unusual person of a rare kind: enthusiastic and passionate, generous and warmhearted, completely unselfish, an exceptional man."[18] The terrace of the Régence on Vence's main square became their regular meeting place. Friends often looked them up there and took part in their discussions. Alexandre Vialatte, Georges Limbour, Philippe Dereux, and Slavko Kopac, the former curator of the Art Brut collections in Paris, and others such as Henri Michaux and Francis Ponge, joined the group when visiting Vence. Over the course of their conversations, Dubuffet introduced the gallery owner to Art Brut and talked about his artistic theories. His counterpart proved to be a true accomplice. He had already demonstrated an unusual receptiveness to marginal forms of art, such as naïve art and the works of self-taught painters, and his gallery, Les Mages (The Magi), had "for a number of years taken a militant stance in favor of works arising from this approach."[19] Dubuffet's intellectual authority and knowledge strengthened Alphonse Chave's convictions and the latter, in his excitement about Art Brut, decided to have his gallery specialize in the sale of these works. His enthusiasm was infectious, in turn renewing Dubuffet's interest. Sometime during the spring of 1959, the two men went off hunting, having decided to establish in Vence a new Collection de l'Art Brut that would be grafted onto the older collection, whose repatriation Dubuffet was already planning.

The search, suspended for the last eight years, was revived. The theorist of Art Brut rediscovered a

passion for it that he would retain for the rest of his life. Motivated by Alphonse Chave, he set out on a new crusade, proclaiming his convictions: "The Art Brut Party is the one that is opposed to the party of the learned, to what the West calls (somewhat noisily) its 'culture.' It is the party of the tabula rasa. Its troops will wear no uniform, they will not be dressed in togas and ermine, nor will they bear self-important titles, they will not be recruited at the exits of schools but will come from the ranks of common folks, they are the voices of the common man as opposed to the voices of learned specialists. Tramps, stubborn speechifying visionaries, legions wielding sticks and shovels not diplomas, they are art's heroes and its saints."[20]

Jean Dubuffet and Alphonse Chave each engaged in their own prospecting. Possessing a more sedentary disposition, the former chose the route of letter writing, renewing contact with some former acquaintances; the latter hunted through the

Francis Palanc, *Blue Writing*, 1953. Crushed and colored eggshell on fabric, 31 1/2 x 23 ins (80 x 59 cm). Collection de l'Art Brut, Lausanne.

Francis Palanc, *Grotto*, 1954–56. Crushed eggshell and lac on hardboard, 23 1/2 × 28 1/4 ins (60 × 72 cm). Collection de l'Art Brut, Lausanne.

François Ozenda, *Lamp and Message*, undated. India ink, 3 ft 4 1/4 ins and 2 ft 1/2 in (102 × 62 cm). Collection de l'Art Brut (Collection Neuve Invention), Lausanne.

countryside around Vence and visited self-taught artists. The goal of their search was twofold: the acquisition of works for a new collection in Vence and finding pieces that could be exhibited in Chave's gallery—a goal that was quickly reached.

A few months later, during the summer of 1959, an exhibition entitled "Art Brut" of around forty works by fifteen or so creators opened its doors at Alphonse Chave's gallery. It was an important moment, because it was the second public exhibition in the history of Art Brut following the one held in René Drouin's gallery in the Place Vendôme, Paris, in 1949. Dubuffet and Chave's discoveries were pooled together. Francis Palanc's alphabets, Marthe Isely's remarkable figures, François Ozenda's saints and monsters were among some of the more striking productions unearthed by the gallery owner. Former representatives of Art Brut—Aloïse, Gaston Duf, Paul End, and Juva—were thrown in, adding to the mix their fantastic birds and imaginary beings. Dubuffet sponsored this show, financing the publication of its catalogue and

Francis Palanc. Collection de l'Art Brut, Lausanne.

114

Eugène Gabritchevsky, *The Dream of an Old Flea*, 1953. Gouache, 10 1/2 × 16 ins (27 × 41 cm). Collection de l'Art Brut, Lausanne.

Eugène Gabritchevsky, *Person*, between 1950 and 1956. Gouache (folding), 12 1/4 × 8 ins (31 × 20 cm). Collection de l'Art Brut, Lausanne.

Eugène Gabritchevsky, *Hollowed out Mask*, between 1950 and 1956. Gouache (folded blot), 7 1/2 × 4 ins (20 × 10.5 cm). Collection de l'Art Brut, Lausanne.

writing the text for it. The following year, a new exhibition was mounted in the same place, introducing small "geological landscapes" by Rose Aubert, a farmer living near Toulon who was discovered by Chave. As for Dubuffet, he contributed gouaches and watercolors by Eugène Gabritchevsky, who used techniques that relied on randomness, such as blots and foldings.

BREAKING THE RULES

Whereas in 1948 Dubuffet wished to give the Foyer de l'Art Brut a somewhat secretive character, ten years later he seemed to have forgotten the rules he had decreed: confidentiality, secrecy, and separation from cultural circles. In Chave's Les Mages gallery, the works were shown to the public, put up for sale,

and circulated on the local art market; Dubuffet paradoxically became an accomplice, indeed the instigator, in the trade of these obscure works. On the surface of it, his collaboration with a dealer required a number of important concessions on his part, but in reality this was not the case. If he agreed to show Art Brut in a gallery, it was because it happened to be in what he considered a small town of little importance. Vence was not Paris. Moreover, during the 1959 exhibition, he was able to impress on Alphonse Chave one of his basic principles: his works were only loaned, they were "works of Art Brut from Dubuffet's collection" that could not therefore be sold. He was also careful to keep his works separate from those that belonged to the gallery owner, which were put up for sale. Later, Dubuffet agreed to works by Rose Aubert and Eugène Gabritchevsky being exhibited for sale

Friedrich Schröder-Sonnenstern. *Scene with Lion*, 1946. Colored pencil, 20 x 28 ¾ ins (51 x 73 cm). Collection de l'Art Brut (Collection Neuve Invention), Lausanne.

because he had already withdrawn some of them so that he could include them in his new collection.

Dubuffet was conscious of the considerable support that this collaboration provided him with. Alphonse Chave had helped restore his interest in Art Brut, discover new creators, and acquire many more works. Aside from the works by Gabritchevsky and Germans Friedrich Schröder-Sonnenstern and Ursula Bluhm, which Dubuffet had already discovered, all the others had been gathered by the gallery owner, notably the works by Marthe Isely, François Ozenda, Rose Aubert, Jacqueline B., Georges Demkin, Boris Bojnev, Marius Oddo, Cathy von Porada, Humbert Ribet, Philippe Dereux, and Francis Palanc. The latter's works represented a major discovery at the time. Obsessed with the idea of inventing an alphabet, this confectioner from Vence had completed a series of characters in an angular, geometric style, using gum arabic or tragacanth, crushed eggshells, and caramelized sugar.

The collector set aside for this new collection the lower floor of his residence in Vence, the Vortex. In this enclosed space, sheltered from view, the works of Art Brut rediscovered their confidential nature. Each one of them was carefully framed, placed on a pedestal or lined up on bookshelves assembled for the purpose. But this set up would only be temporary.

RETURN TO ORDER

Contrary to a number of painters, such as Matisse, Braque, and Derain, who had celebrated the charms of the South of France at the beginning of the century, Dubuffet ended up hating "the way that along

Francis Palanc, *This Fair—Noises—Cries—Words*, c. 1955. Crushed eggshell on fabric, 21 1/4 × 32 ins (54 × 81 cm). Collection de l'Art Brut, Lausanne.

Installation of pieces from the Art Brut collection at the Vortex in Vence, 1961. Collection de l'Art Brut, Lausanne.

Juva, *Flint*, between 1948 and 1949. Collection de l'Art Brut, Lausanne.

the entire Côte d'Azur shepherds, shop owners, and all other bandits who prey on tourists excel at using their cleverness in order to turn everything into a profit and in particular to commercialize unselfishness . . . I fear I should never have opened my mouth about Art Brut in a region as dangerous as this one is, where everything is geared toward profit or the antics of buffoons. Like a prostitute willing to do anything to catch the attention of strangers and get them to empty their pockets, they irrevocably taint everything that might possibly be done here."[21] A growing discord with Alphonse Chave had something to do with his exasperation and eventual departure for Paris. Although Dubuffet had at first authorized the exhibition of Art Brut in Chave's gallery, he was opposed to the making of money from these works, since their creators had worked

Jean Dubuffet in Vence. Fondation Jean Dubuffet, Paris.

with no thought of financial gain, separate from the art market. While he advocated a certain discretion in relation to the collection, Chave still wanted to thrust Art Brut "into the public eye in order to defend the idea that this is what real creativity was about."[22] It was inevitable that such conflicting views would end in disagreement: the dealer abided by economic imperatives, the collector-artist enjoyed the privilege of acquiring works in complete freedom. During the spring of 1961, roughly three years after having resumed his prospecting, Dubuffet gave up on the Art Brut venture in the South of France. The project that he was planning with Alphonse Chave—building a house in Vence to house the works they had collected—was aborted. Furthermore, the collection's return from America was imminent. The group of works at Vence would be grafted onto it and the whole collection would be transferred to a building in Paris that Dubuffet was planning on buying.

DUBUFFET RECLAIMS EXCLUSIVE RIGHTS

Dubuffet's initial feelings of trust and admiration for Alphonse Chave turned into distrust. When Chave stopped sharing the fruits of his prospecting with his "guide," the latter could not tolerate the competition and felt that Art Brut was being taken away from him. He demanded exclusive rights to it. The gallery owner "is in every way a copycat and since I had the idea of putting together an 'Art Brut' collection, he came up with the same idea, an 'Art Brut' collection, but it would be better if he came up with his own ideas and would start collecting pipes or teapots and leave 'Art Brut' alone, seeing as how I'm the one who invented this business and I'm the one who has zealously and methodically worked on it for ten years. But it is not at all in his nature to do so; moreover, I have put together rather large collections and did so through systematic prospecting in various countries for a rather long

Georges Demkin, *Wheels and Flowers*, 1962. Gouache, 13 × 16 ins (33 × 41 cm). Collection de l'Art Brut, Lausanne.

time, and he has no chance of putting together anything equal to that. If he succeeded, it would be a second collection of Art Brut, which would only muddle everything up and wouldn't make any sense; it is best, in my opinion, to keep it all in one group. Chave doesn't have any way to effectively exhibit collections of this kind and can only get rid of them so he can make a little money, which for works like these seems to me rather illegitimate and in any case not very interesting."[23]

Dubuffet was very possessive about his collection. In an authoritarian way, he demanded sole control of Art Brut. If this attitude betrayed a certain fear, it was not the fear of being supplanted in his enterprise by Alphonse Chave, because he knew the value of his personal collection. Dubuffet no longer had any confidence in the gallery owner and also

considered his prospecting work and his exhibitions very confused, his choices very inconsistent.[24] In his opinion, Art Brut was still misunderstood and risked being debased and corrupted. Dubuffet claimed exclusive rights above all because he regarded the invention and development of the concept of Art Brut as intellectual property, in addition to all the research, acquisitions, and activities associated with it. Ten years after his decision in 1952 to distance himself from Art Brut, he reappropriated his discovery. Thus, the idea and the collection that Dubuffet had invented were to be preserved. But this demand for exclusive rights suggested despotic control as well, which meant he could accept or refuse an artist's entrance into the "temple" of Art Brut. Dubuffet was granted complete power. In a paradoxical way, this attitude protected Art Brut

Georges Demkin, *Composition with Eyes and Masks*, 1961. Gouache, 13 × 16 ins (33 × 41 cm).
Collection de l'Art Brut, Lausanne.

from adulteration and dispersion and allowed him to preserve its intrinsic unity and shape.

Alphonse Chave brought about the definitive break with Dubuffet while mounting an exhibition at the Henriette Le Gendre gallery in Paris during the spring of 1964. "La Collection privée d'un marchand de tableaux de province" (The Private Collection of a Provincial Dealer's Paintings) included many of his discoveries, such as Aloïse, Chaissac, Gabritchevsky, Dubuffet, Palanc, Asger Jorn, and Dado. Mixing together creators of Art Brut with painters from the official artistic scene, could only have angered Dubuffet, who believed that these mysterious creators should not only be spared from the art market but should also be seen as distinct from recognized artists.

"VIEWING ART BRUT AS A POLE"

Dubuffet's definition of Art Brut had not changed since its invention ten years earlier in Paris. The only theoretical text on Art Brut to appear during 1959 set out the same criteria for defining its exponents: lack of artistic training, inability to adapt socially, indifference to all recognition and commercial promotion, solitary and clandestine creation, modest technical resources, "burning mental tension, boundless inventiveness, exalted intoxication, complete freedom," and purity of expression."[25]

However, Dubuffet qualified his statements, thereby marking a fundamental step in the evolution of his theory. For the first time, he abandoned his rigid Manichean distinction between Art Brut and "cultural art." The two types of expression were not radically and intrinsically opposed. They interacted

121

Eugène Gabritchevsky, *Rue Falguière*, 1944. Gouache 9 1/2 × 13 1/2 ins (24 × 34 cm).
Collection de l'Art Brut, Lausanne.

Eugène Gabritchevsky, *Lines of Small Strange Beings*, c. 1939. Black pencil, 9 3/4 × 13 1/2 ins (25 × 35 cm).
Collection de l'Art Brut, Lausanne.

and influenced each other. "If the big names borrow occasionally from Art Brut—and it's to their credit—it should be stressed that Art Brut too in many cases dips its brush in their paint and I don't want to pretend that someone could proclaim: this is Art Brut and that is false art made by monkeys at school." From that point on, while admitting to "viewing Art Brut as a pole," Dubuffet seems to have tempered his initial intransigence and modified the definition of his concept. Nevertheless, although he considered Art Brut as a "pole," as a "wind that blows more or less strongly and that is often not the only one to blow," he stressed all the more its rareness and therefore its dissidence. The multiplicity of hybrid works of art, however, proved the complexity of the complete emancipation to which the works of Paul End and Francis Palanc testify. Recognizing that it "is difficult to go against the flow without deviating a little bit from it" is to confer on Art Brut its singularity and all of its subversive value. To acknowledge that it "is difficult to go against the current without deviating slightly" was to recognize the true value of Art Brut and its real subversiveness. The theorist explained—with great clarity—a concept that had remained hidden: the creators' choice, conscious or unconscious, to escape from "the influence of the art of the experts," to avoid conforming to cultural and social norms, and to follow the path of deviance.

According to Dubuffet, insanity, the "cutter of ties" and "eraser of memory," was one of the supreme avenues to creation. The argument outlined in his earliest theoretical writings retains all its power, but also all its ambiguity. Although Dubuffet attached importance to madness because it protected the creator from external influences, in other respects he denied the validity and limits of this concept. In his eyes, creation, by definition, went hand in hand with insanity.

Francis Palanc, Marthe Isely, Rose Aubert, Georges Demkin, Humbert Ribet, and Eugène Gabritchevsky—the major creators discovered during the Vence period—were not in any way representatives of asylum art. The definition outlined fifteen years earlier by Dubuffet remained valid: Art Brut is not synonymous with the "art of the insane."[26]

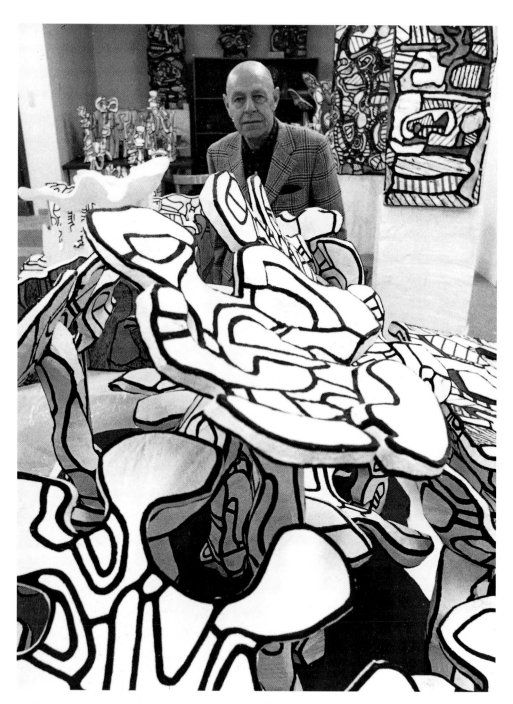

Jean Dubuffet with *L'Hourloupe*, 1970. Fondation Jean Dubuffet, Paris.

THE REBIRTH OF THE COMPAGNIE DE L'ART BRUT

The year 1962 was a key one for the Art Brut venture because the enterprise decisively widened its scope and displayed unprecedented vigor. It also marked a turning point in Dubuffet's work. The artist decided on a radically new direction, initiating the cycle entitled *L'Hourloupe*. He worked on this series for more than a decade, simultaneously using pictorial, sculptural, and monumental media. "This cycle is marked by a much more arbitrary and irrational nature than all of the previous works. A dive into fantasy, into a phantasmagorical parallel universe. My renewed interest in Art Brut's productions was not unrelated to this sudden turning point."[1] Dubuffet's personal search for expression could only have intensified his appreciation for the works invented by creators of Art Brut. His renewed artistic strength and conviction permitted him to take up the torch again; he firmly committed himself to a double life: one as a creator and the other as a collector.

THE COLLECTIONS RETURN TO PARIS

"As you can understand, because I am passionately attached to these collections, seeing a few pieces removed is a sacrifice equivalent to losing an eye, and I kindly ask you to limit yourself to 4 or 5 pieces as agreed upon and none of the important ones," Dubuffet wrote to Alfonso Ossorio in the spring of 1962.[2] The American artist's attachment to the works of Art Brut was so powerful that he was reluctant to let go of them. After some disagreement, Dubuffet finally managed to bring about the return of the collections to Paris, agreeing nevertheless to leave some works with the man considered for the last ten years as just as much the owner of the collection as he was. Ossorio kept four works by Hernandez, Crépin, Wölfli, and Forestier.

Dubuffet then acquired a large mansion at 137 rue de Sèvres, which was destined to be Art Brut's new home. Changes and improvements made it possible to reorganize the layout of the four floors, and, in particular, to create large areas for exhibitions and considerable wall space for hanging works. Six of the fourteen rooms were set aside for showing works, while the others were designated for study, the archives, and offices. In 1974, after the Art Brut collections were moved to Switzerland, the Fondation Jean Dubuffet was created and would be based here, where it still is today. Among the 1,200 pieces brought back to France in the spring of 1962, many were now mounted, protected, framed, or provided with a pedestal. Dubuffet the collector paid close attention to their restoration: "Dubuffet did not say a word when it was a question of his own work, he had complete confidence in me. But when someone would touch one of the Art Brut objects, he was like a mother with her jars of jam. It was unbelievable! He watched over everything! He would always be stopping by the studio . . . he would watch over them as if they were the Blessed Sacrament. I can assure you, he's worse than a curator when someone touches the frame of the Mona Lisa! It was unbelievable. He would come to supervise the work on Art Brut but never supervised his own work," recalled Jean-Paul Ledeur, the restorer hired both for the Compagnie and for Dubuffet's own personal works.[3]

The rooms housed a large number of sculptures, paintings, and drawings, as well as works on paper

The mansion at 137 rue de Sèvres, Paris.
Fondation Jean Dubuffet, Paris.

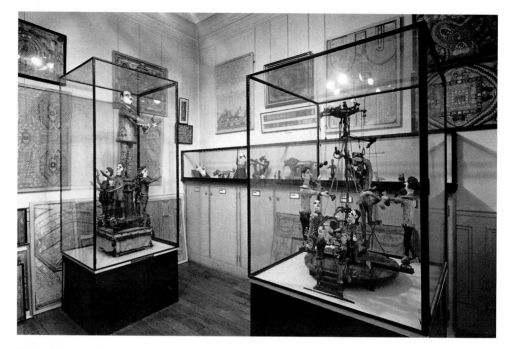

The Art Brut collection at 137 rue de Sèvres, Paris, 1970. Collection de l'Art Brut, Lausanne.

stored in drawers. This profusion of works were displayed haphazardly. No attempt was made to arrange them into groups. The kaleidoscopic, hectic arrangement produced striking juxtapositions and combinations of images, which made the visit a genuine voyage of initiation into the universe of Art Brut. Pierre Bettencourt recalled first discovering this "delicious little museum with a gallery leading to a central stairway lit by a glass roof where so many marvels, seen by the light of day, will never be better displayed—(in surroundings worthy of the tombs of the pharaohs) where one had the impression of having startled them from a sleep which had lasted thousands of years."[4]

"This 'Art Brut' was supposed to be a secret; let's keep it secret."[5] As with the first Compagnie de l'Art Brut, the collector decided to keep these works veiled in secrecy. By keeping them out of sight, he protected them from any unsavory curiosity. Privacy was the watchword. Unlike the Gallimard pavilion in the 1940s, the new institute did not have any public

mission and saw itself "padlocked and reserved for true friends."[6] Art Brut passed from secrecy to confinement. Works of revolt created outside of society, in a prison cell, in a suburban attic, or in a barn were once again kept away from the world. Locked up and isolated behind a set of closed doors, they were blessed in a way in this Parisian temple. Although the general public was forbidden to visit the establishment, visits by appointment were granted to those individuals who displayed a real interest in this type of work. Dubuffet purposely dubbed the premises a "laboratory for study and research."[7] Permission to visit was based on trust. Visits were limited to four guests at the most, enabling them to gain maximum benefit from their introduction to Art Brut and insuring the collection's security. Neophytes were slowly escorted on a tour, enriched with explanations and commentary by Slavko Kopac or by one of the assistants on duty.[8] From this point on, no works would be lent or exchanged and Art Brut would be protected from speculation.

Adolf Wölfli, *The Gigantic City of Cuckoo Birds*, 1923. Colored pencil, 24 1/2 × 18 3/4 ins (62 × 47.5 cm).
Collection de l'Art Brut, Lausanne.

Jean Dubuffet and Slavko Kopac, 1970.
Photograph by Kurt Wyss.

Top right: Jean Dubuffet and Asger Jorn, 1961.
Fondation Jean Dubuffet, Paris.

Right: Jean Dubuffet and Raymond Queneau, 1960.
Fondation Jean Dubuffet, Paris.

NEW COLLABORATORS

On September 24, 1962, eleven years after its disso-
lution, the Compagnie de l'Art Brut was reborn in
Paris in the same form and with the same status: an
association in accordance with the 1901 law. Thanks
to his past experiences, Dubuffet handled the organi-
zation of the association in a more rational and pru-
dent way. He surrounded himself with a dynamic
committee consisting of seven individuals who
shared his ideas about Art Brut and guaranteed him
effective assistance: the art dealer Daniel Cordier;
the painters Asger Jorn and Slavko Kopac; and the
writers Raymond Queneau, Noël Arnaud (pseudo-
nym of Raymond Müller), Henri-Pol Bouché, and a
friend, Emmanuel Peillet.[9]

Opposed to any idea of ownership and preferring
to "live like a tramp, without luggage, memories,
keepsakes, or fetishes," Dubuffet did not record the
collections in his name.[10] He voluntarily declined to
consider the collections as his property, because his

first concern was insuring their future and preventing
their dispersion. He made the organization a legally
autonomous owner of the works and the building.
Also, by giving the committee control of the collec-
tions, he insured that the organization would be able
to continue after his death. Chosen with the greatest
care, the members were "people truly interested in
our endeavors, who share our tastes and views, who
are capable of helping us gather information and

Baya, *Two Dancers*, undated. Gouache on paper, 19 × 24 1/2 ins (48 × 62.5 cm). Collection de l'Art Brut, Lausanne.

Baya, *Woman and Peacock*, undated. Gouache on paper, 42 1/2 × 29 3/4 ins (108 × 75.5 cm). Collection de l'Art Brut, Lausanne.

expand our collections, in short of participating in our enterprise."[11] Jean Dubuffet paid the organization's taxes and the membership dues for all its members.

The project manager hired a number of regular assistants to help with the day to day operations of the organization. Slavko Kopac, curator for the first Compagnie, resumed his duties, playing an active role in this new venture. A trusted friend and Dubuffet's right-hand man, the Croat painter put his own work on hold and helped Dubuffet exhibit and manage the collections. He directed the association when its president was staying in Vence or Le Touquet. Kopac not only proved to be an excellent curator, but he also possessed a unique artistic sensibility close to that of the creators of Art Brut: "Kopac is the one who helped me understand Art Brut better than Dubuffet, whose explanations were too intellectual. His words were simple, but he had an intellectual approach. Kopac's approach, on the other hand, was sensitive; he used to touch the objects. Kopac really had the Art Brut spirit," a donor confided.[12]

Other assistants developed a passion for Art Brut alongside the faithful curator of the collections; their collaboration demanded a twofold commitment.[13] They all had to submit to the strict discipline required by Dubuffet and attend to the cataloguing of archives, files, and documentary photographs, all of which had to be as exhaustive as possible. Additionally, they were required to adapt to the particular demands of studying Art Brut: they had to carry out interviews with marginal, sometimes aggressive individuals; they had to collect information concerning unknown, missing creators; and they had to be able to decipher obscure works and texts, a task that often required a keen wit and a good imagination. Dubuffet directed the Compagnie like a real business and was as demanding with his assistants as he was with himself. "He was very sensitive about Art Brut," Michèle Edelman recounted. "It wasn't easy to work there because there was little room to maneuver. Sometimes there would be a blow up over something as minor as not having enough experience or the ability to understand. He could become a little irritated and subdued. You had to do what you had to do."[14]

Top: Guillaume Pujolle, *The Provence. Cartoon,* 1946. Gouache and ink, 19 x 24 3/4 ins (48 x 63 cm). Collection de l'Art Brut, Lausanne.

Bottom: Guillaume Pujolle. *The Death of the Old Boer and his Horse,* 1940. Ink and pencil, 19 x 25 1/4 ins (48.5 x 64 cm). Collection de l'Art Brut, Lausanne.

Augustin Lesage, *Symbolic Composition of the Spiritual World*, 1925. Oil on canvas, 80 3/4 × 57 ins (205 × 145 cm). Collection de l'Art Brut, Lausanne.

Charles Jauffret, a page from his thirty-six-page
notebook, c. 1900. Writings and drawings
in pencil, 8 3/4 x 6 3/4 ins (22 x 17 cm).
Collection de l'Art Brut, Lausanne.

Camille Renault's yard.
Photograph by Robert Doisneau.
Lucienne Peiry's Archives, Lausanne, Switzerland.

COMPLEXITY OF PROSPECTING

The Art Brut experience, Dubuffet claimed, "has
consisted not in showing Art Brut after having
defined it, but in searching for where Art Brut is,
with a view to gathering information that might
finally make it possible to define what it is. Profes-
sors are only familiar with the initial definition . . . In
enterprises such as mine, whose aim is to seek out, to
grope around in hopes of finding something, they are
in over their heads."[15] If Dubuffet chose to enter into
this universe, it was precisely to pierce through the
mystery surrounding these works and to illuminate
their secrets. He set off in search of Art Brut in order
to understand it. Nonetheless, the prospector had a
few ideas on how he might go about it. He referred to
his earlier ventures, carried out during the tenure of
the first Compagnie de l'Art Brut, in order to "come
into contact with works representative of cerebral
creation in its raw, pure state surging up in all their
spontaneity and artlessness." He then returned to the

asylums and penitentiaries, where it was possible to
find "the champions of non-conformity, the stan-
dard-bearers of personal and unconditioned thought,
the noble devoted to the imagination and the icono-
clasts casting off learned fact."[16]

In the psychiatric hospitals, Dubuffet's approach
was even more complicated than before. Moreover,
he ran into new problems because of the establish-
ment of studios where "art therapy" was practiced.
The creation of special places, the availability of
materials, and above all the encouragement of artis-
tic expression had led to a supervised, organized art,
which in every respect ran counter to the isolated
manifestations of Art Brut. The places that Dubuffet
had visited during his first forays nearly twenty years
earlier had changed: "They used to neglect the sick
and . . . they used to figure out for themselves how to
get out of their mess, using their delirium and culti-
vating it the point where it bore fruit. In certain cases
it undoubtedly resulted in the sick person becoming

132

a marvelous creator and he would be so delighted with his work that it gave him a reason to live again; it was a blossoming that could be considered a cure. Call it a perverse kind of cure. Today, they attempt to dissuade the sick from pursuing any activities . . . that increase their delusions; they attempt to get them to socialize; to make them give up their "idiosyncrasies" and personal ways and adopt instead the accepted way of doing everything . . . As a result, the spontaneous creation of 'Art Brut' has become even rarer now in psychiatric hospitals. In 'art therapy' studios, the stated goal is as elsewhere: to lead the sick back to the generally accepted conventions. This approach runs counter to the creation of 'Art Brut,' which implies a rejection of accepted conventions and is certainly rooted in rebellion and revolt."[17] Dubuffet knew that he had no chance of discovering the works he was looking for in these studios, "those small pieces of work (be it scribbling in a notebook or unusual objects made from nothing in particular, with strings attached to a piece of cardboard, or 'rags,' pieces of embroidery, etc.) that people have secretly devoted themselves to making in an entirely spontaneous way with the meager materials available (and above all not with gouache on lovely sheets of drawing paper under the supervision of monitors and doctors)."[18] Dubuffet had to refine his searches in asylums. He corresponded with doctors recommended to him by members of the association, such as Asger Jorn and Lorenza Trucchi, and made contact with the practitioners who had assisted him many years earlier and who, for the most part, responded once again to his appeals.[19]

Aside from his contacts with psychiatric establishments—his most important sources—Dubuffet established a regular and fruitful relationship with the spiritualist circles in France. During the spring of 1963, he paid a visit to the Maison des Spirites in Paris, became friends with one of its leading members, and subscribed to the *Revue spirite*. For its part, the institution brought to his attention cases of mediumistic creation, notably the work of Laure Pigeon, and provided him with relevant information about creators, together with important documents, such as those by Augustin Lesage. With the same goal,

Dubuffet became a nominal member of the Société Internationale de Psychopathologie de l'Expression from 1962 until 1966, but this organization did not offer the information he had counted on. He also contacted several galleries which deviated from traditional French values, notably the Raymond Cordier gallery in France and the Grosvenor Gallery in England. The interest that they showed foreshadowed the entrance of Art Brut onto the art market in the middle of the 1980s.

Though Dubuffet went prospecting on a number of occasions in France, Switzerland, and Belgium at the beginning of the 1960s, he gradually began to delegate this mission to some of his assistants, devoting himself instead to correspondence.[20] All his correspondents were painstakingly informed about the history, the activities, and the approach of the Compagnie de l'Art Brut, receiving a small brochure together with other information from Dubuffet. As a result, they became part of a valuable network throughout Europe, willingly cooperating with the new organization. Each assistant followed the methods of Dubuffet, who in many instances had infiltrated the strangest of places. In 1963, he uncovered in just this way one of the most important figures in the collections: "Art Brut has been dormant during this vacation . . . but I am on the look out. I knocked on doors in those incredible housing projects for miners in the region near Béthune and dug up paintings by the deceased miner and visionary Augustin Lesage, whose works are quite beautiful."[21] For their part, his emissaries kept their eyes open, in hopes of coming across something while sifting through piles of forgotten junk in a loft, a basement or a garden. The creations they discovered were often about to be destroyed. The calligraphic texts of Charles Jauffret barely escaped the garbage truck: "We got it from a friend who found a child's notebook filled with tiny writing in pencil in a pile of paper trash from some unknown source."[22] The same outcome awaited the important works of Laure Pigeon; after her death, Pigeon's apartment was cleared out and all that remained was a big box of drawings and writings that no one wanted. Notified, Dubuffet picked it up and took it to the Compagnie's offices.

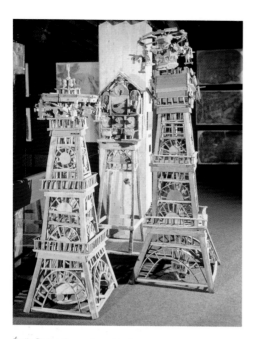

Émile Ratier, *Carousels*, undated.
Collection de l'Art Brut, Lausanne.

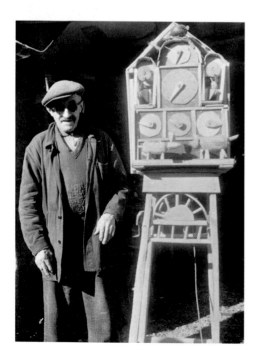

DIVERSE ACQUISITIONS

Even though Dubuffet's intuition was highly developed, he underestimated what would be found. The Compagnie's discoveries surpassed all of his expectations. Day after day in the rue de Sèvres he received a disconcerting number of works, each of which displayed its own mythology, a specific system and set of values. Madge Gill's ink drawings of labyrinthine structures featuring women's faces had nothing in common with Émile Ratier's large carousels erected, despite his blindness, on wooden scaffolding. There was no kinship between Gaston Duf's drawings of the monstrous *Rinôcêrôse* and its nightmarish companion the *Ipôtâme* and Marguerite Sir's wedding dress, which was meticulously designed with threads pulled from her sheets for an imaginary wedding day. Neither was there any link between Carlo's anonymous silhouettes distributed on the paper according to different scales and vantage points and André Robillard's mock guns manufactured out of jam jars, electric bulbs and pieces of scrap wood. Each form of expression was original, and each style and choice of materials unique. Each body of work was the symbolic manifestation of a private history, proving that Art Brut is multiple.

Yet, if anything united these creators, it was above all their humble origins and rudimentary instruction. They were unskilled workers, mailmen, florists, hairdressers, streetcar conductors, and miners. More importantly, each one carried inside them an existential

Émile Ratier. Collection de l'Art Brut, Lausanne.

Gaston Duf, *Rinôcêrôse*, 1950. Colored pencil, 19 1/2 × 26 3/4 ins (50 × 68 cm). Collection de l'Art Brut, Lausanne.

Madge Gill, *Drawing*, 1954. Colored ink on cardboard, 25 1/4 × 20 1/2 ins (64 × 52.2 cm). Collection de l'Art Brut, Lausanne.

Guillaume Pujolle, *The Eagles, The Goose Feather*, 1940. Colored pencil and ink, 19 × 25 ins (48.5 × 63 cm). Collection de l'Art Brut, Lausanne.

Madge Gill working on one of her textile works, c. 1936. Photograph by Jan Reich. Outsider Archive, Dublin.

fracture resulting from a shock or a conflict of some sort: Carlo's and Jean Radovic's experiences during the war, the break up of a love affair for Aloïse, Laure Pigeon, and Miguel Hernandez, the death of someone close for Madge Gill and Jane Ruffié, the stress of exodus for Giovanni Battista Podestà. They never got over these experiences and became perpetually exiled internally. Some were institutionalized, often for life in asylums or medical institutions, while others attempted with difficulty to live in society. Loners, maladjusted, outcasts, they glimpsed only one way out: the creation of an imaginary world where nothing could affect them.

It is therefore not surprising that this new wave of Art Brut exponents included people like Lesage,

Carlo, *Birds and People,* between 1961 and 1962.
Gouache, 13 3/4 × 19 3/4 ins (35 × 50 cm).
Collection de l'Art Brut, Lausanne.

Carlo. Collection de l'Art Brut, Lausanne.

Tripier, Gill, and Lonné, who claimed to be spiritual-
ists or visionaries, guided by divine power or a voice
from the beyond that gave their works a spiritual
dimension, thereby reestablishing the link with sacred
values in art. Neither is it surprising that these creators
included women—Marguerite Sir, Juliette-Élisa
Bataille, Jeanne Tripier—who put to their own use the
means that symbolized their subjection: knitting,
embroidery, and crochet. These techniques took on a
fantastic dimension, becoming the tools for a counter-
offensive in the form of magical works imbued with
a feeling of rebellion. "It has always seemed to me
that cultural art is invented by men for men and
women are hardly able to do it. But as regards Art
Brut, I am amazed to state the contrary: women [are]

137

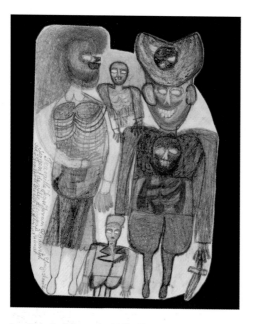

Jean Radovic, *Policeman*, c. 1945–47. Graphite pencil and colored pencil, 11 1/2 × 8 1/4 ins (29.5 × 21 cm). Collection de l'Art Brut, Lausanne.

Jean Radovic. Collection de l'Art Brut, Lausanne.

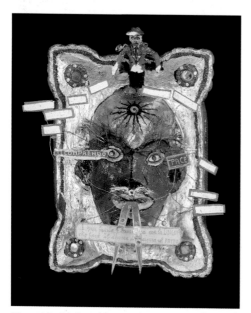

Giovanni Battista Podestà, *Good and Evil*, undated. Mixed media, 14 1/2 × 10 1/4 ins (37 × 36 cm). Jean Tinguely Collection, Milly-la-Forêt.

Giovanni Battista Podestà. *Red Devil's Head*, undated. Mixed media, 11 3/4 × 9 3/4 ins (30 × 25 cm). Private collection.

much more adroit, more at ease than men. Probably because [they are] less conditioned by cultural art's norms," Dubuffet noted.[23] Rejects, misfits, all of them became inventors of a cobbled together replacement ideology or philosophy set in Pujolle's menacing castles, in Lesage's vertiginous constructions, or in Vojislav Jakic's embryonic insects. Some very unusual cases were also accepted into the collections: painters and drawers, sculptors and handymen, seamstresses and embroideresses, builders of environments and sculpted worlds, writers and poets.[24]

Insatiable, Dubuffet was constantly in search of new discoveries as if they were pieces of evidence in his esthetic investigation, indispensable testimony in the preparation of his case for Art Brut: "When new cases would arrive, it was astonishing to see how much satisfaction they gave him," recounted a donor. "He became feverish. It was truly the greatest pleasure one could have granted him: to bring in new things, new creations."[25] However, he was not only interested in the new, he was also keen to add to existing collections. Sometimes, Dubuffet even acted like the curator of a museum: "I am extremely interested in the works by Madge Gill that you have agreed to hand over to the Art Brut collections. I would like, if possible, to acquire some other works by her. I would especially like to acquire a larger work; also, if it is possible, works in color; also other notebooks like the one that you kindly gave us as a gift. I would really like to acquire, if they can be found, the writings of Madge Gill . . . It would be a great help to me to determine the precise dates when some of the works that are now part of our collections were created, beginning with this gigantic drawing on canvas, which is eight meters long, and also the notebook that you offered us." [26] He thought it necessary for each artist to catalogue a large number of works, representative of the different phases they went through and their different modes of expression. For Wölfli, whom he considered as the most prodigious example, he succeeded in obtaining a set of seventy pieces that came from Dr. Julius von Ries's collection, as well as eleven drawings and a folding screen from Dr. Oscar Forel. This body of work was added to a small series acquired previously, making it possible to follow the evolution of Wölfli's work from 1907 to 1928. Dubuffet also expanded his collection of works by Aloïse, thanks

Juliette-Élisa Bataille. Collection de l'Art Brut, Lausanne.

Juliette-Élisa Bataille, *The Eden Casino in Berck-Plage*, 1949. Wool embroidery on cardboard, 20 1/2 × 13 ins (52 × 33 cm). Collection de l'Art Brut, Lausanne.

Vojislav Jakic, *The Frightening Horned Insects*, undated.
Ballpoint pen and colored pencil, 55 3/4 × 39 1/2 ins (141.5 × 100.5 cm). Collection de l'Art Brut, Lausanne.

Adolf Wölfli, *Great Imperial Highness the Princess Olga from the Throne of St. Adolf in Poland*, 1916.
Colored pencil, 16 × 11 1/2 ins (43 × 29 cm).
Collection de l'Art Brut, Lausanne.

Scottie Wilson, *Thinking about Houses*, 1950.
India ink and watercolor, 22 1/2 × 15 ins (57 × 38 cm).
Collection de l'Art Brut, Lausanne.

Vojislav Jakic. Photograph by Mario del Curto.

to regular gifts from Dr. Jacqueline Porret-Forel, and managed to procure new sculptures by Auguste Forestier, masks by Pascal-Désir Maisonneuve, new canvases by Miguel Hernandez, and drawings by Scottie Wilson.[27] Dubuffet expended just as much effort on newly discovered creators, such as Lesage, Gill, Carlo, Jakic, Ratier, and Lonné.

During this period, the Art Brut collections expanded considerably. Around 1963, they numbered more than two thousand works and by 1966 five thousand.[28] At that point, Dubuffet estimated the number of interesting cases at more than seventy. Acquisitions were particularly important during the first half of the decade and obviously slowed at the end of the 1960s: "My opinion is that at this time the Art Brut collections are sufficiently large and diverse that there is no longer any need to go out and add to them—unless of course we come across some exceptionally significant, important works," declared

Raphaël Lonné, drawing, undated. India ink, 19 1/4 × 25 1/2 ins (49 × 64 cm).
Collection de l'Art Brut, Lausanne.

Raphaël Lonné, drawing, 1950. Ballpoint pen, 8 1/2 × 10 1/2 ins (21 × 27 cm).
Collection de l'Art Brut, Lausanne.

Carlo, untitled, 1963. Gouache, 27 1/2 × 19 3/4 ins (70 × 50 cm). Collection de l'Art Brut, Lausanne.

Carlo, *Figure and Crucified*, 1968. Gouache, 27 1/2 × 19 3/4 ins (70 × 50 cm). Collection de l'Art Brut, Lausanne.

Dubuffet in 1970.[29] The Compagnie was more interested by this time in categorizing the collections than in new discoveries; by 1976, when the Art Brut collections were donated and transferred to Lausanne, six thousand five hundred works and more than one hundred creators had been recorded.

Alongside the official collection of Art Brut, a parallel collection brought together secondary works. Established during the first period of the Compagnie, it consisted of naïve and tribal art and works by children. Dubuffet had initially included these within the collection but, as he was collecting and refining his definition of Art Brut, he had separated them. Other works were included, such as those that broke with artistic tradition but did not really display the qualities of inventiveness and independence that characterize Art Brut. The compositions by Louis Soutter, Marguerite Burnat-Provins, and Friedrich Schröder-Sonnenstern figured in this collection. At the

beginning of the 1960s, Dubuffet would move the works of some creators into this auxiliary collection, because he disapproved of their activities in cultural circles. The two departments were divided in 1971 into "Collections de l'Art Brut" and "Collections Annexes"; this division was made the moment that Dubuffet had the idea of donating the collections and creating a museum. He then took precautions to avoid any confusion: "I wanted to create a secondary collection for problematic cases: two distinct collections in order to resolve the problem of hybrid outsiders," he explained. "The collections of Art Brut properly speaking . . . are intended for works done by people lacking in instruction or who are at least completely outside artistic circles . . . in the *subsidiary* collections . . . one finds works by people who have . . . some artistic training, but which are imbued with the spirit of Art Brut."[30] In 1982, this secondary department was named the Collection Neuve Invention.

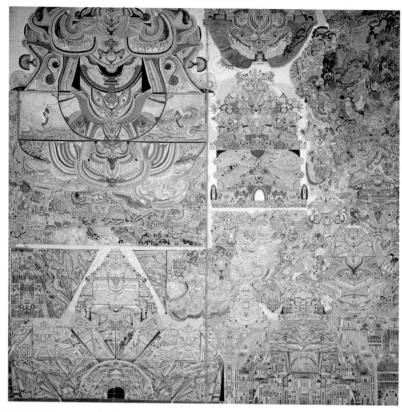

Augustin Lesage, *First Canvas*, 1912–13.
Oil on canvas, 118 × 118 ins (300 × 300 cm).
Collection de l'Art Brut, Lausanne.

Augustin Lesage. Collection de l'Art Brut, Lausanne.

THE PRICE OF A WORK

The first Compagnie's collections had been built up through numerous donations. The second time around, however, many works were purchased either directly from the creators or from an intermediary who was close to the artist. The artists had no basis for knowing how much their works were worth. It was embarrassing for them to have to name a price. Some, like Augustin Lesage the miner, worked out how long they had worked on a piece and worked out a price based on the hourly wage that they had received as workers. Others left it up to Dubuffet. The amounts agreed were modest. Émile Ratier, for

example, valued his wooden sculptures at between one hundred and fifty and four hundred French francs, while Raphaël Lonné agreed to part with 390 drawings for five thousand French francs.

Clément Fraisse, paneling, undated. 67 × 150 3/4 ins (170 × 383 cm). Collection de l'Art Brut, Lausanne.

Clément Fraisse, 1963. Collection de l'Art Brut, Lausanne.

The prices were much higher when a mediator intervened in the transaction. Lesage's daughter-in-law handed over a canvas for one thousand two hundred French francs. The Grosvenor Gallery in London sold twenty-two drawings by Madge Gill for around six thousand French francs and Aleksa Celebonovic, Vojislav Jakic's friend, sold three large compositions by the painter for three thousand French francs.[31] In 1964, Dubuffet acquired "the enormous and marvelous painting, the first one made in 1912 by the miner Augustin Lesage, and which eclipses by far everything he has done since then" for fifty thousand French francs—without doubt the single largest sum ever paid out by Dubuffet for any work in his Art Brut collection. Up to that time, the highest prices had been charged by a few doctors who had no qualms about selling works by their patients. Dr. Ferdière sold Dubuffet eight paintings and two sculptures by Guillaume Pujolle, as well as

145

Carlo, *Boat*, 1963. Gouache, 13 3/4 x 19 3/4 ins (35 x 50 cm). Collection de l'Art Brut, Lausanne.

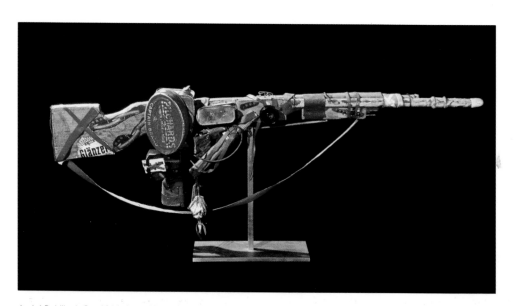

André Robillard, *Gun*, 1964. Assemblage of various materials, length 45 ins (114 cm). Collection de l'Art Brut, Lausanne.

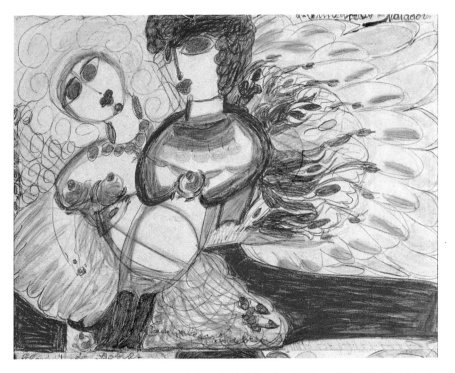

Aloïse, *The Matador's Cloak*, detail, between 1948 and 1950. Colored pencil, 22 3/4 × 28 ins (58 × 71 cm).
Collection de l'Art Brut, Lausanne

three works by an anonymous creator, for ten thousand French francs; Dr. Forel offered eleven drawings and a folding screen by Wölfli for twenty-two thousand six hundred Swiss francs.[33]

But most of the practitioners who collaborated with the Compagnie's search and acquisitions donated the works that Dubuffet was interested in. In such cases, Dubuffet chose a system of exchange, or rather a type of compensation; Jane Ruffié received the small clock she desired, Gérard Olive a roll of film, Raphaël Lonné a record player and records. While making acquisitions, Dubuffet proved to be cagey in his dealings with some creators: "I have corresponded with Clément Fraisse [the creator of the carved paneling]. He first suggested that I offer him a car and garage to park it in, but I found his demands too grandiose and offered to send him fifty thousand francs [five hundred new French francs], with which he was finally satisfied."[34] However,

Clément Fraisse did not hide his surprise, replying that the piece had taken him three years. In another instance, Dubuffet spent twenty-four French francs for two guns by André Robillard, who was astonished not because the price was low, but because he had not been aware that Dr. Paul Bernard had sent his works to the Compagnie de l'Art Brut.

The Compagnie's acquisitions policy obviously differed greatly from the one in use on the art market; as a point of comparison, Dubuffet sold one of his paintings around this time for twenty-five thousand French francs.[35] The artist was conscious of the ambiguity of this situation: "I am very uneasy at the thought of people like Emmanuel D., who create such marvelous works for which they will not make any profit, and I experience a feeling of injustice in comparing the derisory, or even non-existent, prices that these people receive for their works with the absurd prices for which my own works—which I am

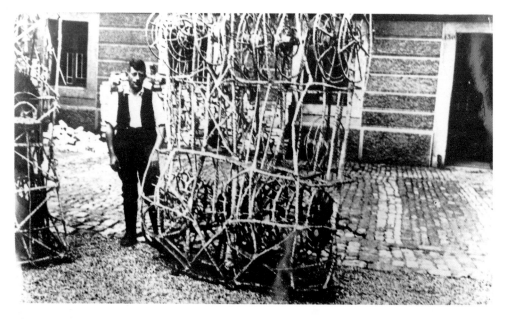

Heinrich Anton Müller in front of one of his sculptures between 1914 and 1922. Collection de l'Art Brut, Lausanne.

aware are not more valuable and even in many cases not as valuable—are sold for commercially."[36]

INTELLECTUAL PROPERTY

Many very cooperative doctors gave away their patients' creations and supplied a large quantity of information about their lives and work. Many of them composed texts for publication by the Compagnie de l'Art Brut. They committed acts that were illegal under French or Swiss law by taking possession of works the rights of ownership and use of which belonged solely to the patients, or their legal guardian or organization charged with their protection.[37] Some who overstepped their authority in this way merely considered the works as part of a medical file, while those who did view them as works of art effectively committed acts of theft. In fact, according to a 1957 law, the code of intellectual property indicates that "in opposition to anyone else, the author of a work of the mind enjoys, due to the sole fact of its creation, incorporeal and exclusive property rights to this work."[38] Furthermore, any information concerning the history and work of an institutionalized individual is confidential. By divulging information about

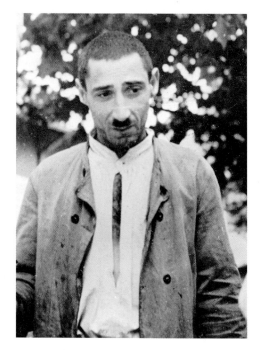

Sylvain Fusco. Collection de l'Art Brut, Lausanne.

Sylvain Fusco, *The Red Woman*, 1938. Pastel, 24 3/4 × 18 3/4 ins (63 × 47.5 cm). Collection de l'Art Brut, Lausanne.

Sylvain Fusco, *Queen*, 1935. Pastel, 24 1/2 × 18 3/4 ins (62.5 × 47.5 cm). Collection de l'Art Brut, Lausanne.

them—often at the insistence of the patient—doctors infringe professional confidentiality and undermine, according to law, the rights to personality, royalties, disclosure, and credit. Dubuffet could have become the subject of legal proceedings for being an accomplice. Still, if these doctors broke the law, they doubtless did so out of misunderstanding or sheer ignorance of the laws applicable. Moreover, their actions seem to have been largely influenced by their patients' attitudes toward their work.

Generally, the relationship between Art Brut artists and their works was not comparable to that between traditional artists and their creations. A number of them did not even sign their works and lost interest as soon as they were completed; they frequently gave them away or put them aside, and sometimes destroyed them. They avoided any act of appropriation—even if some, such as Laure Pigeon,

meticulously arranged and catalogued their works. Aloïse insisted on giving Dr. Porret-Forel her drawings, declaring: "The Madonna [Jacqueline Porret-Forel] will take it and get rid of it for me because it is so ugly that someone might toss it in the garbage."[39] Other creators, carried away in a fit of anger, took it out on their works: Heinrich Anton Müller broke up his kinetic machines; Francis Palanc attacked his paintings with a hatchet and pruning shears; and Katharina tore up her drawings. Moreover, most of them, oblivious to the notion of permanence, used fragile, ephemeral supports and materials. Sylvain Fusco carved his graffiti into the hospital's walls, Müller made machines out of branches, plants, and old rags, and the Prisonnier de Bâle concocted statues out of molded breadcrumbs. For them, the making of the work was a more important element than its conservation; the creative act prevailed over its result.

Furthermore, at the time, the works of patients in psychiatric institutions were normally treated with indifference. Those doctors who paid any attention to them were exceptions; knowledgeable about art, they quickly realized the quality of the work, followed their evolution and succeeded in finding out about the motivating forces behind them. Dr. André Requet recounted how Fusco began to create huge works of female genitalia on the courtyard walls in his wing out of charcoal, plaster, brick, and leaves; these motifs metamorphosed into "strange" and "legendary beasts" then into "underwater landscapes," and finally into "bearded women." The professional's observations contain obvious admiration and fascination: "The courtyard was a museum: all of it has been photographed. After being turned down several times, I was able to intercede and get him to accept some supplies: after having thrown them down and scattered them (much to the advantage of others), he began to paint frenetically. He used pastels . . . he would spread the color with his hands. He created pictures with such passion that, rather than wait for me to procure him another sheet of paper, he painted on the back, so that nearly all of his works are really two."[40] Elsewhere, Requet wrote enthusiastically: "It was fantastic because one had the impression that he had overcome his autism and was conversing with us about his fabulous visions through this grandiose, mute monologue."[41]

The rapport between patient and doctor and the sense of wonder led to bonds being established. These sometimes developed into genuine affection. Dr. Porret-Forel met Aloïse in 1941 and visited her regularly at La Rosière asylum until her death in 1964. For more than twenty years "her work has haunted my mental landscape," the doctor confided. "Like an inexhaustible source of compost, she has fertilized my imagination. I have always sensed her on the horizons of my existence."[42] Fascinated by Aloïse's personal mythology and alchemy, she put together a glossary of the symbols contained in her drawings, entering into this fabulous *Théâtre de l'Univers* (Theater of the Universe). Jacqueline Porret-Forel became the foremost specialist on this Swiss creator's work. Similarly, Dr. Walter Morgenthaler had a life-long admiration for the encyclopedic work of the drawer, composer, and writer Adolf Wölfli.

The psychiatrists acted in full knowledge of the facts when they agreed to donate works by their

Top: Auguste Forestier, *Person Seated on a Cow*, between 1935 and 1949. Carved wood and other materials, height 12 1/4 ins (31 cm). Collection de l'Art Brut, Lausanne.

Bottom: Gérard Vulliamy, *Portrait of Auguste Forestier*, 1945. Pencil, 12 1/4 × 9 ins (31 × 23 cm). Collection de l'Art Brut, Lausanne.

patients to the Compagnie de l'Art Brut: this organization did not behave as an owner but instead as "a collective foundation exempt from any lucrative enterprise, set up to remain and function in future years long after we are no longer here," Dubuffet explained.[43] From the doctors' viewpoint, the Compagnie was the most appropriate place for these works: protected from dispersion and destruction, the works would be exhibited, studied, conserved, and valued.

The institutionalized creators, like all exponents of Art Brut, had known rejection and disdain. Concealing their productions—as the legal texts would have required—would have amounted to a second rejection. The illegal protection of their works constituted the ultimate revenge for these outcasts.

WRITING THE HISTORY OF EACH ARTIST

Despite the failure to publish the *Art Brut* series in 1947, Dubuffet never abandoned the idea of putting together an important work on this subject. He was not the sort of man to give up. His aim was finally achieved at the beginning of the 1960s. During the creation of the second Compagnie de l'Art Brut, he decided to bring out a series of journals devoted to the most important artists and planned around sixty monographs, divided into a dozen fascicles or volumes, which would then be collected under the title *L'Art Brut*. Publishing meant communicating and this project was the first sign of a decisive break with the secrecy that had surrounded Art Brut up until then. Dubuffet now intended to shed light on the creators' lives and works, all the while controlling this disclosure, taking personal charge of the planning of the various editions and bearing all of the costs. The Compagnie de l'Art Brut became its own publishing house.

Although Dubuffet was the most prolific author, he also commissioned works, assembling a small editorial team made up of doctors, friends, and the company's collaborator-investigators. He requested their participation not because of their professional qualifications—none of them were art historians or critics—but because of their ties to the creators: they had discovered these works and had become attached to them. No one was better qualified than Dr. Morgenthaler to study Wölfli's complex works; no one knew Aloïse's work better than Dr. Porret-Forel, and only the poet Victor Musgrave, friend of Scottie Wilson, was in a position to retrace Wilson's life and to present his drawings. Rather than the analysis and interpretations of an art specialist, Dubuffet preferred

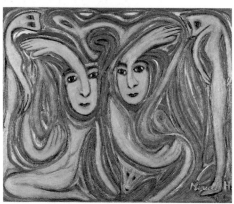

Miguel Hernandez. Photograph by Robert Doisneau. Collection de l'Art Brut, Lausanne.

Miguel Hernandez. *The Life of St. Theresa "Oracion,"* 1949. Oil on Pavatex, 23 3/4 × 29 ins (60.5 × 73.5 cm). Collection de l'Art Brut, Lausanne.

testimony from primary sources, such as someone close to the creator. He insisted that each monograph provide an accurate and lively portrait of its subject.

"Hernandez is a small, agile man, with a yellow and worn face, small hands, little feet. Makes only necessary gestures, brief and precise (with his short arms). No more words than necessary as well. The appearance of hot coal, a somber look. Good like bread." The man lived alone, meagerly, in "a room in the Belleville district of Paris, on the first floor, at the end of a small courtyard." In the same *L'Art Brut* volume, Dubuffet describes Raphaël Lonné as "a small man with a bald head, nice, pleasant face and fresh complexion. A melancholy mood is present in his features. His speech, with a heavy Gascon accent, was typified by a rapid gurgling, a continual glug-glug . . . He is simple and very emotional, easily enthused or disconcerted."[44] Dubuffet asked each contributor for similar information, to bring to the text "elements of biography about the author, and some facts concerning his behavior, his way of life, his physical appearance, and finally details that bring the person to life for those who do not know him."[45] Thus Victor Musgrave introduces Scottie Wilson as "a short, stocky man sixty-five years old, with clever eyes and a superb bulb of a nose. He wears a wool hat with a chinstrap, a slightly rumpled suit and a dark overcoat . . . When he walks down Oxford Street or around Piccadilly, no one even glances at him." As for Dr. Dequeker, he describes Guillaume Pujolle as "rather athletic and muscular with a thick nose"; he also mentions his "graceful manners" and his "immediate, warm, friendly manner."[46]

Such precise, intimate information may be unusual in traditional monographs, but for Dubuffet it was extremely valuable and demonstrated the importance that he attached to their uniqueness as individuals. Down to the smallest details, the artist is inseparable from his or her work. This desire to create highly vivid portraits was accompanied by a concern for rigor with regard to the investigation and commentary: each contributor was prompted to supply information of real substance, gleaned from observation of the works, excluding any personal interpretation. "My goal is a work that is strictly documentary, biographical, objective, with a kind of clinical depiction, without fancy language or artistic judgment. This means one has to talk with the author, reconstruct his entire life and the circumstances

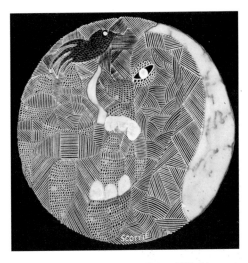

Scottie Wilson, *Composition with Violet Bird*, 1950–51. Colored ink and pencil, 9 1/2 × 9 1/2 ins (24.5 × 24.6 cm). Collection de l'Art Brut, Lausanne.

Scottie Wilson in Kilburn, c. 1965. Photograph by Ida Kar.

Carlo, *Four Figures on a Yellow Background*, 1961.
Gouache, 19 1/2 × 27 1/2 ins (50 × 70 cm).
Collection de l'Art Brut, Lausanne.

Carlo, *Green Figure*, 1967. Gouache and inscriptions
in pencil, 27 1/2 × 19 1/2 ins (70.5 × 50 cm).
Collection de l'Art Brut, Lausanne.

Heinrich Anton Müller. *Man with Flies and Serpent*, between
1925 and 1927. Colored pencil, 22 1/2 × 16 1/2 ins
(57.5 × 42.5 cm). Collection de l'Art Brut, Lausanne.

wherein he began to create his drawings. One must
conduct oneself like a magistrate and piece together
the known facts, avoiding any made-up stories, and
then put together a police report which on all points
must be true," the publisher stipulated; he would
closely follow the progress of the monographs by
very carefully rereading each of them.[47]

Dubuffet insisted on ensuring a rigorous editorial
policy, eliminating all references to psychiatry or
culture. For this reason, he recommended to Dr. Jean
Oury: "It would be best if the Note on Forestier is not
too scientific, too clinical, does not use too much
medical jargon . . . Most people (myself included)
are really flabbergasted by clinical psychiatric jargon
which is Greek to most of them. Surely, there must
be a much clearer way for people to express things
without ruining anything."[48] In fact, Dubuffet was
cleverly trying to suggest how this text should be
approached, because he feared a psychiatric

approach toward Art Brut and the reductive analysis
of a work to a case study: "It's interesting to me . . .
that works created by the mentally ill be closely
examined for once . . . according to mechanisms of

Adolf Wölfli, *Castle on Lake St. Lawrence with Ostriches*, 1909. Colored pencil, 14 1/2 x 38 1/2 ins (37 x 97.5 cm). Collection de l'Art Brut, Lausanne.

artistic creation rather than according to psychotic mechanisms."[49] Moreover, any comparison with "cultural art," considered as a useless appeal to so-called cultural authority, was systematically refused. "There are some minor references, such as to Hieronymus Bosch and Brueghel, to 'surrealism,' to 'informal' and to 'Pop-Art' that I would really like to delete, if you would be willing to consent to that because they imply a consideration of 'cultural' values, which is very unusual given the tone of our Art Brut publications, and contrary to the position which we would like to maintain of completely ignoring the values recognized by academic culture."[50]

In imposing this orthodoxy, Dubuffet occasionally went so far as to censor information which, even though it may have been objective, conflicted with his idea of Art Brut. He asked Victor Musgrave, for example, to rework his text and to take out a number of remarks: the interest taken in Scottie Wilson's work by Surrealists and art dealers, the exhibitions and reproductions of his drawings in major magazines, and his contact—however short-lived—with cultural circles. He regarded these additions as useless facts; on the other hand, he judged it important to point out Scottie's illiteracy. In fact, the information provided in the monographs dedicated to these artists is absolutely authentic. If the facts are sometimes filtered—some of them being well and truly covered up—it was done to deliver a clear message

to readers and keep them from being confused. Also, Dubuffet did not want his name to appear, even in the form of an acknowledgement or homage, and did not allow his own works to be cited next to those of the Art But artists.

The major figures of Art Brut were introduced in nine richly illustrated fascicles.[51] Two of them stood out because they each had an entire volume devoted to them: in 1964 number two was devoted to Wölfli, in 1966 number seven to Aloïse. The other fascicles covered several artists, such as the Prisonnier de Bâle, Heinrich Anton Müller, Augustin Lesage, Carlo, Gaston Duf, Maisonneuve, Palanc, and Madge Gill; and minor artists such as Humbert Ribet, Filaquier, Florent, and Olive. Dubuffet paid careful attention to alternating between authors who were mentally ill and authors considered sane. He often deliberately specified the artist's profession in the title: "The Mediumistic Drawings by the Mailman Lonné," "Lesage the Miner," "Salingardes the Innkeeper," or "Jayet the Butcher." He did this to prevent people from lumping Art Brut with the "art of the insane." When he respected the anonymity of institutionalized individuals, he did so reluctantly. He acknowledged as much in the introduction to the monograph on one of the artists whom he considered the most disconcerting, Heinrich Anton Müller: "We refrain from mentioning [his name] so as to abide by the rules—medical confidentiality—which prescribe

that we keep silent the names of people afflicted with particular mental illnesses. For this reason, all through these publications we have changed or abridged the names of all those who to a greater or lesser extent needed treatment in a psychiatric hospital. We have regrets about doing this when, as in this particular case, the works are admirable and demand that the name of the author, far from being kept secret, be included with them. The old, absurd disgrace attached to insanity, which is at the root of this ban, seems to us in this circumstance iniquitous."[52]

During the preparation of each monograph, it was very important to meet the artist. Often the artist in question led a reclusive life, did not offer his works to anyone, and was generally reticent about discussing them. At first, the investigator had to earn his trust. Dubuffet spent hours with Miguel Hernandez and Francis Palanc and with great patience attempted to gather relevant information about their lives, and the origins, meaning, and development of their work. In the process, he discovered a few key insights that he carefully jotted down in his notebook. The investigations turned out to be much more difficult, as was often the case, when the artist was dead, because the researcher would find it hard to locate anyone who might have any information on works that had remained secret. In such cases, the adventure turned into a kind of police investigation: the relations, friends, neighbors, dealers, prison guards, or head nurse were questioned. If those who knew the artist did not provide enough information, official authorities had to be contacted, the municipal offices in the town where the artist was born had to be visited, or a genealogist was consulted in order to find a relation of the deceased. This was the extraordinary enterprise—a veritable criminal investigation—that Dubuffet and his associates, Michèle and Claude Edelmann, Ludovic Massé and A. Wolff (pseudonym of Philippe Dumarçay), embarked on.

The ingenuity required to edit a volume in the *L'Art Brut* series was equally indispensable in the production of the book. Once more Dubuffet did not hire a specialist, preferring to rely on the abilities of his staff. "The layout for the fascicles was done by hand. We were not publishing professionals. And that is what I think Dubuffet liked best. There was a guarantee of purity and fidelity toward these people [the Art Brut artists], which was something Dubuffet had doubtless rarely encountered," said one of his

assistants.[53] Page layout, corrections, and proofreading, the entire production of the series was carried out by Slavko with help of a few colleagues. The rate of publication was quick; the Compagnie brought out three volumes a year at the beginning. The publications were tackled with the same enthusiasm that characterized the acquisition of works. Concerned about their distribution, Dubuffet contacted various French bookstores and set up foreign distribution.[54]

The press reacted immediately to the event; many reviews marked the appearance of the *L'Art Brut* series. Critics at *Lettres nouvelles, Cahiers du Sud, La Quinzaine littéraire,* and *Nouvelle Revue française* were unanimous: "How does one express the jubilation mixed with anguish which seizes one when looking at these pages filled with a tormented presence, at these cities, these palaces, these tunnels, these clocks, fountains—from Bern and elsewhere—these constellations of masked faces, these signs beyond our grasp, birds, slugs, musical notes?"[55] The same enthusiasm is found in remarks penned by Geneviève Bonnefoi, who describes how the reading of these journals spurs "us to feel dizzying disorientation, to tear ourselves from routine and habits . . . to pursue the path of inquiry and reflection before these often unskilled but sometimes admirable works, such as those by Lesage, Aloïse, Wölfli, Guillaume . . . We really feel that we cannot react as 'consumers' as is so often the case. The barriers that they put in place, the close attention that they demand profoundly modify the notion of rapport that we are able to achieve with a work of art."[56] Many journalists mentioned the care taken with the publications and the perspicacity of Dubuffet, who had managed to avoid the trap of sensationalism and instead focus on the essentials in each monograph. The series was considered "a collection of exceptionally interesting documents" and "an indispensable publication for all those fascinated by the mystery of artistic creation."[57] The nine volumes of the *L'Art Brut* series represented an encyclopedia of one thousand four hundred pages. Their rigor and richness has kept them from becoming obsolete, and they have become important reference works—their publication today is overseen by Michel Thévoz.

Thirty years after Albert Skira's journal *Minotaure* (1933–39), Dubuffet published the *L'Art Brut* series (1964–74). Both of these publications attempted to validate the value and power of works

Aloïse, June 1948. Photograph by Alfred Bader. Collection de l'Art Brut, Lausanne.

Aloïse, *The Bullfighter's Bow*, undated. Colored pencil, 11 1/2 × 8 ins (29.5 × 19.8 cm). Collection de l'Art Brut, Lausanne.

that up until then had remained in obscurity. They attempted to explore hidden realms of expression, and suggested seeing art in a different light. Albert Skira and Jean Dubuffet were both convinced that these tendencies would play an important role in the history of art. They predicted that the disclosure of these unexpected works of art that bear a troubling beauty would result in a radical decentering of the concept of creation. While the journal *Minotaure* still placed the art of mediums and the insane into categories, the *L'Art Brut* series offered monographic studies, focusing on the uniqueness of each artist.

"ALOISE WAS NOT MAD AT ALL"

Nearly half a century earlier, in 1922, Dr. Hans Prinzhorn in his book *Bildnerei der Geisteskranken* (The Artistry of the Mentally Ill) claimed that the works of psychiatric patients betrayed no sign of disease. The philosophy of this pioneer was adopted and further developed by Dubuffet. Distancing himself from any medical approach and paying absolutely no

attention to the symptomatology of the works, Dubuffet challenged the idea of "psychopathological art" and rejected all artistic classifications. As he had already stated, insanity was never one of the criteria used to select works for the Art Brut collections. If his investigations took him to asylums, he discovered there "brilliant works that . . . testify to an exalted mental state not a sick one; as artists they display a mental status that far from being 'pathological' is instead an impressive flowering."[58]

The mastery and energy of artists like Forestier, Pujolle, and Müller proved that these really were exceptional individuals. In Dubuffet's view, their minds were not disrupted by weakness or incoherence: "None of the artists of works gathered together by Art Brut are mad; they guide their work and attend to it with complete, methodical lucidity. Since you are yourself an artist," he wrote to Robert O'Neil, "you know what it means to guide a work without getting off track, adjusting all of the solutions so that they contribute to the intended effect, you know the whole time what innovations need to be

Adolf Wölfli, *Plan for Rebellion in St. Adolf's Castle in Breslau*, 1922. Colored pencil, 20 x 26 1/2 ins (50.5 x 67 cm). Collection de l'Art Brut, Lausanne.

implemented. One who is truly ill is not suited for that; he cannot apply himself to anything; he cannot do anything methodical and coherent; and besides, he doesn't want to."[59] Discussing the encyclopedic work of Wölfli, Dubuffet refuted any suggestion of psychological weakness: "Isn't it ridiculous, in regard to such admirable works, works that are so marvelously inventive, marvelously complex, and exceptionally well handled . . . to say that they are marks of disease?"[60]

According to Dubuffet, "madness" was thus fundamentally distinct from mental illness, which resulted in dysfunction and incapacitation. On this clinical point, the theorist did not declare a verdict. On the other hand, he did view the term "madness" in a positive sense, as playing an active and essential role in the creative process. For him, the artist exalts

the anthropological function of madness, which resides in each individual. Dementia is thus interpreted as an existential state of separation. The lines written by Dubuffet a few days after the death of Aloïse attest to that: "Aloïse . . . was not at all mad. Much less at any rate than anyone believed. She feigned it. She was cured a long time ago. She had cured herself by ceasing to fight the illness, undertaking on the contrary to cultivate it, to make use of it, to marvel at it . . . The marvelous act that she was continually putting on—that nonstop, incoherent, hardly intelligible chatter . . . —was for her an unassailable refuge, a stage that no one would step on, no one could get on. You couldn't be more ingenious, you couldn't do it any better . . . She had discovered the way of incoherence, she had become conscious of the abundant fruit it could provide, the

158

Vojislav Jakic. *The Frightening Horned Insects* (detail, see the whole work on p. 140), undated. Ballpoint pen and colored pencil. Collection de l'Art Brut, Lausanne.

paths it could open up . . . she was passionately in love with it, never ceasing to marvel at it. But mad, absolutely not." [61]

All images and objects in art imply tension, violence, and jubilation. Creation is consequently a synonym for madness. "The best, the most coherent thing to do would be to proclaim once and for all that the creation of art, wherever it happens to occur, is always in all cases pathological," the theorist claimed. [62]

REBELLION AGAINST CONDITIONING

In one of his first theoretical texts from 1948, Dubuffet defined Art Brut artists as individuals untouched by any artistic culture, as inventors of a personal system of expression, free from any traditional legacy. As he

collected works, he made an effort to refine his concept. In the text announcing the formation of the second Compagnie in 1963, he describes the works of the collection as possessing "a spontaneous and highly inventive nature, as little indebted as possible to customary art or cultural clichés." [63] During the following decade, his collecting of various works and his extensive studies of each author allowed him to expand his understanding and to revise his definition once again. "Pure Art Brut, fully exempt from any reference to culture (and all successive strata of culture) would not know how . . . to exist, except . . . as an unattainable complex of values," he admitted. [64]

Moreover, Dubuffet recognized that all forms of education influence the individual and his behavior. "The thinking of a two-year-old is already conditioned. Language constitutes the starting point for

conditioning, which is evidently why one can no longer speak of complete independence from culture. From this point onward, the objects that meet the child's eye and everyone else's, and the accepted ideas surrounding him offer specious conventions for his views and thoughts."[65] Every person is thus bound to a visual apprenticeship from which no one can ever entirely escape—unless one goes over the edge. Analogous to the concept of the "common man," the notion of Art Brut is revealed as an "ideational archetype. Ideational is not saying enough; it would be better to say utopian."[66]

Consequently, starting out from this postulate—complete independence from culture is merely "wishful thinking"—Dubuffet considered the notion of Art Brut as a position that the creators adopt to various degrees: in fact, some show themselves more resistant than others to instituted norms. The theorist's position is no longer based on the principle of artistic virginity and emancipation but on resistance to and rebellion against conditioning—a fundamental nuance in his evolving definition of Art Brut. Aware of the existence of numerous hybrid creations, of "all sorts of mixtures with various proportions of Art Brut and cultural art," Dubuffet imposed even more stringent criteria in the selection of works.[67] He ruthlessly ousted the hybrids and accepted only those works that were "very eloquently foreign to cultural art and, as a result, whose creators are, as far as possible, devoid of training and information."[68]

Ignacio Carles-Tolrà, *Figure*, 1966. Ink, 12 × 19 ins (31 × 48 cm). Collection de l'Art Brut (Collection Neuve Invention), Lausanne.

Philippe Dereux, *The Tight-Lipped Mouth* and *The Primitive*, 1980. Tree bark and paint on compressed wood, 17 1/2 × 12 ins (45 × 30 cm) and 17 1/2 × 12 ins (45 × 30 cm). Collection de l'Art Brut (Collection Neuve Invention), Lausanne.

Gaston Chaissac, *Booted Figure*, 1959. Gouache, 39 1/2 x 25 ins (100 x 64 cm).
Collection de l'Art Brut (Collection Neuve Invention), Lausanne.

Ignacio Carles-Tolrà, *Ménage à quatre*, detail, 1987. Paint and Neocolor crayons, 24 1/2 × 39 1/2 ins (62 × 100 cm). Collection de l'Art Brut (Collection Neuve Invention), Lausanne.

MAKING ART DOES NOT MAKE THE ARTIST

Silence and secrecy remained for Dubuffet the fundamentals of authentic art; the self-taught creator labors for his personal pleasure, without aspiring to communicate or to distribute his work. During the period of the second Compagnie, most of the artists who were discovered were introverts by nature: Madge Gill, Guillaume Pujolle, and Laure Pigeon had "succeeded in bringing to life what they envisioned without caring in the least that they were the only ones to see it."[69] On the other hand, other creators—Philippe Dereux, Magali Herrera, Thérèse Bonnelalbay, Raphaël Lonné, Ignacio Carles-Tolrà—behaved entirely differently. Aware of the attention paid to them by Dubuffet and the Compagnie, they trusted them, were conscious of the value of their works, and wished to exhibit them and sell them on the art market. Some gallery owners gradually, and very discreetly, developed an interest in these artists and exerted growing pressure on them to sell their works. Dubuffet reacted to this sort of approach with hostility. All disclosure and therefore all recognition according to him led to the work's depreciation and alienation; social success could only be detrimental to the creative act. "The climate in which professional artists operate, the way their attention is continually drawn toward the publicity that their works will receive and the way they devote a lot of thought to the publicity use of their works, seem likely to distort completely . . . the very principle of their work, to the point of displacing it . . . and of removing it to a place which has nothing to do with the creation of art and, contrarily, everything to do with games of competition and strategy."[70]

Initially, Dubuffet tried to dissuade his protégés from marketing their works, emphasizing the virtues of secrecy in matters of creation: "What makes your drawings valuable is that they have been done in solitude and without any other objective than to please yourself and if you were to make them in the future in a way that wasn't as pure, by that I mean showing them and deriving fame and other advantages from

162

Magali Herrera, *Homage to Jean Dubuffet*, 1968.
White India ink on black drawing paper, 25 1/2 × 19 3/4 ins
(65 × 50 cm). Collection de l'Art Brut, Lausanne.

Magali Herrera, untitled, 1970. Gouache and white India ink
on black paper, 25 1/2 × 19 3/4 ins (65 × 50 cm).
Collection de l'Art Brut, Lausanne.

them, they would risk losing that which makes them so valuable."[71] But as more years passed, his tone became more strident in his letters to artists tempted by the promotion of their works. Simple advice led to peremptory warnings: "From the standpoint of Art Brut, once your works become part of this scene, their prestige and value will diminish in equal proportion to the prestige and value they gain in cultural circles."[72] Worried that these works would be altered by their disclosure and that they would be appropriated by dealers, Dubuffet pushed his socio-esthetic theory to its limits and denounced the contradiction between the production of art and social recognition: "You cannot be a creator and be hailed as one by the public . . . You have to choose between making art and being regarded as an artist. The one excludes the other."[73] He then removed some artists from Art Brut and transferred their works to the auxiliary collections—such was the fate of Gaston Chaissac, Philippe Dereux, and Ignacio Carles-Tolrà. This new policy reaffirmed social and commercial independence as an important principle in the definition of Art Brut.

More than any of the others, Chaissac's transfer has been and continues to be controversial. Many have accused Dubuffet of having enlisted him in Art Brut, of having fleeced and plagiarized him, before disowning him and relegating his work to the auxiliary collections. At first, Dubuffet saw in Chaissac the common man creator, the type of artist who was central to his philosophical and artistic conception. He later revised his judgment, taking into account not only Chaissac's cultural baggage but also his knowledge and the growing importance of his contacts on the Parisian art scene. When the collections returned to Paris in the early 1960s, Dubuffet decided to transfer Chaissac's work.

These shifts in assessment seem justified by the fact that these creators did not comply with two major criteria: commercial independence and the lack of any relationship with "cultural art." Chaissac was "too steeped in what professional artists are doing"; Carles-Tolrà's personality was that "of a cultivated, refined man"; and Dereux's works did not bear the marks of genuine "rebellion" nor "of being

163

Gaston Chaissac, *Crucified Figure*, c. 1948.
Gouache on paper, 10 x 8 1/4 ins (25.5 x 21 cm).
Collection de l'Art Brut (Collection Neuve Invention),
Lausanne.

small, serenely made paintings that please [him] and do not seek applause."[74] The collector made it clear to the artists that this reassessment did not in any way suggest that such works were any less valuable or should be excluded. Nevertheless, this transfer was perceived by them as condemnation or as an excommunication from Art Brut.

Dubuffet's position is paradoxical in several respects. The theorist valued unconventional, isolated works, acquired them, collected them, studied them, and granted them status as works of art. At the same time, he prevented them from being shown and refused to let them exist outside of the Compagnie, for which he reserved exclusive rights. Dubuffet removed them from obscurity in order to plunge them right back into it again. He acted with complete authority. Furthermore, he declared it necessary to "make art for oneself in the same way others go fishing or for walks and not to put it on show."[75] However, when he exhibited his own work in the most prestigious cultural settings, from New York and

London to Venice and Amsterdam, was he not demonstrating a lack of regard for this principle of obscurity? Dubuffet proved to be incapable of reconciling these contradictions. For him, the only way to escape from his fate as an official artist was to stigmatize his protégés by accusing them of breaking the codes of independence and nonparticipation in commerce and publicity. In condemning others, he sought to prove himself innocent.

His intransigence would soon be tempered. Dubuffet finally conceded that "creation is done with one's eyes shut, but it summons the eyes to look since without eyes there is no existence, and creation wants to exist, and nothing exists unseen. Nothing at all would exist if all eyes were shut."[76] Several artists, although part of the commercial network, escaped having their works transferred to the auxiliary collections. Raphaël Lonné, Thérèse Bonnelalbay, and Magali Herrera exhibited and sold their works while maintaining their status as genuine Art Brut artists. "It would be highly desirable for the trade in works of art not to exist; but since it does and since it is so widespread, it would be absurd if you did not make some money, especially since your financial means are so limited . . . I am quite happy then that your drawings bring you a modest income and I applaud your efforts wholeheartedly."[77] But these artists were the exceptions; did Dubuffet sense that their contacts with the art market would have no impact on their work and would not modify the nature of their work? Whatever the case may be, the theorist continued his defense of the Art Brut collection as a group of "works that have completely eluded channels of cultural distribution, which do not run the least risk of having market values assigned to them." His undertaking must be "forthright and exemplary," and the "anticultural militancy of [the] organization must be revealed with obvious clarity in the public's mind."[78] The idea of an Art Brut exhibition had already crossed his mind.

THE EXHIBITION AT
THE MUSÉE DES ARTS DÉCORATIFS

"I have declared in the past that I don't much care for these funeral homes, these citadels to mandarin culture, which we call museums. Their name and its reference to the idiotic Greco-Latin notion of the *muses* already tell us which way the wind blows. I

am quite convinced of the sterilizing action of its cultural pomp and circumstance. Culture is a state affair, whereas the creation of art is essentially an individualistic and subversive affair . . . The creation of art will always be antagonistic toward culture, and the more that creation is fortified, celebrated, elevated (as it tends to be) to the level of a state religion, with saints, prophets, and bishops, the more likely true artistic creation will disappear. Genuine creation of art is only present when the word art is not pronounced, has not yet been pronounced."[79] Despite his distaste for museums, Dubuffet consented to exhibit the works which he held in the highest regard: seven hundred works of Art Brut by more than sixty creators were shown at the Musée des Arts Décoratifs in Paris from April 7 until June 5, 1967. It was only a small fraction of the collection, which then contained more than five thousand pieces by two hundred artists. "Make Way for the Anti-civic-minded," Dubuffet announced in the catalogue that

L'ART BRUT
MUSÉE DES ARTS DÉCORATIFS
DU 7 AVRIL AU 5 JUIN 1967
TOUS LES JOURS DE 13 H. A 19 H. SAUF LE MARDI. LE DIMANCHE DE 11 A 18 H.

Poster for the "L'Art Brut" exhibition at the Musée des Arts Décoratifs in Paris, 1967. Collection de l'Art Brut, Lausanne.

View of the "L'Art Brut" exhibition in the Musée des Arts Décoratifs in Paris, 1967. Collection de l'Art Brut, Lausanne.

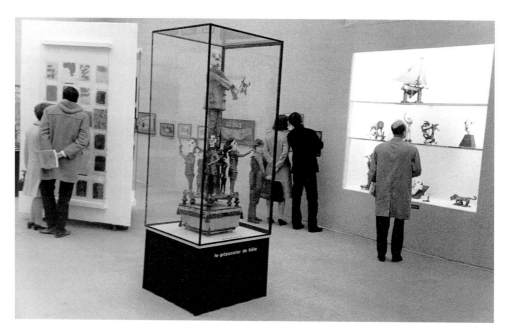

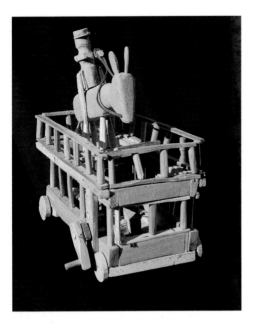

Émile Ratier, *Crocodile*, undated. Elm, height 22 3/4 ins (58 cm). Collection de l'Art Brut, Lausanne.

had the feel of a manifesto. More than twenty thousand people visited the exhibition.[80]

Two years earlier, the theorist would have considered the idea of a public exhibition of Art Brut as perfectly "pointless," posing "major risks for diluting its true position and causing confusion."[81] This abrupt turnaround deserves some explanation. Dubuffet had been on friendly terms with François Mathey, the curator of the Musée des Arts Décoratifs, since 1954. A bold, original figure, Mathey had exhibited not only Picasso, Léger, Chagall, Tobey, and Dubuffet, but he also risked supporting artists such as Manessier, Odincourt, Bazaine, and Le Corbusier. This private museum gave him the freedom to show contemporary artists rather than those generally recognized and appreciated by the public—a policy judged then as scandalous and intolerable. The goal of François Mathey was to "restore life, real life to this museum and put art into proper perspective."[82] Among the artists that he supported enthusiastically, Dubuffet was his first choice. It was therefore completely natural that the painter, in 1967, would loan the most important works of Art Brut to this excep-

tional museum, which was independent of the State and directed by an exceptional figure. At the urging of this man, Dubuffet decided to carry out his desire to exhibit his Art Brut collection in public.

With this show, the artist was first of all eager to silence a rumor: "Many have criticized Dubuffet saying that basically he was a copier, a plagiarist, and that he had assembled . . . under the definition of Art Brut, those things which were the real sources of his inspiration. This idea has been circulating around Paris for a long time."[83] If this accusation was unjustified, the public's right to ask questions was nevertheless legitimate; one could not help wondering if Dubuffet kept Art Brut in secret as a hidden treasure and a wealth of information from which he mined his ideas. With this exhibition, "the public has been reassured of the creator's authenticity. They have realized that the artist, rather than copying, shares the same outlook on life as they do. The Art Brut artists have in some ways given him reassurance in his own quest," explained François Mathey. Furthermore, in the mid-1960s Dubuffet had found an original artistic path and no longer seemed to need to look to Art Brut artists for inspiration of any kind. He had acquired total artistic independence. He "suddenly no longer felt like a collaborator but a curator" of these obscure creations.[84]

For Dubuffet, the time had come to pay homage to his fellow travelers. Joined together in one group, the collection of five thousand works appeared to have reached its maturity. Yet a feeling of consecration did not reign over the Art Brut show; the main reason why he accepted to show these works in a museum arose from a desire to go on the offensive. The intention was above all to create controversy. "If one wants to attack culture, if one wants this attack to be effective, to be really carried out, then it really has to be done in *public*. When Heinrich Anton Müller attacks culture in his cell in the asylum, hiding his drawings under his pillow, his attack has no impact, doesn't really exist . . . I believe that it is in the heart of cultural circles that an awareness of the harmful effects of culture and an awareness of what it is and the manner in which it functions can be created."[85] Dubuffet considered this exhibition as his greatest mission and greatest offense. In order to dynamite the cultural system, he chose to strike right at its heart: "I was hoping for hostility from the cultural milieu. I wanted Art Brut to be an *agent provocateur*

in the museum."[86] With Art Brut, Dubuffet had thus been operating within the most blatant contradiction, as his now legendary assertion proves: "Art does not go to sleep in beds made for it; it runs off as soon as someone speaks its name: what it loves is to be incognito. Its finest moments are those when it forgets its name."[87] Contrary to his own assertion, Dubuffet had named his works, grouped them and sentenced them to confinement, depriving them of their original liberty. This inconsistency reached new heights when he showed them in the museum.

Ideally, Dubuffet should have opted for an entirely different course of action. If he had adhered to his theory, he would not have identified Art Brut, gathered it, or exhibited it. But for him, leaving these works in obscurity would have been akin to scorning and censuring them. One can surely subscribe to the judgment of Claude Lebensztejn and assert that the collector "has mired himself in an inescapable contradiction" and conclude thus: "Under the aegis of Dubuffet, Art Brut has calmly been taken from its secret, unassailable network to the space whose limits he has attacked from all quarters."[88] Nevertheless, by studying Art Brut, Dubuffet had given it the right to exist and allowed it to bring us its message. True enough, he had exhibited these works in a museum, but only because it represented the sole place for exhibitions: "Between the actual state of affairs and what I would like, there exists no place in today's community for works of art, and minds are so perfectly indoctrinated that works of art shown somewhere other than in a museum do not have the least chance of being visited by the public, nor even of being looked at."[89] Displaying Art Brut in a museum was a contradiction, but it resulted from the lack of a better choice.

Dubuffet quickly realized that by drawing attention to Art Brut he had irrevocably set something in motion that could not be stopped. Its assimilation into the art system had thus already begun: "In all honesty, at the start I wanted to introduce into the cultural milieu the idea that cultural art is ridiculous and that a-cultural art is alone inventive, the only one that ignores the cultural milieu and refuses to address itself to that milieu. And I caught myself in my own trap, for I find myself today the exhibitor of Art Brut in a cultural milieu, a victim of my own original position, while I would prefer to be with those who are not making an appearance in this cultural milieu, who ignore it and are ignored by it."[90]

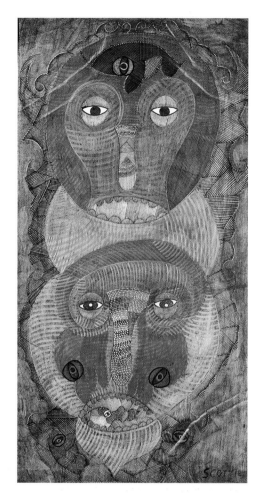

Scottie Wilson, *Overlapping Heads*, 1938–40. Colored ink, 21 × 11 ins (53.2 × 28 cm). Collection de l'Art Brut, Lausanne.

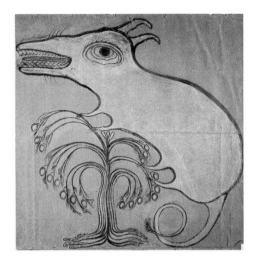

Heinrich Anton Müller, *Horned Squirrel*, 1917–22. Pencil and chalk on two sheets of wrapping paper sewn together, 31 × 31 1/2 ins (79 × 80 cm). Collection de l'Art Brut, Lausanne.

Bogosav Zivkovic, *Tree Trunk*, undated. Carved dogwood, height 8 ft (246 cm). Collection de l'Art Brut, Lausanne.

DIVIDED OPINIONS

The exhibition at the Musée des Arts Décoratifs was covered extensively in the French and foreign press. Some critics refused to attach any value to the works, which they regarded as picturesque, ludicrous, or delirious; others contented themselves with brief reports, reducing the works to a pathological dimension. Still others showed themselves more indulgent and found some interest in these works, to the extent of summoning up the art of great civilizations or masters from the past. André Nakov emphasized multiple connections between the works of Le Goff and those by Miró and Klee, between Maisonneuve's masks and Arcimboldo's compositions, between the sculptures of Zivkovic and the paintings of Munch.[91] More generally, Jean-François Chabrun drew some comparisons with "medieval monsters," "Tibetan banners," "cuneiform writing," "Byzantine mosaic," and "Polynesian huts." These other forms of expression reside in works of Art Brut, he clarified, in "a state of infancy."[92] The act of making references—certainly legitimate—is a reassuring reflex and proves the coercive strength of cultural conditioning.

On the other hand, some journalists recognized the uniqueness of this type of work, declaring that "these creations do not resemble any known thing," or that "it is not a question of searching for what makes them akin to works claimed to be *cultural*."[93] This work was thus considered on its own terms; its difference and autonomy were recognized. Art Brut introduces, emphasized Gilbert Lascault, "a notion radically opposed to art: the skill is suspect; the mimetics, the deference toward myths, the modes, the techniques are fearsome." The essayist refines his point further on: "The writings and drawings force one to compare the notions of Art Brut and *savage thought*, as Lévi-Strauss defined it. Savage thought is not the thought of savages, nor that of primitive or archaic humanity, but thought in a wild

state, distinct from cultivated or domesticated thought whose goal is to obtain a result." This analysis urged the audience to consider the self-taught authors of these productions not as "illiterate artists" infatuated with "uncontrolled spontaneity," but as complete artists. "The comparison between the notions of Art Brut and *savage thought* allows us to avoid the error that results from seeing in Art 'Brut' subject matter that is incomplete, unpolished, not thought out; Art Brut defines itself not by the absence of reflection and method, but by an *other* logic and *other* techniques; starting with seashells, pieces of wood and cloth, mixing with dreams the remembrance of conventions often hurriedly gotten from a dictionary, the 'creator' 'makes it up' as he goes along." Finally, Gilbert Lascault declared, "By putting savage thought into practice, Art Brut offers a variety, a richness that will only astonish those who

want to deny the subtlety of uncultivated, untamed thought."[94]

In other quarters, the Art Brut exhibition provoked a lively controversy. In the *Nouvelle Revue française*, Claude Esteban denounced the impudence of the exhibition: in front of these "drawings by schizophrenics who only comment on themselves and for themselves; under the raw light that renders them vulnerable to our gaze, what are we if not rather mediocre voyeurs?"[95] François Mathey took the opposite position in this declaration from *La Quinzaine littéraire*, envisioning the entry of Art Brut into the museum as an impossible gambit: "You might as well say that it loses its virginity and becomes, for this reason, cultural . . . Revealed to the public, Art Brut ceases to be that, becoming an object of contemplation, speculation; it is integrated into the spiritual, social context, in fact the cultural context

Raphaël Lonné, *Colored Drawing*, 1963. India ink and colored pencil, 9 3/4 × 13 1/4 ins (25 × 33.5 cm). Collection de l'Art Brut, Lausanne.

169

Jules Doudin, *Figure*, between 1927 and 1937.
Pencil, 6 1/4 × 5 1/4 ins (16 × 13.5 cm).
Collection de l'Art Brut, Lausanne.

Jules Doudin, *Leau est Froides*, page 172 of his sketchbook,
1927. Black pencil, 8 × 7 ins (20 × 18 cm).
Collection de l'Art Brut, Lausanne.

Jules Doudin. Collection de l'Art Brut, Lausanne.

which it had up until then eluded. But hasn't the moment come when the foundations of our common culture should be verified, as they are after all great crises? . . . So it is art and its destiny that are at stake in the obscure adventures of the anonymous artists of Art Brut."[96]

Among the ninety articles catalogued in the archives of the Compagnie, most are enthusiastic, describing the exhibition as the strangest and most provocative of the year. Numerous dailies saw it as a historic event. The *New York Times*, for example, declared that "this exhibition is neither a curiosity nor a marginal event. In fact, it strikes a nerve in contemporary art and produces in this way a chain reaction of sensations and implications"; as for the newspaper *Combat*, it viewed it as "a revelation, an

intellectual stand destined to be a historic event . . . In contrast to fashionable art and the paths followed by the majority of people, Art Brut offers a multitude of isolated creations that as time passes will be confirmed as the most authentic expression of art."[97] The Art Brut exhibition in the Musée des Arts Décoratifs proved to be an ephemeral opening up: in keeping with the wishes of Dubuffet, it went back into hiding. In 1970, he explained his decision in these terms: "I fear that the general public is only slightly interested in things of this sort and only isolated, and it has to be said rather rare, individuals are likely to find any use in it."[98]

ART BRUT IN THE LIMELIGHT

The Compagnie de l'Art Brut was not the only organization pleading in favor of this unusual form of art. In the early 1960s, art institutions began to display a real interest; there was a succession of shows, providing opportunities to discover the private universes of artists such as Aloïse, Wölfli, Doudin, and Radovic. These shows differed from exhibitions of psychopathological art and dispensed with the psychiatric approach in order to concentrate on the artistic aspects of the works: they represented a step—still modest—toward the recognition of these artists.

Harald Szeemann, a unique and audacious man who was in charge of the Kunsthalle in Bern, oriented his exhibition policy toward unconventional types of art.[99] In 1963, as part of a series of shows devoted to children's drawings, marionettes, dolls, and votive images, he organized a show devoted to the works of twenty schizophrenic painters and drawers—*Bildnerei der Geisteskranken, Art Brut, Insania Pingens*—which included Aloïse, Adolf Wölfli, and Louis Soutter. The same year, at the urging of the Société Suisse des Femmes Peintres Sculpteurs Décorateurs, the Musée Cantonal des Beaux-Arts in Lausanne devoted an exhibition to the drawings of Aloïse. At the same time, the work of Louis Soutter was the subject of a retrospective mounted in several cities in Switzerland and Germany.[100] Over the following years, museums, galleries, and cultural centers in Europe would increase the number of exhibitions devoted to these amateur artists.

Some publications reinforced this outburst of enthusiasm. Published in Basel in 1961, *Insania Pingens, Petits Maîtres de la folie* presented texts by

Alfred Bader, Jean Cocteau, Georg Schmidt, Hans Steck, and Roger Cardinal, introducing the works of Aloïse, Doudin, and Radovic. *Outsider Art*, published in London in 1972, publicized the discovery of Art Brut creators like Madge Gill, Augustin Lesage, and Laure Pigeon. This publication introduced the term "outsider art," which came to be an English equivalent for "Art Brut."[101] In the realm of drama, the show *Théâtre brut* invited the public to the Musée d'Art Moderne in Paris in 1968, "for the recital or the performance of unknown texts written haphazardly without any motive for their creation . . . in psychiatric hospitals, in prisons, in schools, sometimes even under bridges, or more simply in the isolation of the countryside."[102] Fernando Arrabal, Ariane Mnouchkine, Roland Dubillard, Roger Blin and René de Obaldia, among others, participated in the staging and the reading of the literary universe of Aloïse, Jeanne Tripier, Aimable Jayet, and Sylvain Lecoq.

Even though it was not connected with these shows, the Compagnie de l'Art Brut was at the forefront of this opening up of Art Brut, due to the publication of its monograph series and the exhibition at the Musée des Arts Décoratifs. A symbolic event followed this show: Art Brut and the history of the Compagnie became the subject of articles in the most prestigious encyclopedias, thereby marking their entry into the history of Western culture.[103]

Everything seemed set for the Compagnie de l'Art Brut to acquire important legal status as a result of receiving a "*déclaration d'utilité publique*" (DUP). In hopes of making the association self-sufficient, its president filed the request, but the municipal council of Paris rejected it on April 11, 1967. Dubuffet was indignant; a few years later, he would denounce the indifference of political and artistic representatives toward his enterprise. "It does not seem that the authorities in the church of French culture, and even less the state authorities, have shown much interest in our activities, and evidence of this was given when in 1968 [in fact in 1967] . . . our request for state-approved status was denied by the municipal council of Paris. The state's aim of dictating intellectual activities runs counter to our own views, to keep from consideration works which do not emanate from sanctioned professional artists who are supported by the cultural-commercial body that bureaucratic dealers and certified critics have formed. Faced with works that do not defer to today's

accepted customs and cultural norms, the authorities could only respond with condescension and skepticism." [104]

THE DONATION TO SWITZERLAND: ART BRUT RETURNS TO ITS ORIGINS

As early as 1948, Dubuffet had told his friend Charles Ladame about his idea of collecting unusual works and providing them with a foundation. True to his plan, in 1970 he declared his intention to donate his collections of Art Brut in order to insure their preservation and make them available to the public. Notified of his wish, the Minister of Culture made several offers to Dubuffet. Numerous rumors were circulating about the fate of the collection. It was planned to house it in the new Centre Georges Pompidou, with the aim of mounting periodic exhibitions. However, the prospect of his collection being housed in a museum and being shown in fragmentary, temporary exhibitions led Dubuffet to refuse the offer. Another suggested he install his collections in the Château de Carouge in Normandy, but Dubuffet declined this invitation too.[105] As for François Mathey, he hoped to establish the Collection de l'Art Brut in the Musée des Arts Décoratifs, but once again Dubuffet abandoned the scheme. None of these propositions, nor those from Germany, Austria, and the United States, satisfied the theorist of Art Brut.

Dubuffet then opened negotiations with Switzerland through Michel Thévoz, a young curator from Lausanne who had completed a study on Louis Soutter and who was preparing, at the urging of the theorist, an important book, *L'Art Brut*, which would be published in 1975. Thévoz approached a few small communities in the canton of Vaud, then officials in Lausanne. René Berger, director of the Musée Cantonal des Beaux-Arts, emphasized the attention that a museum of Art Brut would bring to the city, and Georges-André Chevallaz, the mayor of Lausanne, enthusiastically welcomed this project. He undertook to do what was necessary to ensure the administration, conservation, exhibition, and development of the collection, and guaranteed it would be housed—in accordance with the wishes of Dubuffet—in a place devoted solely to the display of the works, safe from any meddling on the part of psychiatric or cultural organizations. A motion was made in support of this collection; a petition was set up, requesting the authorities to implement the plan in full in order to fulfil the conditions demanded by Dubuffet. On July 13, 1971, the municipality of Lausanne signed the agreement for the donation.

After long stays in France and the United States, it seemed to Dubuffet that the collections had come full circle and their installation in Switzerland seemed an apt return to their origins: it was here that his search had begun in 1945, and a number of major creators were of Swiss origin or had lived in the country, namely Wölfli, Müller, Aloïse, the Prisonnier de Bâle, Jules Doudin, and the patients of Dr. Ladame. Moreover, his vision of Switzerland prompted him to prove his trust in the country: "There seems . . . in Switzerland more so than elsewhere to be a willingness to approach artworks lacking in credentials with a completely fresh outlook, while limiting to a far greater extent the intrusion of artists' fame, prestige, and competition. Over the last few years, we have witnessed in the great Swiss museums exhibitions of works by Aloïse, Wölfli, and Soutter, who have all been warmly received by the public and the press. Cultural conditioning seems a little less constraining there than in other nations, and personal taste is more respected." [106] The Swiss public, which according to him knew how to visit a Wölfli exhibition without seeing in it the work of someone who was mentally ill, would be inclined to receive these unique works and understand the motivation for gathering them into a collection. Michel Thévoz, equipped with an "intimate understanding of the positions of Art Brut and a familiarity with the collections," [107] seemed ideally suited to become the administrator and the curator of the future organization. Finally, the city of Lausanne is French-speaking, facilitating access to the archives and documents of the Compagnie and ensuring that research and publication would continue. Circumspect, quiet, and discreet, the city did not possess the prestige of a European cultural capital.

In September of 1971, *Le Monde* announced the news of this donation.[108] Public officials in France reiterated their offer to Dubuffet, but he was standing his ground. Nevertheless, not long before the departure of the collections for Switzerland, he consented to an exception: he met with Alain Bourbonnais—architect, painter, sculptor, and prospector for strange forms of art—and provided him with the

Louis Soutter, *The Cold Parcel*, undated. Black ink
and gouache, 20 1/4 x 27 ins (51.2 x 68.3 cm).
Musée Cantonal des Beaux-Arts, Lausanne.

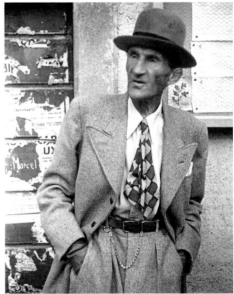

Louis Soutter at the age of sixty-nine.
Photograph by Théo Frey.

173

The southern façade of the Château de Beaulieu in Lausanne. Photograph by Peter Studer.

addresses of a large number of living artists who were part of his Art Brut collection and the auxiliary collections. Having become a collector and dealer, Bourbonnais would use this information while pursuing his own searches and a year later would create a venue in Paris devoted to the exhibition and sale of marginal works, the Atelier Jacob.[109]

The reason Dubuffet gave his assistance to Alain Bourbonnais's enterprise was that it corresponded with plans of his own which he had made a few months earlier, to found in Paris "an organization derived from Art Brut, semi-commercial in nature (managed at a loss) and open—let's say half open—to the public," devoted to the exhibition and sale of "works arising from Art Brut, or more or less connected to Art Brut, or downwind from Art Brut."[110] With this collaboration, Dubuffet urged Bourbonnais to take over in France. The two men chose to name

the works of the new enterprise "art-hors-les-normes" (art-outside-the-norm), the term "Art Brut" being reserved for Dubuffet's venture and the collections now headed for Switzerland.[111]

After major work, renovations, and improvements, the Château de Beaulieu in Lausanne was transformed into a reception center and exhibition space. The Art Brut works, the archives, the photographic documentation and the library arrived in Switzerland in October 1975. Dubuffet refused to refer to the new organization in Lausanne as a museum—having an aversion for the term and its connotations—preferring the name "collection de l'Art Brut," which evoked a simple gathering of objects. He visited Lausanne in order to oversee the installation of his collection and give his final recommendations to Michel Thévoz, appointed curator on July 1, 1975: "Persuade him [the

mayor], I beg you, not to arrange any protocol or ceremony, seeing as how anything of that nature puts a man very much ill at ease who is 1) not very sociable 2) old 3) a very poor guest at the table 4) allergic to all formalities 5) taciturn and very unsuited for toasts and speeches. If he wishes to agree with our rejection of all ceremonial matters, it would be my greatest pleasure."[112] On February 26, 1976, the Collection de l'Art Brut opened its doors in Lausanne. Dubuffet, honored *in absentia*, preferred to skip the inauguration and, the next day, discreetly visited the premises.

Michel Thévoz, curator of the Collection de l'Art Brut, 1996. Photograph by Marc Latzèl.

AN ANTIMUSEUM

The initial idea for the Collection de l'Art Brut was profoundly original, in that the organization was set up to celebrate artists who did not work in traditional artistic settings and had been excluded from cultural life. It put the very concept of the museum as an institution to the test: these non-professional artists provide evidence that all individuals are in fact potential creators and that the ability to express oneself is stunted by "educational domestication"—to use Michel Thévoz's term—as well as by various other methods of conditioning. This type of work calls into question above all else the distinction, specific to our culture, between "transmitters" and "consumers" of art and casts a harsh light on "a collective neurosis about expressive impotency."[1] Furthermore, these works accomplished in secrecy and freedom highlight their disinterested nature. They imply a blacklisting by the traditional networks dedicated to selling art and creating stars. The arbitrary nature of the system whereby art and artists are exhibited, distributed, and valued is thus called into question.

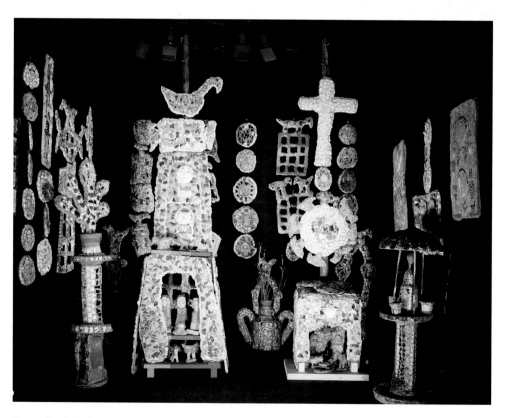

Group of works by François Portrat. Collection de l'Art Brut, Lausanne.

Obviously, a museum was not the ideal repository for these unique works. Paradoxically, by exhibiting Art Brut, Michel Thévoz became responsible for a kind of official promotion which he otherwise resisted. Aware of this paradox, he considered this choice as better than the alternative of silence and occultation. The hijacking of Art Brut was unavoidable: unable to find a better destination for these compositions—already taken out of their context—the curator confirmed that he was gambling "on their contentious power to react on the medium at which and in which they were being exhibited. Putting Art Brut, in other words art that is truly poor, in a museum, providing it moreover with the latest technical innovations in conservation and security was certainly an incongruity, a little like introducing a bum into a palace, but a provocative incongruity that, far from being an appropriation of Art Brut, amounted to putting the museum into crisis, showing the visitor, which is to say the common man, the anthropological potentialities of expression which enculturation had led him to abandon . . . The Art Brut collection thus really does highlight a pathology of art."[2] The first goal of the "museumification"

of Art Brut was to cause, by means of an esthetic and emotional shock, a cultural and institutional upheaval. Seen from this angle, there can be little doubt it was an "antimuseum."

A STRANGE ATMOSPHERE

Loyal to Art Brut, the curator approved of the scheme of the two architects, Bernard Vouga and Jean de Martini, to transform the west wing of the Château de Beaulieu into as neutral a space as possible.[3] This reflected their wish to show all the objects to their best advantage. The interior space was divided into four levels with openings in each floor; a system of staircases created an itinerary, making it possible to visit the museum in a systematic way. This scheme thus made it possible to accommodate the permanent exhibition of the Collection de l'Art Brut, which numbered some eight hundred paintings, drawings, textiles, sculptures, and assemblages of all shapes and sizes. A few huge works are two or three floors in height, including a banner by Aloïse measuring more than 7.5 meters long (nearly 25 feet). This is displayed in the museum's central atrium, which was designed especially for it.

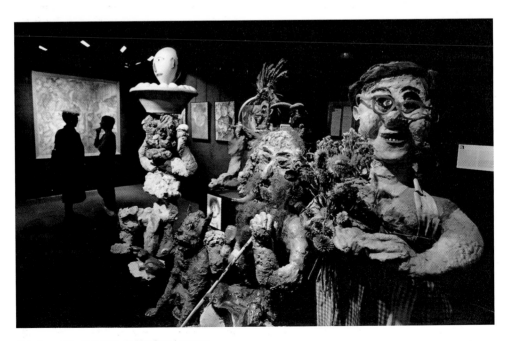

Main floor of the Collection de l'Art Brut, Lausanne.

Pascal-Désir Maisonneuve, *Head with Wide Ears*, between 1927 and 1928. Assemblage of seashells, height 16 1/2 ins (42 cm). Collection de l'Art Brut, Lausanne.

Pascal-Désir Maisonneuve, *Horned Head*, between 1927 and 1928. Assemblage of seashells, height 18 3/4 ins (47.5 cm). Collection de l'Art Brut, Lausanne.

Smaller works are exhibited on panels or in display cabinets that break up the space into smaller sections.[4]

Each Art Brut artist is represented by a small number of works, accompanied by a black-and-white photograph of him or her and a short biographical note. The text contains objective information and offers some relevant points about the creator's life and work. "One could handle this information in numerous ways," Michel Thévoz explains, "medically, esthetically or sociologically . . . It's fortunate that Art Brut is located where all these disciplines intersect . . . Our role is to feed reflection, to provide as much information as possible without taking sides."[5] The curator went on to explain in what way his museum was unique, outlining the philosophy behind the way the works were displayed: "In traditional museums, alas, the relationship is one of knowledge. There are museum officials who introduce visitors to a body of knowledge. One could say that as far as the Musée de l'Art Brut is concerned, the relationship is a Socratic one. The first thing we say is that 'we don't know anything.' In the museum, there are works that resist interpretation, that cannot be assimilated into the usual fine arts system; there are paradoxical

objects of the highest poetry. We show them because they pose a problem for us. Can you explain any of this to us? In the end, that is the question asked by visitors." Thus the museum was conceived to avoid "conditioning" and "manipulating" the public. "Therefore, the first message that we had to get across as directors of the collection was that, if we had any agenda at all, it was to show the works and instigate a process that we were not going to dictate, control, or program."

Contrary to normal museum practice, the title does not appear under the work and there is no label listing the media, the dimensions, or the date of creation—the creators rarely provided such information anyway, since they created their works for themselves, or perhaps for some imagined audience. This lack of information is intended to give precedence to the object, while simultaneously accentuating its secret nature—notably in the case of Ratier's moving machines or Maisonneuve's anthropomorphic masks. The absence of information can also be interpreted as an appeal to consider the visit to the museum as an "unpredictable adventure." The Château de l'Art Brut is indeed suffused with a strange atmosphere, heightened by the black walls that bathe the place in semi-darkness. Originally,

179

Adolf Wölfli, *Composition on a Circular Dial*, c. 1922.
Crayons, 17 1/4 × 17 1/4 ins (44 × 44 cm).
Collection de l'Art Brut, Lausanne.

Madge Gill, *Dress*, undated. Dress embroidered with
mercerized cotton and colored wool threads, embellished
with colored cotton netting, height 36 1/2 ins (93 cm).
Collection de l'Art Brut, Lausanne.

this choice of décor was in keeping with the technical constraints of preserving and protecting the works. Sometimes out of choice, but more often out of necessity, the creators of Art Brut such as Heinrich Anton Müller, Adolf Wölfli, or Guillaume Pujolle used poor quality supports, drawing and painting with pencils, inks, Mercurochrome, toothpaste, and all sorts of other substances. Most of the works on paper are very fragile and are vulnerable to bright light. A dark background allows the museum to reduce artificial lighting to a minimum since the visitor's eyes will adjust to the darkness. Even if it would be wrong to think "that we wanted to dramatize the Collection de l'Art Brut," explained the curator, this is nevertheless one of the first characteristics of the museum that people notice. As soon as the threshold is crossed, the visitor is plunged into an impressive chiaroscuro; no windows or openings offer a glimpse of the outside. This totally enclosed, silent space turns out to be well suited for confronting and considering these emotionally charged works. Yet, it would be wrong

to attribute these dramatic effects to the décor alone, even if the latter does reinforce the troubling aspects of these works. Textiles, statues, and paintings are here restored to a setting much like the one in which they were first created—a place of shadows, secrecy, and confinement. Everything seems to conspire here to ensure that the strangeness of the works combines with the feeling of disorientation experienced by the visitor. The discovery of the Collection de l'Art Brut thus becomes an intense intellectual and human experience, producing what Michel Thévoz terms "the feeling of jubilation mixed with anguish . . . and access to a still unexplored region of the 'distant inner self.'"[6]

Dubuffet did not hide his astonishment when he discovered his collection installed in the mansion; he had imagined a more sober presentation. "Think of some peasants who have given their daughter to the aristocrats, and two or three years later they were about to welcome her back home. They would find her without her wooden shoes, she would no longer have jam on her face, she would be cleaned

Juliette-Élisa Bataille. *Crouching Horse*, 1948. Embroidery, wool, and cotton on cardboard, 4 1/2 × 7 ins (11.5 × 18 cm). Collection de l'Art Brut, Lausanne.

The main floor of the Collection de l'Art Brut, Lausanne.

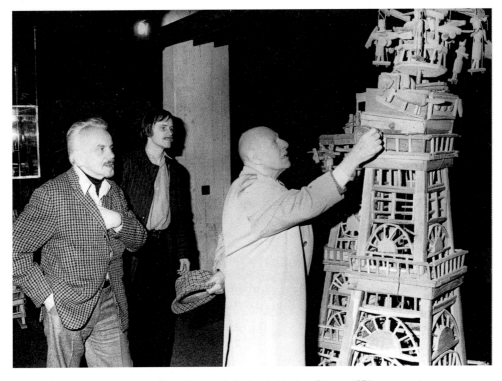

Slavko Kopac, Michel Thévoz, and Jean Dubuffet at the Collection de l'Art Brut, February 1976.

up and well dressed . . . The surprise that they would have in finding her like this is somewhat similar to the surprise that I experienced in seeing this collection in this museum."[7] Dubuffet, like Kopac, the former curator of the collection, had the feeling that someone had dressed "a bum in a wedding gown."[8] But he finally came around to Michel Thévoz's conception of the museum, interpreting it as an effective provocation: "I feel that for once—for the first time, it seems to me—the public is really confronted with the questions that are raised by the exhibition of Art Brut works. It pleases me very much."[9] The prospector envisioned Art Brut's installation in the museum as a new episode in its adventure, as a new challenge which he was no longer in charge of. "Jean Dubuffet had a capacity for remaining detached. It is as if he had collected some seeds and enjoyed watching them grow outside of his control . . . He felt that a work had to fly on its own wings."[10]

DUBUFFET'S SUPPORT

Due to the profound intellectual affinities that linked him to Michel Thévoz, Dubuffet would remain in close contact with the Collection de l'Art Brut for many years. Donor, patron, and advisor, Dubuffet lent his support without overly imposing his presence on the new staff. Furthermore, he was never at heart a collector; after the donation, he did not keep one single piece of the collection that he had patiently and passionately gathered together on his own over thirty years, preferring to contribute to the enrichment of the organization in Lausanne. Dubuffet sent to the museum numerous works that he had personally acquired—such as a large drawing by Vojislav Jakic, *Extermination*—or that had been given to him by various creators. He also provided the museum with substantial financial donations to be used for the purchase of very expensive pieces, such as drawings by Madge Gill and Anna Zemankova. Michel Thévoz kept Dubuffet up to

date on all its activities and sought his invaluable advice; he sent him photographs of recent finds. Dubuffet would derive great pleasure from viewing these works in the small private theater he had set up in his home.

Over the years, the relationship between the two men deepened due to frequent correspondence and their meetings, which were held ritualistically in Paris—by now in his eighties and sick, Dubuffet rarely traveled and only came to Lausanne on two occasions. The theorist of Art Brut expressed his complete satisfaction with the way the museum was developing under Thévoz.[11]

TEMPORARY EXHIBITIONS

Organizing temporary shows is one of the principle activities of the Collection de l'Art Brut and these exhibitions are usually planned as retrospectives centered on an individual artist. The exhibition policy is influenced by a desire to emphasize artistic individuality and to represent artists such as Jules Doudin, Aloïs Wey, or Léontine as creators in their own right. Because of the unique character of their work, Michel Thévoz and his assistant Geneviève Roulin have devoted specific exhibitions to artists such as Madge Gill, August Walla, and Bill Traylor. There have also been collective shows centered on a theme: "Les Bâtisseurs de l'imaginaire" (The Builders of the Imaginary); "Les Écrits bruts" (Brut Writing); "Les Obsessionnels" (The Obsessives); "Les Recycleurs fous" (The Mad Recyclers). For a number of years now, the museum has also focused on the history of the concept of Art Brut and the creation of the collection, presenting exhibitions of a documentary nature which place Art Brut in a historical context—"Hommage à Steck et Ladame" (Homage to Steck and Ladame, 1991); "La Collection Prinzhorn" (1996); and "Cesare Lombroso, explorateur des déviances mentales" (Cesare Lombroso, Explorer of Mental Deviancy, in association with the Institute of Forensic Medicine in Turin). The creators who were part of the subsidiary collection were placed under a new title, Collection Neuve Invention (New Invention), in 1982, and they too are the subject of parallel exhibitions.

Each temporary exhibition is spare and neutral, consisting of a very large number of works. This decision is not merely the result of a desire to show the uniqueness of each artist and as wide a range as

COLLECTION DE L'ART BRUT
DU 22 JANVIER AU 23 MARS 1980
11 AV. DES BERGIÈRES LAUSANNE

Card for the Jules Doudin exhibition, 1980.
Collection de l'Art Brut, Lausanne.

possible of his or her works; the very nature of Art Brut works demands that it be done in this way. Walls teeming with different pieces restore the verbose, repetitive, and serial nature of their creation. During the exhibition devoted to Ted Gordon, for example, the public discovered two hundred portraits arranged in a continuous frieze. In addition, the compositions of Aloïse, Carlo, and Metz, which are done on both sides of the support, are placed between sheets of plexiglass and hung in space. Once more, the method of exhibition is designed to accommodate the specific nature of the creation.

Occasionally, an artist will attend the opening of the exhibition devoted to his or her work, for example Jakic, Wey, Lonné, Hauser, Teuscher, Metz, Van Genk, and Krüsi. Their presence is rare, however, as many of the creators are dead, while others, such as Santoro, Walla, and Mackintosh, appear indifferent or reluctant to take part in the promotion of their works. Some, who are indigent, cannot even

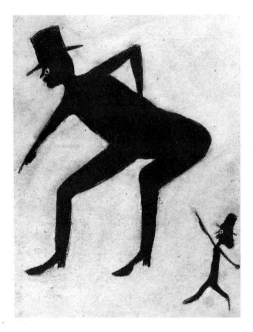

Bill Traylor, *Big Man, Little Man*, undated. Crayons and pencil on cardboard, 13 x 9 3/4 ins (33 x 25 cm). Judy Saslow Collection, Chicago.

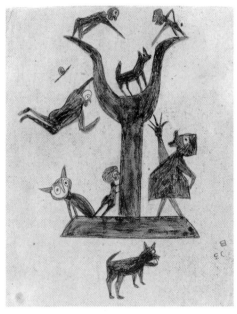

Bill Traylor, *Yawping Woman*, undated. Gouache and pencil on cardboard, 11 1/2 x 7 ins (29 x 18 cm). Judy Saslow Collection, Chicago.

Bill Traylor drawing on the Monroe Street sidewalk in Montgomery, Alabama, 1939. Collection de l'Art Brut, Lausanne.

get to Lausanne. The temporary exhibitions do not have an official preview, but a small press conference is held to which a few dozen friends and important supporters of the museum are invited. The opening of an exhibition is not a cultural event. Art Brut does not attract a sophisticated clientele; it "does not seek out mass membership but flees from it," emphasizes Michel Thévoz, who shuns any self-congratulatory approach on the part of the museum, choosing to maintain a certain discretion in relation to its activities: the secrecy that reigned at the Foyer and the Art Brut pavilion continues to be maintained today and has become historic.[12]

During the first decade, between 1976 and 1986, the museum organized its exhibitions without any outside involvement. Michel Thévoz and Geneviève Roulin marveled at the richness of the Art Brut collection and sometimes had trouble selecting creators for an exhibition. Furthermore, their own discoveries, such as Aloïs Wey, Gaston Teuscher, and Joseph Wittlich, were so interesting that they too became the subject of solo exhibitions. The clause

Léontine, composition, undated. Crayon and pencil, 11 3/4 × 9 ins (29.9 × 22.5 cm). Collection de l'Art Brut, Lausanne.

Theodore H. Gordon, *Twelve Heads*, 1992. Ballpoint and felt-tip pen, 4 × 5 ins each (10 × 13 cm each). Collection de l'Art Brut, Lausanne.

Reinhold Metz, *Don Quixote page 137*, 1981–82. India ink, watercolor, and enamel paint, 21 × 15 1/2 ins (53.5 × 39.5 cm). Collection de l'Art Brut, Lausanne.

relating to the institution's independence formulated by the advisory council was thus respected to begin with: "The Collection de l'Art Brut will not agree to any exhibition of Art Brut organized by other museums, nor will it lend any of its works to another institution."[13] However, this rule was partially broken in subsequent years.

Gradually, the museum agreed to collaborate with some institutions—the Gugging House of Artists in Klosterneuburg, Austria; the museums in Arras and Béthune; Malmö's Konst Museum; the Lagerhaus Museum in Saint-Gall; the Wölfli Foundation and the Kunstmuseum in Bern—as well as with various collectors, such as Jean Tinguely, Pierre Chave, and Alfred Bader. It became a center that hosted artists, individually or in small groups,

Theodore H. Gordon, *Man's Head, 1849*, 1978. Ballpoint and felt-tip pen, 9 3/4 × 8 ins (25 × 20 cm).
Collection de l'Art Brut, Lausanne.

Reinhold Metz, *Don Quixote page 119*, 1981–82. India ink, watercolor, and enamel paint,
21 x 15 1/2 ins (53.5 x 39.5 cm). Collection de l'Art Brut, Lausanne.

Hans Krüsi, *Figures and Animals*, c. 1983. Gouache, 40 × 30 × 2 ins (101.5 × 76 × 5.5 cm).
Collection de l'Art Brut, Lausanne.

Hans Krüsi, 1990. Photograph by Mario del Curto.

Josef Wittlich. Collection de L'Art Brut, Lausanne.

as well as traveling exhibitions. In the 1990s, the museum in Lausanne began cooperating more actively with various American organizatons, public and private, because of the American public's growing interest in "outsider art." Teaming up with other organizations has permitted the Collection de l'Art Brut to introduce new artists to the public, as well as to mount important retrospectives. In fact, the clause that limits the museum to exhibiting solely creators of whom it already possesses works has led to fruitful negotiations and has become one important way for acquiring new works. Because of this stipulation, works by Hauser, Walla, Schöpke, Krüsi, Pankoks, Settembrini, and Mackintosh now grace the collection.

PRESERVING A WHOLE

"Let me confirm my opposition to the lending of works belonging to our Collection de l'Art Brut in all cases when the object of the request is to supply exhibitions organized in other cities or even in Lausanne outside of our premises," Jean Dubuffet wrote to Michel Thévoz in 1975. "I believe it necessary that our collection be—at least for the first two years after its installation in the Château de Beaulieu—exhibited to the public continuously in its entirety and without temporary absences. Furthermore (and saying nothing about the risk of accident and damages resulting from transportation), I fear that by mixing works from our collection with works that are not likely to be entirely of the same nature, the end result for the public would be an assimilation, which would distort the proper place of Art Brut and would weaken its meaning and prestige."[14]

The curators adopted a policy in accordance with the condition stipulated by Dubuffet and refused to loan works from the collection, declining invitations from renowned institutions such as the Stedelijk Museum in Amsterdam, the Musée d'Art Moderne in Paris, the Arts Council of Great Britain, and the Smithsonian Institution in Washington D.C. However, Michel Thévoz and Geneviève Roulin have on

occasion violated this rule; for example, the Halle Saint-Pierre in Paris mounted a major exhibition in 1995, "Art Brut and Compagnie," in order to commemorate the tenth anniversary of Dubuffet's death and twenty years of Art Brut in Lausanne. The museum played an important role in this event. But these rare infractions have not had any harmful effects on the institution. On the other hand, its refusals can contribute to confusion and provoke equivocal situations at times. In fact, the curators have seemed somewhat embarrassed by Dubuffet's instructions;[15] when they refuse to loan works belonging to the collection, they often point the interested organizations in the direction of other sources. Consequently, Art Brut is represented in international exhibitions by works that do not belong to the collection, but which have been assembled with the help of those in charge of the museum.

These collaborations, which have been increasing since the 1990s, have been in response to a growing demand for, and fascination with, Art Brut. By an irony of fate, this growth has been inversely proportional to the discovery of new artists. These partnerships with various organizations also testify to a more flexible attitude on the part of the museum regarding the disclosure of Art Brut outside of its walls—undoubtedly the death of Dubuffet in 1985 has played an important role in this.

"PAINTINGS THAT SPEAK"

Art Brut invites an emotional approach and participation. For this reason, most visitors dispense with rapid, simplistic evaluations—"I like it" or "I don't like it"—experiencing instead a desire to understand and connect with the works: "These are paintings that speak, that shake things up, that make you think. I remember the first time that I came to the museum, I stayed maybe half an hour and then I had to get out because everything was going around too fast. It was so emotionally overwhelming that I had to get out for a moment so that I could finish my

Josef Wittlich, *Poilu and Frederick's Officer of the Guard*, between 1964 and 1975. Gouache, 35 1/2 x 24 1/2 ins (90 x 62.4 cm). Collection de l'Art Brut, Lausanne.

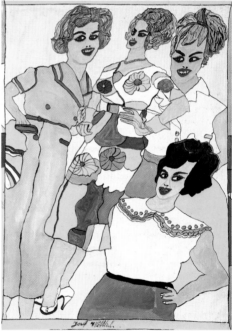

Josef Wittlich, *Four Women*, undated. Gouache, 34 1/2 x 24 1/2 ins (88 x 62 cm). Collection de l'Art Brut, Lausanne.

visit later. I had to get used to it. Because they are truly paintings that speak."[16]

Questioned about the public's reactions, Michel Thévoz revealed that "misunderstandings are less numerous than [you] might have thought a few years ago. The public at large is always smarter than you imagine. Art Brut gets visitors to ask questions that go way beyond the field of esthetics, as if they were experiencing not only an artistic emotion but also an actual philosophical exultation."[17] If the museum's guest book contains some negative remarks—incomprehension and denigration, refusal to attribute artistic value to the works—in no way is it a collection of complaints as is the case in many museums.[18] It contains such comments as: "Sometimes fear, at others anguish or admiration; lots of different feelings. You leave filled with wonder but also perturbed. Thanks for all of that"; or "This is fascinating art . . . a million times more interesting than my art history class! Bravo."[19] One reason for this satisfaction is connected to the type of people

that the institution attracts. As a general rule, before crossing the threshold, visitors are already curious, already briefed on the nature of the collection. Rare and specific, this collection boasts an international audience—it is estimated today that around eighty percent of visitors are foreigners. [20]

A visit to the Collection de l'Art Brut is done freely. In the months following the opening of the museum, Michel Thévoz and Geneviève Roulin gave daily lectures that served as an introduction to the collection or led discussions—even today, they occasionally offer this type of service to groups that request it. Today, however, the museum does not offer guided tours with prearranged itineraries, "for what we have is a drunken boat that doesn't lend itself to being steered," the curator explains.[21] No debates are organized, no conferences are scheduled: in keeping with the neutrality sought for the presentation of the works, this decision is in agreement with the desire to avoid "conditioning people, manipulating them, preparing a message, and presenting it."[22]

PRESS REACTION

In praiseworthy, indeed eulogistic, terms, the international press reported on the donation and the opening of the Collection de l'Art Brut. Here is a small sample of their comments: "The peaceful city of Lausanne has undergone a strange, bloodless, invisible revolution"; Dubuffet's "extraordinary donation" is a "princely gift," a present "of inestimable value"; this "exceptional event" stirred up excitement among cultural circles; "It's magnificent! It's a great opportunity for Lausanne!"; how could anyone avoid being pleased about the opening of this "museum [which] has a very important historical dimension [and recognizes] works that up till now have been thought of as marginal or even as completely foreign to the realm of art." In France, there was bitter regret over the loss of this collection, "that a certain lack of understanding let escape," this "treasure within reach" that Paris "neglected"; "This donation, what a lost opportunity!"[23] The discovery of Aloïse's imaginary gardens, Gaston Duf's bestiary, or even Carlo's silhouettes proved to be a startling, intense experience. Many journalists commented on the paradoxical response that Art Brut elicits, a mixture of intimacy and strangeness, described by one person as

ART INCOGNITO

COLLECTION DE L'ART BRUT, LAUSANNE

Card for the "Art Incognito" exhibition, 1997.
Collection de l'Art Brut, Lausanne.

Carlo, *Yellow Animal*, 1964. Gouache, 27 1/2 × 19 3/4 ins (70 × 50 cm). Collection de l'Art Brut, Lausanne.

Aloïse, *Gothard Tunnel's Bed*, undated. Colored pencil, 72 1/2 × 34 1/2 ins (184 × 87.5 cm). Collection de l'Art Brut, Lausanne.

"a feeling of complete strangeness while at the same time a unique feeling of familiarity."[24]

The exhibition of artistic works from asylums raised some ethical questions of its own: "We are in the presence of an indescribable mental and spiritual distress containing mute violence, terror, and dark regions of infinite solitude and unbearable isolation . . . Sacralizing the mentally ill who are suffering, no."[25] Furthermore, the inclusion of Art Brut within the institutional framework of art was rejected: this "art which is opposed to cultural art" would become a hazy "artistic category"; this would amount to the same phenomenon in the art world which involved the "appropriation of primitive art, naïve art and anti-art."[26] However, most critics focused more on the restorative effect of these inventive works; the opening of a place dedicated exclusively to Art Brut was an urgent matter, "because no matter how necessary it is, we have still not disabused ourselves of the confusion between culture—in the most widely used sense of the term—and the collection of references and knowledge that turns someone into a 'cultivated' person."[27] The Collection de l'Art Brut was deemed to hold two promises: the chance "to rediscover a purity of vision and spirit, to achieve an apprehension of the world and oneself from a new point of view"; it "can also bring to cultural art a period of creative ferment . . . inspiring a new attitude which then frees it from cultural and

Carlo, *Figures*, 1964. Gouache, 27 1/2 × 19 3/4 ins (70 × 50 cm). Collection de l'Art Brut, Lausanne.

Willem Van Genk, *Parnasky Culture*, 1972. Oil on assembled planks of wood, 27 1/2 x 56 ins (70 x 142 cm). Collection de l'Art Brut, Lausanne.

social structures which it has willingly submitted and limited itself to."[28]

Some journalists resorted to comparisons, for example drawing parallels between Aloïse's drawings and works by the Fauves, Orphists, and Matisse, comparing Wölfli's work with Tantric art or Tibetan painting, Müller's machines with those by Tinguely.[29] Despite these comparisons, they all considered the makers of Art Brut as independent creators and urged their readers to dispense with stereotypical ideas about madness and suffering: Scottie Wilson "gives us a real, extraordinary thrill with his drawings, which do not betray any disturbing aspects of a tormented soul," while the works of Aloïse display no pathological symptoms, "On the contrary, one sees works that are like the multiple symbols of a liberation from self-restraint and a veritable voyage into the mind, as is so often the case with brut artists."[30] No one can walk away from Lausanne's museum unscathed. "We found there incantations, pain, hidden messages, rags, alphabets, rumors of joy, and each tongue spoke its own unheard of tongue . . . The people in there did not speak to us, they led us in silence and our good manners prevented us from laughing, bursting out in anger, blushing, dancing. A pity. We went in. We will never get out . . . The guides . . . know how to

startle us, leave us with our mouths open. They dared and now they leave us with our bombastic art that is so well suited to elderly fourteen-year-old ladies. We will never sleep again. That's a promise."[31]

CAMPAIGNING FOR CREATIVITY

In 1980, Michel Thévoz wrote: "During the transfer of the Collection de l'Art Brut to Lausanne in 1975, the question came up about limiting it or expanding it: should we have regarded the discovery of new cases of Art Brut as improbable, and the collection complete? The fact is that inventive creations have not been located in psychiatric hospitals since the 1950s, when drug therapies became widespread, except for the few notable exceptions who are represented by precisely those patients who are not medicated. Of course, Art Brut is not just the work of the mentally ill, but also that done by those who resist cultural conditioning, original creators, dissidents, who can eventually fall into the hands of psychiatry, but who can escape from it as well. Must we consider then the psychiatric hospital as a model of normalization radiating out through society and preparing for the establishment of the 'Therapeutic State'? The fact is that the mass media functions in many respects as an institutional drug, conditioning

195

Angelo Meani, *Head with Blue Eyes*, undated.
Various materials, height 20 1/2 ins (54 cm).
Collection de l'Art Brut, Lausanne.

Angelo Meani, *Head with Large Green and Yellow Bottle Nose*,
undated. Various materials, height 20 ins (51 cm).
Collection de l'Art Brut, Lausanne.

and leveling minds . . . Is it now still possible to imagine the existence of inventive, individual counterattacks on 'mass-mediatization'?"[32]

Jean Dubuffet and Michel Thévoz accepted the challenge and took a stand on creativity, convinced that there still remained individual dissidents who were creating a unique, imaginary world free from any kind of conformity. The gamble paid off. Joseph Wittlich, Willem Van Genk, Angelo Meani, and even Gaston Teuscher one by one made their entry into the museum. Paradoxically, Thévoz increased acquisitions over the next two decades, but without organizing a system for prospecting. The public opening of the collection played a major role in the search for and discovery of new creators. During the 1960s, Dubuffet had assembled an indispensable network of correspondents in Europe who located, recovered, and sometimes saved from destruction at the last moment works of Art Brut. Ten years later, Art Brut had an international reputation and new messengers appeared spontaneously.

Every visitor is a potential informant: after discovering the collection, the work of an artist may remind them of solitary, secret works by a relation, a friend, or acquaintance. The museum has put to good use this unusual but particularly effective network of communication.

Over time, the enrichment, effective management, and notoriety of the museum convinced collectors, psychiatrists, patrons, relations, and friends of creators to donate various works. In 1979 Dr. Alfred Bader presented the drawings of Jules Doudin, and in 1995 Nathan Lerner gave some large watercolors by Henry Darger as a gift. Some enthusiastic researchers offered their friendly support by passing on their finds, such as John M. MacGregor, who donated the drawings of Dwight Mackintosh. Furthermore, the growing interest in Art Brut since the end of the 1970s—when the museum was opened—has contributed to the formation of new collections and the establishment of numerous organizations devoted to art of this type:

Dublin's Outsider Archive were inaugurated in 1981; the Fabuloserie in Dicy opened its doors in 1983. Art Brut has also made its entry into the art market, and many works have been offered at prestigious art auctions. The Collection de l'Art Brut is in regular contact with these organizations, which often offer the museum new acquisitions. The curators try however to beat the dealers, collectors, and journalists to new discoveries, attempting to act before the objects have increased in value and become too costly for the museum.

But Art Brut conceals itself from others. By definition, it slips into hiding and moves on as soon as someone flushes it out. A number of creators most likely do exist in isolated places, producing works strictly for their own pleasure.

ARTISTIC AND SOCIOLOGICAL CRITERIA

The spiritual descendant of Jean Dubuffet, Michel Thévoz adheres to the idea of Art Brut as it was presented and developed by Dubuffet: "It is art practiced by people who, for one reason or another, have avoided cultural conditioning and social conformity: the solitary, the maladjusted, patients in psychiatric hospitals, prisoners, eccentrics of all sorts. These artists, indifferent or oblivious to all artistic traditions and fashions, have created for themselves, without being concerned about the appreciation of the public, or the views of others in general, works which are in every respect highly original."[33] In order to determine whether an artist is suitable for inclusion, an examination of his or her work is carried out. It is necessary to have a body of works in order to evaluate how independent and original the artist is. A person knowledgeable in art history assesses whether the works bear traces of cultural, traditional, or folk art. The artist's works are then studied in order to assess whether the system of expression is fully developed and whether they display a personal artistic syntax. Finally, the examination requires information about the life and personality of the artist, his motivations and the conditions of creation. The museum's selections and acquisitions are based on the following five criteria: social marginality, cultural virginity, the disinterested character of the work, artistic autonomy,

Eugenio Santoro, *Pig*, 1991. Carved and painted wood, 31 1/2 × 55 ins (80 × 140 cm). Collection de l'Art Brut, Lausanne.

Eugenio Santoro riding one of his sculptures, 1991. Photograph by Mario del Curto.

197

Francis Mayor, *Port Saintes-Marie-de-la-Mer*, between 1993 and 1994. Paint and collage on paper, 22 × 16 1/2 ins (56 × 42 cm). Collection de l'Art Brut, Lausanne.

Josef Wittlich, *Blue Soldiers in Combat*, undated. 40 1/4 × 28 3/4 ins (102 × 73 cm). Collection de l'Art Brut, Lausanne.

and inventiveness. The artistic and biographical criteria go hand in hand. The idea of Art Brut rests on esthetic and sociological foundations.

Whether it be a matter of theme, iconography, style, or technique, no single characteristic links or defines all of these creators. New discoveries are invariably cause for astonishment: from the whirling, aquatic collages by Francis Mayor to the multicolor battle scenes by Josef Wittlich; and from Angelo Meani's grotesque masks to Eugenio Santoro's bestiary of sculptures—all of these works are distinguished by their uniqueness.

The Collection de l'Art Brut's new acquisitions come only from contemporary Western artists. Dubuffet had followed this rule all along and would explain it in this way: "I have always refrained from including works from other ethnic groups (current or old) in the collection, because that would risk widening the scope beyond what the name Art Brut is intended to describe. I wanted to limit it to inventions profoundly distinct from our cultural norms

but produced by those who live among us and in our own times. The term Art Brut, along with its antagonistic relationship toward culture, is only meaningful within the present context of our own Western culture. It loses its *raison d'être* . . . if one thinks of its works as arising from ethnic groups other than our own, making it impossible for us to distinguish clearly between what defers to public institutions and what arises on the contrary from personal, subversive invention."[34]

ART BRUT IS NOT ART THERAPY

The psychiatric hospital had long been the preferred place to search for Art Brut, but the spread of art therapy workshops throughout these institutions made any real prospecting impossible according to Michel Thévoz, for "therapeutic concerns and supervision had finally neutralized spontaneity, personal commitment, and the spirit of anti-authoritarianism, which are the necessary components for artistic creation." What is more, the goal was to

August Walla, *Russo Adolli*, 1984. Colored pencil on paper glued to Pavatex, 27 1/2 × 19 3/4 ins (70 × 50 cm).
Collection de l'Art Brut, Lausanne.

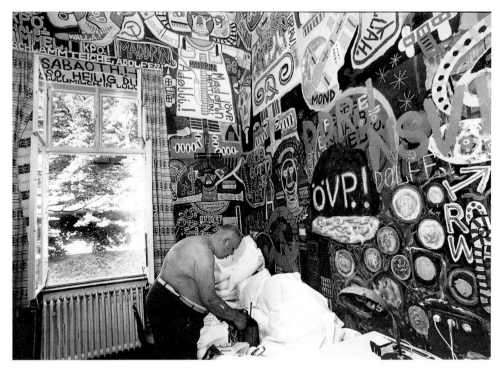

August Walla in his room in the Gugging House of Artists in Klosterneuburg, 1993. Photograph by Mario del Curto.

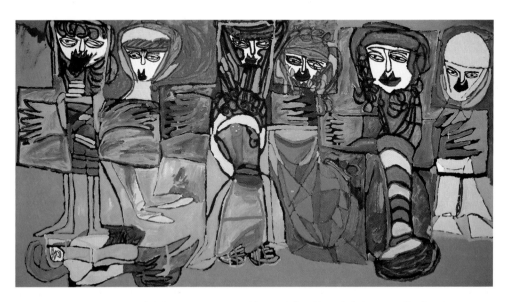

Franca Settembrini, *Crucifixion*, c. 1990. Paint on canvas, 61 × 100 3/4 ins (155 × 256 cm). Collection de l'Art Brut, Lausanne.

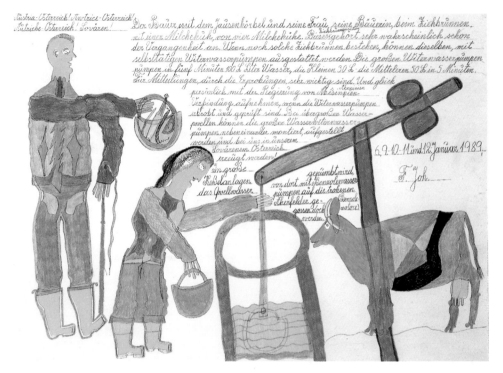

Johann Fischer, *Austria-Österreich Antrice-Österreich*, 1989. Crayon and black pencil, 17 1/4 × 24 1/2 ins (44 × 62 cm). Collection de l'Art Brut, Lausanne.

help patients readapt, so these developments acted as a barrier to any form of insolent, heuristic expression: "Art, like sexuality, loses its attraction when prescribed as hygienic exercise," Michel Thévoz added.[35] Furthermore, although developments in pharmaceuticals made it possible to soothe their suffering, they bore heavy consequences for the creative capacities of patients, capacities which from that point on became of limited interest to those responsible for the museum in Lausanne.

However, some works by mentally ill individuals—August Walla's paintings with multiple mythologies, Oswald Tschirtner's long silhouettes, and Franca Settembrini's women in turbans—figure among the acquisitions made by the museum. They came from two particular institutions: Gugging, the House of Artists at the psychiatric hospital in Klosterneuburg near Vienna, and La Tinaia, the center for expression at the San Salvi psychiatric hospital in Florence.[36] In contrast to traditional art

therapy workshops, these organizations give their patients complete freedom to express themselves: there is no group work and they are not supervised; each person chooses his work place and pursues his own interests. For Michel Thévoz, they are extraordinary experiments, "A place that is not therapeutic narrowly speaking, but rather libertarian, and pretty autonomous in respect to the institution so that creative individuals can assert themselves."[37]

All the same, La Tinaia and to an even greater extent Gugging have adopted a philosophy that is diametrically opposed to that of the Collection de l'Art Brut, for they strive to rehabilitate the creator-patients by requesting their admission into official artistic institutions, such as museums, galleries, and other cultural centers. This seeking for recognition—which implies integration into the art market and increasing speculation—is aimed at reentry into society and corresponds to a therapeutic goal. In the end, the works are more important than the philosophy,

Johann Hauser, *Plane*, between 1958 and 1964. Crayon and black pencil, 8 × 11 3/4 ins (20.7 × 29.6 cm). Collection de l'Art Brut, Lausanne.

Johann Hauser, *Hearse*, undated. Black pencil and colored marker, 11 3/4 × 15 3/4 ins (29.8 × 40.2 cm). Collection de l'Art Brut, Lausanne.

Franz Kernbeis, *Bicycle*, 1990. Black pencil, 59 × 71 ins (150 × 180 cm). Collection de l'Art Brut, Lausanne.

the end justifies the means. The curators of the Collection de l'Art Brut are satisfied with the "flowering of works that attest to the engagement and inventive authenticity of their artists."[38] The works of patients such as Johann Hauser, Philipp Schöpke, Franz Kernbeis, Marco Raugei, and Giordano Gelli stand out in particular among the new acquistions.[39]

CHILDLIKE ENERGY AND SACRED VALUES

Although the psychiatric hospital was no longer a source for Art Brut, Michel Thévoz discovered new

dissidents among those whom he called "today's pariahs," by which he means the elderly.[40] It was only after they reached the age of retirement that Aloïs Wey, Benjamin Bonjour, Eugenio Santoro, Hans Krüsi, Louise Fischer, and Francis Mayor discovered artistic expression; they drew on cigarette packs, painted on cartons, or carved trunks of plum trees, creating turbulent silhouettes, structures with ornamented cupolas and carriage entrances, or impish figures climbing through mountain pastures. The curator explains the dazzling birth of these belated vocations as a reaction to the social banishment to which these old folk have been consigned in present-day Western civilization: "Contrary to what used to be the case in traditional societies, we have lost interest in the elderly; their existence has been relegated to the lowest level of social status; they have even been interned in what are aptly termed old folks' homes. The image of the patriarch has been replaced by the senile old fool . . . They are the new immigrants . . . Having nothing left to gain and nothing left to lose, relieved of all responsibility and all communication, free from public opinion, they take advantage of the situation and make a virtue out of necessity, they slip free from social and mental bondage and enter into wild worlds wherein they are the only protagonists . . . One has the feeling that overnight such people have been able to pick up the thread of childlike energy that they had been following in a discontinuous way, but with what was now a maniacal obstinacy, as if the period

202

Top: Benjamin Bonjour, *Flowers*, c. 1982. Ink, felt-tip pen, and Neocolor crayon. 12 × 17 ins (30.5 × 43 cm). Collection de l'Art Brut, Lausanne.

Bottom: Benjamin Bonjour, 1984. Photograph by Mario del Curto.

Top: Hans Krüsi, climbing through the high mountain pasture, 1983. Assemblage of painted milk cartons, 20 1/4 × 31 × 2 1/2 ins (51.5 × 79 × 6.5 cm). Collection de l'Art Brut, Lausanne.

Above: Hans Krüsi, 1991. Photograph by Mario del Curto.

Right: Giovanni Battista Podestà. Collection de l'Art Brut, Lausanne.

Giovanni Battista Podestà, *I Feel Great Dread in Me*, undated. Mixed media, 20 × 11 3/4 ins (51 × 30 cm).
Collection de l'Art Brut, Lausanne.

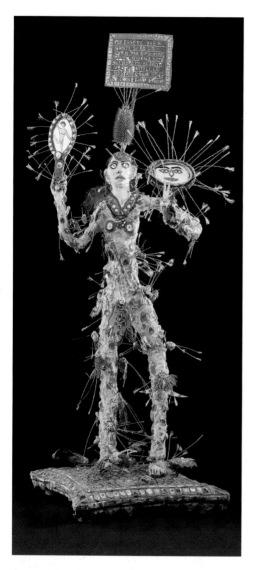

Edmund Monsiel, drawing, undated. Pencil, 7 1/2 × 6 ins (19.2 × 15.5 cm). Collection de l'Art Brut, Lausanne.

Giovanni Battista Podestà, *The Diet Plan*, undated. Mixed media, height 31 1/2 ins (80 cm). Jean Tinguely Collection, Milly-la-Forêt.

between the age of ten and seventy had merely been an unpleasant time they had to get through."[41]

Desocialized, Art Brut artists reconstruct a universe that is their own. While some of them rediscover the insolent ingenuity of childhood, others recover the ancestral sacred values of the creative act through its religious, spiritual, magical, and metaphysical components. These manifest themselves in very diverse ways. In Edmund Monsiel's profusion of faces, the image of Christ emerges in an obsessive way, accompanied by "professions of faith" and "exhortations of devotion."[42] These are echoed by the moralizing statements and edifying words contained in the works of Giovanni Battista Podestà. For both of them, the ethical and the esthetic seem inseparably intertwined. In a similar way but much more expansively, August Walla's imaginary pantheon gathers together gods, demons, saints, prophets, miracle workers, and imaginary geniuses who have the names Allah, Buddha, Zeus, Satan, Rasputin, Kappar, and Satttus—a polytheistic collection that begs for a new, symbolic mythology. As for Michel Nedjar's dolls, they arise from universal powers captured in the fetishes made of rags and plants which then undergo a bath in dye made from earth and blood; the creative act is accompanied by a magical, sacred ritual. Finally, Armand Schulthess's works also mix the universal and the spiritual: his immense chestnut grove was crisscrossed

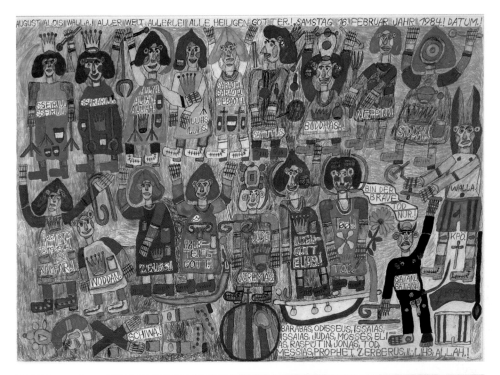

Top: August Walla, *The Whole World, All Kinds, All the Gods*, 1984. Colored pencil, 24 1/2 × 34 1/2 ins (62 × 88 cm). Collection de l'Art Brut, Lausanne.

Bottom: August Walla, 1993. Photograph by Mario del Curto.

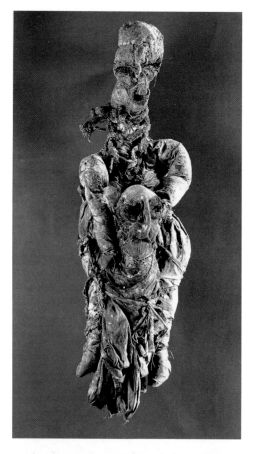

Laure Pigeon. Collection de l'Art Brut, Lausanne.

Left: Michel Nedjar, *Adult and Child*, between 1976 and 1982. Assemblage of rags, string, jute, various materials soaked in water and dirt, height 35 ins (89 cm).
Collection de l'Art Brut, Lausanne.

Below: Michel Nedjar, 1984. Photograph by Mario del Curto.

by routes connected to plaques bearing texts fixed to walls and trees that drew together a wide range of learning and various beliefs, such as geology, crystallography, astronomy, philosophy, literature, astrology, and parapsychology. The utopia proposed here was a mythology of encyclopedic nature. [43]

Among the artists already part of the collection, there were many who claimed to be guided by the dead or by a divine voice, such as Augustin Lesage, Madge Gill, Laure Pigeon, and Giovanni Battista Podestà. Similarly, recently discovered creators speak of maintaining a connection with the beyond or with invisible entities and create emblematic images of an imaginary cosmogony. A mystic, magical, or religious component is one of the principle characteristics of the major figures in the collection. For many, art is a visionary experience.

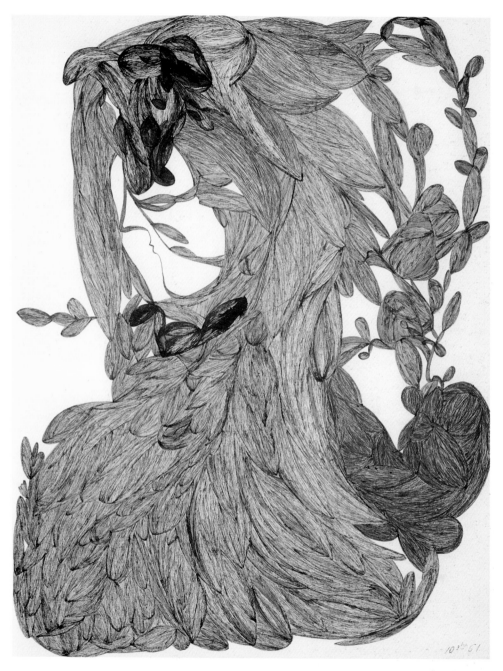

Laure Pigeon, *Drawing "November 10, 1961,"* 1961.
Violet and blue ink, 25 1/2 × 19 3/4 ins (65 × 50 cm).
Collection de l'Art Brut, Lausanne.

Eugenio Santoro, *The Egyptian Woman*, 1987–88.
Carved wood, height approximately 8 feet (240 cm).
Collection de l'Art Brut, Lausanne.

Right: Eugenio Santoro, 1991. Photograph by Mario del Curto.

Many of the new acquisitions have rounded out bodies of works by artists already part of the museum. The "classics" of Art Brut—Gill, Wilson, Lesage, Aloïse, Jakic, Carlo, Doudin, and Robillard—are represented by large collections characteristic of their work. The compositions "can only take on their true meaning when seen as a series, in the persistence and obstinacy of their creative principles, like a piece of writing or continuous text whose pages should not be scattered about," Michel Thévoz wrote.[44]

During these two decades, the collections grew considerably. At the time of their donation to Lausanne, they contained in all more than 6,500 works; twenty years later, there were more than twenty thousand.[45] Ironically, the acquisition of works by new creators of Art Brut has diminished markedly in recent years.

THE VALUE OF THE WORKS

The creators of Art Brut display disconcerting attitudes when curators find their works interesting

and, in particular, when they express a desire to acquire them and exhibit them. Although most of them accept the offer, each one sees the transaction differently. Eugenio Santoro, for example, quickly gave his consent to exhibit *L'Égyptienne* (The Egyptian Woman), but when Michel Thévoz wanted to offer him six thousand Swiss francs, he refused and demanded to sign a kind of anti-contract stipulating that no amount of money would be paid to him. Selling the sculpture simply did not occur to him. In addition, he believed that the sculpture would be exhibited at the museum under his friend's name, Maurice Born, who served as an intermediary in notifying the museum's staff about Santoro's work. In contrast, some creators demand exorbitant sums, which correspond to the symbolic value of the work for the artist: Gaston Teuscher stated that the price for his drawings was "out of reach" for the city of Lausanne. Almost all of the creators eventually decide to donate hundreds, even thousands of works to the museum, thereby thwarting any commercial transaction—the curators are sometimes even forced to put limits on such prodigality. Some of them prefer to barter, such as André Robillard, who has asked for an accordion, a television or

Gaston Teuscher, *Drawings,* undated. India ink, ballpoint pen, gold and silver paint, 3 1/4 × 2 ins (8.2 × 5.1 cm); 2 × 3 1/4 ins (5.1 × 8.2 cm); 1 3/4 × 3 ins (4.3 × 7.6 cm). Collection de l'Art Brut, Lausanne.

Gaston Teuscher, 1983. Photograph by Mario del Curto.

André Robillard, 1983. Photograph by Mario del Curto.

Joseph Vignes, 1986. Photograph by Mario del Curto.

radio, an army knife, and a helmet with a visor in exchange for his guns and his imaginary sputniks.[46]

Ignorant of or unconcerned about the ins and outs of the art market, indifferent to or reticent about the status of artists, incapable of estimating the financial value of their works or resistant to any commercial activity, the creators of Art Brut—Bonjour, Santoro, Vignes, Gordon, and Teuscher—have acted as dissidents in regard to cultural practices. They have chosen to give their works to the museum, considering it the best possible place for them; there they would be exhibited as full-fledged members of Art Brut and not as curiosities, enabling a sensitive, interested public to discover them. Throughout the past two decades, the collection has been enriched by numerous acts of generosity.[47]

There have also been donations from collectors and patrons, and from conscientious doctors who respected the creators' wishes and refused to involve them in the commercial arena, preferring to spare them from any speculation by offering their works to the Collection de l'Art Brut, which guaranteed them a permanent home.[48]

If the museum's growth was due primarily to donations, acquisitions made on the art market have also contributed to its enlargement. But this practice has provided no new discoveries, since these networks only handle the promotion and sales of the "classics" of Art Brut, whose "guarantee" is this label. In general, works purchased from gallery owners and dealers are by creators who are already a part of the collection. Prices vary depending on the organization and the quoted value of each artist: two paintings by Lesage were valued respectively at fifty thousand and sixty-five thousand Swiss francs; one of Forestier's sculptures sold for twenty-eight thousand Swiss francs; a work by Pujolle for eighteen thousand Swiss francs. The prices are much lower for works by creators who are not as well known, such as Podestà and Radovic. Having a small budget at its disposal, the Collection de l'Art Brut does not come close to rivaling collectors. When it cannot acquire works because of their prohibitive cost, such as those by Martín Ramírez, the museum offers to make an exchange.[49] Occasionally, the curators have benefited from their close links with certain institutions; for example, La Tinaia and Gugging have agreed to reduce their prices for the museum.

Vahan Poladian. Photograph by Eryck Abecassis.
Collection de l'Art Brut, Lausanne.

The collection makes acquisitions in this way by paying modest, even symbolic sums of money.

COLLECTION NEUVE INVENTION

Jean Dubuffet had mixed emotions about the Collection Annexe—the parallel department to the Collection de l'Art Brut. His attitude is explained in part by the development of his research, as well as his artistic theories; additionally, this conflicting attitude clearly reveals the boundary that both separates and links creators in the Collection Annexe and those in the Collection de l'Art Brut.

When Dubuffet had the idea of donating the entire collection of works, he decided to separate the two collections: at first, he planned to let the parallel department go to the Musée Cantonal des Beaux-Arts in Lausanne, fearing that there was insufficient space for exhibiting works at the Château de Beaulieu. In addition, he was particularly

Top: François Burland, untitled (detail), undated. Crayon on wrapping paper, 9 ft 3 ins × 13 ft 3 ins (280 × 403 cm). Collection de l'Art Brut (Collection Neuve Invention), Lausanne.

Bottom: François Burland, untitled, 1990. Crayon, 43 1/4 × 43 ins (111 × 109 cm). Collection de l'Art Brut (Collection Neuve Invention), Lausanne.

concerned that the impact of Art Brut works would be weakened and that the public would be misled into confusing the two categories. Dubuffet finally chose to leave the two collections grouped together. After the museum's official opening, he continuously demanded that it be extended so that a space could be created for the display of works from the Collection Annexe, while at the same time admitting his uneasiness about these clans: "I am bothered—I always have been—by the subtlety of the criteria that prompt us to classify works—some of those criteria at least . . . —into either the collection de l'Art Brut or the 'Collection Annexe.'"[50]

Michel Thévoz, on the contrary, had a very clear approach to the two collections. Although the notion of designating categories seemed authoritarian, the curator emphasized the necessity of doing so: "Art Brut is a word, a label, a category just like any other noun in the dictionary. Just as general and imprecise as the rest of them. Take the word 'bread': it designates a lot of things, made from all sorts of grains; it can be dry or moist, flavorful or bland . . . With all of this imprecision, it does not prevent the word 'bread' from being rather useful in

making yourself understood while doing the shopping. Like the noun Art Brut when someone is interested in art."[51] However, the classification of works into two closely related departments gave rise to moments of hesitation on occasion. Aware of this "arbitrary zone" that separates the two, Michel Thévoz insisted on clarifying the point: "Art Brut. Collection Annexe. Evidently, it is the price that has to be paid in order to deal with borderline cases. The majority of cases are not borderline at all and it is much easier, clearer, and more advantageous to make use of the two categories, the justification for which seems increasingly evident to me."[52]

From the earliest days of the museum, a few decisions slightly shifted the direction of Art Brut. The new curator sometimes showed little inclination to adhere to his predecessor's orthodoxy. In particular, Thévoz reinstated some of the artists Dubuffet had excluded, notably Michel Nedjar and Giovanni Battista Podestà, followed later on by Wittlich, Bonjour, Gordon, Van Genk, and Mackintosh. He would also make a case for Gaston Chaissac, some of whose works have been exhibited in the permanent exhibition of Art Brut since 1996. The contacts that Chaissac maintained with intellectuals and the art market did not justify his exclusion. In Chaissac's case, they "have neither watered down nor swayed in the least the positions of a supremely independent spirit, positions brazenly liberated from any cultural legacy and conditioning. It seems to me that this individualism became even more pronounced at the end of his life, and is translated in his most intensely original paintings ever. If Art Brut is characterized as a kind of artistic and sociological autism (in the non-pathological sense), it can be stated that Chaissac is somewhat more autistic artistically than socially; and, all in all, the artistic criteria have the edge over sociological ones."[53] Similarly, the works of Louis Soutter, like those of Hill and Gabritschevsky, display such a significant split between his artistic education and his artistic training that the curator would also place him in the same category as Aloïse, Wölfli, and Lesage.

Under the direction of Michel Thévoz, the Collection Annexe has been renamed the "Neuve Invention" (New Invention) collection, a name that suggests positive meanings and values.[54] The curator characterizes these pieces as "works that do not arise from the radical psychological rupture found

Ignacio Carles-Tolrà. *Perhaps She Will Arrive One Day*, 1968. Ink and crayon, 28 3/4 × 40 1/4 ins (73 × 102 cm). Collection de l'Art Brut (Collection Neuve Invention), Lausanne.

in creators of Art Brut as it is understood in the original sense, but that are independent enough from the fine arts system to create their own kind of unorthodox position and a kind of cultural and institutional protest."[55] Like Dubuffet, Thévoz adopted a definition by analogy with Art Brut, while adding some specifications that served to enhance the standing of the artists: "They are not counterfeiters, but rather smugglers who continuously cross the border between the country of savagery and that of society, and who succeed in bringing to us images from Hell or the beyond . . . these artists are just as important as those in Art Brut, but with a slightly different mindset."[56] He was not worried about juxtaposing the two collections. Thévoz responded to Dubuffet's reservations about confusing the two collections with audacity: it is necessary to "use the conflict between Art Brut and cultural art. The Collection Neuve Invention, which represents fringes of both of them, can have a beneficial disruptive effect."[57] In this spirit, the Collection Neuve Invention has been considerably enlarged, notably with works by François Burland, Ignacio Carles-Tolrà, Claudia Sattler, Gérard Lattier, Philippe Dereux, Rosemarie Koczÿ, and Kosta Alex.[58] Donations were flooding in, purchases were increasing and acquisitions were plentiful—despite the fact that the criteria were not clearly defined and that some of the works did not quite fit in.[59] The curators resolved, as an experiment, to mount solo

Marie-Rose Lortet, *Window*, 1977. Knitting, 15 × 16 1/2 ins (38 × 42 cm).
Collection de l'Art Brut (Collection Neuve Invention), Lausanne.

exhibitions devoted to the major figures of the collection and to bring out a publication devoted to a hundred or so artists. The intensification of interest in this category is connected to the difficulty of finding Art Brut and the likelihood that there will be fewer discoveries in future.

At the end of the 1980s, the expansion of the Collection Neuve Invention was suddenly interrupted. Neither the public nor the press harbored any reservations with regard to these shows, but the members of the advisory council expressed their misgivings, fearing a dangerous confusion between Art Brut and Neuve Invention, as well as the possibility of deviation from the organization's original vocation. But the primary motive for the change in philosophy behind the policies for acquisitions, exhibitions, and publications was institutional. The prominence given to the parallel artists had unexpected effects: a number of artists felt a kinship with the creators of Neuve Invention and claimed to be in the same unorthodox position with regard to artistic creation and to be equally at odds with the promotional network instituted by cultural circles. Painters, drawers, and sculptors flooded into the museum, hoping to "get involved with this breach in the institutional dam."[60] Conscious that they had come to an impasse, Michel Thévoz and Geneviève Roulin felt obliged to break with this movement, which they were neither able nor willing to confront, and they put an end to all promotional publicity on the part of the museum for the creators of Neuve Invention. This collection has not been abandoned, but has resumed its original, secondary status.[61]

Carol Bailly, *What Happens After the Marriage Bureau*, 1986. India ink, crayon, and gouache, 26 1/2 × 35 1/2 ins (67 × 90 cm). Collection de l'Art Brut (Neuve Invention), Lausanne.

NEW SERIES OF JOURNALS

The publication of monographs has always been an essential part of the Art Brut adventure. Between 1977 and 1995, ten volumes devoted to new discoveries were added to the nine published earlier by the Compagnie de l'Art Brut.[62] Some of them were devoted to a single creator of Art Brut (Metz, Podestà, Hodinos, and Schwartzlin-Berberat), but most of them cover around a dozen artists in each volume, alternating between major figures (Walla, Hauser, Wittlich, Krüsi, Van Genk) and minor ones (Robert, Zéphir, le Bedeau).

Michel Thévoz was both author and commissioning editor; he surrounded himself with a small editorial staff made up of doctors, relations, and friends of creators. None of them was an expert on art, but all of them had forged close relationships with artists and were willing to supply first-hand information about them. They were able to maintain the same tone that characterized the first monographs and to paint a lively, energetic portrait.[63] The reader discovers, in turn, Camille Renault, "small in stature, with mischievous eyes and something of the tireless elf"; Gaston Teuscher, "extremely animated, thin . . . lively, especially at night"; André Robillard, described as "a small, dry, active man with short, thick hair, and eyes that are simultaneously mobile, direct, burning, and filled with tenderness."[64] Dr. Roger Gentis describes Robillard's living and creative space as a veritable pigsty of light bulbs and electric tubes, jam jars, cogs, pieces of wood, screws, and scotch tape, an "enormous proliferation in three dimensions of barely defined objects" which makes it necessary to "thread one's way as

217

Reinhold Metz, *Don Quixote page 167*, 1983–84. India ink, watercolor, and enamel paint, 21 × 15 1/2 ins (53.5 × 39.5 cm). Collection de l'Art Brut, Lausanne.

Giovanni Battista Podestà, *Selfishness and Dishonesty*, undated. Mixed media, 16 × 12 1/2 ins (41 × 32 cm). Jean Tinguely Collection, Milly-la-Forêt.

best one can along trails produced by this exuberance." For his part, Michel Thévoz tells how Teuscher "draws anywhere and at any time . . . in the restaurant, on a stained piece of paper tablecloth or an oyster shell, or on the train . . . or even while standing in the street," whereas Wey "works like a possessed man about ten hours a day and completes a painting in about two weeks."[65] This type of personal information reveals the importance of each creator's personality, as well as their unique power and character.

In accordance with Dubuffet's wishes, each fascicle is intended to be as comprehensive as possible: each contributor was obliged to conduct as detailed a documentary inquiry as possible and had to avoid all "esthetic and poetic considerations" when discussing the works. As far as hospitalized artists were concerned, Michel Thévoz permitted the patient's diagnosis to be mentioned, but stipulated that "any explanation and connection of a medical nature between the psychological affliction and the style of the drawings" be left in abeyance.[66]

Over the years, the Art Brut publications took a new direction. Although information about the artist's life and personality remained a key element, an attempt was made to reveal the meaning of the works through analysis and with the help of high-quality illustrations. To begin with, the curator got involved in this new type of study, writing a number of texts and delegating the rest, surrounding himself with specialized assistants: art historians, professors, psychoanalysts, and experts in speech therapy.[67] This new staff modified the original spirit of the *L'Art Brut* series: most of the contributors did not know the creator—who was usually dead—and had to rely on indirect sources, often records, in order to paint a portrait that inevitably lacked the vitality and spontaneity of the early monographs. However, the authors devoted themselves to detailed analyses and deciphered the works for which they had become the exegetes. The use of historical and sociological context, together with the esthetic, philosophical, psychological, and psychoanalytical interpretations,

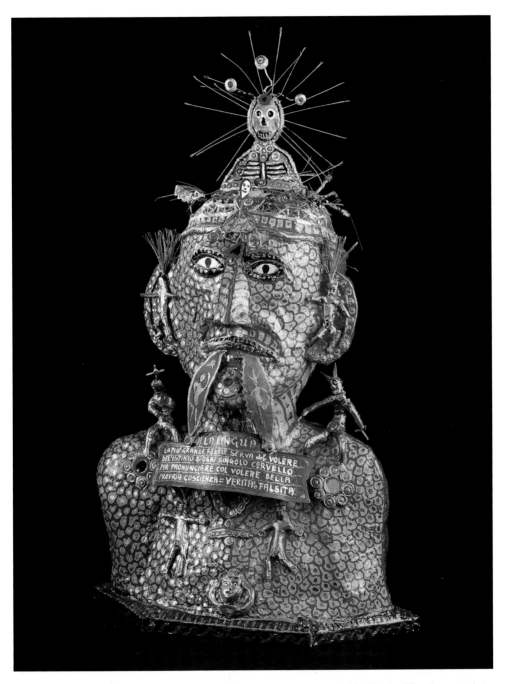

Giovanni Battista Podestà, *Large Scaled Bust with Two Tongues*, undated. Mixed media, height 27 1/2 ins (70 cm). Jean Tinguely Collection, Milly-la-Forêt.

Émile Josome Hodinos, *Melopomene*, between 1876 and 1896. Ink, 13 1/4 × 8 1/4 ins (33.5 × 20.8 cm). Collection de l'Art Brut, Lausanne.

led to penetrating essays, bringing about complex, occasionally esoteric interpretations. The psychoanalyst Lise Maurer, for example, was interested in the works of Émile Josome Hodinos and regarded his numismatic fantasies as a quest for origins that she calls the "construction of the ancestor." Michel Thévoz emphasized that "this text is not at all in the same simple, prosaic, documentary, informative style of the *L'Art Brut* series. In the second part, especially, you begin with rather elliptical Lacanian references that seem to imply that all of your readers have been exposed to Lacan's ideas somewhere along the way. It would be desirable pedagogically if you met your readers halfway."[68] Similarly, the multidisciplinary perspective adopted by Florence Choquard Ramella—combining linguistics, the

Émile Josome Hodinos, construction of the ancestor, between 1876 and 1896, 8 1/4 × 26 ins (21.2 × 66 cm). Collection de l'Art Brut, Lausanne.

Constance Schwartzlin-Berberat, a page from her diary, between 1891 and 1906. Ink, 14 3/4 × 9 3/4 ins (37.5 × 25 cm). Universitäre Psychiatrische Dienste, Bern.

Jeanne Tripier, *Monstrous Figures of Barbarian Kings*, between 1935 and 1939. Ink, 6 1/2 × 8 3/4 ins (16.6 × 22 cm). Collection de l'Art Brut, Lausanne.

psychopathology of language, and psychoanalysis—proved rather complex. In the monograph that she devoted to Constance Schwartzlin-Berberat, she tackles the texts of this calligrapher by proposing numerous relationships between her mental illness, schizophrenia, and the nature of her literary and graphic work, adopting an approach that was a long way from that of the early volumes in the series.

Michel Thévoz and Geneviève Roulin have thus continued the series of works begun by Dubuffet thirty years earlier, albeit in modified form. The collection of monographs has grown; the 19 volumes consist of 135 texts and number close to 3,000 pages. These publications have received little coverage in the press; generally, journalists are content to note the appearance of a monograph that accompa-

nies an exhibition. On the other hand, the dozen works written by Michel Thévoz and published outside of the museum have received more attention.[69] The curator has devoted two books in particular to the literary works of Art Brut's creators, *Le Language de la rupture* (The Language of Rupture) and *Écrits bruts* (Brut Writing): Aloïse and her sensuous poems, Jules Doudin and his pornographic tales, Jeanne Tripier and her mediumistic messages are all interpreted as "intruders in their own language, like thieves, who work by systematic abductions betraying the meaning of words and upsetting the proprieties of syntax."[70] In *Nouvelles littéraires*, Pierre Enkell expresses some reservations about these publications: "Isn't there a significant lack of rigor in recognizing art and poetry in places where the sadness of incommunicability reigns unchallenged?"

In contrast, Henri-Charles Tauxe considers that "it is undoubtedly a rather exceptional discovery that Michel Thévoz has led us to . . . with these two important books in which he analyzes and presents a realm of human expression that is still unknown, or is quite simply dismissed by passionately 'reasonable' people." Pierre Enkell concludes that the attempt by the curator, "firm and measured, opens wide the horizons to whoever loves poetry"; it "sheds a fundamental light on madness."[71]

"A SYMBOLIC FOUNDATION"

Jean Dubuffet on many occasions claimed exclusive rights to the title of his collection and his organization. Above and beyond the name, he insisted on protecting the original idea of Art Brut. Inventor of the term, he considered Art Brut as intellectual property. He made his donation so that the enterprise's orientation would be maintained. Aside from an occasional bending of the rules, Michel Thévoz and Geneviève Roulin have respected these precepts, defending the integrity and exclusiveness of the concept. The museum in Lausanne has become the home of the historical collection, as well as the place for the authentication of Art Brut, the only center for its preservation and selection. The two curators alone carry out the appraisal and approval of new works. This power to make decisions magnifies the importance of their judgments and verdicts. The organization is seen by Michel Thévoz as the "worldwide center of Art Brut"[72] and the name has acquired the attributes of a "label" and an artistic guarantee.

Certainly, the enterprise has the hallmarks of a hegemony. Twenty years after it opened, the museum still demonstrates to what degree the original intent of Art Brut has been preserved from confusion and assimilation: the coherence of the collection and the idea of Art Brut have been guaranteed. The inheritors of Dubuffet's ideas, those in charge of the museum, apply his criteria in the strictest sense, rigorously following the theorist's esthetic principles. Far from constituting the only institution devoted to marginal forms of artistic expression, the Collection de l'Art Brut presents itself as the historical entity and as "a symbolic foundation: it claims responsibility for the value and the power of Art Brut, insuring its protection from contamination and false interpretation."[73]

Henry Darger, *Burning the Crazy Images Tossed in all Directions by the Explosion* (detail), undated.
Tracing, watercolor, and collage, 31 1/2 × 126 1/2 ins (80 × 321 cm).
Collection de l'Art Brut, Lausanne.

AFFINITIES AND INFLUENCES

Virtually unknown in the middle of the twentieth century, Art Brut experienced considerable growth over the next twenty years. At the beginning of the 1960s and through the 1970s, interest in this obscure, unique form of creation continued to intensify. The spirit of social and intellectual rebellion that was reigning in Europe created favorable circumstances for the introduction of new ideas about marginal artistic creation. Dubuffet's theories established a rationale for the latent aspirations of many dissidents. A number of key events would bring about a change in how people approached the visual arts and creative acts of rebellion.

The inauguration of the Musée de l'Art Brut in 1976 laid the groundwork for a new way of viewing art, which had been set in motion by the Art Brut exhibition in 1967 at the Musée des Arts Décoratifs in Paris. Then at the end of the decade, Paris and London hosted two shows of works by Le Facteur Cheval, Armand Schulthess, Aloïse, and Henry Darger. In 1978, due to the efforts of Michel Ragon and Alain Bourbonnais, "Les Singuliers de l'Art" assembled in one show at the Musée d'Art Moderne de la Ville de Paris paintings, drawings, sculptures, and installations, as well as slides of garden layouts and unusual environment sculptures. The works included in the exhibition—primarily from the Atelier Jacob—were described as "mixed productions, meaning each work has combined in uniquely varying amounts elements of traditional, naïve, and brut art."[1] The considerable success of this exhibition suggests that the public had responded to Suzanne Pagé's appeal in the introduction to the exhibition's catalogue: "To inform as much of the public as possible about works which in our opinion are of the highest possible importance and which are almost always subjected to an 'innocent' vandalism tacitly accepted in the name of taste, order, and hygiene. This modest sampling of works by a number of artists is intended to serve as a testimony to overindulgence, excess, barbarity, in short life, that is to say life's very excess and fundamental wildness."[2]

Henry Darger, At Jennie Richee's. Lost in the Wilderness in the Dark (detail), undated. Tracing and watercolor, 23 1/2 × 108 3/4 ins (60 × 276 cm). Collection de l'Art Brut, Lausanne.

In 1979, the Hayward Gallery in London hosted an important show entitled "Outsiders," consisting of four hundred works borrowed from museums and collections in Europe and America. The show featured such notable artists as Aloïse, Karl Brendel, Gaston Duf, Simon Rodia, Clarence Schmidt, Henry Darger, Francis Marshall, and Joseph Yoakum. "For the first time, the people of London were confronted by an uncompromising form of visual brut art. This exhibition has created quite a stir and sparked a number of debates. What's more, it has served to unite artists and students."[3] The exhibition then made two stops, at the Louisiana Museum of Modern Art in Humlebaek, near Copenhagen, and at the Liljevalchs Museum, Stockholm, attracting considerable attention at both venues.

Henry Darger, untitled, undated. Tracing, watercolor, and collage, 24 × 107 ins (61 × 272 cm). Collection de l'Art Brut, Lausanne.

Camille Renault's garden destroyed by vandals. Photograph by Robert Doisneau. Lucienne Peiry's Archives, Lausanne.

The spread of Art Brut had begun. These four shows in various European capitals have become important events in the history of Art Brut, or Outsider Art. At the end of the 1970s, the publication of two seminal works, *Outsider Art* by Roger Cardinal and *L'Art Brut* by Michel Thévoz, marked a real turning point. A breach had now been opened in the intellectual and contemporary art world.

LA FABULOSERIE, L'ARACINE AND COMPANY

The Collection de l'Art Brut flourished in this effervescent atmosphere. Many centers for marginal art were opened in France, Great Britain, Austria, Belgium, Switzerland, the United States, and Australia. Organizations opened their doors to the self-taught and unconventional art: La Fabuloserie, L'Aracine, Outsider Archive, Gugging, Art en Marge, Art Cru Museum, La Site de la Création Franche, and the Lagerhaus Museum were all founded between

1982 and 1990. The "collections of the second generation of Art Brut" were born.[4] For most of these new crucibles of unusual art, Dubuffet's notion of Art Brut served as a reference point. The exclusive nature of Dubuffet's *appellation d'origine* led to the coining of various, synonymous terms related to Art Brut: "Art Extraordinary," "outsider art," "Singular Art," "art cru," "création franche," and others.[5] Like Dubuffet, the founders of these organizations were artists: Alain Bourbonnais at La Fabuloserie, Victor Musgrave at the Outsider Archive, Madeleine Lommel, Michel Nedjar, and Claire Teller at L'Aracine, Guy Lafargue at the Art Cru Museum, and Gérard Sendrey at the Site de la Création Franche. These people, who felt confined and uncomfortable within conventional artistic and cultural systems, were keen to set up a parallel network of centers, generally outside of the large cities, for example in the Burgundy countryside (La Fabuloserie) or on the outskirts of Paris (L'Aracine). These places have none of the solemnity of museums and are much more reminiscent of the old Foyer de l'Art Brut in the basement of René Drouin's gallery and in Gallimard's pavilion. They are reminiscent of Ali Baba's cave or a study filled with curiosities. The profusion of works on display, a practice which runs counter to contemporary museological practice, contributes to a convivial atmosphere. Many of these organizations publish reviews or reports, and some of them also function as centers for documentation and study. Moreover,

the Fabuloserie, the Outsider Archive, and the Site de la Création Franche, among others, put up for sale—generally for nominal sums—a portion of the exhibited works. In contrast to the Compagnie de l'Art Brut, which was veiled in secrecy, these places are dedicated to publicizing and disseminating these works. On the other hand, following Dubuffet's example, nearly all of them claim to be in a state of rebellion. For instance, Alain Bourbonnais defined

Josué Virgili, untitled, undated. Cement and earthenware on wheel, 18 3/4 × 1 1/2 ins (50 × 3.5 cm). Collection de L'Aracine, on loan to the Musée d'Art Moderne, Villeneuve-d'Ascq.

Adolf Wölfli, untitled, undated. Colored pencil, 25 1/2 × 30 3/4 ins (65 × 78 cm). Collection de L'Aracine, on loan to the Musée d'Art Moderne, Villeneuve-d'Ascq.

Josef Wittlich, untitled, before 1982. Gouache, 35 1/2 × 24 1/2 ins (90 × 62 cm).
Collection de L'Aracine, on loan to the Musée d'Art Moderne, Villeneuve-d'Ascq.

Michel Nedjar, untitled, 1987. Paint, 23 1/2 × 15 3/4 ins (60 × 40 cm).
Outsider Archive, Dublin.

Guillaume Pujolle, untitled, undated. Gouache, 19 × 24 3/4 ins (48 × 63 cm). Collection de L'Aracine, on loan to the Musée d'Art Moderne, Villeneuve-d'Ascq.

Auguste Forestier, untitled, undated. Wood, fabric, wool, leather rings, medal, and screws, 25 1/2 × 8 3/4 ins (65 × 22 cm). Collection de L'Aracine, on loan to the Musée d'Art Moderne, Villeneuve-d'Ascq.

his Fabuloserie as "a decentralized anti-Beaubourg [the Centre Georges Pompidou], a powerful citadel for the Marginal, for creation freed from cultural conditioning."[6]

Although these foundations largely share the same lineage, each one has defined its own identity, established its own mission, and adopted a set of principles based on its own vision of marginal art. Originally created to compensate for the loss of Jean Dubuffet's collection to Lausanne and to re-establish an Art Brut collection in France, L'Aracine scrupulously adheres to the theorist's

230

thinking and models its collection on the Collection de l'Art Brut. Some familiar artists are found there, such as Forestier, Carlo, Wilson, Crépin, Robillard, Wittlich, and Tschirtner, as well as creators discovered by L'Aracine's staff. Although it has collected an impressive number of works, L'Aracine's intense desire to identify with Dubuffet's original collection is very evident.[7]

However, other organizations have chosen to adopt a more specialized approach. La Fabuloserie has chosen to limit the amount of space allocated to works from asylums and has been receptive to works outside of Art Brut, such as naïve and folk art. Some of its works are fairground paintings, hairdressers' signs from Ivory Coast, chromolithographs from Afghanistan, and Brazilian votive offerings. The Lagerhaus Museum stocks works of the same kind, but by Swiss artists. Gugging handles

works produced solely by its patients, while Art en Marge welcomes among others works by the mentally disabled.[8]

The Collection de l'Art Brut in Lausanne approves of the spread of parallel institutions and is in contact with most of them. Rejecting any notion of having a monopoly on this sort of art, the curators have shared their information, supported various kinds of exchanges, and supplied the addresses of dozens of creators in the Art Brut and Neuve Invention collections.[9] Although several organizations have expanded their holdings due to assistance from their friends in Lausanne, the staff at each one of these organizations have conducted their own prospecting too. New discoveries are made through this collegial network or by means of some unconventional but surprisingly effective methods of enquiry: "We would go to bistros or restaurants in

Reinaldo Eckenberger, *Lady with Dog*, undated. Upholstery and trim, 78 3/4 × 31 1/2 × 11 3/4 ins (200 × 80 × 30 cm). Collection de La Fabuloserie, Dicy.

Carlo, untitled, 1968. Gouache and lead pencil, 27 1/2 × 19 3/4 ins (70 × 50 cm). Collection de L'Aracine, on loan to the Musée d'Art Moderne, Villeneuve-d'Ascq.

Simone Le Carré-Galimard, *Mask*, undated. Mixed media, 15 × 11 ins (38 × 28 cm). Private collection.

Jano Pesset, *Aristide Milking his Cow*, undated. Wood. Collection de la Fabuloserie, Dicy.

the countryside, and we had devised a sentence that they couldn't avoid answering: 'We heard that there's a man or woman around here, we can't remember which, who makes things that haven't been seen anywhere else.' And it would work: we would get some information and directions. Of course, it wasn't always what we were looking for, but that's how we would go poking around. Often we arrived without warning at the home of some artist, who had been holed up alone in his dreamlike universe, and all of sudden Alain [Bourbonnais] would open the door and start talking."[10] Jean Dubuffet, who knew only too well the rarity of such works and, above all, the difficulties of searching for it, was delighted by the energy as well as the perspicacity of his new allies: "I can't understand how you were able to uncover all of the various, quite excellent practitioners who are in Atelier Jacob's orbit. I heartily congratulate you on your splendid energy and your extraordinary success"; and "It pleases me to see that your efforts are paying off and that 'L'Aracine' is really taking shape . . . You have made some valuable discoveries."[11]

The atmosphere of excitement at these various centers was rekindled with each find, with each acquisition. Objects of differing kinds and origins were obtained, illustrating various aspects of singular creation. Displaying them side by side could yield fruitful dialogues, but it could sometimes work to the detriment of the particularly innovative works by veiling their dissident nature. Moreover, some works designated as marginal were obviously incomplete, because their creators had simply been content to revel in their creative freedom or their use of salvaged materials. In this melange of works, several curators were responsible for creating confusion. They focused more on the "unbridled, spontaneous, creative act" by these "simple folks . . . who get straight to the point in complete innocence,"[12] neglecting the strangeness and gravity of some works, as well as the questions of an existential and insurrectional nature that works of Art Brut raise. The idea of Art Brut and Outsider Art were tarnished at times. Still, numerous ties have developed between these organizations, and exchanges between the foundations in various countries have helped the collections grow.[13] Indeed, the number of visitors to these places has continued to grow, with many people coming from abroad.

Watts Towers in Los Angeles, by Simon Rodia. Photograph by Robert Doisneau. Lucienne Peiry's Archives, Lausanne.

Yanko Domsic, *Mont Saint Michail*, c. 1970. Ballpoint pen, 12 1/2 × 9 ins (31.5 × 22.5 cm). Collection de l'Art Brut, Lausanne.

A PROFUSION OF BOOKS AND REVIEWS

Numerous publications have been started up on the topic of Art Brut and marginal creation. Architectural and environmental works have proven to be the most popular subjects. After the appearance in 1962 of pioneering works by Gilles Ehrmann and Seymour Rosen, studies have been done on *habitants-paysagistes* (resident-landscapers), "builders of the imagination," and "roadside geniuses," such as Abbé Fouéré of Rothéneuf and Ferdinand (Le Facteur) Cheval in France, and Simon Rodia and Clarence Schmidt in the United States. In addition to anthologies and encyclopedias, there have been monographs on Gaston Chaissac, August Walla, Hans Krüsi, Aloïse, and Heinrich Anton Müller among others.

Furthermore, various intellectuals in Europe and America have been conducting epistemological, historical, and artistic research, publishing essays on the relationships between art, madness, and marginality. "In our 'postmodern' epoch, with its limitless aesthetic possibilities, we might ask about the very origins of such an unrestricted artistic field, and seek its sources at least partially in those works hitherto excluded from the official histories of art—works which constitute art's dark interior, its disturbing netherworld. Excluded, secluded, occluded, such works of Art Brut nevertheless extended the limits of creativity and aesthetic discourses, regardless of whatever anxiety this development may have caused."[14] Roger Cardinal, Allen S. Weiss, Michel Thévoz, Laurent Danchin, Fabienne Hulak, and John M. MacGregor (author of the famous work *The Discovery of the Art of the Insane*) have all become specialists on Art Brut, Outsider Art, and marginal creation.

Along with these fundamental works, a large number of reviews and periodicals have sprung up. Created in 1982, *Artension* was intended as a "tribute to those who, like Chaissac, far from all the hubbub and talk, make useful, functional objects due to the power of their poetry, humor, and humanity . . . *Artension* aspires to be [a] place for the exchange of

Clarence Schmidt, *Woodstock Environment* or *House of Mirrors*, 1948–71 (destroyed by fire). Woodstock, New York.

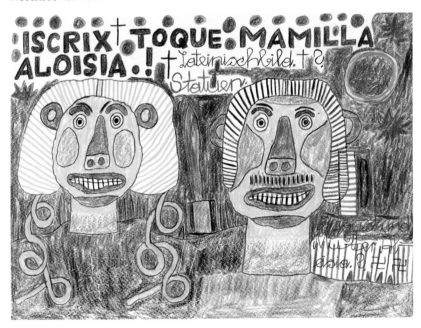

August Walla, *Iscrix*, undated. Ballpoint pen and pencil, 8 x 11 1/4 ins (20.5 x 28.5 cm). Collection de l'Art Brut, Lausanne.

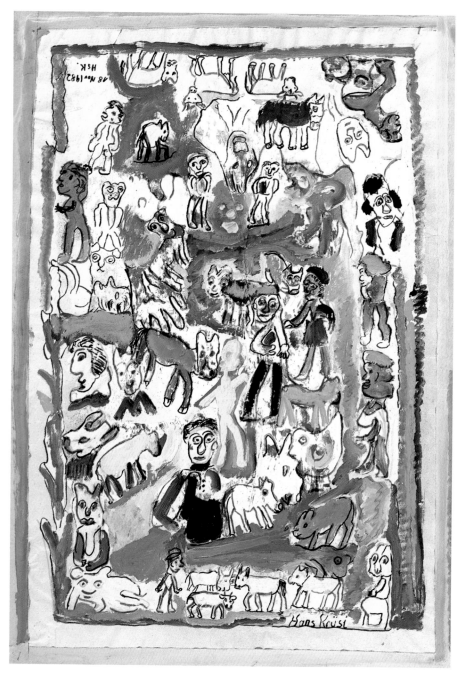

Hans Krüsi, untitled, 1982. Paint, 39 1/2 × 27 1/2 ins (100 × 70 cm).
Collection de l'Art Brut, Lausanne.

[creation] both interdisciplinary and disorderly." A few years later, at the end of the 1980s, the first international review devoted to intuitive and visionary art, *Raw Vision*, appeared, while in 1991 *L'Oeuf sauvage* (The Wild Egg) was launched, claiming to be a "wild vision of the world whose only limitation would be its liberty" and promising to go beyond "contemporary art's all too narrow limits."[15] Art Brut was also the subject of documentary and artistic films and videos, and radio and television programmes were devoted to it. These often focused on a group of artists or an individual and his or her work, for example Ferdinand (Le Facteur) Cheval, Picassiette, André Robillard, Johann Hauser, Raphaël Lonné, and Sylvain Fusco. Practically unknown just after World War II, forty years later Art Brut was the subject of foundations and museums, books and journals, news reports and archives. Open to the public and brought to the world's attention, the Collection de l'Art Brut quickly became one of the most important places for many contemporary artists to visit.

ART BRUT AND CONTEMPORARY ART

"No pivotal topic in the twentieth-century has received less serious attention than primitivism— the interest of modern artists in tribal art and culture, as revealed in their thought and work."[16] William Rubin advances this claim and initiates a discussion of it in his book, *"Primitivism" in 20th Century Art: Affinity of the Tribal and the Modern*, which appeared in 1984. Indeed, for more than half a century, this topic had been the subject of very few studies. If the contribution of the primitive arts to modern art had been little analyzed, the contribution of Art Brut and Outsider Art to contemporary art had been similarly neglected. These influences have prompted little in the way of research and been the subject of only a few esoteric works. They have been pushed to one side and eclipsed, and yet they play an essential role in the history of twentieth-century art.

Numerous European and American painters, sculptors, graphic artists, and architects, as well as musicians, actors, and writers, have felt a profound connection with marginal creation, frequently drawing on it to fuel their own experiments. The works of people like Ferdinand Cheval, August Walla, and Adolf Wölfli have had the same sort of impact that tribal arts exerted on modern art. They influenced contemporary art esthetically and formally, as well as philosophically and spiritually. Some references are explicit, appearing as obvious stylistic borrowings; others, not as easily spotted, relate more to the creative act itself.

During the 1960s, large numbers of works became known to artists, thanks to exhibitions mounted in Europe and the United States, and to the permanent collections in places such as the Musée de l'Art Brut in Lausanne or the Fondation Adolf Wölfli in Bern. Collections in psychiatric hospitals were opened to the public: Waldau's in Bern, Prinzhorn's in Heidelberg, and the one at Gugging in Klosterneuburg. Sculptors took an interest in unusual environments, such as Ferdinand (Le Facteur) Cheval's *Palais idéal* in Hauterives, Simon Rodia's Watts Towers in downtown Los Angeles, and Clarence Schmidt's constructions in Woodstock, New York. Books and journals provoked discussion. A number of others even decided to begin their own collection of Art Brut or Outsider Art, notably Arnulf Rainer, Georg Baselitz, Ray Yoshida, Roger Brown, and the couple Jim Nutt and Gladys Nilsson.

THE MOVING MACHINE

When Jean Tinguely discovered the moving sculptures of Heinrich Anton Müller, he was overcome with admiration. Cobbled together out of branches and rags, these machines with large gears were operated with a small crank. They turned in space, as if powered by a sort of perpetual motion, and many were set up in the courtyard of a psychiatric hospital far from cultural circles and renown. "They [the machines] impressed him as much as Müller's story . . . It was no longer a question of art as merchandise or art as a material object, but art as a pure form of expression, an art that was free of social rank. The external appearance of Müller's machines had an equally powerful effect on him," wrote Pontus Hulten.[17] Tinguely was fascinated by the way Müller had assembled unusual materials and the non-functional character of these mechanisms. This moving disorder delighted him. In the search for a "revolutionary, anarchist, and rebellious" manner of expression, he doubtlessly envisioned this creation as a new, still untried path.[18] In 1954, Daniel Spoerri, who was a friend of Tinguely's, visited the

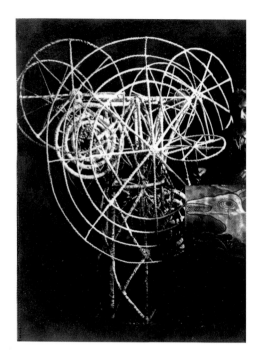

Heinrich Anton Müller in front of one of his machines. Collection de l'Art Brut, Lausanne.

Jean Tinguely, *Prayer Wheel III*, 1954. Wood, metal rods, and wire, 19 3/4 x 15 3/4 x 11 3/4 ins (50 x 40 x 30 cm). Private collection.

collections of the Waldau hospital, where a number of photographs of Müller's sculptures were preserved, and Tinguely could conceivably also have discovered them that same year.

In 1954, Tinguely completed his first wire constructions operated by crank or motor and their form bears a striking resemblance to Müller's moving machines; the horizontal and vertical arrangements of the gears are handled in much the same way as Müller's.[19] "The moment that Tinguely created his first wire wheel, a mechanism whose object is not precision but anti-precision, a mechanics of chance, he discovered a nearly inexhaustible, untapped resource."[20] Müller's machines seem to have set in motion Tinguely's own kinetic adventure, which would last for nearly forty years. The gigantic, ephemeral sculpture which the latter completed much later in 1962 for the "Dylaby" exhibition at the Stedelijk Museum in Amsterdam was entitled *Hommage à Anton Müller* (Homage to Anton Müller).

He manufactured the work out of various salvaged materials such as cables, springs, rings, wires, and pieces of fur, referring to it as "mobile scrap-and-rubbish sculpture." It was clearly a gesture of allegiance with the Art Brut artist.[21]

FANTASTIC STRUCTURES

In 1962, Jean Tinguely met a young artist in Paris, Niki de Saint-Phalle, who stimulated his interest in marginal creation. The latter had recently been to Barcelona and Hauterives, which had both made a big impression on her. "I will talk to you about Gaudí and Le Facteur Cheval, whom I just discovered and who have become my heroes: they represent the beauty of mankind, alone in his madness, no intermediaries, no museums, no galleries . . . I offended you by saying that Le Facteur Cheval was a greater sculptor than you are. 'I have never heard of this idiot,' you said. 'Let's go and see his work right now.' You insisted. So we did and the discovery of

this marginal creation was immensely satisfying for you. 'You're right. He is a greater sculptor than I am.' You were seduced by the poetry and the fanaticism of this mere postman who had achieved his immense, mad dream."[22]

A few years later, Niki de Saint-Phalle and Jean Tinguely continued their architectural tour in Los Angeles, where they admired the Watts Towers, created by Simon Rodia between 1919 and 1954. Built out of steel rods and covered with various materials—shards of ceramic, glass, and seashells—it was a highly unusual body of work, an environment that ignored all rules of artistic construction, the offspring of an unbridled spirit abounding in imagination.

Inspired by these delirious structures, the Swiss sculptor embarked in 1969 on the construction of *Tête* (Head), or *Cyclope* (Cyclops), a labyrinth on

Le Facteur Cheval's *Ideal Palace*.
Photograph by Robert Doisneau.
Lucienne Peiry's Archives, Lausanne.

Jean Tinguely, *Head* or *Cyclops*, created in 1969 at Milly-la-Forêt.

Niki de Saint-Phalle, *The Garden of the Tarots*, created in 1979 at Garavicchio, Italy.

several levels equipped with a complex network of passages, lights, and moving objects and primarily constructed with salvaged materials. Tinguely chose to erect this monumental structure outside of Paris, at Milly-la-Forêt, without asking for permission to build it. It was an attempt to create a utopian, anarchistic vision comparable to those of Cheval or Rodia.[23]

Equally captivated by these extraordinary structures, Niki de Saint-Phalle acknowledged the fundamental role these works have played in her own art: "For me, these works were profoundly inspiring, but at the same time they were not considered serious by my fellow artists, who thought of them as 'Folk Art' . . . I identified with them, I too felt like an outsider among my fellow artists. I have never been to art school, and I am self-taught . . . I feel these people are my teachers and my masters and I feel much

closer to them than to my contemporaries."[24] The discovery of the works of Cheval and Rodia also sparked her desire to complete large, unusual constructions. In 1979, she started planning her major work *Il Giardino dei Tarocchi* (The Garden of the Tarots), which would eventually comprise twenty-two monumental sculptures. Like that of Tinguely, Niki de Saint-Phalle's architectural complex was constructed in an isolated region, at Garavicchio in the Tuscany countryside. It was completed "without any pre-ordained plan, without technicians, specialists or architects."[25] Her *The Garden of the Tarots* was an attempt to reproduce her own sort of *Ideal Palace*. In 1996, in collaboration with Jean Tinguely and Per Olof, she installed the vast sculpture/environment *Hon* (She) in the lobby of Stockholm's Moderna Museet, then created several fantastic environments in France, Belgium, and Israel.

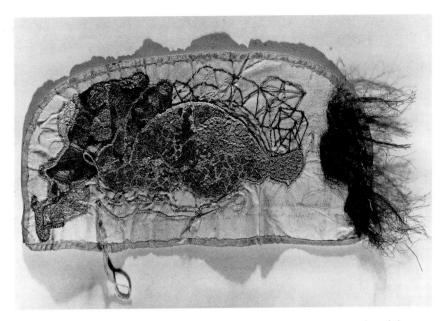

Jeanne Tripier, *Embroidery with Black Tufts of Hair*, between 1935 and 1939. Colored cotton, horse hair, and inscriptions in pencil on white cloth bordered with sky blue silk, 6 3/4 × 13 1/4 ins (17 × 33.5 cm). Collection de l'Art Brut, Lausanne.

Annette Messager, *My Works* (detail), 1988. Calligraphy in colored pencil on the wall with black and white photographs under glass, 13 × 36 1/4 ins (400 × 100 cm).

240

Jean Tinguely and Niki de Saint-Phalle did not copy the structures of Simon Rodia or Le Facteur Cheval, but they were very receptive to these earlier works and consciously adopted the same approach based on freedom and rebellion. Both Tinguely and Saint-Phalle drew from these earlier works the ferment necessary for their own work and allowed their presence to resurface in varying forms in the heart of their own works. Throughout his life, Tinguely paid frequent visits to the Collection de l'Art Brut. This museum "was for him a constant source of inspiration. He was so bored with normal life that he needed an almost physical relationship with these works. He seemingly needed to return to Lausanne to see them. 'What's new in madness?' What sorts of madness still exist?' he would exclaim. He would come back from there with new ideas . . . He drew strength from this museum, it stimulated him."[26]

August Walla, *Aqua, Toque, Flufius, Vita!*, undated. Enamel paint on sheet metal, 21 × 23 1/2 ins (53 × 59.5 cm). Gugging House of Artists, Klosterneuburg.

CALLIGRAPHY

Annette Messager, for her part, discovered Art Brut at the 1967 exhibition in the Musée des Art Décoratifs, Paris, simultaneously acquiring a set of fascicles published by the Compagnie. These works served as important references, providing an indispensable repertory of images for the work she would embark on in 1970.

Annette Messager picked up a wide variety of materials and everyday objects that she would include in assemblages, using various techniques such as collage, sewing, drawing, and writing. These strategies are reminiscent on more than one count of those used by Art Brut artists. The artist seemed particularly interested in the embroidery work of Jeanne Tripier and Juliette-Élisa Bataille, whose works were shown at the exhibition in the Musée des Arts Décoratifs and were reproduced in monographs. Like them, Annette Messager took up this domestic, traditionally female activity while moving off in a new direction and subverting its age-old rules. The edgy works of compulsive needlework by the two Art Brut artists would be sources of inspiration for one of Messager's works, *Mes Ouvrages* (My Works, 1988), which is made up of cursive inscriptions. It is based on the repetition of words in a manner similar to embroidery techniques, where stitches are continuously repeated. Annette Messager uses letters as if they

Julian Schnabel, *Flaying of the Unjust Judge*, 1987. Oil paint, 10 ft 6 ins × 10 ft 6 ins (320 × 320 cm). Private collection, San Francisco.

Armand Schulthess. *Second Bend*, Auressio (Ticino), Switzerland, 1963. Photograph by Hans-Ulrich Schlumpf.

Annette Messager, *The Garden of Tenderness*, 1988. Writing on metal plaques in a garden. Centre d'Art Contemporain, Castres.

were a long thread that she was unraveling on the support. The words are strung together and delineate lines, forming a composition made up of texts that interlace or form arabesques, similar to the patterns in some of Jeanne Tripier's textiles. "I have borrowed a great deal from religious and folk art, from Art Brut, from images of hysteria as well as from Arab, Indian, and Tantric traditions. These works are usually tied to human suffering, poverty, misery, and distress. I felt very guilty about these individuals and artists. I swiped their beautiful designs; egotistically, I took them for myself, I stole them, I transformed these worlds into 'my thing,' into 'my world!' . . . Conceptual art has interested me in the same way as Art Brut, astrology, or religious art," she declared. "I'm not interested in the ideologies conveyed by them: first and foremost they are repertories of forms."[27]

Le Jardin du Tendre (The Garden of Tenderness) also shows signs of Art Brut's influence. Annette Messager drew up an imaginary map, giving her own names to various roads, hills, and paths. The routes are marked off with small signs bearing handwritten messages attached to tree trunks. The allusion to Armand Schulthess's work is obvious; during the 1950s, he completed a similar work in an immense chestnut grove in Ticino consisting of various itineraries matched to hundreds of plaques covered in writing fastened to walls and trees. They displayed a wide range of knowledge and beliefs. Annette Messager appropriated the spiritual principles as well as the formal aspects of this fantastic environment and described her own composition as a genuine "tribute" to Schulthess.[28] However, interest in marginal creation is sometimes combined with an insidious type of borrowing.

The works of Julian Schnabel, another artist who has expressed an interest in Art Brut, bear the marks of the Austrian artist August Walla's influence.[29] The series *Reconocimentos* (Recognitions), which he completed in 1987 at a Carmelite monastery in Seville, copies Walla's calligraphic style of the early 1980s. It is obvious that Schnabel imitated Walla's uppercase letters which, painted in large characters, are impressive in their absolute frontality. In both the Austrian's and the American's creations, words not only constitute the basic denotation of the signifier but are also endowed with a sculptural quality, emphasizing the physicality of

the letters. Some of the supports and the background stained with colors are also reminiscent of murals by marginal creators. Both artists place their signs on walls and the façades of buildings, or raise them up so they appear to hang in mid air. Fascinated with foreign languages, Walla's works abound in Indonesian, Bulgarian, Congolese, and Latin terms. His polyglot compositions seem to have influenced Schnabel, who has cultivated his own multilingual interplay by putting on his canvases words in English, French, Spanish, and Latin. The former uses exotic, imaginary languages while the latter restricts himself to those of established Western culture. Schnabel has borrowed from Walla's delirious universe and normalized it. The American artist's *Idiota*, moreover, seems like a reworking that hardly differs from *Idiotenanstalt* by the Austrian artist; Walla's protest was here popularized by a professional artist.

In Jonathon Borofsky's work, on the other hand, Art Brut prompted a desire for emulation. The American artist was especially impressed with Adolf Wölfli's art, which he had first encountered in books and later during a stay in Switzerland; he was fascinated by his carefully detailed compositions and the way drawings, calligraphy, and musical scores are mingled together. They had links, he said, to the equally obsessive works that he himself had embarked on some years before. The variety of media that Wölfli employs within a single work— figuration, writing, and music—inspired Borofsky to embellish his use of numerical notation with

August Walla, *Idiotenanstalt!*, undated. Fragment of an inscription on the street by the Gugging House of Artists, Klosterneuburg.

Julian Schnabel, *Idiota*, 1987. Oil paint. El Carmen Monastery, Seville.

243

Carlo, *Composition with Four Birds*, 1963. Gouache, 19 3/4 × 13 3/4 ins (50 × 35 cm). Collection de l'Art Brut, Lausanne.

Carlo, *Red Animal*, 1967. Gouache and inscriptions in pencil, 27 3/4 × 19 3/4 ins (70.5 × 50 cm). Collection de l'Art Brut, Lausanne.

scribbles in his conceptual work *Counting from 1 to Infinity*, which was begun in 1969.[30]

FORMS AND MOTIFS

The iconographic repertory of many marginal creators has proved to be equally important. The human face has been at the forefront of the myriad motifs used by contemporary artists. The human form and the face in particular offer many possibilities and their symbolic treatment lies at the heart of many artists' work. Georg Baselitz has conceded that works by many outsiders have had a major impact on his own work since the 1960s. He admires the "complexity" of certain pieces and emphasizes to what extent they have contributed to "an unexpected enhancement of [his] understanding of painting and sculpture."[31] He was fascinated by the geometric and optical distortion of bodies and faces. The silhouettes that haunt paintings by

Carl Fredrik Hill, Ernst Josephson, and Paul Goesch, which he discovered soon after his arrival in West Berlin, had a profound effect on him. The way each artist handled the human body was directly related to Baselitz's own interests and signs of their influence can be detected in his own treatment of the human form—the elongation of the body, limbs, and neck and the disproportionate hands and feet—notably in his series *Neuer Typ*, begun in 1965. According to Mark Gisbourne, the inverted images that have appeared in his work since 1969 and have now become his trademark might also be interpreted as Baselitz's debt to outsider artists. Inversion of the image is indeed commonly found in works by artists such as Aloïse, Wölfli, and Carlo, who worked along the edges of a painting in a circular manner, rotating the picture as they went, even working on it upside down, thereby creating a variety of points of view.[32]

Alfonso Ossorio in his studio.
Ossorio Foundation, Southampton.

There is little doubt that the American painter Alfonso Ossorio fell under the spell of the Collection de l'Art Brut, which he exhibited in his East Hampton estate from 1951 until 1962. The works that Dubuffet entrusted to him, as well as his own collection of Mexican votive offerings, baroque crucifixes, shells, fossils, and rocks, were points of reference that stimulated his creativity. The change in direction that his work took in the 1950s is probably connected to his familiarity with these works. Ossorio would spread a base over the surface of his support—sand or gravel for example—then arrange on it shells, pieces of broken glass and mirror, metal, bones, and bits of wood. The way Art Brut artists freely employed salvaged materials and various odds and ends must have served as a model for these works, which he called "congregations."

Finally, the connections between the paintings of A. R. Penck and those of Louis Soutter seem obvious.

The black, elongated, spindly silhouettes emerging from shadows that Penck began painting in the late 1960s are reminiscent of those by the Swiss artist. However, Penck's figures conform to a specific principle and are very different in form from the creatures that the visionary Swiss artist painted with his fingers.[33] Penck incidentally denies that Soutter has influenced his art in any way.[34]

MADNESS AS INSPIRATION

Whether or not Soutter's works might have been a source of pictorial and stylistic inspiration for A. R. Penck, the former's method of composition—painting with his fingers—was taken up by Arnulf Rainer. During a visit to the Musée Cantonal des Beaux-Arts in Lausanne, the Austrian painter studied a massive body of works by Soutter in the museum's reserves: "An inexplicably profound sense of kinship immediately drew Rainer to these

Louis Soutter, *The Supreme Symbol*, between 1937 and 1942. Black ink finger painting, 22 3/4 x 17 1/2 ins (58 x 44.1 cm). Musée Cantonal des Beaux-Arts, Lausanne.

A. R. Penck. *A Possible System*, 1965. Oil on canvas, 35 1/2 x 78 3/4 ins (90 x 200 cm). Michael Werner Gallery, Cologne and New York.

works. He discovered certain themes he had in common with Soutter—notably the motif of the cross—but he was also struck by the method of painting and drawing with his fingers, which ran counter to everything in pictorial culture."[35]

A few years later, Arnulf Rainer adopted Soutter's unique method of painting, using his fingers to complete several series of paintings, the first produced between 1973 and 1975 and the second between 1980 and 1984. The artist's hands were freed of any intermediary tools and he was forced to make direct contact with the picture surface. The method demanded rapid execution and left no opportunity for second thoughts. Rainer developed this intrinsically physical, gestural technique to the point of expressing internal explosions of rage. Finger painting was a liberating act for him: it freed him to "find a psychological zone that gave him the strength to take on anything and to release his fury in works that are both aggressive and destructive." Rainer appropriated Soutter's work, which he considered a "descent into the primitive history of mankind and the individual."[36]

The works from asylums that Rainer began collecting in the 1960s have contributed to his quest. He acquired paintings, drawings, and writings from patients, as well as documents, photographs, and books, all of them linked to his fascination with mental illness. "I didn't confront these materials the way a typical art collector would. For me it represented

Louis Soutter, *Flexibility*, 1939. Black ink embellished with gouache, finger painting, 17 1/2 × 22 3/4 ins (44 × 58 cm). Musée Cantonal des Beaux-Arts, Lausanne.

Arnulf Rainer, *Blauer Tatscher auf…*, 1981–82. Oil on cardboard mounted on wood, 28 3/4 × 40 1/4 ins (73 × 102 cm). Private collection.

Arnulf Rainer, *Angry Venus*, 1994. Chalk wash and pencil on an engraving by Johann Hauser, 15 3/4 x 11 3/4 ins (39.9 x 30 cm). Gugging House of Artists, Klosterneuburg.

years later he took possession of works by Soutter, Schröder-Sonnenstein, Artaud, Hauser, Walla, and others. He worked directly on the drawings or paintings of others, often covering them to the point of obliterating the work. Thus in the work of Arnulf Rainer, marginal art does not serve as a creative inspiration, but rather as a basis for iconoclastic acts.[39]

Other artists have shown the same fascination with works of creative madness. A number of them have recognized the profound impact these works have had on their own work. Leon Golub looked on works from asylums as "atavistic, primitive, archaic, close to the origins of the human psyche."[40] He discovered them in Hans Prinzhorn's book, *Bildnerei der Geisteskranken* (Artistry of the Mentally Ill), which was published in 1922. In his series *In-self*, which he completed in the early 1950s, Golub tried to achieve a "schizophrenic sense." Claes Oldenburg also admitted his attraction to works by the mentally ill, which he associated with "compulsive, instinctual areas of creation." He claimed that his environment *The Street*, created in 1960, was infused with this type of creative freedom.[42]

The attitude of all of these artists is reminiscent of that displayed by André Breton and Paul Eluard in their *Immaculate Conception* (1930), in which they attempted to summon up and reproduce creative madness (see page 33). Many years later, continued to fascinate artists. But the quest to reenact the intensity of works created in madness remains a utopian artistic endeavor.

POEMS AND MUSIC

Although Art Brut played an important role in the visual arts, it has also proved influential in other areas of expression, particularly music. One of the most innovative artists of his generation, the Dane Per Nørgard, discovered Wölfli's works in 1979 and to this day continues to be influenced by them. The piece he composed in 1980, *Wie ein Kind* (Like a Child), is a good example of the Swiss artist's influence. Wölfli's nonsensical texts are used in the first and second parts of this drama, framing a poem by Rainer Maria Rilke.[43] In the concluding funeral march, the male soloist begins singing the cacophonous words of the Art Brut artist and interprets in song his doomed attempt to join the others. Nørgard was fascinated by the spirit of independence

more of a spiritual and mental encounter than an artistic one. What I have collected has become a subject for study."[37] Rainer utilizes this information as a tool for his art. He considers it as a means for gaining access to—or inducing through stimulation—a state of dementia in his artistic undertakings. His works by Aloïse, Wölfli, Soutter, and other, anonymous artists do not interest him so much for their iconographic and stylistic aspects as for their transgressive possibilities. They pave the way for a "confrontation with a type of primitive art."[38]

Among the various methods he adopted, those employed in the *Übermalungen* (Overpaintings) series were the ones he used most often. During the 1950s, Rainer had used the works of past masters or artists like Franz Xaver Messerschmidt, but twenty

displayed in Wölfli's dissident works: "He was completely free to express himself, entirely uninhibited by rules. That results in a nearly wild mode of expression," which enabled him to translate a "human emotion into a nearly superhuman work of art." Drawn to musical experimentation, the Scandinavian composer has defined himself as a "professional observer" who immerses himself in various types of music, in this case lyrical, delirious poems, which he restores to an original formulation.[44]

Regina Irman has also drawn on the poetic repertory of Wölfli. Enraptured by the "extraordinary rhythmic and sonorous power of his language" and by "the artistic quality and explosive modernity" of his work, the young Swiss composer is particularly drawn to this "direct," "non-academic," "undisguised" approach. A native of the Bern region, she is particularly drawn to these works because they are "full of dialect," mixing the Germanic Bern dialect with words analoguous to those created by the Dadaists and words invented by Wölfli himself. The mysterious juxtaposition of colloquialisms and unquestionably modern literary forms "provoked" and "excited" her. Regina Irman chose to enter into this strange universe by putting it to music.[45]

"Wölfli often provides musical information in his works. Beneath his poems, you can read: polka, mazurka, and waltz. As for his funeral marches, he regarded them as music. He has even said that those who know anything about music should be able to 'play' these funeral marches . . . For a long time, nobody took art by the mentally ill seriously. To my way of thinking, Wölfli was first and foremost an artist and that is what I have tried to emphasize."[46] In her composition *Ein Vatter=ländischer Lieder-bogen* (A Collection of Songs for the Father=Land) for female voice and piano (1985–86), Regina Irman relies on one instrument, letting the musicality of Wölfli's texts carry the work. A similar process recurs in a subsequent piece created for a trio of percussionists and one soloist, *Ein Trauermarsch* (Funeral March, 1987). She attempts to reveal the essence of his poems and prose through strange sonorities obtained from saucepans, basins of water, gourds, and a mortar and pestle. Regina Irman regards Wölfli as an artist who was ahead of his time and who inspired the "musicalization of language in the twentieth century."[47]

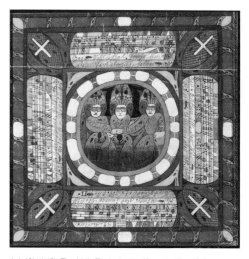

Adolf Wölfli, *The Holy Trinity in the Gigantic City of Chant-Saint-Adolf*, 1922. Colored pencils, 20 × 20 ins (51 × 51 cm). Collection de l'Art Brut, Lausanne.

First page of the musical score of a composition by Regina Irman, illustrated by Adolf Wölfli, 1985–86. Regina Irman's Archives, Winterthur, Switzerland.

249

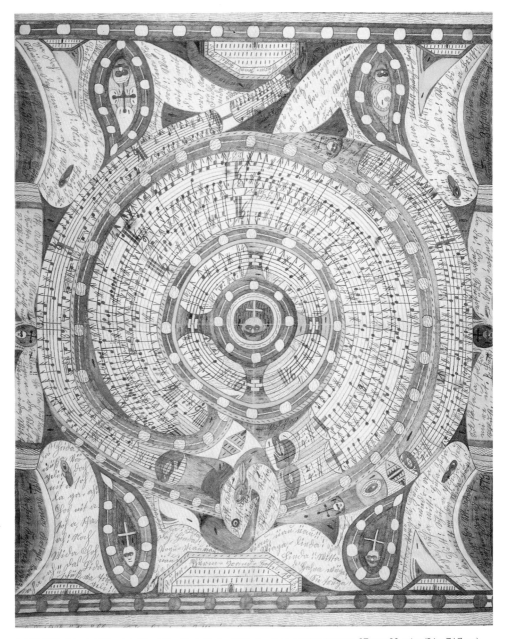

Adolf Wölfli, *Saint-Adolf-Fountain-Island-Ring-Giants-Snake*, 1913. Pencil on notebook paper, 37 3/4 × 29 1/2 ins (96 × 74.7 cm). Fondation Adolf Wölfli, Bern.

Other composers have been inspired by Wölfli's work. The German Wolfgang Rihm wrote *Wölfli-Liederbuch* (Wölfli Songbook) for baritone, piano, and two bass drums. The German composer employs "a minimal number of thematic chords and units which are obsessively reprised in each *Lied*." Austrian Gösta Neuwirth wrote a "tragifarce," *Eine wahre Geschichte* (A True Story), with a libretto in which Wölfli's works are linked to a news story by the Swiss journalist and writer Niklaus Meienberg. The work features a chamber orchestra and a rock group.[48]

Art Brut has also left its mark on rock music, notably that of David Bowie, a performer who is continually looking for new ideas. In 1994, he went to Gugging with Brian Eno, an experience that proved inspirational to him. This is how he described his visit: "Gugging was an incredible experience . . . We went to talk with the patients there and look at what they were doing . . . I just like the sense of exploration and their lack of self-judgement . . . And it became one of the atmospheres for the album [*Outside*]. I enjoyed it very much."[49] Bowie's twentieth album, *Outside*, released in 1995, which he worked on with Brian Eno, was obviously influenced by this encounter. Almost all of the nineteen tracks were recorded live and improvised.

A MODEL OF FREEDOM

Among other artists, marginal creation plays a more subtle, less obvious role. Assimilation can be a complex process and is often not immediately apparent. In such instances, the influence of Art Brut is of a more philosophical nature. It stands as a true lesson in artistic freedom, providing what could be described as an existential alternative.

Art Brut has on occasion provided impetus at the beginning of an artist's career. Walter Navratil—the son of Dr. Leo Navratil—grew up around Gugging's artists and said that he was shaped by their "authenticity": "I felt as if I were educated and formed by their company and their works. That helped me find my own voice."[50] For other artists, the revelation of marginal creation occurs during their search for new ways of expressing themselves, providing confirmation of a particular direction they have taken. Roger Brown, for example, explained how Outsider Art, and in particular the works of Joseph Yoakum, made

him aware of the idea of cultural independence. Some painters have been very receptive to the self-trained aspect of Art Brut artists. This was the case with Jim Nutt and Gladys Nilsson, who admire the work of Martín Ramírez.

The kinship between Art Brut and his own work had always pleased Dubuffet; their use of crude materials and ignorance of traditional rules were among the things that had reinforced his convictions. Daniel Spoerri also felt a deep affinity between his own works and those considered as marginal. The innovativeness of the latter mirrored his own experiments: "At this time, no one wanted to reveal his true feelings, but something objective instead. What disgusted us was sentimentality. Perhaps art from primitive societies interested us because in it, the feelings that are so powerfully expressed are not personal feelings; it is the expression of an entire

Johann Hauser, *Young Girl in Yellow Dress*, 1966. Colored pencil and chalk, 17 1/4 x 11 3/4 ins (44 x 30 cm). Collection de l'Art Brut, Lausanne.

Johan Fischer, *Ritual Dancing Already Existed 5,000 Years Ago*, 1990. Colored pencil, 24 1/2 × 34 1/2 ins (62 × 88 cm). Collection de l'Art Brut, Lausanne.

Guillaume Pujolle, *The Electric Chair*, 1939. Watercolor and ink on cardboard, 18 × 23 1/2 ins (46 × 60 cm). Collection de l'Art Brut, Lausanne.

Giovanni Battista Podestà, *The Dragon-Monster*, undated. Various materials, 31 1/2 × 26 ins (80 × 66 cm). Collection de l'Art Brut, Lausanne.

culture. In children's drawings, it is the same thing. They are not 'sentimental' drawings. They don't know how to draw in any other way and what comes out is all the more striking. The works go far beyond personal sentimentality."[51]

Art Brut came as a shock and a revelation for many contemporary artists, serving as a "poetic detonation," to borrow an expression from Jean Genet. They were astonished by the intensity and radicalism of works by artists such as Müller, Wölfli, and Ramírez, recognizing in them the fundamental values of creation. Their fascination demonstrates to what extent they felt imprisoned by a bankrupt system of expression and esthetics, and

enslaved by culture's artistic norms. They felt the need to shake off society's yoke and find sustenance in a truly dissident otherness. Art Brut was seen as an alternative, regenerative universe, as a way that might allow them to recapture mysterious, magical, and spiritual powers.

Such a quest is without a doubt utopian. Neither Dubuffet, Tinguely, or Baselitz were able to attain the level of freedom that Wölfli, Müller, and Hill had reached. "Art Brut's artists are always the winners, they are always the strongest," Annette Messager underscored.[52] The artists were aware of it, but even though the attempt may have been in vain because of the impossibility of summoning up madness on demand, their reference and recourse to this type of art highlighted a blockage that many contemporary artists were feeling at the time. Art Brut appeared to be a route to the full realization of inventive, autonomous, and rebellious expression. Christian Boltanski noticed in these works the universal nature of creation: "The greatness of outsider art lies in its ability simultaneously to be timeless and individual and in its ability to elicit strong emotional reactions from the viewer."[53]

CONFRONTATION WITH "CULTURAL" ART

In 1937, the Nazi exhibition "Entartete Kunst" (Degenerate Art) brought together works by modern painters such as Paul Klee, Oskar Kokoschka, and Wassily Kandinsky and creations by patients in psychiatric hospitals, such as Karl Brendel, Paul Goesch, and Georg Birnbacher. This comparison with confiscated works was intended to demonstrate the degeneracy of avant-garde artists and their works, "the disintegrating forms of 'perfect madness.'"[54] This side by side exhibition was paradoxically the first show in history which deliberately mingled creations from asylums with "professional" works.

During the 1970s, several exhibitions combining the works of Art Brut artists with those of contemporary artists were organized in Europe, according to diametrically opposed considerations and motivations. Harald Szeemann gave new impetus to this trend by including drawings by Adolf Wölfli in the Documenta at Kassel in 1972. He repeated the experiment a few years later in "Les Machines célibataires" (Celibate Machines), which contained photographs of sculptures by Heinrich Anton Müller

alongside works by Marcel Duchamp and Jean Tinguely, then with "La Suisse visionnaire" (The Visionary Swiss), which grouped together Aloïse, Soutter, Klee, and Giacometti among others. Szeemann was convinced that Art Brut should lose its marginal status and be considered equal to contemporary art. His exhibitions and criticism were aimed at "giving value to individual expression and dispensing with the voyeurism inherent in the presentation of a 'case.'" "De-limitation" was his priority, because "Wölfli is prolific in the same way as Picasso, Aloïse is close to Matisse, Müller goes through various phases of development like Duchamp, Schulthess attempts to create order through an overabundance of knowledge."[55]

Furthermore, Szeemann objected to the idea of Art Brut, as well as the existence of its museum. Above all, he called into question the artistic autism of the artists, offering as an example Wölfli, who was aware of the keen interest his drawings elicited, was proud of the monograph that Morgenthaler had written on him, was surrounded by assistants, and was conscious of being an artist, a status to which he laid claim. His work, Szeemann added, is far from being devoid of cultural influences. Finally, he regarded the museum in Lausanne as a ghetto and thought that the display of Art Brut works was a "laborious attempt" to invite the public to associate with artistic oddities.[56]

Others have demonstrated their desire to abolish the barriers separating Art Brut from "cultural" art. In 1980, Pontus Hulten mounted the major exhibition "Paris-Paris, 1937–1957," in which he placed the emergence of Art Brut and its exhibition by the Compagnie alongside various other cultural landmarks, such as Surrealism, geometric abstraction, the Nouveau Roman and Structuralism. For his part, Maurice Tuchman conceived of "Parallel Visions" in 1991 as a way of shedding light on the influence exerted by Outsider Art on the development of twentieth-century art. Art Brut found itself incorporated within official art even though that was not the aim of these exhibitions.

For their part, the two directors of the Gugging House of Artists in Klosterneuburg have tried to integrate their patient-creators into the contemporary art world. In 1970, Dr. Leo Navratil began showing their works in various cultural institutions, such as the Museum Moderner Kunst in Vienna, the

Johann Hauser, *Queen Elizabeth*, c. 1969. Colored pencil, 15 3/4 × 11 3/4 ins (40 × 30 cm).
Collection de l'Art Brut, Lausanne.

Kunsthalle in Helsinki, and the Kunsthalle in Cologne. The doctor's goal was for "his patients' art to be recognized in the same way as that of professional artists" and to give Walla and Hauser "a new social identity."[57] Following the example of his predecessor, Dr. Johann Feilacher feels that this integration does justice to outsider artists: "They number among the greatest artists in the world who have created new images and have extended the horizons of our culture, similar in stature to Dürer, Michelangelo, Renoir, Picasso, Miró, Tàpies, to name just a few. Art Brut artists like Wölfli, Soutter, Aloïse, Nedjar, Hauser, Tschirtner, Walla, and others have taken their rightful place as members of this group."[58] The interest shown by galleries and collectors and the numerous sales are, in his view, additional evidence of the value of this work.

All of these developments demonstrate that Art Brut has tended to become absorbed in the predominant artistic movement, a phenomenon that was far from being approved by Jean Dubuffet: "I deplore your idea to show extra-cultural works in the exhibition at the Centre Georges Pompidou entitled 'Paris-Paris' . . . Works of this sort, produced outside cultural circles, do not have any place in an organization devoted to promoting the culture from which they are estranged. Attaching them to a show that is entirely concerned in all other respects with commercial works done by professionals alters their very status and meaning."[59] Their introduction into a cultural setting would have led to its being identified with cultural art, resulting in its corruption. Michel Thévoz took a similar stance with regard to this dissident form of artistic expression: "One is entitled, required even, to draw a distinction between a cultural work, which derives its power from a complex social dialectic, and a work of Art Brut, which derives its intensity from its social disconnection and nearly autistic idiosyncrasies, especially if its origins are found in psychoses. These are two separate paths, which both end at two entirely distinct destinations." According to Thévoz, this distinction must be maintained because it concerns a "specific form of creation, which it would quite simply be wrong to associate with that of professional artists who are socially and psychologically integrated into society."[60] Like Szeemann, Hulten, Navratil, and Feilacher, Michel Thévoz feels that Art Brut artists are the equal of contemporary artists.

Louis Soutter, *Tortures of the Nudes, Time of the Tire*, 1938. Black ink, 25 1/2 × 19 3/4 ins (64.9 × 50 cm). Kunsthaus, Zurich.

But he considers the cultural domain as truly a "world of prostitution."[61] Museums and other institutions have been so "corrupted by a variety of concessions to fashion and the art market" that they are not "worthy of playing host" to these works.[62] The introduction of Art Brut into the cultural sphere has not only led to confusion, but also constitutes an act of corruption. "The fact that Dr. Navratil and Dr. Feilacher have taken advantage of the interest that art museums and major galleries of contemporary art have begun to show in Hauser, Walla, or Schöpke is tantamount to boasting of the Mafia's approval."[63]

Michel Thévoz demands a different status and reception for, and way of looking at, these resolutely marginal works: they "deserve to be looked at differently from those works that conform to the tastes of the day in the most prestigious contemporary art museums. If you want to be thoroughly disgusted with the most prestigious museums of contemporary art, you only need to take a good look at a work by Hauser, Walla, Tschirtner, or Schöpke."[64]

Henry Darger, *At Calmanrina*, undated. Tracing and watercolor, 24 × 37 3/4 ins (61 × 96 cm) Collection de l'Art Brut, Lausanne.

Henry Darger, *The Trial is Going to Begin in 3 Minutes*, undated. Tracing and watercolor, 32 × 113 3/4 ins (81 × 289 cm). Collection de l'Art Brut, Lausanne.

Michel Thévoz militates in favor of subversion and resists integration.

It is worth emphasizing that most art historians, sociologists, and philosophers have been unwilling to take a reasoned adversarial position toward Art Brut and its museum. Except for Harald Szeemann, who has argued his own position, other detractors have been content to dismiss Art Brut and its

museum in Lausanne with a few cutting words and little else.[65]

ART AUCTIONS

The opening of the museum in Lausanne and other allied collections, the introduction of marginal works in major exhibitions, the publication of books and journals set in motion the institutionalization of

Willem Van Genk, *Tube Station*, undated. Mixed media and collage, 29 1/2 × 48 3/4 ins (75 × 124 cm).
Collection de l'Art Brut, Lausanne.

Art Brut, which also precipitated its entry into the international art markets. Galleries and salesrooms have responded to recent demands from collectors: Christies and Sotheby's, Phyllis Kind in New York and Chicago, and Susanne Zander in Cologne have all shown interest in obscure artists.[66] Since 1993, the "Outsider Art Fair"—the first show of this type—has taken place annually in Soho, New York City, bringing together dozens of galleries and welcoming thousands of visitors.[67] At Basel's major art show, "Art 27'96," Adolf Wölfli, Joseph Crépin, and Louis Soutter have rubbed shoulders with Picasso, Klee, Dubuffet, and Francis Bacon.

Commercial speculation is mostly concerned with the "established" creators of Art Brut. In Europe, Wölfli, Aloïse, Chaissac, Soutter, Wilson, Gill, Hauser, Walla, and Tschirtner are considered as major figures, while in the United States Ramírez, Darger, and Traylor are looked on as the most important representatives of Outsider Art on the market. Prices have skyrocketed. In 1985, a drawing by Wölfli was valued at two thousand Swiss francs and two years later this had doubled; another that was valued at twelve thousand five hundred Swiss francs in 1989 had risen to twenty-five thousand Swiss francs by 1995.[68] Drawings by Gugging's artists have attracted just as much interest.[69] In North America, the works of American artists have brought still higher prices.[70]

If the value of Art Brut has experienced dizzying growth over the last decade, it is still far from rivaling the increase in value of works by modern and contemporary artists. At an auction in Kornfeld in 1996, one of Wölfli's drawings was valued at fifty thousand Swiss francs, while a watercolor by Egon Schiele was offered for two hundred seventy-five thousand Swiss francs; at Christies in New York in 1996, a pastel by Edgar Degas was auctioned for between six and eight million dollars, an oil by Juan Gris between two and three and a half million dollars; at Sotheby's in London in 1989, one of Jean Tinguely's sculptures was sold for seventy-six thousand pounds.[71]

257

Willem Van Genk, *50 years of the Soviet Union,* detail, 1967. Ink, gouache, and collage, 37 3/4 × 68 1/2 ins (96 × 174 cm). Collection de l'Art Brut, Lausanne.

Laure Pigeon, *Pierre*, 1961. Blue ink, 25 1/2 x 19 3/4 ins (65 x 50 cm). Collection de l'Art Brut, Lausanne.

"After decades of indifference and scorn, Aloïse, Lesage, Van Genk, Wittlich, Madge Gill, and many others have made their way onto artistic stardom's best-seller lists," stated Michel Thévoz, who puts forward a twofold reasoning in regard to this appropriation.[72] "Logically," he declares "if one is offended by art speculation and by its recent extension to Art Brut, you should be first offended by the market economy in general from which, on principle, nothing escapes, neither bodies, nor souls, nor works of the mind." Although Art Brut was created outside of any commercial system, it has not escaped it. Thévoz has raised the stakes, emphasizing that ambiguity lies not so much in its introduction to the art market, but in the fact that "as soon as one accepts the law of supply and demand, one has to wonder why a work by Aloïse or Wölfli costs so little in comparison to, let's say, a painting

by Chagall or Baselitz."[73] Philosophical, the curator recognizes the danger in the institutionalization and appropriation of Art Brut as "an anthropological inevitability . . . humanity oscillates between order and chaos, between organization and subversion, between routine and innovation. It's best that artists and patrons of art be confronted with this danger, this temptation, this challenge."[74]

According to Michel Thévoz, the integration of Art Brut into the heart of contemporary art may turn out to be beneficial. Like Dubuffet, who hoped that opening Art Brut up to the world would lead to the destruction of the cultural world's values, the curator thinks that "the sudden intrusion of authentic adventurer-artists into art's sacred cloisters will at least have the result of worsening the crisis."[75]

Adolf Wölfli, *Her Great, Great Imperial Highness Princess Olga of the Saint-Adolf Throne in Poland*, 1916. Colored pencil, 17 x 11 1/2 ins (43 x 29 cm). Collection de l'Art Brut, Lausanne.

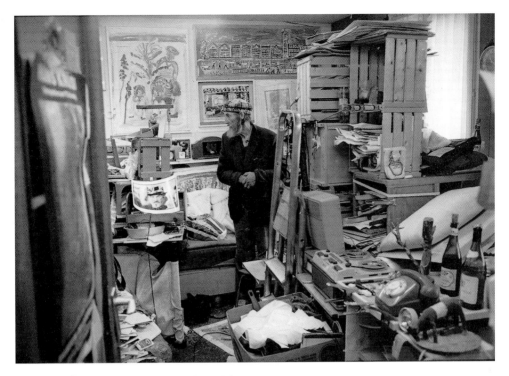

Hans Krüsi in his home, 1991. Photograph by Mario del Curto.

The institutionalization of Art Brut thus possesses a doubly subversive power: it exerts its virulence by playing "the positive role of a litmus test for truth and as a foil" and it also represents "our bad conscience about our cultural conduct."[76] The sensitive questions that Art Brut raises are both artistic and political in nature.

The machinery of publicity and promotion that operates in cultural milieux has harmful effects on some artists. Ted Gordon is a prime example. In a monograph devoted to him, John M. MacGregor recounted his artistic career in a chapter entitled, "The Undermining of a Brut Artist."[77] Gordon had secretly produced small drawings for his own pleasure until one day his work was unveiled and disseminated in artistic circles. Abandoned "in the jungle of museums, dealers, critics and collectors," Gordon was entirely vulnerable: "Lured by an unappeasable longing for recognition, he responded, as well he could, to external advice, which he naturally and naively assumed pointed him in the right direction." His enormous desire to be recognized made him vulnerable to influence. In the face of praise, he allowed himself to be manipulated. In response to requests from collectors, he executed works on particular subjects; to satisfy gallery owners, he changed his materials and supports, his formats, his colors, and his titles. He signed a contract. Gordon dreamed of glory. From that point on the power of his work began to decline, because it had been altered. For a short time he produced drawings with the sole purpose of exhibiting them, participating "in the creation of a faux l'Art Brut, a parallel art of Ted Gordon . . . thus does America destroy its outsiders."

Hans Krüsi's story was similar. Anonymity and serenity were followed by fame and continual demands from art dealers who speculated in his works. In the film devoted to his life and work,

Hans Krüsi, Cows, 1983. Gouache and stencil, 27 1/2 × 39 1/2 ins (70 × 100 cm). Collection de l'Art Brut, Lausanne.

Pierre Biner tells how some dealers and collectors snapped up some of his paintings, made him sign dubious contracts, and took advantage of an old man's gullibility. His house was robbed. He was dispossessed of his works, his art was pillaged. Krüsi's later works provide clear evidence of decline, not just because of weakness and illness, but also because of the pressures exerted on him by those around him.[78] Similarly, the last drawings of Scottie Wilson, which were done after signing contracts with some gallery owners, lacked much of the intensity of his earlier works.

Ignorant of business practices, Art Brut artists who give in and submit to this system are perilously vulnerable. They often participate in their own demise. On this subject, Michel Thévoz—like Dubuffet—oscillates constantly between subversive integration and healthy preservation, denouncing the flippancy with which one "talks in glowing terms about success with artists who have a much more fragile constitution than that of authorized artists . . . It's like sending them to the front, it's like forcing them into an impasse and into the most vicious traps of the society of spectacle."[79]

CONCLUSION

Art Brut as it was when Jean Dubuffet originally discovered it is dying out. Half a century has passed since he presented these marginal creators, these "obscure individuals," "patients in hospitals," "prisoners," or "individuals who resist society's conventions in all aspects of life."[1] In the first half of the twentieth century, institutions of exclusion and confinement, such as the psychiatric hospital and the prison, were places where various untutored and autistic forms of artistic expression developed. Adolf Wölfli, Jeanne Tripier, and the Prisonnier de Bâle constructed dream-like worlds that allowed them to make a symbolic escape from confinement. Over the years, these institutions evolved and adopted a new attitude toward creativity. However, as soon as artistic expression is actively proposed, encouraged, and supervised in art workshops, Art Brut is neutralized and takes flight.

The emergence of Art Brut, an anachronistic, rebellious form of art, was helped by a number of social, political, and economic events. The miner Augustin Lesage contacted the dead, becoming a spiritualist painter at the height of the industrial revolution. Giovanni Battista Podestà, who was initially a victim of the rural exodus, then later a witness to and participant in the initial stages of capitalism, revived a medieval spirituality, creating sacred, utopian works. Vahan Poladian experienced exile and resurrected the splendors of a past Armenia. Alongside other forms of rebellion, Art Brut grew out of the conflict and rejection of modern, newly industrialized society.

The isolation and sedentary way of life of the rural populations of western Europe at the beginning of the twentieth century proved to be fertile ground for the sudden emergence of a personal, independent artistic universe. Isolation ensured that such artists were not at all exposed to conditioning by the dominant culture. Many self-taught artists worked freely, in silence and secrecy, cut off from the rest of the world. Émile Ratier designed his unusual, moving assemblages in a barn on his farm, while Henri Salingardes cast his anthropomorphic medallions in his own small garden. Various transformations in society—the spread of modern, instantaneous means of communication, the growth of the mass media, and the expansion of mandatory schooling—favored contact and movement, facilitated the transmission of images and information, and made universal education possible. They put an end to self-sufficient life. Creators of Art Brut can no longer be like those of the past. The artistic, social, and economic contexts are different; priorities have changed. Yet contemporary Western civilization, which is driven by economic performance and competition, is still far from being rid of marginality and deviance. The new social outcasts at the beginning of the third millennium are the elderly, who, stripped of their role and social status, now appear to be "today's pariahs."[2] Gaston Teuscher, Hans Krüsi, and Francis Mayor can be included among the new marginal artists—these are today's "obscure individuals." It remains to be seen whether or not the new outcasts from our fundamentally individualist society will pick up where earlier artists left off; perhaps it will be those who live in defiance of accepted codes of conduct or those who go against the flow and disrupt social harmony: one possible group may be refugees and survivors of war and genocide, or perhaps socially and psychologically exiled individuals. The fact that there are people who remain unmoved or largely unaffected by social and cultural pressures and norms and who resist normalization allows for the possibility that some sort of dissident creation will survive. Art Brut's distinctive characteristic is its secret, clandestine, and unpredictable nature. Its sphere of activity being entirely free of any limitations, works of Art Brut are probably being created without our knowledge in places we would never have imagined. Art Brut undoubtedly still has some surprises in store.

One suspects, however, that though Art Brut may already have transformed itself or is in the process of some new metamorphosis, it is nevertheless moving down the path toward extinction. Discoveries of new works have dwindled; obviously Art Brut is becoming rarer. Its institutionalization has robbed it of its strangeness.

Scorned and rejected half a century ago, marginal creation has gradually made its way onto the social and cultural scene through the efforts of its advocates in museums, publishing, and business. Art from the humblest of origins has acquired an aristocratic title. This recognition marked the debut of a double life for Art Brut. Lifted out of the obscurity and anonymity to which they had been consigned, these creations began to be considered as full-fledged works of art. At the same time, this official acknowledgement altered and misrepresented them, since it partially distorted their originally rebellious and uncultured virtues. Having on the one hand given us a glimpse of a "hidden side of contemporary art"—one that is both exhilarating and violently subversive—the exposure of Art Brut in museums and books has on the other hand thrust it into the cultural system from which it had been estranged, and which it was by definition opposed to. Moreover, this esthetic and ethical recognition has gone hand in hand with social exploitation and commercial appropriation. The process of making this art popular and democratic has led to a confusion about the nature of Art Brut, the emergence of bogus works, and consequently a perversion of its otherness. Renown cuts both ways.[3] Jean Baudrillard explains this dialectic in these terms: "Over the last few centuries, all forms of violent otherness have, willingly or by force, been set within the discourse of difference, which implies simultaneously inclusion and exclusion. Childhood, madness, death, primitive societies, have all been integrated, assimilated, absorbed within the universal context. Madness, once it has broken free from its status of exclusion, has found itself caught in far more subtle psychological traps. The dead, as soon as their identity as the dead is recognized, find themselves herded into cemeteries and kept at a distance, even to the point of completely obscuring the face of death. The Indians' right to existence was only recognized so that they could be herded into reservations. Such are the reversals of circumstance wrought by a logic of difference."[4]

Art Brut is suffering and possibly dying because of the interest it has aroused. Its integration, which has undoubtedly been both fruitful and legitimate, has led it toward assimilation and neutralization. Michel Thévoz has drawn attention to the disappearance of creative madness, exoticism, archaism, "in short, of anything that is different." In his opinion, "it really seems as if, like Orpheus, Western culture is doomed to destroy whatever is—or rather whatever was—strange, merely by gazing lovingly at it."[5] From now on, one wonders whether the worship of Art Brut divests it of its otherness and if the Other and the Elsewhere have not already been colonized. One wonders if Jean Dubuffet in his cynicism did not unconsciously and prophetically announce its extinction: "Art does not sleep in beds that have been made for it; it flees as soon as someone speaks its name: what it loves is to be incognito. Its finest moments are those when it forgets its own name."[6]

Who knows, perhaps the major works—now classics—that we marvel at are those of a dead and vanished art. Maybe Art Brut should be seen as a theoretical point of reference, which has become nothing more than a historical footnote. For the moment, we can only wait and see, since this kind of art has moved into a crucial, transitional phase, oscillating between exaltation and extinction, between life and death.

The survival of Art Brut—historically, at least—depends on abolishing all fundamentalism and refraining from parochial, Cyclopean attitudes. The Manichean crusade, which condemned all modern and contemporary art the better to indulge in the dogmatic and apologetic worship of Art Brut, has lost all of its relevance today. The tendency toward dichotomy and hierarchy, which judges one type of art as over-intellectualized and sophisticated, and the other as emotionally pure and naturally primitive, has been shown to be not only meaningless but also totally erroneous. Works of Art Brut express powerful emotions and arise from a highly developed vision, as testified by Wölfli's sophisticated universe, Aloïse's complex cosmogony, and Palanc's philosophy. Schulthess's work is encyclopedic in nature, while

Walla's bears the traits of a subtle mythology. All of their works have unquestionably been nourished by deep reflection and are the product of the tenacious pursuit of art. The creation and articulation of forms, images, and symbols in many works attest to an often highly complex and specific system of expression. Although the works of Müller, Metz, and Podestà appeal to the eye, they address primarily the mind. Art Brut's attraction is both emotional and intellectual. In addition, their work cannot be viewed as an open book that reveals their pain, suffering, and desires. As in all genuine works of art, they certainly contain extraordinarily intimate details, but these creators are not content to merely commit their urges to canvas. Adolf Wölfli, Aloïse, Scottie Wilson, and Madge Gill have done more than simply offer us their autobiographies and their memoirs. Even though each of them worked in autistic circumstances brought about by a real withdrawal into the self, their works nevertheless demonstrate a genuine transcendence and a sublimation of the self, resulting in visionary works. Creators of Art Brut are far from being innocent or naïve. The personal commitment of these artists to art—their works number in the thousands and were completed over the course of many years—as well as the rebellion, parody, and humor evident in their creations, has proven this.

Dubuffet had hoped that the revelation of Art Brut would shake the very foundations of contemporary Western culture, but "the crash never materialized."[7] All the same, Art Brut has raised questions—if not debate—about the training of professional artists and the status of artists at the dawn of a new century, about present-day channels of artistic communication, and about art's relation to society. Art Brut has removed the sacred aura surrounding the creative act, while sanctifying artistic creation afresh. When faced with these mysterious works, Dubuffet's words resonate all the more forcefully: "I am pretty much convinced that in every human being there are vast reserves of mental creations and interpretations of the highest value . . . I believe these ideas, no matter how widely held, about rare men who are marked by destiny and privileged enough to have an internal world worth expressing, are entirely wrong."[8]

Art Brut is an ideological phenomenon. It was one of the key phases in the decentering and fragmentation of esthetics, society, and institutions that marked twentieth-century culture. Without doubt, we have not heard the last of it.

NOTES

Amounts cited in Chapter 2 are given in old French francs unless otherwise stated. Amounts cited in Chapter 4 are given in new French francs unless otherwise stated.

Chapter 1
The Other and the Elsewhere

1. Jean Dubuffet seems to have chosen the expression "Art Brut" (raw art) in 1945 during his trip to Switzerland with Jean Paulhan. Paulhan stated that his friend was in search of an "immediate, unpracticed art—an Art Brut" (*Guide d'un petit voyage en Suisse*, [Paris: Gallimard, 1947], 20). To my knowledge, the expression appears for the first time in a letter Dubuffet wrote to the Swiss painter René Auberjonois on August 28, 1945 (*Prospectus et tous écrits suivants*, vol. 2 [Paris: Gallimard, 1967], 240).

2. Letter to Charles Ladame, Paris, August 9, 1945 (Archives of the Collection de l'Art Brut, Lausanne).

3. "Notice sur la compagnie de l'Art Brut," September 1948 (Archives of the Collection de l'Art Brut, Lausanne); text reprinted in *Prospectus et tous écrits suivants*, vol. 1 (Paris: Gallimard, 1967), 489–91.

4. Pierre Bourdieu (*The Rules of Art*, trans. Susan Emanuel [Stanford, CA: Stanford University Press, 1996], 245–46) is one of a number of intellectuals who takes issue with Dubuffet's position.

5. Catherine Charpin, *Les Arts incohérents (1882–1893)* (Paris: Syros Alternatives, 1990), 15 and 18.

6. Rodolphe Töpffer, *Réflexions et menus propos d'un peintre genevois ou Essai sur le Beau dans les arts* (1848) (Paris: Hachette, 1865), 261.

7. Ibid., 259.

8. Meyer Schapiro recognized Töpffer's original point of view and Switzerland's long tradition of progressive education. See his "Courbet and Popular Imagery," *Theory and Philosophy of Art: Style, Artist, and Society*. Selected papers by Meyer Schapiro (New York: George Braziller, 1994).

9. Children's art had for centuries been disparaged as being "chaotic, irrational, and bad." Any idea of children's art was discounted. It was not until the eighteenth century, and Jean-Jacques Rousseau in particular, that childhood was redefined; children became "a kind of distant cousin to the pure, good and natural 'Noble Savage'" (Bruno Duborgel, *Imaginaires à l'oeuvre* [Paris: Greco, 1989], 28).

10. Wassily Kandinsky, *Kandinsky, Complete Writings on Art*, trans. Kenneth C. Lindsay and Peter Vergo (New York: First Da Capo Press, 1994), 251–52. Originally appeared in *Der Blaue Reiter* (Munich and Zurich: R. Piper & Co. Verlag, 1912).

11. See *Mit dem Auge des Kindes. Kinderzeichnung und moderne Kunst*, exh. cat. (Munich: Lenbachhaus; Bern: Kunstmuseum, 1995). See also *Kinderzeichnung und die Kunst des 20. Jahrhunderts*, an anthology edited by Jonathan Fineberg (Ostfildern-Rui bei Stuttgart: Hatje, 1995).

12. See *Paul Klee*, exh. cat. (New York: Museum of Modern Art, 1949–1950).

13. This account of the first Blaue Reiter exhibition in Munich appeared in the Swiss review *Die Alpen*, 1912; the quotation appears in *The Diaries of Paul Klee, 1898 to 1918*, ed. Felix Klee (Berkeley, CA: University of California Press, 1964), 266.

14. See what Fabienne Hulak has to say on this topic in her introduction to *L'Art chez les fous* by Marcel Réja (1907) (Nice: Z'éditions, 1994). At the end of the nineteenth century and the beginning of the twentieth, the idea of human and cultural progress was challenged; ethnology started to emphasize the diversity of cultures and societies in its research.

15. See Otto Karl Werckmeister, "The Issue of Childhood in the Art of Paul Klee," *Arts Magazine* 1 (1977), 138–51.

16. Felix Klee, *Paul Klee*, trans. Richard and Clara Wilson (New York: George Braziller, 1962), 182.

17. *Revue Spirite. Journal d'études psychologiques et de spiritualisme expérimental* (Paris, May-June 1953), 81.

18. See Pierre Thuillier, "Le spiritisme et la science de l'inconscient," *La Recherche* 149, vol. 14 (November 1983), 1359–68. See also Michel Thévoz, "Augustin Lesage et le spiritisme," *Augustin Lesage 1876–1954* (Paris: Philippe Sers, 1988), 33-50.

19. He published *Le Livre des médiums* in 1861.

20. Recounted in *La Revue spirite*, 1858; André Breton cites it in "Le message automatique," *Minotaure* 3–4 (Paris: Skira, 1933), 59.

21. Ibid.

22. See Françoise Will-Levaillant, "L'analyse des dessins d'aliénés et de médiums en France avant le surréalisme. Contribution à l'étude des sources de 'l'automatisme' dans l'esthétique du XXe siècle" (1980), in *La Mesure des irréguliers*, ed. F. Hulak (Nice: Z'éditions, 1990), 129–58.

23. Pierre Janet, *L'Automatisme psychologique. Essai de psychologie expérimentale sur les formes inférieures de l'activité humaine* (1889) (Paris: Masson, 1989).

24. Théodore Flournoy, *Des Indes à la planète Mars. Études sur le cas de somnambulisme avec glossalalie* (1900) (Paris: Le Seuil, 1983).

25. Eugène Osty, "M. Augustin Lesage, peintre sans avoir appris. Aux confins de la psychologie classique et de la psychologie métapsychique," *Revue métapsychique* (January-February, 1928), 13.

26. André Breton, "Entrée des médiums," *Les Pas perdus* (1924) (Paris: Gallimard, 1949), 153.

27. "Le message automatique," *Minotaure* 3–4 (Paris: Skira, 1933), 60.

28. Walter Morgenthaler, *Madness and Art: The Life and Works of Adolf Wölfli*, trans. Aaron H. Essman (Lincoln, NB: University of Nebraska Press, 1992). Originally, *Ein Geisteskranker als Künstler* (Bern-Leipzig: Bircher, 1921). Hans Prinzhorn, *Artistry of the Mentally Ill*, trans. Eric von Brockdorff (2nd ed., New York: Springer-Verlag, 1995). Originally, *Bildnerei der Geisteskranken* (Berlin: Springer Verlag, 1922).

29. Marielène Weber, "Note sur l'émergence de 'l'art des fous,'" in *La Mesure des irréguliers*, ed. F. Hulak (Nice: Z'éditions, 1990): 92; Jean Starobinski, preface to the French version of Hans Prinzhorn's work, *Expressions de la folie*, trans. Alain Brousse and Marielène Weber, ed. Marielène Weber (Paris: Gallimard, 1984), IX.

30. See Michel Thévoz's introduction to *Wölfli dessinateur-compositeur* (Lausanne: L'Âge d'Homme et Collection de l'Art Brut, 1991): 7.

31. See Marielène Weber, "Note sur l'émergence de 'l'art des fous,'" in *La Mesure des irréguliers*, ed. F. Hulak (Nice: Z'éditions, 1990): 91-98.

32. In his work, Prinzhorn does not reveal the names of the creators, but instead uses pseudonyms or numbers when referring to them.

33. Hans Prinzhorn, "À propos de l'art des aliénés" (1929), an article reprinted in *Expressions de la folie*, trans. Alain Brousse and Marielène Weber, ed. Marielène Weber (Paris: Gallimard, 1984), 373–76. The article does not appear in the English version.

34. Hans Prinzhorn. *Artistry of the Mentally Ill* (New York: Springer-Verlag, 1995), 228.

35. See the seminal work by John M. MacGregor, *The Discovery of the Art of the Insane* (Princeton: Princeton University Press, 1989).

36. Françoise Will-Levaillant, "L'analyse des dessins d'aliénés et de médiums en France avant le surréalisme. Contribution à l'étude des sources de 'l'automatisme' dans l'esthétique du XXe siècle" (1980), in *La Mesure des irréguliers*, ed. F. Hulak (Nice: Z'éditions, 1990), 135–56.

37. Joseph Rogues de Fursac, *Les Écrits et les dessins dans les maladies mentales et nerveuses* (Paris: Masson, 1905).

38. Marcel Réja, *L'Art chez les fous* (Paris: Mercure de France, 1907). This book was preceded by the article "L'art malade: dessins de fous," *La Revue universelle* I, vol. 2 (Paris: Larousse, 1901), 913–15 and 940–44. See Michel Thévoz, "Marcel Réja, découvreur de 'l'art des fous,'" *Gazette des Beaux-Arts*, 1408–9 (May-June 1986); reprinted in *Art Brut, psychose et médiumnité* (Paris: La Différence, 1990), 87–109.

39. Dr. Browne from Scotland directed the Crighton Royal Hospital and figures among the pioneers, beginning his collection around 1834. The criminologist Lombroso began his at the Forensic Medicine Institute in Turin, Italy; Dr. Marie was the director of the Villejuif asylum; Dr. Ladame headed the Bel-Air psychiatric asylum; Professor Steck was posted at the insane asylum in Cery, Switzerland; and Dr. Ferdière practiced first at the Sainte-Anne asylum in Paris, and later at the psychiatric hospital in Rodez.

40. Auguste Marie, "Le musée de la folie," *Je sais tout* IX (October 15, 1905), 353–60.

41. Charles Ladame, "Un vernissage à l'asile d'aliénés," unpublished manuscript, Geneva, undated (Archives of the Collection de l'Art Brut, Lausanne).

42. The first exhibition of this type was mounted in 1900 at the Bethlem Royal Hospital in Beckenham, England.

43. See John M. MacGregor, *The Discovery of the Art of the Insane* (Princeton: Princeton University Press, 1989). Part of the exhibition at Basel's Gewerbemuseum in 1929 had appeared in Paris the previous year. The exhibition at the Vavin gallery, which included works from Dr. Marie's collection, took place in 1926 according to Sarah Wilson, but in 1928 according to MacGregor; the one at the Max Bine gallery took place in 1929. The Sainte-Anne hospital also mounted two exhibitions, in 1946 and 1950. See Sarah Wilson, "From the Asylum to the Museum: Marginal Art in Paris and New York, 1938–1968," in *Parallel Visions. Modern Artists and Outsider Art*, exh. cat., Los Angeles County Museum of Art, Los Angeles; Museo Nacional Reina Sofía, Madrid; Kunsthalle, Basel; Setagaya Art Museum, Tokyo (Los Angeles County Museum of Art and Princeton University Press, 1992–93), 124–26.

44. It provoked the interest of Rainer Maria Rilke and Lou Andreas-Salomé, as testified by a letter from their correspondence dated September 22, 1921.

45. Félix Klee, *Paul Klee*, trans. Richard and Clara Wilson (New York: George Braziller, 1962), 182.

46. Alfred Kubin had also visited Prinzhorn's collection before the publication of his book; he described the discovery as a startling experience in his article "Die Kunst der Irren," *Das Kunstblatt* (May 5–6, 1922), 185–88.

47. See John M. MacGregor, *The Discovery of the Art of the Insane* (Princeton: Princeton University Press, 1989), 222–44. See also Reinhold Heller, "Expressionism's Ancients," *Parallel Visions. Modern Artists and Outsider Art*, exh. cat. (Los Angeles County Museum of Art and Princeton University Press, 1992–93), 78–93.

48. Max Ernst, *Écritures. Notes pour une biographie* (Paris: Le Point du Jour, 1979), 20.

49. *Bulletin D*, exh. cat. (Cologne, 1919). The exhibition also displayed objects that came from industry and the applied arts.

50. Hans Prinzhorn, "À propos de l'art des aliénés" (1929), op. cit., 375.

51. In his youth, Breton had a number of experiences within asylums; after his medical studies he was assigned to various psychiatric hospitals. He was an avid reader of Freud's works.

52. Paul Eluard, "Le génie sans miroir," *Les feuilles libres*, 35 (1924), 301–8.

53. See André Breton and Paul Eluard, *L'Immaculée Conception* (Paris: José Corti, 1930). The quotation is taken from "prière d'insérer," undoubtedly written by Salvador Dalí.

54. See Paul Eluard, "Le génie sans miroir," *Les feuilles libres*, 35 (1924), 301–8.

55. André Breton, "L'art des fous, la clé des champs" (1948), *La Clé des champs* (Paris: Sagittaire, 1953), 227.

56. For example, "International Surrealist Exhibition," Burlington Galleries, London, 1936; "Fantastic Art, Dada, Surrealism," Museum of Modern Art, New York, 1936; "Exposition Internationale du surréalisme," Galerie des Beaux-Arts, Paris, 1938.

57. See "Exposition surréaliste d'objets," Galerie Charles Ratton, Paris, 1936; "Surrealist Diversity," Arcade Gallery, London, 1945; "Exposition internationale du surréalisme," Galerie Maeght, Paris, 1947. The third show displayed masks by Pascal-Désir Maisonneuve; the last two included works by Scottie Wilson.

58. Michel Thévoz, *Art Brut, psychose et médiumnité* (Paris: La Différence, 1990), 206.

Chapter 2
The First Art Brut Venture

1. Dubuffet, "Note pour les fins-lettrés" (1945), *Prospectus et tous écrits suivants*, vol. 1 (Paris: Gallimard, 1967), 88.

2. Dubuffet, "Biographie au pas de course" (1985), *Prospectus et tous écrits suivants*, vol. 4 (Paris: Gallimard, 1995), 465–66.

3. "The rejection of all tradition seems therefore all the more deliberate since Dubuffet was perfectly aware of the past which he was challenging," Daniel Abadie points out ("Réflexions aux couleurs de Jean Dubuffet," *Dubuffet* [Paris: Éditions du Jeu de Paume, 1992], 49).

4. Dubuffet, "Avant-projet d'une conférence populaire sur la peinture" (1945), *Prospectus et tous écrits suivants*, vol. 1 (Paris: Gallimard, 1967), 33, 51, and 52.

5. However, in the 1930s, Dubuffet found value in works of this sort: "I intended to do paintings in the same vein as folk art, or in a way similar to store signs or signs on stalls at fairs" ("Biographie au pas de course," *Prospectus et tous écrits suivants*, vol. 4 [Paris: Gallimard, 1995], 477).

6. Dubuffet, "Honneur aux valeurs sauvages" (1951), *Prospectus et tous écrits suivants*, vol. 1 (Paris: Gallimard, 1967) 213.

7. Dubuffet, "Avant-projet d'une conférence populaire sur la peinture," ibid., 47.

8. Dubuffet, "Honneur aux valeurs sauvages," ibid., 207–8.

9. Dubuffet, "Avant-projet d'une conférence populaire sur la peinture," ibid., 48.

10. Dubuffet, "Positions anticulturelles," which was read at a conference in Chicago on December 20, 1951, ibid., 94-100.

11. To my knowledge, Dubuffet used this expression for the first time in 1944: letter to Jean Paulhan, no. 105, *Jean Paulhan à travers ses peintres*, exh. cat. (Paris: Galeries Nationales du Grand Palais, 1974). Dubuffet described himself as a common man. His lectures on painting were aimed at an audience made up of common men. The idea of the "common man" occupies a preeminent place in his collection of texts, *Prospectus aux amateurs de tout genre* (Paris: Gallimard, 1946).

12. J. Dubuffet, "Plus modeste" (1945), *Prospectus et tous écrits suivants*, vol. 1 (Paris: Gallimard, 1967), 91.

13. See Huber Damisch's note 16 in ibid., 474–75.

14. Dubuffet, "Saint-Ouen. Le marché" (1944), ibid., 108–9.

15. Dubuffet, "Avant-projet d'une conférence populaire sur la peinture," ibid., 36. In 1937, Dubuffet got married

for the second time, to Émilie Carlu, known as Lili, a "common woman." He portrays her as follows in his biography: "She didn't have much education, her personality—very poetic—was particularly marked by her insubordination to social norms. Opposed to phoniness, opposed to any obligations, affection for the frugal, simple life."

16. Michel Thévoz, *Dubuffet* (Geneva: Skira, 1986), 47. Dubuffet later elaborated on this point: "I know very well that as things stand, both cultivated and barely cultivated people are in reality even more embedded in culture . . . and are even less inclined to get excited about relatively profound and innovative experiments, when it concerns artistic creation at any rate" (letter to M. Terrini, November 20, 1969, *Prospectus et tous écrits suivants*, vol. 4 [Paris: Gallimard, 1995], 278).

17. Dubuffet, "Avant-projet d'une conférence populaire sur la peinture," *Prospectus et tous écrits suivants*, vol. 1 (Paris: Gallimard, 1967), 53 and 42.

18. Dubuffet, "Biographie au pas de course," *Prospectus et tous écrits suivants*, vol. 4 (Paris: Gallimard, 1995), 468–69.

19. Dubuffet, letter to René Auberjonois, Paris, 28 August 1945, *Prospectus et tous écrits suivants*, vol. 2 (Paris: Gallimard, 1967), 240.

20. Dubuffet, letter to Jean Paulhan, Lausanne, December 11, 1945 (Fondation Jean Dubuffet, Paris). Their two trips to Switzerland took place in July and December 1945.

21. Dubuffet was a frequent client of the Café Baty in 1923, meeting "all the Swiss in Montparnasse" there (letter to Paul Budry, Paris, September 5, 1923, *Prospectus et tous écrits suivants*, vol. 3 [Paris: Gallimard, 1995], 82). In the years after the war, he visited the Auberge de l'Onde in Saint-Saphorin, which was a popular spot for many Swiss artists, novelists, and musicians. See Françoise Fornerod, *Lausanne, le temps des audaces. Les idées, les lettres et les arts de 1945 à 1955* (Lausanne: Payot, 1993), 26.

22. Henry-Louis Mermod published Swiss writers from French-speaking Switzerland, such as Charles Ferdinand Ramuz, Gustave Roud, and Charles-Albert Cingria, as well as French writers. He played an important role in the flowering of Romande literature in the 1920s.

23. See Michel Thévoz, "La Suisse de Jean Dubuffet," *Dubuffet*, exh. cat. (Martigny: Gianadda Foundation, 1993).

24. Dubuffet interviewed by Frank Jotterand, *Gazette littéraire* (May 22 and 23, 1971).

25. See Waldemar Deonna, *De la planète Mars en Terre sainte. Art et subconscient. Un médium peintre: Hélène Smith* (Paris: De Boccard, 1932), 1.

26. "Zeichnung und Malerei der Geisteskranken," Gewerbemuseum, Basel, October 13–November 3, 1929; "L'Art et les maladies mentales. Desseins, peintures, sculptures, broderies," Musée d'Art et d'Histoire, Geneva, January 16–February 16, 1930.

27. See L. Florentin, "L'art des possédés," *La Suisse* (January 28, 1930); A. J. and M. X., "Parlons du tout," *La Tribune* (February 4, 1930); W. Matthey-Claudet, in *La Tribune de Genève* (February 7, 1930).

28. "Ausstellung Kinder- und Jugendzeichnungen aus dem Besitz der Mannheimer Kunsthalle. Sonderausstellung Zeichnungen eines Geisteskranken," Gewerbemuseum, Winterthur, February 23–March 30, 1930.

29. See Le Corbusier, "Louis Soutter, L'inconnu de la soixantaine," *Minotaure* 9 (1936). See also *Regards sur Minotaure. La revue à tête de bête*, exh. cat., Musée Rath, Geneva; Musée d'Art Moderne de la ville de Paris, Paris, 1987–1988.

30. See Françoise Fornerod, *Lausanne, le temps des audaces. Les idées, les lettres et les arts de 1945 à 1955* (Lausanne: Payot, 1993).

31. Jean Starobinski in the preface to the French translation of Hans Prinzhorn's work, *Expressions de la folie* (Paris: Gallimard, 1984), XIV–XV.

32. John M. MacGregor, "Art Brut chez Dubuffet. An Interview with the Artist. 21 August 1976," *Raw Vision* 7 (1993), 42; reprinted in Dubuffet, *Prospectus et tous écrits suivants*, vol. 4 (Paris: Gallimard, 1995), 40–58.

33. Two artists whose works are among those in Prinzhorn's book. A number of artists were at Waldau, including Heinrich Anton Müller, Adolf Wölfli, the writer Robert Walser, the dancer Vatslav Nijinski, the set designer Adolf Appia and the art historian Heinrich Wölfflin.

34. Because the project for the *L'Art Brut* series had been canceled, the article appeared in issue no. 10 of the periodical *Werk* in Winterthur, October 10, 1948. The text "Souvenir de Louis Soutter" was reprinted in the book by Thévoz, *Louis Soutter ou l'Écriture du désir*, (Lausanne: L'Âge d'Homme, 1974), 238–39.

35. In his travel log entitled *Voyage en Suisse, juillet 1945*, Dubuffet mentions a number of works (masks from the Valais, votive offerings from Ticino, engraved bamboo from New Caledonia, works made out of bones from the Capuchin church in Rome) and gives details of a variety of works devoted to mediumistic creation, works by the insane and prisoners, of a psychiatry manual, and of Rorschach's book and his test.

36. Dubuffet, *Communication aux membres de la Compagnie de l'Art Brut*, Paris, August 10, 1971 (Archives of the Collection de l'Art Brut, Lausanne).

37. Dubuffet met Charles Ladame in December, 1945. For more details, see Lucienne Peiry's *Charles Ladame ou le Cabinet fou d'un psychiatre* (Lausanne: Collection de l'Art Brut, 1991).

38. R. Auberjonois, letter to his son Fernand Auberjonois, Lausanne, December 14, 1948 (*Études de lettres* 4, University of Lausanne [1972], 47-48). Dubuffet discovered Aloïse's drawings in April 1946 (see the Archives of the Collection de l'Art Brut, Lausanne).

39. See Lucienne Peiry, *Hans Steck ou le Parti pris de la folie* (Lausanne: Collection de l'Art Brut, 1991).

40. Dubuffet paid a visit to Antonin Artaud, who was a patient at the psychiatric hospital in Rodez (September 4 and 9, 1945). He also met Dr. Ferdière. Undoubtedly it was between these two dates that he went on to Saint-Alban-sur-Limagnole (see the "Antonin Artaud" file at the Fondation Jean Dubuffet, Paris).

41. See Laurent Danchin, "Hommage à Gaston Ferdière," *Artension* 22 (1991), 21. Numerous pieces from his own collection would be included in many Surrealist exhibitions as well as in shows devoted to the art of the insane, the best known being the one at Sainte-Anne in 1946.

42. G. Ferdière sent him Dr. Jacques Vié's address in Neuilly-sur-Marne, the same doctor who would guide Dubuffet in his research and reading. He pointed out for him the drawings of Marguerite Burnat-Provins, Dr. Georges de Morsier's patient. Moreover, he suggested Dubuffet should get in touch with Dr. Ladame and visit his little "museum of madness" in Geneva. Dubuffet had already been told about this collection: Eugène Pittard, the curator of the Musée d'Ethnographie in Geneva, had given him the psychiatrist's address during their meeting in July 1945; Henri Bersot, a doctor at the Bellevue clinic in Landeron, Switzerland, advised him to make contact with Dr. Ladame and to visit his collection of asylum art (letter dated August 20, 1945, Archives of the Collection de l'Art Brut, Lausanne). G. Ferdière is therefore the third source for Dubuffet's information. The chronology of these events matters insofar as Ferdière would openly attack Dubuffet a few years after this visit, accusing him of having "spirited away" Ladame's collection, although the Swiss doctor had promised it to him. If Ladame had made a commitment to Ferdière, he did not say so in his letters to Dubuffet. Clearly, Dubuffet had not forced the psychiatrist to donate his collection to the Compagnie de l'Art Brut. See the correspondence between Ladame and Dubuffet (Archives of the Collection de l'Art Brut, Lausanne) and L. Danchin, *Le Cabinet du docteur Ferdière* (Paris: Séguier, 1996). It is wrong to assert—as Michel Ragon did—that G. Ferdière "would reveal to Dubuffet the rich vein of works of art in three Swiss hospitals: Waldau's . . . Bel-Air's . . . and Cery's (Lausanne)" (M. Ragon, *Du côté de l'Art Brut* [Paris, Albin Michel, 1996], 46).

43. Dubuffet, letter to J. Paulhan, Paris, September 1945 (Fondation Jean Dubuffet, Paris).

44. Dubuffet, letter to André Breton, Paris, September 23, 1951, *Prospectus et tous écrits suivants*, vol. 1 (Paris: Gallimard, 1967), 496–97.

45. Dubuffet, letter to Dr. G. de Morsier, Paris, November 3, 1945 (Archives of the Collection de l'Art Brut, Lausanne).

46. Ibid. See G. de Morsier, *Art et Hallucination. Marguerite Burnat-Provins* (Neuchâtel: La Baconnière, 1969), 23.

47. This text is conserved in the archives at the Fondation Jean Dubuffet, Paris.

48. According to the photographer's wife, Dubuffet visited Brassaï regularly to look at his vast collection of photographs of graffiti: "He [Dubuffet] told Brassaï that he wished to publish them in his Collection de l'Art Brut, but Brassaï never followed up on the offer" (see Brassaï, *Graffiti* [Paris, Flammarion, 1993], 5).

49. Dubuffet, letter to C. Ladame, Paris, August 9, 1945 (Archives of the Collection de l'Art Brut, Lausanne).

50. Dubuffet, letter to J. Paulhan, Paris, October 1945 (Fondation Jean Dubuffet, Paris).

51. Dubuffet, letter to J. Paulhan, Paris, October 26, 1945 (Fondation Jean Dubuffet, Paris).

52. Dubuffet, letter to J. Paulhan, Paris, November 1945 (Fondation Jean Dubuffet, Paris).

53. Except for the masks from Lötschental, the paintings by a native of Bougainville and a few drawings by children, no other works like these would be included in the

Art Brut exhibition at the Galerie René Drouin or the *Almanach de l'Art Brut*.

54. M. Thévoz's remarks recorded by Véronique Mauron, "Le son des choses," a radio broadcast about Heinrich Anton Müller. Radio Suisse Romande, Espace 2, October 15, 1994.

55. Michel Ragon, *Vingt-cinq ans d'art vivant* (Paris: Casterman, 1969), 98–99.

56. Dubuffet, letter to M. Ragon, Paris, November 25, 1950, *Prospectus et tous écrits suivants*, vol. 4 (Paris: Gallimard, 1995), 131.

57. Jean-Claude Drouin [René Drouin's son], letter to L. Peiry, May 8, 1989 (L. Peiry's Archives, Lausanne).

58. Ibid.

59. See L. Peiry, "Le mystère parfait," *Construire* 36 (September 6, 1989).

60. Michel Tapié, letter to Marcel Rothan, Paris, undated [early 1948] (Archives of the Collection de l'Art Brut, Lausanne).

61. René Guilly, "M. le Zouzou (du Doubs) représentant de 'L'Art Brut,'" *Combat* (December 16, 1947).

62. *Sculptures de Krizek. L'Art Brut*, text by M. Tapié (Paris: Éditions René Drouin, undated [1948]); and *Miguel H. (Hernandez). L'Art Brut*, text by M. Tapié (Paris, Éditions René Drouin, undated [1948]) (Archives of the Collection de l'Art Brut, Lausanne). Another exhibition displayed the works of Véreux and Lamy, which were introduced in a small booklet: *Robert Véreux. Art Brut*, text by M. Tapié (Paris: Éditions René Drouin, undated [1948]) (Archives of the Collection de l'Art Brut, Lausanne). Robert Véreux is the pseudonym of the phthisiologist Robert Forestier (see the file "Véreux," in the Archives of the Collection de l'Art Brut, Lausanne).

63. Four works by Aloïse were sold during the exhibition for 2,000 French francs apiece (one of them was purchased by A. Breton). The Foyer retained 3,000 francs from the purchase of the four works (which works out at 26%). In 1948, a gouache by Chaissac was sold for 3,000 francs, a drawing by Jeanne Tripier for 1,000 francs, an embroidery by Juliette-Élisa Bataille for 1,000 francs, an oil painting by Hernandez for 3,000 francs, a wood sculpture by Forestier for 1,500 francs. For comparison's sake, during an art sale in 1949 at the Charpentier Gallery in Paris, a drawing by Matisse (*Femme nue assise*) was sold for 33,000 francs, a drawing by Toulouse-Lautrec (*Le Fiacre*) for 40,000 francs, a pastel by Picasso (*Le Paquet de Gauloises*) for 100,000 francs (see the archives at the Hôtel Drouot, Paris). Furthermore, Michel Tapié worked with other galleries, lending them works that belonged to the Foyer de l'Art Brut; in 1948, for example, three paintings by Hernandez were sent to the L'Arc-en-ciel gallery in Paris.

64. Dubuffet, letter to Madeleine and Zoltan Kemeny, Paris, June 3, 1948 (Archives of the Collection de l'Art Brut, Lausanne).

65. Dubuffet, letter to Jacques Berne, Paris, 6 May 1948, *Lettres à J. B., 1946-1985* (Paris: Hermann, 1991), 40.

66. Dubuffet, letter to J. Paulhan, Paris, 1948 (Fondation Jean Dubuffet, Paris).

67. Dubuffet, letter to J. Berne, Paris, June 25, 1948, *Lettres à J. B., 1946-1985* (Paris: Hermann, 1991), 41.

68. See Robert Dauchez's interview with L. Peiry, Paris, June, 1988 (L. Peiry's Archives, Lausanne); see also his letter to Dubuffet, December 2, 1948 (Archives of the Collection de l'Art Brut, Lausanne). The formal announcement of the association's formation was made at Paris police headquarters on July 1, 1949 (no. 14115); the announcement appeared in the *Journal officiel* on July 25 and 26, 1949.

69. John M. MacGregor, "Art Brut chez Dubuffet. An Interview with the Artist. 21 August 1976," *Raw Vision* 7 (1993), 47.

70. Dubuffet, letter to A. Breton, Paris, June 26, 1948 (Bibliothèque Littéraire Jacques Doucet, Paris). Michel Seuphor describes the pavilion as follows: "Four ionic columns, three large arched windows separated by two Roman busts placed at about the midpoint of the façade, and all of it crowned by an entablature with simple, uncomplicated lines: these were the pleasant surroundings which M. Gallimard had lent to *l'Art Brut*. It is complemented by a wide terrace and a dry fountain. The staircases lend it an even more ceremonious air." ("'L'Art Brut' est maintenant domicilié chez M. Gallimard," *L'Aube* [September 1948]).

71. Dubuffet, letter to A. Breton, Paris, June 26, 1948 (Bibliothèque Littéraire Jacques Doucet, Paris).

72. Dubuffet, "Bâtons rompus" (1986), *Prospectus et tous écrits suivants*, vol. 3 (Paris: Gallimard, 1995), 122. The garden connected to the Éditions Gallimard building is located at the tip of an intersection between 17 rue de l'Université and 5 rue Sébastien-Bottin. The pavilion had only one floor and offered three times as much space as they had had in the basement beneath the Galerie Drouin: there were three spacious rooms for exhibiting work and space for an office and printing operations; a cellar provided a place to store works.

73. Dubuffet, letter to J. Paulhan, Paris, April 19 or 24, 1944, *Prospectus et tous écrits suivants*, vol. 4 (Paris: Gallimard, 1995), 90.

74. Dubuffet, letter to P. Salingardes, Paris, December 16, 1949 (Archives of the Collection de l'Art Brut, Lausanne).

75. Dubuffet, letter to C. Ladame, Paris, October 2, 1948 (Archives of the Collection de l'Art Brut, Lausanne).

76. See the exhibitions listed in the bibliography (p. 313).

77. Gaston Chaissac rejected the idea of becoming part of Art Brut: "I could pass off my work as Art Brut, but I don't think that's what I actually do" (letter to Jean l'Anselme, August 31, 1949, cited by Henri-Claude Cousseau, "L'origine et l'écart," in *Paris-Paris, 1937-1957* (Paris: Gallimard, 1992, p. 244). In other respects, Chaissac made it sound as if he had been dealt an injustice or betrayed: "I christened my figures quite simply rustic, modern folk art. Better informed, Dubuffet talked of Art Brut, the name caught on and I remained thwarted." (Letter to M. Ragon, Vix, November 1962, Coll. Jean-Pierre Gallois; see also G. Chaissac, *Le Laisser-aller des éliminés. Lettres à l'abbé Coutant* [Paris: Plein Chant, 1979]). These statements are often cited in the dispute over Chaissac being reputedly forced into Art Brut. However, a review of the archives reveals that the artist from Vence willingly offered dozens of works to the Compagnie de l'Art Brut up until 1951, the year the Compagnie disbanded. During the first Art Brut venture (1948–51), Dubuffet considered him a full-fledged

Art Brut artist and his works were on display in the pavilion and were part of the exhibition of Art Brut at the Galerie René Drouin. With Paulhan's help, Dubuffet undertook to publish his famous book, *Hippobosque au bocage* (Paris: Gallimard, 1951); in the early 1960s, Dubuffet decided to put Chaissac's works in the Collections Annexes (later to become the Collection Neuve Invention).

78. Slavko Kopac, interviewed by L. Peiry, Paris, June 22, 1988 (L. Peiry's Archives, Lausanne).

79. See Jean-Claude Lebensztejn's analysis, *Zigzag* (Paris: Flammarion, 1981).

80. Dubuffet, Kopac, Hernandez, and Jean l'Anselme took advantage of the opportunity to print copies of their own texts and engravings. *Ler dla canpane* was by Dubuffet, *Tir à cible* by Kopac, *Evolucíon* by Hernandez, and *Histoire de l'aveugle* by Anselme. This was the only occásion Dubuffet sold his own works alongside those of Art Brut; from then on, he would carefully keep his own works separate.

81. Dubuffet, letter to D. Varbanesco, Paris, November 6, 1948 (Archives of the Collection de l'Art Brut, Lausanne).

82. Dubuffet, letter to Pierre Maunoury, Paris, May 30, 1963 (Archives of the Collection de l'Art Brut, Lausanne).

83. Dubuffet, letter to Pierre Bettencourt, Paris, December 29, 1949 (*Poirer le papillon. Lettres de Jean Dubuffet à Pierre Bettencourt, 1949–1985* [Paris: Lettres Vives, 1987], 9-10).

84. Dubuffet, lettre to J. Paulhan, Paris, October 1948 (Archives of the Collection de l'Art Brut, Lausanne). See *Les Cahiers de la Pléiade* 6 (Paris: Gallimard, autumn 1948-winter 1949).

85. Dubuffet, letter to J. Berne, Paris, April 29, 1949, *Lettres à J. B., 1946-1985* (Paris: Hermann, 1991), 47.

86. Ibid., November 6, 1949, 56.

87. See *Prospectus et tous écrits suivants*, vol. 1 (Paris: Gallimard, 1967), 198–202.

88. Ibid., 203–24. The artists who were introduced were Paul End, Alcide, Stanislas Liber, Gaston Dufour, Sylvain Lecoq.

89. The archives for the Compagnie de l'Art Brut contain some eighty articles that appeared between December 1947 and December 1949, twenty of which concern the exhibition at the Galerie René Drouin in October and November 1949.

90. Charles Estienne, "Les Arts," *Combat* (December 27, 1947); [anonymous], "Les expositions," *Paru* (January 1948).

91. Alexandre Klerx, "L'Art Brut," *Le Phare* (May 14, 1948); D. C., "Krizek," *Arts* (February 20, 1948); [anonymous], "À l'exposition de l'Art Brut un plombier-zingueur peint en entendant des voix," *Point de vue* (September 16, 1948).

92. Jean Bouret, "Racines de bruyères et cailloux ou la fumisterie de l'Art Brut,'" *Ce soir* (September 10, 1948); "L'Art Brut," *Arts*, (September 17, 1948).

93. René Domergue, "L'Art Brut (l'art fou) qui n'effraie plus personne gîte place Vendôme," *L'Aube* (October 20, 1949); G. Joly, "L'Art Brut: l'art roublard plutôt," *L'Aurore* (October 18, 1949).

94. D. F., "Art Brut," *Journal de Genève* (November 6, 1949).

95. Joly, op. cit.; Domergue, op. cit.

96. Jean Rousselot, "La peinture à Paris," *L'Écho d'Oran* (November 12, 1949).

97. J. Bouret, "L'Art Brut," *Arts* (October 14, 1949).

98. [Anonymous], "À la galerie Drouin: Crépin, Antinéa and quelques autres bruts," *Combat* (October 13, 1949); [anonymous], "Un autre procès: celui de l'art culturel,'" *Gazette de Lausanne* (October 23, 1949).

99. Henri Héraut, "Heinrich Anton Müller, Auguste et Jeanne," *Le Rayonnement des beaux-arts* (June 1, 1948).

100. Gaston Diehl, in *La Gazette des lettres* (October 29, 1949); Frank Elgar, "L'Art Brut et l'art de faire de l'Art Brut," *Carrefour* (November 8, 1949).

101. Robert Laugier, "L'Art Brut," *À mon point de vue* (October 1948).

102. Claudine Chonez, "L'Art Brut à l'honneur," *La Nef* (October 1948).

103. See Charles Estienne, "Lyrisme ou délire," *Combat* (June 1949); Patrick Waldberg, "L'Art Brut," *Paru* (November 1949).

104. Chonez, op. cit.; [anonymous], [untitled], *Les Nouvelles littéraires* (October 27, 1949).

105. Chonez, op. cit.

106. Héraut, op. cit.

107. See the archives of the Collection de l'Art Brut, Lausanne, or *Prospectus et tous écrits suivants*, vol. 1 (Paris: Gallimard, 1967), 499–508.

108. Dubuffet, letter to A. Breton, Paris, June 3, 1948, *Prospectus et tous écrits suivants*, vol. 2 (Paris: Gallimard, 1967), 267.

109. Dubuffet, letter to J. Paulhan, Paris, September 7, 1948 (Fondation Jean Dubuffet, Paris).

110. Dubuffet, letter to A. Breton, Paris, undated [1948] (Archives of the Bibliothèque Littéraire Jacques Doucet, Paris).

111. Dubuffet, letter to J. Paulhan, July 21, 1948 (Fondation Jean Dubuffet, Paris).

112. The Auberjonois family was committed to helping the Compagnie de l'Art Brut. The painter René Auberjonois, father of Maurice and Fernand, offered his pay for the article on Louis Soutter, originally commissioned by Dubuffet and finally published in the Swiss review *Werk* in 1948 (50 Swiss francs was equivalent to 5,750 French francs).

113. Dubuffet, letter to J. Paulhan, Paris, September 1948 (Fondation Jean Dubuffet, Paris).

114. See the minutes for the Compagnie de l'Art Brut's membership meeting, October 8, 1951 (Archives of the Collection de l'Art Brut, Lausanne).

115. This amount did not include his travel expenses in France and abroad.

116. John M. MacGregor, "Art Brut chez Dubuffet. An Interview with the Artist. 21 August 1976," *Raw Vision* 7 (1993), 47.

117. Dubuffet also had photographs taken of works by Pascal-Désir Maisonneuve and Scottie Wilson in Breton's collection. The artists that Breton singled out in 1948 had been part of the "Exposition Internationale du Surréalisme" the year before at the Galerie Maeght.

118. He sent also letters to Italy, Spain, Hungary, Denmark, Germany, Holland, Mexico, and Haiti.

119. Dubuffet, letter to Dr. Hubert Mignot, Paris, October 25, 1948, and letter to Dr. Paul Bernard, Paris, November 16, 1948 (Archives of the Collection de l'Art Brut, Lausanne).
120. Dubuffet, letter to J. Berne, Paris, September 19, 1950, *Lettres à J. B.*, *1946-1985* (Paris: Hermann, 1991), 68. They also visited with the artist Eugène Gabritchevsky and with Dr. von Braunmühl, the director of the Eglfing-Haar hospital near Munich.
121. Claude Lévi-Strauss, letter to Dubuffet, Paris, November 15, 1948 (Archives of the Collection de l'Art Brut, Lausanne).
122. Dubuffet, letter to C. Lévi-Strauss, Paris, November 11, 1948 (Archives of the Collection de l'Art Brut, Lausanne).
123. Dr. Paul Bernard donated works by Paul End, Alcide, Gaston Duf, Sylvain Lec, and Stanislas Lib; works by Joseph Heu, Julie Bar, Jean Mar, Robert Gie, and Berthe Ura were gifts from Dr. Charles Ladame; works by the Bernese artists Wölfli and Müller came from a number of donors—Dr. Max Müller, Dr. Jacob Wyrsch, Dr. Julius von Ries, Dr. Münch, and Dr. Oscar Forel; Auguste Forestier's sculptures were the result of Dr. Jean Oury's generosity; finally, dozens of drawings by Aloïse were gifts by Dr. Jacqueline Poret-Forel, while the medium Jeanne Tripier's drawings and embroideries were donated by Dr. Henri Beaudoin.
124. See Dubuffet, *Prospectus et tous écrits suivants*, vol. 4 (Paris: Gallimard, 1995), 658.
125. Dubuffet, letter to Alfonso Ossorio, New York, February 14, 1952 (Archives of American Art, Smithsonian Institution, Washington, D.C.).
126. Robert Doisneau interviewed by L. Peiry, Paris, November 1, 1990 (L. Peiry's Archives, Lausanne).
127. Dubuffet, "L'Art Brut préféré aux arts culturels" (1949), *Prospectus et tous écrits suivants*, vol. 1 (Paris: Gallimard, 1967), 201.
128. Dubuffet, "Honneur aux valeurs sauvages," ibid., 215 and 202.
129. Dubuffet, "L'Art Brut," *Les Barbus Müller* (Paris: Gallimard, 1947); *Prospectus et tous écrits suivants*, vol. 1 (Paris: Gallimard, 1967), 176.
130. Dubuffet, "Honneur aux valeurs sauvages," *Prospectus et tous écrits suivants*, vol. 1 (Paris: Gallimard, 1967), 217.
131. Dubuffet, "Petites ailes" (1965), ibid., 2, 54–55.
132. The quotations in this paragraph come from two works by Dubuffet: "Notice sur la compagnie de l'Art Brut" and "Honneur aux valeurs sauvages," ibid., 489, 215, 200, 206, and 218.
133. See Marielène Weber, "Note sur l'émergence de 'l'art des fous,'" in *La Mesure des irréguliers*, ed. F. Hulak (Nice: Z'éditions, 1990).
134. Dubuffet, "Honneur aux valeurs sauvages," *Prospectus et tous écrits suivants*, vol. 1 (Paris: Gallimard, 1967), 218 and 202.
135. Dubuffet, letter to Dr. Robert Volmat, Paris, December 28, 1952, ibid., p. 512.
136. Dubuffet, "Cinq petits inventeurs de la peinture," exh. cat. (Lille: Librairie Marcel Évrard, 1951), ibid., 510.
137. Dubuffet, "Notice sur la compagnie de l'Art Brut," ibid., 490.

138. Dubuffet, "L'Art Brut préféré aux arts culturels," ibid., 202.
139. Dubuffet, "Honneur aux valeurs sauvages," ibid., 221–22.
140. Dubuffet, letter to R. Auberjonois, Paris, January 1947 (Centre de Recherches sur les Lettres Romandes, Lausanne).
141. The primary texts are "Notice sur la compagnie de l'Art Brut" (1948), "L'Art Brut préféré aux arts culturels" (1949), "Honneur aux valeurs sauvages" (1951), and "Cinq petits inventeurs de la peinture" (1951), ibid., 489–91, 198–202, 205–24 and 509–10.
142. Dubuffet, "L'Art Brut," ibid., 175.
143. Ibid., 176. See Didier Semin, "Chaissac et Dubuffet," in *Dubuffet* (Paris: Éditions du Jeu de Paume, 1992), 62-70; and Pierre Vermeersch, "L'Art Brut c'est l'Art Brut. De tautologie en topologie," in *La Mesure des irréguliers*, ed. F. Hulak (Nice: Z'éditions, 1990), 175–80.
144. Dubuffet, letter to A. Breton, Paris, May 28, 1948, *Prospectus et tous écrits suivants*, vol. 1 (Paris: Gallimard, 1967), 265.
145. When Breton discovered Scottie Wilson's drawings, he acquired a number of works which he wanted to exhibit in the Foyer, with the intention of retaining a 30% commission (Archives of the Collection de l'Art Brut, Lausanne and Dubuffet, *Prospectus et tous écrits suivants*, vol. 1 [Paris: Gallimard, 1967], 495).
146. Dubuffet, letter to A. Breton, Paris, June 8, 1948, *Prospectus et tous écrits suivants*, vol. 2 (Paris: Gallimard, 1967), 270–71.
147. Dubuffet, letter to A. Breton, Paris, March (or April) 12, 1949 (Archives of the Bibliothèque Littéraire Jacques Doucet, Paris).
148. Dubuffet, letter to J. Paulhan, Paris, June 6, 1948 (Fondation Jean Dubuffet, Paris).
149. Dubuffet, "Honneur aux valeurs sauvages," *Prospectus et tous écrits suivants*, vol. 1 (Paris: Gallimard, 1967), 220.
150. See an unpublished work by A. Breton on Joseph Crépin, originally requested for the *Almanach de l'Art Brut* (Archives of the Collection de l'Art Brut, Lausanne).
151. Neither of the two Surrealist shows paid much attention to painting or sculpture. See William S. Rubin, *Dada and Surrealist Art* (London: Thames and Hudson, 1969).
152. A. Breton, letter to Dubuffet, Paris, September 20, 1951, *Prospectus et tous écrits suivants*, vol. 1 (Paris: Gallimard, 1967), 493.
153. John M. MacGregor, "Art Brut chez Dubuffet. An Interview with the Artist. 21 August 1976," *Raw Vision* 7 (1993), 47.
154. Dubuffet, letter to A. Breton, September 23, 1951, *Prospectus et tous écrits suivants*, vol. 1 (Paris: Gallimard, 1967), 494.
155. See F. Elgar, "L'Art Brut et l'art de faire de l'Art Brut," *Carrefour* (November 8, 1949); Harald Szeemann, "Ein neues Museum in Lausanne," *Individuelle Mythologien* (Berlin: Merve Verlag, 1985), 145–48; Sarah Wilson, "From the Asylum to the Museum: Marginal Art in Paris and New York, 1938–1968," in *Parallel Visions. Modern Artists and Outsider Art* (Los Angeles County Museum of

Art and Princeton University Press, 1992–93), 131–32; M. Ragon, *Du côté de l'Art Brut* (Paris: Albin Michel, 1996).

156. Dubuffet, "Notes pour les fins-lettrés," *Prospectus et tous écrits suivants*, vol. 1 (Paris: Gallimard, 1967), 65–66.

157. Dubuffet, letter to G. Chaissac, Paris, "lundi matin," [1947], ibid., 464–65.

158. Pablo Picasso, in *Les Nouvelles littéraires, artistiques et scientifiques* 42 (August 4, 1923), 2.

159. Georges Limbour, *L'Art Brut de Jean Dubuffet. Tableau bon levain à vous de cuire la pâte* (New York: Pierre Matisse Gallery; Paris: Galerie René Drouin, 1953), 59.

160. Dubuffet, "Batons rompus," *Prospectus et tous écrits suivants*, vol. 3 (Paris: Gallimard, 1995), 160.

161. Dubuffet, unpublished interview with J. M. MacGregor (Collection de l'Art Brut, Lausanne).

162. Dubuffet, letter to J. Paulhan, Paris, August 1948 (Fondation Jean Dubuffet, Paris).

163.Dubuffet, letter to G. Chaissac, Paris, June 23, 1949 (Fondation Jean Dubuffet, Paris).

164. Dubuffet, letter to J. Berne, Paris, September 14, 1951, *Lettres à J. B., 1946-1985* (Paris: Hermann, 1991), 72.

165. Ibid.

166. Dubuffet, letter to Pierre Matisse, Paris, May 15, 1949, *Prospectus et tous écrits suivants*, vol. 2 (Paris: Gallimard, 1967), 287.

167. This correspondence is conserved at the Ossorio Foundation in Southampton, NY. Dubuffet wrote a book on his friend's work: *Peintures initiatiques d'Alfonso Ossorio* (Paris: La Pierre volante, 1951; reprinted in *Prospectus et tous écrits suivants*, vol. 2 (Paris: Gallimard, 1967), 21–42 and n. 61, pp. 402–25.

168. Alfred Pacquement, "Jean Dubuffet à New York, Américains à Paris dans les années 50," *Paris-New York* (1977) (Paris: Gallimard, 1991), 679.

Chapter 3
New York and Vence

1. Jean Dubuffet, "Biographie au pas de course," *Prospectus et tous écrits suivants*, vol. 4 (Paris: Gallimard, 1995), 494–95. A community of painters, poets, and art critics lived in the East Hampton area, including Jackson Pollock, Lee Krasner, Willem de Kooning, Clyfford Still, Robert Motherwell, John Little, Clement Greenberg, and Harold Rosenberg.

2. Ibid.

3. Dubuffet, letter to Jacques Berne, New York, January 24, 1952, *Lettres à J. B., 1946-1985* (Paris: Hermann, 1991), 74.

4. See Dubuffet, "Positions anticulturelles," *Prospectus et tous écrits suivants*, vol. 1 (Paris: Gallimard, 1967), 94–100.

5. See Bernard H. Friedman, *Alfonso Ossorio* (New York: Harry N. Adams, 1972), 59-71; Sarah Wilson, "From the Asylum to the Museum: Marginal Art in Paris and New York," in *Parallel Visions. Modern Artists and Outsider Art* (Los Angeles County Museum of Art and Princeton University Press, 1992–93), 120–49.

6. See Alfonso Ossorio, letter to Dubuffet, East Hampton, November 1953 (Fondation Jean Dubuffet, Paris, and Ossorio Foundation, Southampton, NY).

7. These three quotations are from: A. Ossorio, letter to Dubuffet, East Hampton, November 1953 (Fondation Jean Dubuffet, Paris, and Ossorio Foundation, Southampton, NY); A. Ossorio interviewed by S. Wilson on February 20, 1990 and quoted in her article, op. cit., 139.

8. A. Ossorio, letter to Dubuffet, East Hampton, November 1953 and April 19, 1954 (Fondation Jean Dubuffet and Ossorio Foundation, Southampton, NY).

9. A. Ossorio, letter to Dubuffet, East Hampton, May 29, 1952 (Fondation Jean Dubuffet, Paris).

10. Friedman, op. cit., 61.

11. See Luc Debraine, "Eugène Gabritchevsky," *Donations Daniel Cordier. Le regard d'un amateur* (Paris: Éditions du Centre Georges Pompidou, 1989), 210–58.

12. John Canaday, "Art: Dubuffet at the Modern Museum," *The New York Times* (February 21, 1962).

13. Extracts from the following articles: Irving Sandler, "In the Art Galleries," *The New York Post*, March 4, 1962; J. Canaday, "Jean Dubuffet," *The New York Times*, February 25, 1962; Dorothy Adlow, "Dubuffet's L'Art Brut," *Christian Science Monitor*, February 24, 1962; Canaday, op. cit.

14. Dubuffet, letter to A. Ossorio, Paris, June 15, 1952 (Fondation Jean Dubuffet, Paris and Ossorio Foundation, Southampton, NY).

15. Dubuffet, letter to J. Berne, Paris, September 29, 1952, *Lettres à J. B., 1946-1985* (Paris: Hermann, 1991), 75.

16. Dubuffet, letter to J. Berne, Vence, February 5, 1956 (*Lettres à J. B., 1946-1985* [Paris: Hermann, 1991], 84), and letter to Philippe Dereux, Vence, October 26, 1955 (P. Dereux's Archives, Villeurbanne).

17. Dubuffet, letter to Jean Paulhan, Vence, February 20, 1956 (Jean Paulhan's Archives, Paris), quoted in *Le Monde d'Alphonse Chave ou la Vision d'un amateur de l'art* (Lyon: Elac, 1981), 48.

18. Dubuffet, letter to Georg Gabritchvesky, Vence, November 12, 1960 [unsent] (Archives of the Collection de l'Art Brut, Lausanne).

19. Dubuffet, "Note sur les circonstances dans lesquelles ont été acquises par MM. Chave et Ulmann les peintures de M. Eugène Gabritchevsky," Vence, November 12, 1960 (Archives of the Collection de l'Art Brut, Lausanne).

20. Extract from Dubuffet's introduction to the catalogue for the exhibition "L'Art Brut," at the Les Mages gallery, Vence, 1959 (*Prospectus et tous écrits suivants*, vol. 1 [Paris: Gallimard, 1967], 513–16.)

21. Dubuffet, letter to P. Dereux, Paris, February 13, 1962 (P. Dereux's Archives, Villeurbanne).

22. Pierre Chave (Albert Chave's son) interviewed by L. Peiry in Vence, April 5, 1989 (L. Peiry's Archives, Lausanne).

23. Dubuffet, letter to P. Dereux, Paris, January 10, 1962 (P. Dereux's Archives, Villeurbanne).

24. Dubuffet, see letters to P. Dereux, Paris (P. Dereux's Archives, Villeurbanne).

25. Found in the catalogue for the exhibition *L'Art Brut* (op. cit., 513–16). All of the quotations that follow are extracts.

26. See Chapter 2, p. 57 and note 45.

Chapter 4
The Rebirth of the Compagnie de l'Art Brut

1. Dubuffet, "Biographie au pas de course," *Prospectus et*

tous écrits suivants, vol. 4 (Paris: Gallimard, 1995), 509–10.

2. Dubuffet, letter to Alfonso Ossorio, Paris, March 4, 1962 (Archives of the Collection de l'Art Brut, Lausanne).

3. Jean-Paul Ledeur interviewed by L. Peiry, Paris, October 31, 1990 (L. Peiry's Archives, Lausanne).

4. *Poirer le papillon. Lettres de Jean Dubuffet à Pierre Bettencourt, 1949–1985* (Paris: Lettres Vives, 1987), 116.

5. Dubuffet, letter to Gaston Ferdière, Paris, February 16, 1965 (Archives of the Collection de l'Art Brut, Lausanne).

6. Dubuffet, letter to François Michel, Paris, March 4, 1962 (Archives of the Collection de l'Art Brut, Lausanne).

7. Dubuffet, letter to Robert Dauchez, Paris, April 11, 1963 (Archives of the Collection de l'Art Brut, Lausanne).

8. Slavko Kopac denied having played the role of Cerberus: "Whoever wanted to see it [the collection] saw it. Those are nasty rumors that claim you had to show your credentials in order to get in the building. Believe me, I did not know how to say no" (interviewed by L. Peiry, Paris, March, 17, 1989, L. Peiry's Archives, Lausanne).

9. Daniel Cordier was treasurer, Henri-Pol Bouche secretary, Slavko Kopac curator and administrator; the three other founder members assisted the organization by locating new works of Art Brut. A few resignations resulted in new members being nominated to fill various administrative posts: Gaëtan Picon (1966), François Mathey (1966), Edmond Bomsel (1967), and Pierre Brache (1969).

10. Dubuffet, letter to Dolores Ormandy, Le Touquet, July 16, 1964, *Prospectus et tous écrits suivants*, vol. 2 (Paris: Gallimard, 1967), 383.

11. Dubuffet, letter to Robert Dauchez, Paris, April 11, 1963 (Archives of the Collection de l'Art Brut, Lausanne). The Compagnie was made up of doctors (François Tosquelles, Jean Vinchon, Walter Morgenthaler, Hans Steck, Jacqueline Porret-Forel, Jean Oury, Roger Gentis, Paul Bernard, Vittorino Andreoli, Pierre Maunoury, Alfred Bader, Jean Dequeker) and artists and intellectuals (Gaëtan Picon, François Mathey, Georges Limbour, Gilbert Lascaux, Georges-Henri Rivière, Alfonso Ossorio, Georges Borgeaud, Jacques Berne, Jacques Ulmann, Alphonse Chave, André Pieyre de Mandiargues, Max Loreau, Pierre Bettencourt, Victor Musgrave, Charles Ratton, Jean Revol, Jean Planque, Michel Thévoz). The Compagnie numbered only twenty-two members in January 1963, but by February 1969 there were 115.

12. Pierre Maunoury interviewed by L. Peiry, Paris, November 1, 1990.

13. Upon the return of the collections, Michèle Edelmann helped out for number of years. A number of secretaries followed over the Compagnie's next fifteen years in Paris: Michel Petitjean, Jacqueline Voulet, Geneviève Bert-Riberolles. Powers of attorney were assumed by Georges Borgeaud, Claude Edelmann, and Claude Véran.

14. M. Edelmann interviewed by L. Peiry, Paris, December 7, 1988 (L. Peiry's Archives, Lausanne).

15. Dubuffet, letter to Jacques Berne, Paris, August 3, 1970, *Lettres à J. B., 1946-1985* (Paris: Hermann, 1991), 175.

16. Dubuffet, "Place à l'incivisme" (1967), *Prospectus et tous écrits suivants*, vol. 1 (Paris: Gallimard, 1967), 456.

17. Ibid.

18. Dubuffet, letters to Dr. Jean Benoiston, Paris, April 11 and 24 1963, in *Prospectus et tous écrits suivants*, vol. 4 (Paris: Gallimard, 1995), 573–74 and 186.

19. In particular, Jacqueline Porret-Forel, Paul Bernard, Jean Oury, and Jean Titeca. Other doctors were contacted too: Roger Gentis, Pierre Maunoury, Jean Benoiston, François Tosquelles, Vittorino Andreoli, Henri Dagand, Aimé Perret, H. Beaudoin, P.-A. Chatagnon, François Michel, Henri Faure, Paul Renard, André Requet, Leo Navratil, Alfred Bader. They all formed an important network of researchers and donors of Art Brut.

20. Except for the doctors, the network in France was made up of, among others, Gaston Puel, Raymond Fleury, and Ludovic Massé; in Italy Lorenza Trucchi and Gabriele Stocchi; in Yugoslavia Aleksa Celebonovic.

21. Dubuffet, letter to Dr. R. Gentis, Le Touquet, August 23, 1963 (Archives of the Collection de l'Art Brut, Lausanne).

22. Dubuffet, "Les télégrammes de Charles Jauffret," *Art Brut* 3 (1965), 97.

23. Dubuffet, letter to M. Thévoz, Paris, April 15, 1981, *Prospectus et tous écrits suivants*, vol. 4 (Paris: Gallimard, 1995), 404.

24. Among the painters and drawers were Carlo, Jules Doudin, Jean Radovic, Madge Gill, Laure Pigeon, Vojislav Jakic, Augustin Lesage, Gustav, Joseph Vignes and Jane Ruffié, Émile Josome Hodinos; among the "sculptors": Émile Ratier, Clément Fraisse, the Prisonnier de Bâle, André Robillard and Giovanni Battista Podestà; among the seamstresses and embroiderers: Madge Gill and Marguerite Sir; among the builders of environments and statuary worlds: Camille Renault and Filippo Bentivegna; among the writers and poets: Laure Pigeon, Jules Doudin, Jeanne Tripier, Émile Josome Hodinos, and Aimable Jayet.

25. P. Maunoury, from the interview cited above with L. Peiry.

26. Dubuffet, letter to Eric Estorick, Paris, December 20, 1968 (Archives of the Collection de l'Art Brut, Lausanne).

27. A sculpture by Forestier was purchased by Dr. J. Oury's intermediary in 1963; Maisonneuve's masks were sold by Edmond Bomsel in 1963; Hernandez's paintings were sold by M. Mateo in 1963; the Furstenberg Gallery bought Scottie Wilson's drawings in 1961. Around forty of Pujolle's works were donated to the collections in 1963 by Dr. Aimé Perret and through the purchase of a dozen paintings owned by Dr. G. Ferdière. The collection of works by Paul End, Alcide, Gaston Duf, Sylvain Lec, Stanislas Lib—Dr. Paul Bernard's patients—expanded the second Compagnie's collections. The Prisonnier de Bâle's sculptures were given in 1962 by the prison warden thanks to Dr. Louis Lambelet.

28. See the *Complément (pour mise à jour) à la Notice sur la Compagnie de l'Art Brut*, April 30, 1966 (Archives of the Collection de l'Art Brut, Lausanne).

29. Dubuffet, letter to Frédéric Baal, Paris, July 26, 1970 (Archives of the Collection de l'Art Brut, Lausanne).

30. Dubuffet, unpublished interview with John M. MacGregor (Collection de l'Art Brut, Lausanne) and letter to Pierre Carbonel, Paris, May 13, 1964, *Lettres à un animateur de combats de densités liquides* (Paris: Hesse, 1992), 11.

31. These three transactions took place in 1963, 1968, and 1974.

32. Dubuffet, letter to Dr. R. Genti, Vence, April 15, 1964 (Archives of the Collection de l'Art Brut, Lausanne).

33. See the *Registre d'entrée, acquisitions*, vols. 1-5, and the correspondence files (Archives of the Collection de l'Art Brut, Lausanne).

34. Dubuffet, letter to Dr. R. Gentis, Le Touquet, August 23, 1963 (Archives of the Collection de l'Art Brut, Lausanne).

35. See Dubuffet, *Prospectus et tous écrits suivants*, vol. 4 (Paris: Gallimard, 1995), 658.

36. Dubuffet, letter to Dr. P. Maunoury, Paris, July 1, 1963 (Archives of the Collection de l'Art Brut, Lausanne).

37. See Jacques Dauchez's analysis and advice (notary, member of the Conseil Consultatif de la Collection de l'Art Brut and president of the Fondation Jean Dubuffet) in a letter to L. Peiry, Paris, September 22, 1995 (L. Peiry's Archives, Lausanne). Laurent Schweizer's opinion is that the rights revert to the artist even if he is unable to understand what he is entitled to: "In no case would the patient's legal representative be allowed under law to dispose of his client's work. The patient's ideal rights, as artist, are exclusive of any representation" (letter to L. Peiry, November 24, 1995, L. Peiry's Archives, Lausanne). See L. Schweizer, *De la production et de l'exploitation des oeuvres des beaux-arts du patient soigné en établissement psychiatrique*, diss. (Zurich: Schulthess Polygraphischer Verlag AG, 1995), 279. Furthermore, Schweizer claims the patient has the right to "freely enjoy his work even to the point of destroying it during his completing of it or upon its completion" (op. cit., 84).

38. Articles L. 111-1 and L. 121-1 of the *Code de la propriété intellectuelle* (1957 law), edited by Yves Marcellin (Paris: Cedat, 1995).

39. See J. Porret-Forel, *Aloïse ou le Théâtre de l'Univers* Geneva: Skira, 1993), 24.

40. A. Requet, letter to Dubuffet, Bron, March 25, 1962 (Archives of the Collection de l'Art Brut, Lausanne).

41. A. Requet, "Sylvain Fusco," *Art Brut* 11 (1982), 34.

42. Porret-Forel, op. cit., 22. During her medical studies, Porret-Forel was introduced to Aloïse's work by Professor Hans Steck. She wrote her doctoral dissertation [1953] on Aloïse (*Aloïse ou la Peinture magique d'une schizophrène* [Lausanne: Jaunin, 1953]) and wrote a fascicle for publication by the Compagnie in 1966 (*Art Brut* 7).

43. Dubuffet, letter to Dr. A. Requet, Paris, March, 4, 1962 (Archives of the Collection de l'Art Brut, Lausanne).

44. Dubuffet, "Miguel Hernandez" and "Les dessins médiumniques du facteur Lonné," *Art Brut* 1 (1964), 65 and 49.

45. Dubuffet, letter to Dr. J. Oury, Paris, January 28, 1962 [1963 or 1964] (Archives of the Collection de l'Art Brut, Lausanne).

46. Victor Musgrave, "Scottie Wilson" and Jean Dequeker, "Guillaume," *Art Brut* 4 (1965), 7 and 68.

47. Dubuffet, letter to Charles Gimpel, Paris, December 14, 1962 (Archives of the Collection de l'Art Brut, Lausanne).

48. Dubuffet, letter to Dr. J. Oury, Paris, January 28, 1962 [1963 or 1964] (Archives of the Collection de l'Art Brut, Lausanne).

49. Dubuffet, letter to Dr. J. Dequeker, Paris, February 18, 1965 (Archives of the Collection de l'Art Brut, Lausanne).

50. Dubuffet, letter to Dr. V. Andreoli, Le Touquet, September 19, 1965 (Archives of the Collection de l'Art Brut, Lausanne). V. Andreoli immediately accepted these deletions.

51. The monographs begin with a photographic portrait of the artist, followed by reproductions of his works (between ten and eighty). Each fascicle contained between 140 and 190 pages. The first printing was 1,500 copies.

52. Dubuffet, "Heinrich Anton M.," *Art Brut* 1 (1964), 131. Dr. Gentis was of the same opinion as Dubuffet. He wrote: "Her [Marguerite Sirvin's] identity, as with all of the artists at Saint-Albanais, should have been kept secret and actually should not have been published—for this reason she is listed as Marguerite S. in *L'Art Brut*. I do not know how or when her surname was revealed, but to be honest I am not upset: I do not see why one would want to conceal an artist's madness. There is no shame in it. Thank God; Camille Claudel and Aloïse Corbaz, to mention the most publicized cases, are examples that seem to have finally put an end to this hypocrisy, and at the very least can most assuredly be credited to the Art Brut movement" (letter to L. Peiry, Bizac, November 4, 1995, L. Peiry's Archives, Lausanne).

53. M. Edelmann interviewed by L. Peiry.

54. The publishing house Hachette was responsible for distribution, and the Compagnie became a distributor as well. The requests were numerous. *L'Art Brut* was gradually distributed in France, Switzerland, Belgium, Germany, the Netherlands, Spain, and Italy.

55. Philippe Dhainaut, "L'Art Brut," *Cahiers du Sud* (October 8, 1965), 383–84.

56. Geneviève Bonnefoi, "L'Art Brut," *La Quinzaine littéraire* (June 1, 1966).

57. Ibid. However, Werner Spies reproached Dubuffet for omitting any discussion of the emergence of Art Brut and for never mentioning pioneers such as Hans Prinzhorn or artists who were interested in this type of art, such as Eluard, Ernst, and Breton ("Genie und Irrtum," *Frankfurter Allgemeine Zeitung* [May 16, 1967]).

58. Dubuffet, letter to Dr. A. Bader, Paris, May 14, 1974, in *Prospectus et tous écrits suivants*, vol. 4 (Paris: Gallimard, 1995), 337.

59. Dubuffet, letter to Robert O'Neil, Paris, December 31, 1967, ibid., 562.

60. Dubuffet, letter to Dr. Mario Berta, Paris, September 17, 1972, ibid., 326–27.

61. Dubuffet, letter to Dr. J. Porret-Forel, Vence, April 11, 1964 (Archives of the Collection de l'Art Brut, Lausanne).

62. Dubuffet, "Place à l'incivisme," *Prospectus et tous écrits suivants*, vol. 1 (Paris: Gallimard, 1967), 456.

63. Dubuffet, "La Compagnie de l'Art Brut" (1963), announcement, *ibid.*, 167.

64. Dubuffet, letter to J. Berne, Paris, February 3, 1972, *Lettres à J. B., 1946-1985* (Paris: Hermann, 1991), 249.

65. Dubuffet, "Pièces d'arbre historiées de Bogosav Zivkovic," *Art Brut* 8 (1966), 123.

66. Dubuffet, letter to J. Berne, Paris, February 3, 1972, op. cit., 249.

67. Dubuffet, letter to Pierre Geering, Paris, July 10, 1969, *Prospectus et tous écrits suivants*, vol. 4 (Paris: Gallimard, 1995), 272.

68. Dubuffet, letter to Pierre Domec, January 13, 1968, ibid., 229.

69. Dubuffet, "Batons rompus," *Prospectus et tous écrits suivants*, vol. 3 (Paris: Gallimard, 1995), 160. Some of the artists, such as Wölfli, Wilson, Forestier, and Podestà, could be considered as exceptions. They displayed an interest in the display and sale of their work. They departed from the conventional ways of doing things and spurned the traditional system of distribution: Wilson would take his works on the road and show them at fairs or in abandoned shops. Podestà mounted informal exhibitions on the street without official permission.

70. Dubuffet, letter to Bernard and Ursula Schultze, Paris, December 25, 1964 (Archives of the Collection de l'Art Brut, Lausanne).

71. Dubuffet, letter to Raphaël Lonné, Le Touquet, July 23, 1963 (Archives of the Collection de l'Art Brut, Lausanne).

72. Dubuffet, letter to Magali Herrera, Paris, September 27, 1968 (Archives of the Collection de l'Art Brut, Lausanne).

73. Dubuffet, letter to P. Carbonel, Paris, July 8, 1966, op. cit., 16.

74. Dubuffet, letter to P. Dereux, Paris, January 28, 1963 (P. Dereux's Archives, Villeurbanne); letter to Ignacio Carles-Tolrà, Paris, January 31, 1976 (Ignacio Carles-Tolrà's Archives, Santander); letter to P. Dereux, Paris, April 28, 1963 (Archives of the Collection de l'Art Brut, Lausanne).

75. Dubuffet, letter to P. Carbonel, Paris, November 10, 1970, op. cit., 30.

76. Dubuffet, letter to Luc and Titi Parant, Paris, April 12, 1976, *Prospectus et tous écrits suivants*, vol. 4 (Paris: Gallimard, 1995), 615.

77. Dubuffet, letter to R. Lonné, Paris, October 15, 1970 (Archives of the Collection de l'Art Brut, Lausanne).

78. Dubuffet, letter to P. Geering, Paris, July 10, 1969, and letter to P. Domec, Paris, January 13, 1968, *Prospectus et tous écrits suivants*, vol. 4 (Paris: Gallimard, 1995), 272 and 229.

79. Dubuffet, in *Connaissance des arts*, June 1967 (published under the title "Ma donation au musée des Arts décoratifs" in the donation catalogue, *Les Dubuffet de J. Dubuffet*, Paris, 1992, 13, and "Dubuffet au musée," *Prospectus et tous écrits suivants*, vol. 4 [Paris: Gallimard, 1995], 23–24).

80. Around 500 people a day visited the show (by comparison, the Bonnard exhibition in Paris drew roughly 2,500 a day while Picasso averaged about 6,000). Visitors were mostly young people, doctors, sociologists, students, artists, writers, and art lovers (see Jean-Pierre Crespelle, "Expositions: à nouveau public, nouvelle présentation," *France Soir* [May 6, 1967]).

81. Dubuffet, letter to Dr. G. Ferdière, Paris, February 16, 1965 (Archives of the Collection de l'Art Brut, Lausanne).

82. F. Mathey interviewed by L. Peiry, Paris, June 24, 1988 (L. Peiry's Archives, Lausanne).

83. J.-P. Ledeur interviewed by L. Peiry.

84. F. Mathey interview with L. Peiry, cited above.

85. J. Dubuffet, letter to Pierre Dhainaut, Paris, June 28, 1970, *Prospectus et tous écrits suivants*, vol. 4 (Paris: Gallimard, 1995), 287–88.

86. Dubuffet, interviewed by J. M. MacGregor, "Art Brut chez Dubuffet. An Interview with the Artist. 21 August 1976," *Raw Vision* 7 (1993), 50. The 1960s saw some of Dubuffet's strongest attacks on culture: the Art Brut exhibition, the publication of his manifesto, "Place à l'incivisme," the appearance of *Prospectus et tous écrits suivants* vols. 1 and 2, and his virulent *Asphyxiante Culture*.

87. Dubuffet, exhibition card, Basel, Beyeler Gallery, undated [1965].

88. Claude Lebensztejn, *Zigzag* (Paris: Flammarion, 1981), 35.

89. Dubuffet in *Connaissance des arts* (June 1967).

90. Dubuffet, letter to P. Carbonel, Paris, February 6, 1970, in *Prospectus et tous écrits suivants*, vol. 4 (Paris: Gallimard, 1995), 613.

91. André Nakov, "L'Art Brut à Paris," *Gazette de Lausanne*, April 15, 1967.

92. Jean-François Chabrun, "L'art des consciences perdues," *Nouveau Candide*, May 1, 1967.

93. Anya Méot, "Le génie commun de Jean Dubuffet," *Valeurs actuelles*, April 13, 1967; J.-J. Fouché, "La brutalité des 'oeuvres,'" *Réforme*, April 22, 1967.

94. Gilbert Lascault, "Situation de l'Art Brut," *Les Temps modernes*, May 1967; Claude Lévi-Strauss, *La Pensée sauvage* (Paris: Plon, 1962), 289.

95. Claude Esteban, "L'art dépossédé," *Nouvelle Revue française* 174 (June 1, 1967).

96. F. Mathey, "L'Art Brut," *La Quinzaine littéraire* (April 15–30, 1967).

97. Paul Waldo Schwartz, "The Art of the Insane. A Pertinent Message," *The New York Times* (April 11, 1967); François Pluchart, "L'Art Brut remet en question notre conception de l'histoire," *Combat* (April 10, 1967).

98. Dubuffet, letter to Lionel Miskin, Paris, September 27, 1970 (Archives of the Collection de l'Art Brut, Lausanne).

99. Harald Szeemann later mounted the following major exhibitions: "Wenn Attitüden Form werden. Leben im Kopf," 1969; Documenta 5, Kassel, 1972; "Junggesellenmaschinen," 1975; "Monte Verità. Die Brüste der Wahrheit," 1978; "Visionäre Schweiz," 1991–92.

100. The retrospective was mounted in 1961 and 1962: Musée Cantonal des Beaux-Arts, Lausanne; Aargauer Kunsthaus, Aargau; Museum am Ostwall, Dortmund; Kunsthalle, Recklinghausen; Braunschweiger Kunstverein, Braunschweig; Heidelberger Kunstverein, Heidelberg. Between 1960 and 1970, around twenty exhibitions were devoted to Soutter in Lausanne, Geneva, Neuchâtel, Fribourg, Lucerne, Zurich, Berne, and Saint-Gall.

101. The author wanted to title his book *Art Brut*, but he had to invent his own term, Outsider Art, which is now widely used in anglo-saxon countries.

102. [Anonymous], "Théâtre brut," *Le Nouvel Observateur* (March 13-19, 1968). The performances were scheduled for December 28, 29 and 30, 1968.

103. Hubert Damisch, "L'Art Brut" (Paris: Encyclopedia Universalis, 1968); M. Lépine, "L'Art Brut" (Compagnie de l') (Paris: Larousse, 1970); José Pierre, "Le surréalisme," *Historie générale de la peinture* (Lausanne: Rencontre), XXI; Elka Spoerri, introduction to Adolf Wölfli in

Künstler Lexikon der Schweiz XX. Jahrhundert, ed. Eduard Plüss and Hans Christoph von Tavel, vol. 2 (Frauenfeld: Huber, 1958–67).

104. Dubuffet, *Communication aux membres de la Compagnie de l'Art Brut*, Paris, August 10, 1971 (Archives of the Collection de l'Art Brut, Lausanne).

105. See F. Mathey interviewed by L. Peiry. Concerning the propositions that he had received, Dubuffet was more specific: "It is not true, as journalists have claimed, that they [the collections] had been rejected by the French authorities; one can only say that no really satisfactory offer for the management of these collections in France was made to me and several factors—beginning with the most important one which is that there were works from Switzerland—supported this solution" ("Biographie au pas de course," *Prospectus et tous écrits suivants*, vol. 4 [Paris: Gallimard, 1995], 533–34). Moreover, he wrote: "The public authorities in France did not have a chance to turn this gift down because it had never been offered to them. I deliberately offered it to Lausanne, which was my preference . . . What had been turned down was our previous request for a declaration of state-approved status (DUP). This refusal was obviously one of the reasons which convinced me to accept the city of Lausanne's offer" (letter to Madeleine Lommel, Paris, June 28, 1983, Archives of the Collection de l'Art Brut, Lausanne.)

106. Dubuffet, *Communication aux membres de la Compagnie de l'Art Brut*, Paris, August 10, 1971 (Archives of the Collection de l'Art Brut, Lausanne).

107. Dubuffet, letter to Georges-André Chevallaz, Paris, July 10, 1972 (Archives of the Collection de l'Art Brut, Lausanne).

108. Jacques Michel, "Jean Dubuffet parle de sa donation d'Art Brut à Lausanne," *Le Monde*, September 15, 1971.

109. Together with his wife, Caroline, Alain Bourbonnais pursued his venture in Dicy (Yonne) with the opening of La Fabuloserie in 1983; see Laurent Danchin, "Dicy, Alain Bourbonnais (1925-1988)," *Artension* 5 (August 1988).

110. Dubuffet, letter to P. Carbonel, Paris, September 17, 1969, op. cit., 23, and letter to I. Carles-Tolrà, Paris, August 20, 1969 (Ignacio Carles-Tolrà's Archives, Santander).

111. During the second Compagnie's ten-year existence, Dubuffet always insisted on the exclusiveness of the name, which he invented. "L'Art Brut" designated the organization, the monographic works, and the collections of works. "This name can be protected by virtue of laws governing corporations and by virtue of laws governing the rights of authorship (literary and artistic property)," the lawyer Éric Charpentier stated in a letter addressed to Dubuffet, Paris, August 23, 1965 (Archives of the Collection de l'Art Brut, Lausanne).

112. Dubuffet, letter to M. Thévoz, Paris, September 15, 1975 (Archives of the Collection de l'Art Brut, Lausanne).

Chapter 5
An Antimuseum

1. Michel Thévoz interviewed by Esther González Martínez, Lausanne, October 15, 1993 (E. G. Martínez's Archives, Lausanne), and "Le sémioticien ventriloque," *Analyser le musée*, a collection of articles from the international conference of the Association Suisse de Sémiotique, Neuchâtel, Centre de Recherches Sémiologiques, 1996, 149–53.

2. Michel Thévoz, *Requiem pour la folie* (Paris: La Différence, 1995), 67.

3. Only the exterior of the building is classified as historic and is therefore under the control of the canton of Vaud's historical monuments commission. The redesign of the interior had to be carried out without altering the integrity of the building's original design. The west wing of the mansion is devoted to the Collection de l'Art Brut and is divided into three parts: the old loft serves as an exhibition space (1,800 sq. ft.), the south part of the wing is set aside for offices and a study, which are open to researchers (500 sq. ft.), and the sloped roof to the north provides an entrance hall to the museum. See *Château de Beaulieu. Collection de l'Art Brut*, notice 116, Lausanne, March 23, 1976. The city of Lausanne granted three million Swiss francs for work on the Château de Beaulieu. In 1984, a major extension to the museum was built.

4. More than a thousand works are on permanent display (1,122 in April 1996).

5. Interview with M. Thévoz by E. González Martínez, op. cit.

6. Michel Thévoz, *Art, Folie, graffiti, LSD, etc.* (Lausanne: L'Aire, 1985), 79–80.

7. Dubuffet, quoted by André Kuenzi, "Jean Dubuffet: 'La petite fille n'a plus de confiture sur le nez!'" *24 Heures* (February 26, 1976).

8. Slavko Kopac interviewed by Lucienne Peiry, Paris, March 17, 1989.

9. Dubuffet, letter to M. Thévoz, Paris, March 21, 1976 (Archives of the Collection de l'Art Brut, Lausanne).

10. Interview with M. Thévoz by E. G. Martínez, op. cit.

11. Since its opening the museum has been directed by Michel Thévoz and Geneviève Roulin, his assistant; together, they have planned exhibitions, examined new discoveries, and agreed on new acquisitions. Their findings are submitted to an advisory council, which, according to the bylaws, is supposed to "maintain the spirit that presided over the establishment of the collections of Art Brut" (*Château de Beaulieu. Collection de l'Art Brut*, op. cit., art. 6). Upon the inauguration of the museum, a council of seven members was formed: Jean Dubuffet, Michel Thévoz, Jacqueline Porret-Forel, Étienne Porret, Slavko Kopac, Bernard Vouga, and Jean Planque. At the time of this book's first edition, Jacques Dauchez had taken over the presidency of this body; Geneviève Roulin and Bernard Chevassu were also part of the council, while John M. MacGregor and Lucienne Peiry had been appointed as consulting members. All of these people supported M. Thévoz and G. Roulin rather than issue directives to them, and were normally informed rather than consulted about decisions concerning acquisitions, exhibitions, and publications. The city of Lausanne allocates two and a half positions to the museum and the curator is a 50% position, excluding museum staff who work in reception, security, and maintenance. The Collection de l'Art Brut had an operational budget of 400,000 Swiss francs in 1976, wages included; it had risen to 581,500 Swiss francs by 1997.

12. M. Thévoz's remarks recorded by Catherine-France Borrini in "À la brocante de l'âme," *L'Hebdo* (February 6, 1986). Still, a number of exhibitions have drawn thousands of visitors and some of the artists have become known in

their own right as major artists—Wölfli, Aloïse, Krüsi, Traylor, Lesage, and Hill. "Les Obsessionels," which included Teuscher's agoraphilic works, Lamy's mascarades, and Bonjour's idyllic mountains, drew record crowds. The exhibitions ran for three or four months at a time; the recorded attendance fluctuated between 5,000 to 6,700 visitors (a ticket to an exhibition permitted guests to view the permanent collection and the temporary show).

13. Minutes of the Collection de l'Art Brut advisory council's meeting on October 21, 1975 (Archives of the Collection de l'Art Brut, Lausanne).

14. Dubuffet, letter to M. Thévoz, Paris, October 26, 1975 (Archives of the Collection de l'Art Brut, Lausanne).

15. M. Thévoz retorted that this requirement has not embarrassed them: "The truth is the opposite: it works out well for us. It prevents us from lending works and from having to take precautions. We are lucky to have this requirement to refer to; it has made our work easier" (thesis defense, Lausanne, September 5, 1996, L. Peiry's Archives, Lausanne).

16. Reaction by a visitor recorded by E. González Martínez, "Le Visiteur à l'oeuvre," master's thesis in sociology and anthropology, University of Lausanne, 1994, 50.

17. M. Thévoz interviewed by Jean-Christophe Aeschlimann, "L'art d'inventer," Construire 11 (March 11, 1987). On this subject, M. Thévoz wrote to Dr. Leo Navratil: "Visitors who come to see the Collection de l'Art Brut for the first time are almost always enthusiastic. But one can distinguish between two sorts of enthusiasm. The first sort usually say, 'Wölfli, Laure or Aloïse deserve to be in a museum alongside the likes of Dufy or Picasso'; it is a sign of respect based on established values and a somewhat paternalistic attitude toward the Art Brut artists. The other sort of reaction consists in saying, 'The Collection de l'Art Brut is not like anything else; here is art in all its power and authenticity. In comparison, traditional museums seem a little bland and lifeless.' The visitors who react like those in the second group are becoming more numerous and I believe that they are right" (April 1979, Archives of the Collection de l'Art Brut, Lausanne).

18. See Nathalie Heinrich's analysis, "Un événement culturel," Les Immatériaux, exh. cat. (Paris: Centre Georges Pompidou, Expo Média, 1986), 84.

19. Guest book for the Collection de l'Art Brut, 3 (Archives of the Collection de l'Art Brut, Lausanne).

20. Interest is growing: the number of visitors has doubled in twenty years (15,000 visitors in 1976). Today, the museum welcomes on average seventy visitors a day.

21. M. Thévoz, letter to the director of the Centre Régional de Formation des Maîtres de Besançon, Lausanne, June 6, 1991 (Archives of the Collection de l'Art Brut, Lausanne).

22. Interview with M. Thévoz by E. G. Martínez, op. cit.

23. Jacques Michel, "Les derniers 'peintres maudits' à Lausanne," Le Monde, February 24, 1976; Philippe Barraud, "Le château de Beaulieu deviendra 'l'Institut de l'Art Brut,'" La Nouvelle Revue de Lausanne (September 1, 1972); A. Kuenzi, "La ville des occasions manquées?" La Gazette littéraire (May 29–30, 1971); P. Barraud, "L'Art Brut a offert à la Ville de Lausanne un don d'une valeur inestimable," 24

Heures (June 7, 1971); A. Kuenzi, "Collection de l'Art Brut. Ouverture 26 février au château de Beaulieu," 24 Heures (November 5, 1975); P. Barraud, "L'Art Brut a offert à la Ville de Lausanne un don d'une valeur inestimable," op. cit.; Hugo Verhomme, "Non-musée pour non-art," Les Nouvelles littéraires (March 4, 1976); [anonymous], "L'Art Brut; capitale: LAUSANNE," La Galerie (February 1976); Bernard Teyssèdre, "L'art des innocents massacrés," Le Nouvel Observateur (March 8, 1976).

24. [Anonymous], "L'Art Brut," L'Oeil (May 1976).

25. Remarks of Fabienne-Xavière Sturm, curator of the Musée de l'Horlogerie, recorded by C.-F. Borrini, "À la brocante de l'âme," L'Hebdo (February 6, 1986).

26. Edmond Charrière, "Inauguration d'un nouveau musée à Lausanne. Qu'est-ce que l'Art Brut?" La Tribune de Genève (March 3, 1976).

27. Jean-Claude Poulin, "Asphyxiante éducation?" Journal de Genève and Gazette de Lausanne (March 14, 1976).

28. Françoise Jaunin, "Art Brut en question," La Tribune de Genève, (March 7, 1976).

29. P. M., "Les Suisses au sommet de la capitale," Le Figaro (March 5, 1977); [anonymous], "Ça va pas la tête?" Libération (August 7, 1982).

30. P. H., "Scottie à l'Art Brut," Gazette de Lausanne (December 28, 1977); J.-C. Aeschlimann, "L'art d'inventer," Construire 11 (March 11, 1987).

31. Frédéric Pajak, "Brut de brut," Passeport pour l'Art Brut (1986).

32. M. Thévoz, extract from the text on an invitation to the exhibition "Acquisitions 1980" (Archives of the Collection de l'Art Brut, Lausanne).

33. M. Thévoz, Collection de l'Art Brut Lausanne, leaflet on the Collection de l'Art Brut, 1976 (Archives of the Collection de l'Art Brut, Lausanne).

34. Dubuffet, letter to Herbert Eckert, Paris, November 15, 1976 (Archives of the Collection de l'Art Brut, Lausanne).

35. M. Thévoz, Requiem pour la folie (Paris: La Différence, 1995), 50 and 33.

36. Gugging was opened in 1981 by the psychiatrist Leo Navratil, who was succeeded by Johann Feilacher in 1986. La Tinaia was established in 1975 by the artist Massimo Mensi; after his death in 1990, his widow Dana Simionescu took charge of the organization.

37. M. Thévoz, "La Tinaia," Art Brut 17 (1992), 136–38. According to M. Mensi's article (ibid., 129–37), artistic independence is far from being fully achieved: "We had become 'teachers' or 'professors' and our advice was taken more and more often," he wrote (131). Those in charge utilized "therapeutic strategies" and, during the 1980s, the "art laboratory" implemented a method of work that "was essentially based on the experiments by avant-garde twentieth-century artists, particularly those from the expressionist and surrealist movements" (136).

38. M. Thévoz, Art Brut 12 (1983), 9.

39. In this regard, see J. M. MacGregor, "Marginal Outsiders: On the Edge of the Edge," Portraits from the Outside: Figurative Expression in Outsider Art, exh. cat. (New York: Parsons School of Design, 1990), 18. See also Allen S. Weiss, Shattered Froms, Art Brut, Phantasms, Modernism

(New York: State University of New York Press, 1992), 67–76. M. Thévoz has challenged the diagnosis of these creators: "Aloïse, Wölfli, Walla are not ill. Anyone who has set out to express themselves through painting, music or literature, with or without success, has been able to weigh the dangers of such an undertaking. A work of art is just as complex in its creation as a scientific theory. Even more complex. It concerns mastering a highly complex system of expression and even going beyond mastery in order to reach a level of authentic invention. That suggests the possession of mental faculties that are beyond the norm. If you are absolutely determined to apply this label, then you have to apply it to those who have lost their artistic faculties as well . . . If there are any people who are mentally ill in the museum, they are not the ones who created a work of art, they are the visitors" (Letter to Roman Buxbaum, Lausanne, November 10, 1989, Archives of the Collection de l'Art Brut, Lausanne).
40. M. Thévoz, *Requiem pour la folie* (Paris: La Différence, 1995), 55.
41. Ibid., 52–53.
42. M. Thévoz, "Edmund Monsiel," *Art Brut* 11 (1982), 62. Even though M. Thévoz maintains that Monsiel's religiosity exhausts itself through repetition, his representations—redundant as they may be—are no less an indication of it.
43. Schulthess's work inspired Max Frisch's novel, *Der Mensch erscheint im Holozän* (1979).
44. M. Thévoz, letter to Vittorino Andreoli, Lausanne, July 28, 1992 (Archives of the Collection de l'Art Brut, Lausanne).
45. These acquisitions make up the works in the Collection de l'Art Brut and the Collection Neuve Invention (15,000 and 5,000 respectively, as of 1996).
46. For some years, Robillard has nonetheless preferred to receive some money. This change came about after his exhibition in Susanne Zander's prestigious gallery in Cologne, Germany, where such transactions were not the practice. Still, Robillard seems to have developed a taste for money. Other creators have also changed their minds after meeting collectors and dealers. Benjamin Bonjour learned that his drawings could be exchanged for money and sells them today for a few francs apiece. As for Ted Gordon, he has been overwhelmed by attention from collectors and artists, to the extent that he asked Geneviève Roulin not to give out his address. This attention embarrasses him and he feels smothered by all of the "flattering letters" he gets from collectors and artists. See Ted Gordon's letters to G. Roulin, Laguna Hills, November 13, 1995, and December 15, 1995 (Archives of the Collection de l'Art Brut, Lausanne). Willem Van Genk has been reluctant to let go of his own works, some of which he has hidden under his bed. He has nevertheless agreed to part with some so that they could be hung in a museum. "Van Genk created his compositions for himself and not for an audience. Despite the urgent offers of many dealers, he has refused to sell them to private individuals. He is aware that his work might be admired by many people, but he cannot get used to the idea that his works can be part of a commercial transaction" (M. Thévoz, unpublished document, Archives of the Collection de l'Art Brut, Lausanne).

47. Around 70% of the works in the museum were donated; a letter from the curator is all that is needed to make it official. As a sign of its gratitude, the museum sends to the creators a sum of money to cover their expenses for materials. For example, 1,400 Swiss francs were given to Mayor in 1995 in exchange for his works; 4,000 Swiss francs were allotted to Olivier Cuendet in exchange for drawings by Failloubaz.
48. Many doctors have provided major works. V. Andreoli passed on Carlo's paintings; A. Requet donated Fusco's pastels; and Benedikt Fontana sculptures by Pankoks. Alfred Bader parted with works by Radovic, Doudin, and Hauser among others; and L. Navratil and later J. Feilacher contributed those by Walla, Kernbeis, and Schöpke. Jacqueline Porret-Forel and Eva Steck-Dürenmatt generously provided a large body of works by Aloïse. Other persons, parents or friends who were close to the creators, have donated works to the museum: Albert Dasnoy contributed drawings by Léontine; Franz Stelzig gave paintings by Wittlich; and Adèle Garabédian costumes by Poladian. More recently, Christiane Coinchon and Lilian Bürki have contributed works by Mayor and Trösch; Nathan Lerner donated a number of watercolors by Darger. If the curators at first refrained from mentioning the names of donors in connection with the works on display, they have since adopted this practice in order to thank the contributors for their donation and to encourage other likeminded individuals to do the same.
49. Since 1990, the Collection de l'Art Brut has had an acquisitions budget at its disposal. In 1990, it amounted to 7,500 Swiss francs; in 1995 it exceeded 20,000 Swiss francs. Exchanges of works are made involving items from the museums holdings that are entirely separate from the Collection de l'Art Brut, which is left intact.
50. He goes on: "We have had a certain tendency (let's be honest) to apply this label to those who have come from psychiatric hospitals and to deny it to those whose lives are rather normal socially. But it is, without doubt, a shortcoming to be avoided" (Dubuffet, letter to M. Thévoz, Paris, October 6, 1982, Archives of the Collection de l'Art Brut, Lausanne).
51. M. Thévoz, letter to M. Bouscaillou, Lausanne, September 4, 1991 (Archives of the Collection de l'Art Brut, Lausanne).
52. M. Thévoz, letter to A. Bader, Lausanne, June 30, 1986: letter to Dubuffet, Lausanne, October 14, 1982 (Archives of the Collection de l'Art Brut, Lausanne). The Neuve Invention department functions on occasion as a sort of "waiting room."
53. M. Thévoz, letter to Françoise Brutsch, Lausanne, February 28, 1986 (Archives of the Collection de l'Art Brut, Lausanne). Independence from cultural settings is no longer as important as it once was; a creator—according to Thévoz and Roulin—can be in contact with the art market today without having to conform to official art and without it comprising his work.
54. The collection's name change was initiated by Dubuffet. In a letter to M. Thévoz, he suggested "looking for a name like 'Open Collection' ['Collection CHAMP LIBRE'] or the 'New Sources' collection ['collection NOUVELLES SOURCES']"; in a postscript he suggested

"collection NEUVE INVENTION" (letter to M. Thévoz, Paris, October 23, 1982, Archives of the Collection de l'Art Brut, Lausanne).

55. M. Thévoz, *Neuve Invention*, Collection de l'Art Brut, Lausanne, 1988, 8.

56. M. Thévoz, letter to Claudia Sattler, Lausanne, February 1, 1994 (Archives of the Collection de l'Art Brut, Lausanne).

57. M. Thévoz, minutes from the advisory council's meeting, Lausanne, October 7, 1988 (Archives of the Collection de l'Art Brut, Lausanne).

58. When the collections were donated to Lausanne, the Neuve Invention collection numbered around 1,300 works; as of 1996 there were roughly 5,000. The collection had nearly quadrupled in size in twenty years.

59. The notions of "inventiveness" or "smugglers," "unorthodox position" or "institutional and cultural protest" remain general and imprecise.

60. M. Thévoz interviewed by Gérard Preszow, "Quelques questions à Michel Thévoz," *L'Art Brut et après . . . expériences et réflexions (Suisse, France, États-Unis, Grande-Bretagne, Belgique)*, an anthology of articles gathered by G. Preszow, ed. Françoise Henrion (Brussels: Art en Marge, 1988), 51.

61. Upon S. Kopac's request, and with the backing of the city of Lausanne, all of the works in the Collection Neuve Invention were part of an exceptional donation to the Prostor Museum in Zagreb in January 1993. Many works by artists in this collection are lent by the museum for exhibitions at cultural institutions in various countries. The rule that prevents the lending of works of art does not apply to those in the Collection Neuve Invention.

62. Following the example of the Compagnie de l'Art Brut, the Collection de l'Art Brut has become its own publishing house and distributor. With the exception of Doudin and Jakic, all the artists who have been presented are new ones. The printing continues on a small scale and has grown from 1,500 copies to 2,000.

63. Those who did not actually know the artists had to go and conduct their investigations in the area where the artist once lived, seeking information among their parents and close friends: the daughter of François Portrat, Louise Fischer's friends, Giovanni Battista Podestà's family have all provided valuable information. Their personal testimonies have often become part of a monograph—as is the case with Olivier Cuendet in the essay on Failloubaz or Joseph Podda in the study on Poladian.

64. Pascal Sigoda, "Camille Renault et le jardin des surprises," *Art Brut* 14 (1986), 126; M. Thévoz, "Gaston Teuscher," *Art Brut* 10 (1977), 76; Roger Gentis, "André Robillard," *Art Brut* 11 (1982), 68.

65. Gentis, op. cit., 68; Thévoz, "Gaston Teuscher," op. cit., 77–78; Guy Filippa, "Aloïs Wey," *Art Brut* 11 (1982), 39.

66. M. Thévoz, letters to A. Bader and L. Navratil, Lausanne, December 13, 1982 (Archives of the Collection de l'Art Brut, Lausanne).

67. John M. MacGregor, Thomas Breymann, Roger Cardinal, Luc Debraine, Lise Maurer, Florence Choquard Ramella, and Lucienne Peiry, etc.

68. M. Thévoz, letter to Lise Maurer, Lausanne, April 22, 1995 (Archives of the Collection de l'Art Brut, Lausanne).

69. M. Thévoz is the author of the best-known book on this subject, *L'Art Brut* (Geneva: Skira, 1975 and 1995). For different translations see the bibliography.

70. M. Thévoz, *Le Langage de la rupture* (Paris: PUF, 1978), 13.

71. Pierre Enkell, "Je ne parviens pointement à m'exprimer," *Nouvelles littéraires*, March 29, 1979; Henri-Charles Tauxe, "Les écrits bruts," *24 Heures*, February 16, 1979.

72. M. Thévoz, letter to Krystyna Kotula, Lausanne, September 5, 1995 (Archives of the Collection de l'Art Brut, Lausanne).

73. Roger Cardinal, "Singular Visions," *Outsiders. An Art without Precedent or Tradition*, exh. cat. (London: Hayward Gallery, Arts Council of Great Britain, 1979), 22–23.

Chapter 6
Affinities and Influences

1. Raymonde Moulin, "Les marges de l'art populaire," *Les Singuliers de l'art. Des inspirés aux habitants paysagistes*, exh. cat. (Paris: Musée d'Art Moderne de la Ville de Paris, ARC 2, 1978). The title of this exhibition gave birth to the name "art singulier" ["singular art"].

2. Suzanne Pagé, "Introduction," ibid.

3. "Les Outsider Archives," *L'Art Brut et après . . . expériences et réflexions (Suisse, France, États-Unis, Grande-Bretagne, Belgique)* (Brussels: Art en Marge, 1988), 31. The exhibition was organized by Victor Musgrave and Roger Cardinal.

4. Laurent Danchin, *Art Brut et Compagnie. La face cachée de l'art contemporain* (Paris: La Différence, 1995), 9. The Outsider Archives (recently transferred to Dublin) opened in London in 1981; Gugging in Klosterneuburg in 1982; La Fabuloserie in Dicy in 1983; L'Aracine in Neuilly-sur-Marne in 1984 (association founded in 1982); Art en Marge in Brussels in 1985; the Museum im Lagerhaus in Saint-Gall in 1988; Art Cru Muséum in Monteton in 1988; Le Site de la Création Franche in Bègles in 1990. Other places exist with a similar mission, such as the Petit Musée du Bizarre in Lavilledieu (1969); the collection Röthlisberger in Davos (1980); the Museum of Naïve and Outsider Art in Zwolle (1994); Eric Cunningham's collection of psychiatric art in Melbourne (1987); the American Visionary Art Museum in Baltimore (1995). This is not an exhaustive list. Most of the organizations are private, except for L'Aracine, which acquired its status in 1986 as a member of the museums under the direction of the Musées de France.

5. "Outsider Art" has turned out to be the best equivalent in English for the name "Art Brut." According to John M. MacGregor, "The English term has the disadvantage of directing attention to the creators of Art Brut, the art of 'Outsiders,' whereas Art Brut implies no reference to its makers" ("Marginal Outsiders: On the Edge of the Edge," *Portraits from the Outside: Figurative Expression in Outsider Art* [New York: Parsons School of Design, 1990], 18.) On the other hand, Allen S. Weiss believes that "the term *outsider art* is more precise than Art Brut because . . . the word *brut* seems to denote a pictorial aspect about the works in question which are not 'brut' nor 'crude'" (*Shat-*

tered Froms, Art Brut, Phantasms, Modernism [New York: State University of New York Press, 1992], 69). Evidently, "Outsider Art" calls attention to its difference while "Art Brut" is a name in itself. Paradoxically, works by the same creator, such as Podestà or Ratier, are designated as Art Brut in one collection and Outsider Art in another.

6. Caroline Bourbonnais, "La Fabuloserie," *L'Oeuf sauvage* 2 (December 1991–January 1992).

7. See Gérard Preszow, "Art Brut et Compagnie. Une visite guidée," *L'Art Brut et après . . . expériences et réflexions (Suisse, France, États-Unis, Grande-Bretagne, Belgique)* (Brussels: Art en Marge, 1988), 279. L'Aracine closed its doors in 1996 in Neuilly-sur-Marne. The collection was transferred to the Musée d'Art Moderne in Villeneuve-d'Ascq where space had to be made for its permanent display.

8. Through its an annual exhibition "Les Jardiniers de la mémoire," Le Site de la Création Franche plays more of a role in publicizing works than searching for them.

9. In return, some of the organizations have shared their discoveries with them and have helped in the Musée de l'Art Brut's acquisitions.

10. C. Bourbonnais, "La Fabuloserie," *L'Oeuf sauvage* 2 (December 1991–January 1992).

11. Dubuffet, letter to Alain Bourbonnais, Paris, February 28, 1974, quoted by Michel Ragon in his introduction to "*La Fabuloserie, Art hors-les-normes* (Paris: La Fabuloserie, 1983), 5, and letter to Madeleine Lommel, Paris, June 18, 1983 (Archives of the Collection de l'Art Brut, Lausanne).

12. Gérard Sendrey interviewed by Martine Lusardy in *Art Brut et Compagnie. La face cachée de l'art contemporain* (Paris: La Différence, 1995), 63; Bourbonnais, op. cit. The exhibition in Paris, "Art Brut et Compagnie," provided a good range of Art Brut pieces by presenting master works from various collections. It also included works of poor quality, which doubtless did harm to the concept of marginal creation.

13. Aside from L'Aracine which tried to duplicate the museum in Lausanne, each collection has its own purpose. However, exchanges between them could paradoxically result in a blurring of distinctions between them. Many works by familiar artists can already be found in most of the collections: Wölfli, Aloïse, Teuscher, Boschey, Podestà, Ratier, Wilson, Darger, Bonjour, Gordon, Robillard, Lonné, Nedjar, and more than a dozen artists from Gugging, as well as Burland, Carles-Tolrà, Sattler, Koczÿ, Verbena, Fillaudeau, Sanfourche, Chichorro, etc.

14. A. S. Weiss, "Prefatory Remarks: Art Brut Occlusions," *Art Brut, Madness and Marginalia*, ed. A. S. Weiss, Art and Text 27 (Sydney and Melbourne: Art & Text Pty. Ltd., December-February 1988), 4.

15. Pierre Souchard, "La cafetière anti-impérialiste," *Artension* 5-6 (November-December 1982); Claude Roffat, "De l'oeil à l'oeuf. L'oeil existe à l'état sauvage," *L'Œuf sauvage* 1 (October-November 1991).

16. William Rubin, "Modern Primitivism, An Introduction," *Primitivism in Twentieth Century Art: Affinity of the Tribal and Modern*, ed. William Rubin (New York: Museum of Modern Art, 1984), 1.

17. Pontus Hulten, *Jean Tinguely. "Méta"* (Paris: Pierre

Horay, 1973), 171.

18. Armin Heusser (Jean Tinguely's assistant) interviewed by L. Peiry, Paris, May 11, 1996 (L. Peiry's Archives, Lausanne).

19. Roman Kurzmeyer first suggested this possibility and it was taken up again by A. Heusser. See R. Kurzmeyer, "Hinweis auf einige Freunde seiner Maschinen," *Heinrich Anton Müller 1869–1930. Katalog der Maschinen, Zeichnungen und Schriften* (Kunstmuseum, Bern; Basel and Frankfurt: Strœmfeld, 1994), 189; *Der letzte Kontinent*, ed. A. Heusser and Michel Beretti (Zurich: Limmat Verlag, 1997), 72.

20. Hulten, op. cit., 8.

21. Tinguely highlighted his debt to Müller in his mechanical works entitled *Hommage et Trophee pour Anton Müller No. 2* and *Radau/Kravall/? Hommage à & Trophée pour Anton Müller No. 2*. These projects gave rise to the completion of monumental moving sculptures: *Klamauk* (Din) in 1979 and *Radau* (Hullabaloo) in 1980. In 1960, Daniel Spoerri created a work, *Hommage à Anton Müller, père de Dieu*, which incorporated a card on which Müller had written a poem (Jesus Raphaël Soto's collection, Venezuela).

22. Niki de Saint-Phalle, letter to Jean Tinguely, in *Niki de Saint-Phalle*, exh. cat. (Bonn: Kunst- und Ausstellungshalle der Bundesrepublik Deutschland; Glasgow: McLellan Galleries; Paris: Musée d'Art Moderne de la Ville de Paris, 1992–93), 153.

23. Tinguely included works by his friends in his sculptures, for instance Eva Aeppli and Daniel Spoerri, as well as numerous creations from one of his favorite Art Brut creators, Giovanni Battista Podestà.

24. Niki de Saint-Phalle, letter to Barbara Freeman, July 19, 1991, quoted by Carol S. Eliel and B. Freeman in "Contemporary Artists and Outsider Art," *Parallel Visions. Modern Artists and Outsider Art* (Los Angeles County Museum of Art and Princeton University Press, 1992–93), 205.

25. P. Hulten, "La fureur et le plaisir du travail," *Niki de Saint-Phalle*, op. cit., 16.

26. A. Heusser interviewed by L. Peiry.

27. Remarks by Annette Messager recorded by Bernard Marcadé in "Annette Messager ou la taxidermie du désir," *Annette Messager. Comédie tragédie 1971-1989*, exh. cat. (Grenoble: Musée des Beaux-Arts; Bonn: Bonner Kunstverein; La Roche-sur-Yon: Musée Municipal; Düsseldorf: Kunstverein für die Rheinlande und Westfalen), 112 and 126.

28. A. Messager telephone interview with L. Peiry, July 20, 1996 (L. Peiry's Archives, Lausanne).

29. To my knowledge, Julian Schnabel's view of Walla's work has never been published; a letter I sent him received no reply. It appears that Schnabel wishes to remain silent on this matter.

30. See Eliel and Freeman, op. cit., 217.

31. Georg Baselitz, letter to L. Peiry, Holle, March 26, 1996 (L. Peiry's Archives, Lausanne).

32. See Mark Gisbourne, "Playing Tennis with the King: Visionary Art in Central Europe in the 1960s," in *Parallel Visions. Modern Artists and Outsider Art* (Los Angeles County Museum of Art and Princeton University Press, 1992–93), 189.

33. See B. Marcadé, *A. R. Penck* (Paris: La Différence,

1988), 12.

34. See Gisbourne, op. cit., 190–93.

35. Erika Billeter, "Avant-propos," *Arnulf Rainer, Louis Soutter. Les doigts qui peignent*, exh. cat. (Lausanne: Musée Cantonal des Beaux-Arts; Frankfurt: Shirn Kunsthalle; Linz: Neu Galerie der Stadt Linz, Wolfgang Museum, 1986–87), 6.

36. A. Rainer's remarks recorded by E. Billeter, "Quand ce sont les doigts qui peignent," ibid., 12.

37. A. Rainer's remarks recorded in *Arnulf Rainer. Art Brut Hommagen*, exh. cat. (Cologne: Susanne Zander Gallery, 1991), 9–10.

38. A. Rainer's remarks recorded by Mark Gisbourne, op. cit., 177.

39. These works were exhibited in 1991 under the title "Arnulf Rainer. Art Brut Hommagen." Four years later, the artist set out to change the "monologue" into a "dialogue" and covered over around thirty works by artists from Gugging, demonstrating their influence on his works. The resulting works appeared in the same gallery in Austria in an exhibition called "Arnulf Rainer und die Künstler aus Gugging. Miteinander-Gegeneinander."

40. Leon Golub, letter to L. Peiry, New York, April 1, 1996 (L. Peiry's Archives, Lausanne).

41. See Russel Bowman,"Looking to the Outside," in *Parallel Visions. Modern Artists and Outsider Art* (Los Angeles County Museum of Art and Princeton University Press, 1992–93), 151–73. According to the author, Golub's interest in "a tradition of looking to outsider art as an inspiration" started in Chicago (153). The lecture that Dubuffet gave was on December 20, 1953, at the Arts Club of Chicago and it was entitled "Anticultural Positions" *(Prospectus et tous écrits suivants*, vol. 1 [Paris: Gallimard, 1967], 94-110); there is no doubt that it played an influential role in cultural circles at that time and in the following years.

42. Claes Oldenburg's remarks cited by C. S. Eliel and B. Freeman, op. cit., 214. Oldenburg's letter to Alfonso Ossorio in which he asks to see the Collection de l'Art Brut (which was housed at the latter's estate in East Hampton), demonstrates his interest in dissident works of art. The letter is reproduced in *Parallel Visions. Modern Artists and Outsider Art* (Los Angeles County Museum of Art and Princeton University Press, 1992–93), 213.

43. *Wie ein Kind* sets to music three poetic works: a lullaby, *Wiigen-Lied* by Wölfli, a song by Rilke, *Frühlingslied* (Song of Spring, which comes from his *Sonnets to Orpheus*), and finally an *a capo* of the lullaby *Trauermarsch mit Unglücksfall* (Funeral March with Accident) by Wölfli.

44. Per Nørgard's remarks recorded by Jean-Pierre Amann in *Concert du monde*, radio broadcast, Radio Suisse Romande, Espace 2, February 8, 1993.

45. Regina Irman, "Kompositorische Auseinandersetzung mit Adolf Wölfli," talk given during the symposium, "Was interessiert die Künste an Aussenseitern?" devoted to the plastic arts and music, Bad Emstal-Merxhausen, Kassel, June 15, 1995; R. Irman, letter to L. Peiry, Winterthur, June 25, 1996 (L. Peiry's Archives, Lausanne).

46. R. Irman's remarks recorded by J.-P. Amann, "Musiques pour une fin de siècle. Vingt entretiens avec des

compositeurs suisses," *Revue musicale de Suisse romande* (1994), 124–25.

47. Ibid. See Jürg Stenzl, "Adolf Wölfli vu par trois compositeurs," *Wölfli, dessinateur-compositeur* (Lausanne-Bern: L'Âge d'Homme-Fondation Adolf Wölfli—Collection de l'Art Brut, 1991), 61–69.

48. Wölfli has inspired artists in other areas such as film and theater: Pierre Koralnik made a film about him in 1984, *La Passion d'Adolf Wölfli*, with the actor Roger Jendly; Alphonse Layaz wrote a radio-play in 1979, *Wölfli: le condamné de la Waldau*. Aloïse's work and life also interested the filmmaker Liliane de Kermadec, who made a feature film in 1975 with Delphine Seyrig and Isabelle Huppert, as well as Aurore Prieto who created a theater show in 1988 devoted to the artist from Gugging. The Geneva-based company Basors staged a theatrical production in 1990, *Usessaud ou le Changement des basors*, based on a dozen texts by Art Brut authors. Other artists have produced work connected to Art Brut, such as Mario del Curto, who took a wide series of portraits of Art Brut artists.

49. Press conference, London, November 13, 1995.

50. Walter Navratil, letter to L. Peiry, Vienna, March 16, 1996 (L. Peiry's Archives, Lausanne).

51. Daniel Spoerri interviewed by L. Peiry, Paris, May 10, 1996.

52. Interview of A. Messager by L. Peiry cited above.

53. Christian Boltanski interviewed by C. S. Eliel, Eliel and Freeman, op. cit., 220.

54. Bettina Brandt, "La collection d'oeuvres de malades mentaux de la clinique psychiatrique universitaire de Heidelberg, des origines jusqu'en 1945," *La Beauté insensée, Collection Prinzhorn—université de Heidelberg, 1890–1920*, exh. cat. (Charleroi: Palais de Beaux-Arts, 1995–96), 38, and *Entartete Kunst: Ausstellungsführer* (Berlin, 1937).

55. Harald Szeemann, "Und siegt der Wahn, so muss die Kunst: Mehr inhalieren," *Von einer Wellt zur Andern*, exh. cat. (Cologne: Kunsthalle, 1990), 73 and 68, and letter to L. Peiry, Tegna, May 19, 1996 (L. Peiry's Archives, Lausanne).

56. Harald Szeemann, "Ein neues Museum im Lausanne. Die 'Collection de l'Art Brut,'" *Individuelle Mythologien* (Berlin: Merve Verlag, 1985), 146.

57. Leo Navratil, "Talent und Kreativität," text sent to Michel Thévoz, Vienna, May 6, 1993 (Archives of the Collection de l'Art Brut, Lausanne); "Das Haus der Künstler in Gugging," *Von einer Wellt zur Andern* (Cologne: Kunsthalle, 1990), 84.

58. Johann Feilacher, "Introduction," *Gugging* (Vienna and Helsinki, 1993), n.p.

59. Dubuffet, letter to Henry-Claude Cousseau, Paris, August 2, 1980 (Archives de la Collection de l'Art Brut, Lausanne).

60. M. Thévoz, *Requiem pour la folie* (Paris: La Différence, 1995), 24 and 23.

61. M. Thévoz, letter to J. Feilacher, Lausanne, 15 June 1995 (Archives of the Collection de l'Art Brut, Lausanne).

62. M. Thévoz, *Art Brut, psychose et médiumnité* (Paris: La Différence, 1990), 84.

63. M. Thévoz, *Requiem pour la folie* (Paris: La Différence, 1995), 25.

64. M. Thévoz, *Art Brut, psychose et médiumnité* (Paris: La Différence, 1990), 84.

65. Among those who have expressed a critical viewpoint on Art Brut, the museum or Dubuffet's approach, see Pierre Bourdieu's, *The Rules of Art*, trans. Susan Emanuel (Stanford, CA: Stanford University Press, 1996); Didier Semin's "Chaissac et Dubuffet," in *Dubuffet*, (Paris: Éditions du Jeu de Paume, 1992); Robert Thilmany's *Critériologie de l'art naïf* (Paris: Vilo, 1984); and Michel Ragon, *Du côté de l'Art Brut* (Paris: Albin Michel, 1996).

66. Art Brut only really entered the art market in the early 1980s, but several works appeared in sales before then. For example, the Kornfeld Gallery in Bern offered a work by Soutter in 1962, a drawing by Wölfli in 1970, one of Chaissac's pieces in 1974 (see Eberhard W. Kornfeld, letter to L. Peiry, Bern, June 15, 1996, L. Peiry's Archives, Lausanne).

67. The "Outsider Art Fair: Self-taught, Visionary, Intuitive, Outsider, Art Brut" has been held in the Puck Building in Soho (New York City) for a number of years. The show in 1996 featured thirty-five galleries, of which thirty-two were American. It drew 5,000 visitors in 1995 and 7,000 the following year. See Jean-David Mermod, "L'Art Brut au pays de l'art contemporain," *L'Éveil culturel* (March 11, 1996). Many of the galleries offered both folk art and Art Brut. In the United States, Art Brut rose to prominence in the wake of folk art and most think that Art Brut is "usually represented as a sub-category of Folk Art," A. S. Weiss explained in "Art Brut Today," *Portraits from the Outside: Figurative Expression in Outsider Art* (New York: Parsons School of Design, 1990), 20. J. M. MacGregor provides a similar viewpoint, explaining that contemporary examples of Art Brut are valuable in America because real folk art had become extremely rare and very expensive there. Thus the confusion of Art Brut and folk art was maintained deliberately because it was financially rewarding for dealers and collectors ("Ted Gordon," *Art Brut* 16 [1990]).

68. Louis Soutter's works have experienced the same phenomenon: a drawing was offered for 2,700 Swiss francs in 1987, another work in the same format was offered the following year for 7,500 Swiss francs, and a similar piece went for 8,000 Swiss francs in 1991. Some compositions sold for more than 100,000 Swiss francs in 1996. See the catalogues for the auctions at the Kornfeld and Dobiaschofsky Galleries in Bern.

69. The Setagaya Museum in Tokyo paid 200,000 Austrian schillings for a work by Johann Hauser in 1996, while three works had been valued by Christie's in 400,000 schillings a few years earlier. See J. Feilacher, letter to L. Peiry, Maria Gugging, May 22, 1996, and Ursula Diedam (Christie's, Manson & Wood Ltd.), letter to L. Peiry, London, June 18, 1996 (L. Peiry's Archives, Lausanne).

70. In 1996, one of Ramírez's drawings sold for 85,000 dollars at an auction in New York; at the same show, a watercolor from the *Vivian Girls* by Henry Darger went for 50,000 dollars; a painting by Traylor was valued at 28,000 dollars. See J.-D. Mermod, "L'Art Brut au pays de l'art contemporain," *L'Éveil culturel* (March 11, 1996)

71. See the Kornfeld gallery's catalogue for its auction in Bern in 1996; as for the sales at Christie's and Sotheby's, see Laura Tansini, "Collection Hazen: du fifty-fifty à New York," *Journal des arts* (May 25, 1996), and letter from Sotheby's to L. Peiry, London, June 13, 1996 (L. Peiry's Archives, Lausanne).

72. M. Thévoz's remarks recorded by G. Preszow, "Quelques questions à Michel Thévoz," *L'Art Brut et après . . . expériences et réflexions (Suisse, France, États-Unis, Grande-Bretagne, Belgique)* (Brussels: Art en Marge, 1988), 53. "I had naively believed that the interest of dealers in Art Brut was going to result in new discoveries. But I found out to my consternation that most gallery owners do not trust their own ability to judge and so they depend on labels. In this case, the label Art Brut means being a part of the museum with the same name. If Aloïse was going to offer them some drawings, they would begin by verifying if she was already included in our fascicles. Artistic fashions change, habits don't" (M. Thévoz, "Y a-t-il un marché pour l'Art Brut?" *Artension* 29 [November 1991]). The museum does indeed participate in the promotion of Art Brut on the art market. In the Burkard gallery's fall 1995 catalogue, it mentions under a work by Karl A. Höllrigl: "Werke im Art Brut Museum Lausanne." The institution serves as an authenticator of Art Brut and paradoxically fuels financial speculation in these works.

73. M. Thévoz, "Y a-t-il un marché pour l'Art Brut?" *Artension* 29 (November 1991).

74. M. Thévoz, remarks recorded by M. Lusardy in *Art Brut et Compagnie. La face cachée de l'art contemporain* (Paris: La Différence, 1995), 17.

75. M. Thévoz, remarks recorded by G. Preszow, "Quelques questions à Michel Thévoz," op. cit., 52.

76. M. Thévoz, remarks recorded by M. Lusardy, op. cit., 17; M. Thévoz, "Y a-t-il un marché pour l'Art Brut?" op. cit.

77. J. M. MacGregor, "Ted Gordon," *Art Brut* 16 (1990), 52–58.

78. See Simon Edelstein, *Hans Krüsi* (TSR, 1983); Peter Schaufelberger, telephone interview with L. Peiry, June 21, 1996.

79. M. Thévoz, *Requiem pour la folie* (Paris: La Différence, 1995), 34–35.

Conclusion

1. Jean Dubuffet, "La Compagnie de l'Art Brut" and "Place à L'incivisme," *Prospectus et tous écrits suivants*, vol. 1 (Paris: Gallimard, 1967), 167–68 and 455.

2. Michel Thévoz, *Requiem pour la folie* (Paris: La Différence, 1995), 52.

3. "Any attempt to judge or differentiate, when taken to its limits, leads to a sanction that operates both in terms of recognition and discrimination and that results in the last analysis in reducing alterity" (Marc-Olivier Gonseth, "Quelle différence y a-t-il entre un canard?" *La Différence* [Neuchâtel, Musée d'Ethnographie, 1995] 43).

4. Jean Baudrillard, *La Transparence du mal* (Paris: Galilée, 1990), 133.

5. Thévoz, *Requiem pour la folie*, op. cit., 7.

6. Dubuffet, exhibition card, cited document.

7. Thévoz, *Art Brut, psychose et médiumnité*, op. cit., 26.

8. Dubuffet, "Honneur aux valeurs sauvages," *Prospectus et tous écrits suivants*, op. cit., 207–8.

BIOGRAPHIES

Most of the artists have been classified in alphabetical order according to their last name. Others have been classified under the name by which they are best known: their pseudonym, nickname or abbreviated name given to them for the sake of medical confidentiality. Wherever possible, their first and last names are indicated in parentheses.

Artists whose names are followed by an asterisk have works in the Collection de l'Art Brut at Lausanne, in either the Art Brut or the Neuve Invention department.

ALCIDE* (1903–?)

Born in the *département* of Pas-de-Calais (France), Alcide left school at the age of twelve. He trained to be a locksmith, married, and had children. At thirty, he was interned in a hospital in Lille; his behavior was agitated and occasionally aggressive. He started drawing fifteen years later, in 1948. He began by tracing wrought-iron motifs on asphalt, using pieces of brick, and later drew female figures in notebooks with colored pencils.

ALOISE* OR ALOYSE (CORBAZ, ALOISE) (1886–1964)

Aloïse is regarded as one of the major figures of Art Brut. Born in Lausanne, she completed high school in 1906. She dreamed of having a career as a singer. After a disappointment in love, she left Switzerland in 1911 and held several positions as schoolteacher and governess, notably for the family of Wilhelm II's chaplain in Potsdam (Germany). She developed a deep infatuation with the emperor and imagined a passionate affair with him. The war forced her to return to the city of her birth, Lausanne. She showed such a fervent preoccupation with religious, pacifist, and humanitarian matters that, in 1918, she was admitted into the Cery-sur-Lausanne asylum. From 1920 until her death in 1964, she resided at the La Rosière asylum in Gimel-sur-Morges (Switzerland). During her first years in hospital, Aloïse went through a period of autism. She then began to write and draw in secret. During this period, almost all her creations were destroyed. Later, Pastor Hans Steck, and subsequently Dr. Jacqueline Porret-Forel and Dr. Alfred Bader, took an interest in her work. Aloïse preferred using colored pencils, and later, crayons. She also used juice from leaves and petals. Most of her works were drawn on brown wrapping paper, which she collected and repaired, often assembling the pages by sewing them together. Aloïse drew on the back and front of each sheet. A number of her compositions also feature collages. Her work is haunted by the notion of the ideal couple and draws largely on some of history's great romantic heroines, such as Juliette, La Traviata, and Manon Lescaut. Jacqueline Porret-Forel has deciphered Aloïse's work and cosmogony, calling it the "Theater of the Universe."

AUBERT,* ROSE (1901–?)

Born near Toulon (France), Rose Aubert and her husband owned a small farm in the nearby countryside. At the age of fifty-one, following an illness, she began producing first drawings, and then gouache and oil paintings, depicting fantastic landscapes.

BAILLY,* CAROL (1955)

Born in Brockton, near Boston (United States), Carol Bailly attended school and then moved to the Swiss canton of Fribourg with her family in 1970. She learned French and found work as a medical care worker from 1972. She then left for Lausanne, before returning to Fribourg, where she worked as a telex operator. At this time, she began creating collages, which she then reproduced in silkscreen prints. She married in 1983. Two years later, she underwent a depression, during which she was briefly hospitalized. She taught herself to draw and has been doing so ever since. Carol Bailly uses India ink, gouache, and colored pencils, with a preference for warm, bright tones. Her works, which feature comical human figures, are incisive denunciations of the shortcomings of contemporary society. Her narrative compositions combine text and images.

BAR,* JULIE (1868–1930)

Julie Bar did not go to school and never married. She was placed in the Bel-Air asylum in Geneva. Her drawings in colored pencil filled the pages of several notebooks.

BASKINE, MAURICE (1901–?)

Originally from Kharkov (Lithuania), Maurice Baskine worked in several large banks in Paris, became a head accountant in a factory, later a certified public accountant, and then a traveling salesman. At the end of the 1930s, he put an end to his professional activities to devote himself to art. Baskine saw himself as an "occult painter." He tried to interpret and continue the work of Nostradamus. He is best known for his stone statuettes and bas-reliefs depicting human figures and faces.

BATAILLE,* JULIETTE-ÉLISA (1896–?)

Born in Étaples in the *département* of Pas-de-Calais (France), Juliette-Élisa Bataille worked as a florist for several years in Paris. A psychological disorder led to her being interned in the Ville-Évrard hospital. At the end of the 1940s, she created embroideries and drawings with a feverish enthusiasm, which faded after two or three years of creative activity.

BLUHM,* URSULA (1921)

Born in Mittenwalde (Germany), in 1938 she settled in Berlin, and then, from 1949, in Frankfurt. The following year, she began painting and writing. She married in 1955 and has lived in Cologne since 1968.

BONJOUR,* BENJAMIN (1917)

Benjamin Bonjour was originally from Frenières-sur-Bex, in the Swiss canton of Vaud, where his father was a foreman in a sawmill. His mother died when he was a child. At the age of eighteen, he had a serious bout of illness—probably meningitis—from which he never fully recovered. Cared for by his elder brother, who later died in a road accident, Bonjour became a pedlar, offering to sing for the sick and bedridden. When he was almost sixty, he stopped all professional activity and concentrated on drawing, singing, taking long walks, and leading the life of a recluse, cared for by his two younger sisters. Bonjour collects different types of paper—leaflets, envelopes, chocolate boxes—and draws on them using pencils and felt-tipped pens. His work is based on a limited number of simple visual themes. Flowers, trees, landscapes, mountains, and churches recur in his brilliantly colored compositions. His graphic style is characterized by a shaky line.

BONNELALBAY,* THÉRESE (1931–1980)

Born in Magalas, Hérault (France), Thérèse Bonnelalbay, daughter of a charcoal burner, trained as a nurse and found a job in Marseille in 1950. Nine years later, she married a schoolteacher and later gave birth to two children. In 1964, she began drawing with India ink on little pieces of paper. Encouraged by her husband, she devoted herself single-mindedly to the development of an imaginary alphabet made up of microscopic signs. She later settled in the suburbs of Paris, first in Achères and then in Ivry-sur-Seine, where she worked in the municipal childcare service. Thérèse Bonnelalbay committed suicide in 1980—she was found drowned near the locks of Suresnes.

BOURBONNAIS,* ALAIN (1925–1988)

Born in Ainay-le-Château in the *département* of Allier (France), Alain Bourbonnais studied architecture before becoming chief architect of the Bâtiments Civils et Palais Nationaux (Civic Buildings and National Palaces Service). He began to collect all kinds of unusual objects, such as the creations of self-taught artists or pieces of fairground art. Bourbonnais himself began to create large mechanical sculptures, which he called his "Turbulents," as well as collages and engravings. He contacted Jean Dubuffet when he learned that the latter was donating his Art Brut collections to Lausanne. Dubuffet gave him many addresses of "marginal" creators and supported his project. In 1972, Bourbonnais opened the "Atelier Jacob," a Parisian gallery dedicated to unconventional art. Eleven years later, he and his wife, Caroline Bourbonnais, opened "La Fabuloserie" at Dicy (France).

BRENDEL (GENZEL), KARL (1871–1925)

One of eight children, Karl Brendel was born in a town in Thuringia (Germany). After several years at primary school, he became a mason in Westphalia and in Lorraine, working on stucco projects. From age twenty, he had several run-ins with the law. He was convicted twelve times and imprisoned. Unstable and mentally disturbed, Brendel was admitted to a psychiatric hospital. Around 1912–13, he began modeling statuettes from chewed bread, and later wooden sculptures and bas-reliefs that he sometimes painted. Brendel created imaginary beasts, strange, often hermaphroditic characters, as well as Christ-like figures. He also produced several written texts and drawings. Dr. Hans Prinzhorn gave a detailed description and analysis of his work in *Bildnerei der Geisteskranken* (1922). Several artists, notably Paul Klee and Max Ernst, were fascinated by his work. Two Brendel works also featured in the Nazi exhibition "Entartete Kunst" in 1937.

BURLAND,* FRANÇOIS (1958)

Born in Lausanne, François Burland was a dropout during his teenage years. He devoted himself to drawing and painting, using ballpoint pens, waxy chalks or lead pencils on brown wrapping paper. His work brings together different mythologies and beliefs, mixing elements from ancient and contemporary American, African, and Australian sources. He also creates objects from junk materials.

BURNAT-PROVINS,* MARGUERITE (1872–1952)

Born in Arras (France), Marguerite Burnat-Provins was the daughter of a lawyer and the eldest in a family of eight children. She left for Paris in 1891 and studied drawing, painting, and art history in various academies. In 1896, she married and settled in Vevey (Switzerland). Two years later, she discovered the village of Savièse, in Valais (Switzerland), where she went to stay several times. Her work, both visual and literary, flourished at this stage. In 1908, she divorced and adopted a dynamic lifestyle. Accompanied by her second husband or else alone, she stayed in various towns in Switzerland, France, Egypt, Lebanon, and Algeria. Her artistic career continued to thrive and she devoted herself to writing, painting, and creating illustrations and posters. In 1914, she began having visions that would lead to a large series of drawings she called "Ma Ville," consisting of over three thousand works. She claimed that these compositions, as well as the identities of the figures portrayed, were dictated to her. In these works, human forms mingled strangely with animal ones. For this series, Marguerite Burnat-Provins used pencil and gouache, but watercolors were her favored medium. She lived as a recluse in France for the last thirty years of her life, devoting herself to painting and writing. About twenty works of hers were published between 1903 and 1943, including her major literary work, *Livre pour toi* (1907).

CAPEDEROQUE* (C. 1890–?)

Born in a little village in the French Pyrenees, Capederoque lived near the rue Mouffetard in Paris in the early 1940s. He earned his living from occasional

masonry and painting jobs. In particular, he decorated the bar of the hotel where he lived with landscapes and views of châteaux. He also decorated the shop fronts of wood and coal traders in working-class districts of Paris.

CARLES-TOLRÀ,* IGNACIO (1928)

Born in Barcelona, he left Spain at the age of thirty for Zurich and then Stuttgart, before settling in Geneva in 1960. He found a job as a mimeograph operator at the Red Cross. It was around this time that he started to draw and paint. He produced a number of series of works featuring various burlesque and lyrical characters: show girls, Lolitas, insects, and birds. Carles-Tolrà specialized in several techniques, including acrylic paint, gouache, and wax crayons, showing a preference for bright tones, which he enhanced by creating striking contrasts. He sometimes worked the colors by scratching and scraping them and leaving imprints in them. In his early painting days, he also produced some exuberant and joyful texts. Today, Carles-Tolrà is retired. He lives in Santander (Spain), and devotes himself entirely to his work. His artistic career has spanned over thirty years.

CARLO* (ZINELLI) (1916–1974)

Born in San Giovanni Lupatoto in the province of Verona (Italy), Carlo was the son of a carpenter. He lost his mother at the age of two and had a lonely childhood. At the age of nine he started working on a farm, before becoming an apprentice butcher in the municipal abattoirs of Verona. It was during this period that he developed a passion for music and also began to draw. His behavior swung between excessive kindness and violent bouts of anger. Carlo was suffering from major psychological troubles when he began his military service in the mountain infantry. Victim of a persecution complex and suffering from hallucinations, he was admitted into San Giacomo Hospital in Verona in 1947. Placed in a ward for extremely disturbed patients, he found refuge in music and, from 1957, art. Carlo had been secretly making engravings with a sharpened stone on hospital walls for two years when he was admitted into the painting and sculpture workshop created by the institution. This workshop allowed the patients who attended it to work freely. Carlo produced a total of about three thousand works. His compositions, primarily in gouache, covered the front and back of each surface he worked on, without interruption, as if he did not want to lose the thread of a feverish internal narration. They are filled with human silhouettes, often in groups of four, as well as animals represented from various viewpoints. Carlo's paintings were accompanied by collages and inscriptions.

CHAISSAC,* GASTON (1910–1964)

Born in Avallon (France) to a family of modest background, Chaisac left school early and did a number of odd jobs, working as a kitchen hand, a hardware clerk, an apprentice saddler, and a groom. In 1926, he settled with his mother in Villapourçon (France), where he began an apprenticeship as a cobbler. His first works date back to 1936, but the war and illness slowed his productivity. Chaissac married in 1942 and settled with his wife in Vix, in the French *département* of Vendée. From then on, he constantly painted and sculpted, and wrote letters and poems. Extracts from his prolific correspondance with Jean Paulhan, Jean Dubuffet, Jean l'Anselme, and Raymond Queneau were published in his work *Hippobosque au bocage* in 1951. He continued his artistic pursuits despite his delicate health, financial difficulties, and a feeling of being isolated and misunderstood. His work started to gain recognition in artistic milieus at the start of the 1960s.

CHAVE, ALPHONSE (1907–1975)

Born in Lyon (France), he attended the École des Beaux-Arts, married, and worked as a decorator in his city of birth until 1940, when he settled in Vence (France) with his wife, a native of the town. Three years later, he took over a store where he sold toys and painting materials. In 1947, he opened his gallery Les Mages, later the Alphonse Chave Gallery, where he featured the works of self-taught and marginal artists. In 1955, he met Jean Dubuffet, who had settled in Vence. The two men became friends and scoured the area for Art Brut together. In 1969, they organized an exhibition called "L'Art Brut" in the gallery in Vence. After Dubuffet's departure, Chave continued to manage the gallery and the store.

CHEVAL, FERDINAND, OR LE FACTEUR ("POSTMAN") CHEVAL (1836–1924)

Born in Charmes-sur-Herbasse (France) to a farming family, he worked as a baker, farmer, and finally postman at the Hauterives post office for over ten years. Every day he covered thirty-two kilometers on foot on his mail run, and dreamed of a palace. One day in 1879, he noticed a strange stone and decided to build his "ideal palace" by himself. He started work that same year and finished it some thirty years later, around 1912. During his mail runs, he picked up stones which he transported in a wheelbarrow. He became a mason, builder, architect, and visionary. The edifice brings together various historical and legendary characters, animals, and plants. This syncretic work draws from Cheval's wide-ranging knowledge, to which he added a large dose of imagination. The grotto-like sculpture contains a labyrinth of galleries and staircases. Giants and columns support the construction. Numerous inscriptions, mainly maxims, are engraved around the palace.

CHICHORRO,* MARIO (1932)

Born in Torres Vedras (Portugal), he studied architecture at the École Supérieure des Beaux-Arts at Porto for two years before giving up. He then found work in several architectural firms in Porto and Lisbon. He left for Perpignan (France) in 1963 and married three years later. Chichorro moved in with his parents-in-law—sheep farmers and wine-makers—and devoted himself entirely to painting. He worked on canvas, paper, corrugated cardboard or chipboard, and also used synthetic resin and several other

materials. His works combine painting and sculpture and are in the form of narrative bas-reliefs.

CRÉPIN,* JOSEPH-FLEURY (1875–1948)

This disciple of Augustin Lesage lived in Pas-de-Calais (France) and owned a small plumbing business. He played clarinet in his father's café-nightclub. Later he directed a brass band before heading a group of trumpets. Crépin was introduced to spiritualism in 1930 and became a spirit-healer the following year. His first drawings date back to 1938, when he was sixty-three. He then produced some paintings dictated to him by the dead, which he named his "marvelous paintings." This production occupied him for the last ten years of his life. His rigorously detailed works—flat compositions—portray fantastic architectural forms. They are decorated by series of droplets of color paint produced by a secret method. In accordance with his wishes, he was buried with all the drawings which had served as his drafts.

DARGER,* HENRY (1892–1973)

Henry Darger was born in Chicago. In 1896, his mother died giving birth to a baby girl, who was immediately adopted. Darger lived alone with his father for a year, before being placed in a Catholic home for boys, and then an institution for the mentally retarded, from which he ran away at the age of seventeen. There is little information about Henry Darger, and almost all trace of his existence has apparently been destroyed. In 1913, it seems that he witnessed the destruction of a town by a tornado, an experience which would leave a lasting impression on him. He can later be traced in the 1920s, working as a cleaner in a Chicago hospital, a position he held until his retirement in 1963. Secretive and reserved, Darger went to mass almost every day and took long walks during which he collected all sorts of junk (magazines, bottles, etc.). At the age of eighty-one, he chose to enter a Catholic retirement home. After his departure, the owner of his former home, the photographer Nathan Lerner, found his bedroom filled with junk, paper, and newspapers. He discovered Darger's treasure: a 2,000-page diary and an illustrated saga of over 15,000 pages in fifteen volumes, entitled "In the Realms of the Unreal." Darger had begun his work around 1911 at the age of nineteen. He continued this solitary and secret epic for the rest of his life. He described appalling wars, scenes of carnage, earthquakes and storms featuring the seven "Vivian Girls" (male in gender), and virtuous princesses helped by Captain Henry Darger, head of an organization for the protection of children. Several hundred pictures—collages and watercolor tracings—illustrate this literary work. Darger collected, cut up, traced, and enlarged all sorts of elements from magazines and included them in his compositions. His works show the influence of coloring books, comic books, and children's literature from the start of the century.

DEMKIN,* GEORGES (1929–?)

Russian by birth, Demkin was a parachutist in Indochina before finding work as a mason in a Mediterranean town. He created abstract works in gouache.

DEREUX*, PHILIPPE (1918)

He was from a modest family of shopkeepers in Lyon (France) and spent much of his childhood in the countryside. At fourteen, "haunted by plant forms," he created a herbarium. Philippe Dereux became a schoolteacher and held the same position in Villeurbanne (France) throughout his career, from 1940 to 1973. He married in 1947 and had a child. He gives an account of his initial—and unsuccessful—artistic, literary and poetic attempts in L'Enfer d'écrire (1955). In the same year, during his holidays in Vence, he met Jean Dubuffet and became his close collaborator for eight years. He caught three thousand butterflies for Dubuffet and helped him with his collages of "botanical elements." In 1959, he began his own plant collages, before embarking on his first fruit and vegetable peel paintings, to which he added a variety of seeds. He developed this original technique into a complex system of expression. In his early works, he highlighted his compositions with paint, but gradually he relied more and more on peel. His rigorously figurative series depict crowds and theaters. Philippe Dereux also wrote the Petit Traité des épluchures (1966).

DOUDIN,* JULES (1884–1946)

Born near Lausanne, he was a railroad employee before becoming a servant in the countryside. At the age of twenty-six, he was interned for schizophrenia in an asylum in Cery, near Lausanne, remaining there until his death. Almost twenty years after being admitted into the hospital, he devoted himself entirely to drawing for several months, stopped, and then drew occasionally for the next ten years. Doudin worked on small sheets of paper, tracing human figures and animals in graphite. He is also the author of a number of texts.

DUF* (DUFOUR), GASTON (1920)

Originally from the mining region of Pas-de-Calais (France), Duf was incarcerated at the age of twenty in a hospital in nearby Lille. His doctor noticed six years later that he hid unusual pictures of monstrous beasts in his clothing. Over the next six years, using the colored pencils and gouache that were given to him, he produced larger-format works featuring the creature he called the "rinâûçêrshôse" in all manner of guises. After this period of intense activity, Gaston Duf became increasingly disturbed and he finally stopped all artistic activity.

ELI JAH* (C. 1950)

Born in Alderton (Jamaica), in the province of Saint Anne, on completing high school she found an office job. After a long illness which doctors were unable to diagnose, she claims that God revealed Himself to her and asked her to get baptized. She became a healer and became ordained as a priestess. God then apparently commanded her to preach and set up the "Ark of Alliance with God" in a district in Kingston. Eli Jah is the birth mother of seven children, but she has also raised many others. She also spends much of her time on artistic creation. She draws inspiration from Bible

scenes, in which she sometimes depicts herself. Her large, brightly colored compositions are painted on a flat surface.

EMMANUEL* (1908–1965)

This accounting clerk from Brest (France) was repeatedly treated for alcoholism in the Quimper psychiatric hospital. During one of his hospital stays, he began drawing, and then painting, highly ornate works featuring the alphabet. In his paintings, he used oils, gouache or watercolors.

END,* PAUL (ENGRAND, LOUIS) (1895–?)

Born in the *département* of Pas-de-Calais (France), Paul End was a factory worker for twenty-two years. In 1933, he was admitted into the psychiatric hospital at Lille. Several years later, he began creating methodically composed works featuring various buildings—factories, churches, and castles. He used graphite pencils, colored pencils, and gouache.

FILAQUIER,* HENRI (1901–?)

He lived in a hospice in the region of Tarn (France). He was often seen wandering around town with a joyful, playful demeanor, wearing his trademark cap decorated with medals. His drawings are in graphite and colored pencils.

FISCHER,* LOUISE (1896–1987)

Born in Mulhouse (France) of working-class parents, she was a switchboard operator until she retired in 1961. She led a solitary life, creating comical human figures and animals in her garden using stones, shells, pieces of broken glass, and various other scrap materials, which she assembled using cement and clay. "Tempus" is the central figure in her work. Louise Fischer claimed that her creatures had magic powers.

FLORENT* (1885–1955)

Born into a farming family, he worked as a mechanic, a grocer, and café owner, a charcoal burner, a farmer, and an employee in a transport company. He was admitted into a psychiatric hospital before being transferred to a hospice. Together with his works, drawings, and writings, he preciously guarded a "collection of mineral samples," which he kept in a locked box that never left his side. The exact contents of this box remained secret until his death.

FORESTIER* OR FOR, AUGUSTE (1887–1958)

Originally from Lozère (France), Forestier was the seventh child in a farming family. He was obsessed by trains and several times ran away from home by train. He even subsequently found a job as a railroad worker. One day in 1914, curious to see how the wheels of train would crush an obstacle, he caused the derailment of train by piling up stones on the rails. At the age of twenty-seven, he was interned at the psychiatric hospital at Saint-Alban-sur-Limagnole, where he stayed until his death. He took on several tasks, firstly in the asylum store, then in the kitchen. At the same time, Forestier began drawing with colored pencils, making medals that he wore proudly, and carving bones he obtained from the asylum kitchen. Later,

he set up a small workshop in a corridor of the institution, where he made various sculptures from discarded pieces of wood. These consisted of human figures and animals with human characteristics. He adorned his statuettes with pieces of cloth, leather, medals, string, and other junk materials he found in the garbage. His artistic activity spanned many years. Auguste Forestier displayed his works for sale on the wall of the hospital courtyard.

FOUÉRÉ OR FOURÉ, ADOLPHE-JULIEN (1839–1910)

Adolphe-Julien Fouéré, or Fouré, was a priest. Suffering from hemiplegia, he retired to Saint-Malo, in his native Brittany, where he began to sculpt the rocks around Rothéneuf, using nothing more than a hammer and chisel. He produced three hundred human figures in this way. He drew inspiration from the history of the Rothéneuf family, who had been pirates during the reign of King François I. He followed the contours of the granite rocks to produce grimacing faces with pronounced cheekbones, sometimes with beards. The bas-reliefs were originally polychrome, but the rain, sun, and wind have obliterated most of the color.

FRAISSE,* CLÉMENT (1901-1980)

Born in a village in the *département* of Lozère, Fraisse began his working life as a shepherd. At the age of twenty-four, he attempted to set the family home on fire by setting light to banknotes and as a result he was interned in a psychiatric ward. His rejection of authority and violent ways meant he was kept in isolation for two years, from 1930 to 1931. The walls of his cell were paneled with poor-quality, rough wood; Fraisse began to sculpt the panels with the handle of a spoon, and when this was confiscated, with the handle of his chamber pot. The iconographic motifs varied according to the forms suggested by the panels.

FUSCO,* SYLVAIN (1903-1940)

Fusco left school at the age of thirteen and, like his father, began a career as a carpenter and cabinet-maker. He studied at the Ecole des Beaux-Arts for a few months before he was sentenced to two years' imprisonment for a crime of passion. On his release, he spent his military service in a disciplinary division in Algeria, during which he found refuge in silence. Once back in Lyon with his mother, his behavior grew more unsettled and he was interned in Vinatier hospital in 1930. He was twenty-seven, and was never to speak again. Five years later, he began to draw graffiti on the wall of his dormitory. At this time, he refused all offers of painting materials, preferring to use leaves and pebbles he found on the ground. Dr. André Requet began to take an interest in his work, copying them using tracing paper. Fusco's first subjects were huge female genitalia, then androgynous figures with enormous breasts. Next came naked female figures. Having abandoned his drawing for six months, Fusco accepted some paper and pastels in 1938. He started frantically drawing opulent female effigies. He completed about one hundred works before giving up all creative activity. In 1940, food

supplies to asylums were restricted and thousands of patients died of hunger. Fusco was one of the earliest victims of this tragedy.

GABRITSCHEVSKY, EUGENE (1893-1979)

Born in Moscow, the son of a famous bacteriologist, Gabritschevsky studied biology before specializing in genetics. His articles soon attracted attention, and he was invited to carry out research at Columbia University in New York. In 1926, he was working at the Institut Pasteur in Paris. Mental health problems forced him to give up his work. He moved to Munich to be with his brother and sister, and was institutionalized there in 1931 for schizophrenia. He remained there until his death over forty years later. During this time, he executed some five thousand paintings and drawings. He used scrap paper—pages from a calendar, administrative documents—and pencil or, more often, watercolor and gouache. His technique was random, spreading color with a brush or finger, rag or sponge, creating evocative forms, which he then developed with a few brushstrokes. He also applied other techniques, such as tachism or folding painted paper to create unexpected shapes. His artistic universe was filled with monstrous human-like figures and strange animals against enigmatic landscapes.

GELLI,* GIORDANO (1928)

Born in Prato (Italy), Gelli worked as a weaver in a factory. Bombardments he witnessed during World War II disturbed him greatly and coincided with the beginning of his mental health problems. After a brief stay in a clinic at the age of twenty-three, he was interned in 1970. Five years later, he began to attend La Tinaia art therapy center in Florence. At first, he remained passive, but little by little started to work, finding his own personal style. His preferred subjects were large figures in hieratic poses, full-face or in profile. His art blossomed at the beginning of the 1980s, as he became more intimate with a woman he met at the clinic. Her death in an accident plunged Gelli into despair, and he stopped his regular attendance at the workshop, painting only rarely.

GIE,* ROBERT (1869–?)

Gie was a patient of Dr. Ladame, director of the Bel-Air asylum in Geneva. He was born in the canton of Solothurn (Switzerland) and trained as a carpenter. He underwent fourteen years of treatment for alcohol-related problems, and was released in 1922 at the age of 53. Gie worked in lead pencil or graphite, and also had a tendency to draw on the walls of the hospital. Dr. Ladame copied his works onto tracing paper.

GILL,* MADGE (1882-1961)

Born out of wedlock, she grew up in a London suburb with her mother and aunt, who hid her from the world for several years. She was then handed over to an orphanage, from where she was sent to Canada to work as a servant on a farm. She returned to London at the age of nineteen and found work as a nurse. She became interested in spiritualism and astrology in around 1903. Four years after that, she married and had three sons, the second of whom died at age eight in the Spanish influenza epidemic of 1918. Her next child was stillborn, and she fell gravely ill, losing the sight in her left eye. A year later, she began to draw, knit, and write, "guided by an invisible force." She also sang and improvised airs on the piano. She felt impelled to produce drawings on calico and cardboard in ink and ballpoint pen, working round the clock, particularly at night, in a trance-like state in which she felt protected by a spirit called "Myrninerest." Her works were sometimes no larger than a postcard, but some were up to ten meters wide. Her work was shown in exhibitions, but she obstinately refused to sell any of it, explaining that it did not belong to her. After her death, hundreds of drawings were found in her home, piled in cupboards and beneath her bed. Her drawings feature a woman's head wearing a hat, a motif repeated obsessively against a background of imaginary architecture with a multitude of staircases, checkered patterns, and columns drawn from various perspectives.

GIRONELLA,* JOAQUIM VINCENS (1911)

Like his parents, Gironella was a cork producer in the province of Gerona, in Spain. He left Spain for France in 1939. On his arrival, he was imprisoned in the camp at Bram for a year, before finding work as a cork-maker. Toward the end of 1946, he began to carve in cork, using different knives he sharpened specially for the purpose. He created high-reliefs of exquisite detail, featuring imaginary scenes.

GOESCH,* PAUL (1885–1940)

Originally from northern Germany, Goesch studied architecture in Munich, Karlsruhe, and Dresden, and worked in this field for several years before dedicating himself wholly to painting. The principal motifs of his work are dream-like constructions and human figures, using gouache, chalks, and colored pencils. Interned in a psychiatric hospital in Teupitz during the Nazi regime, he was executed in 1940.

GORDON,* THEODORE H. (1924)

Born in Louisville, Kentucky, where he was abandoned by his mother, Gordon was brought up by his paternal grandparents. The family moved to Brooklyn when Gordon was fifteen, and he finished his schooling there. He settled in San Francisco in 1951, and married three years later. He graduated from university and occupied several office jobs. He began to draw at the age of twenty-seven, starting with simple doodlings before moving onto more complex forms. His main motif is the human face, which he draws with a variety of expressions, working with ballpoint pen on small notepads. These portraits, which can also be considered self-portraits, number in the hundreds.

GUSTAV* (SCHAEFFER, GERHARD) (1885–between 1960 and 1963)

Gustav was born in Germany. Leaving his home country, he traveled on foot to France, then Spain, where he stayed

for some time, before moving on to Italy. He then returned to Germany, before finally settling in Spain. During this time he worked as a miner, gardener, wine merchant, and shopkeeper. At the outbreak of the Spanish Civil War, he returned to France where he was declared stateless. He remained in a refugee camp for several years. It was during this period that he began to paint and draw, continuing during eighteen years of hospital internment. His compositions are in colored pencil and gouache, and occasionally the purple ink used by the hospital staff. Each work is dated.

HAUSER,* JOHANN (1926–1996)

Born in Pressburg, now Bratislava in the Czech Republic, Hauser was illiterate. Displaced by war, he was hospitalized suffering from manic depression. In 1949, he was transferred to the psychiatric hospital of Klosterneuburg near Vienna. He took up painting at the Gugging House of Artists, encouraged by Dr. Leo Navratil. He often drew inspiration from ordinary magazine illustrations, in particular female portraits, which he transposed into his own personal style.

HERNANDEZ,* MIGUEL (1893–1957)

The son of a farming family from a Castilian village near Avila, Hernandez emigrated to South America at age nineteen. He moved between Buenos Aires, Sao Paolo, and Rio de Janeiro, where he worked as a farmhand, grain salesman, pastry chef, valet to a countess, and chef. He became involved in politics in Rio, then returned to Europe, collaborating on an anarchist magazine in Lisbon. Back in Madrid, he published propaganda leaflets, for which he was imprisoned on several occasions. He married in 1938, but was forced to flee Spain. Detained in a concentration camp in the South of France, he chose to send his wife back to Spain to spare her the ordeal. He never saw her again. As soon as France was liberated, he went to Paris to pursue his political activities. At the same time, he took up drawing again, which had occupied him in prison, and painted tirelessly, in particular female faces, human silhouettes, and birds formed of arabesques. He lived in poverty in a tiny Parisian apartment, in the working-class district of Belleville.

HERRERA,* MAGALI (1914–1992)

Magali Herrera was born in Rivera (Uruguay) to an important local family. She taught herself dance, theater, and photography, and was fond of organizing poetry evenings. She also wrote tales and poems, which were never published, and worked as a journalist on several daily papers. However, she did not commit herself fully to any of these various artistic activities. Suffering from depression, she attempted suicide on several occasions. She began painting on and off from the early 1950s, and gave herself over to art entirely in 1965. Her cosmic compositions display minute attention to detail and are executed in black, white or colored India ink on white, black or colored paper. She took her own life at the age of seventy-eight.

HEU* (HEUER), JOSEPH (1827–1914)

Heu was a cabinet-maker, bookbinder, and machine adjuster before being interned in Bel-Air asylum in Geneva at the age of thirty-three. There, he chose to remain in his room, spending his time writing, drawing, and reading. His works are in graphite, ink and colored pencil, and the drawings are interlaced with writings.

HILL, CARL FREDRIK (1849–1911)

Carl Fredrik Hill was born in Lund (Sweden). He came from an intellectual family background and studied for a while at the Stockholm Academy of Fine Arts, before leaving for Paris. He was intimate with some members of the Barbizon circle. His works of this period show a certain flair for landscapes. In 1875, his beloved sister and his father both died within a short space of time; a few months later, he began to suffer mental health difficulties, and in 1878 entered a psychiatric hospital in Paris. After two years, he was returned to his family in Lund, where he remained until his death. His illness seems to have provoked a surge in his creative activity, and his work underwent a complete transformation. The works of this period show human and animal creatures set in grandiose architectural schemes, or apocalyptic visions of floods and cataclysms. The perspective and proportions of the works vary. Hill would draw and paint frenetically, while lying on his bed in semi-darkness. He used pencil, quill, gouache, and pastel. At his request, his sister kept his creations.

HODINOS,* EMILE JOSOME (MÉNÉTRIER, JOSEPH ERNEST) (1853–1905)

Parisian by birth, Hodinos began his career as an apprentice for a well-known engraver of medals. Seven years later, aged twenty-three, he was interned at the hospital of Ville-Evrard in Paris, and stayed there until his death. He drew obsessively: countless designs for medals in pencil and in ink, accompanied by highly detailed calligraphy. Another favorite subject was the female form, with certain aspects exaggerated, such as the breasts, stomach, and arm and leg muscles.

HYPPOLITE, HECTOR (C. 1900–1947 OR 1948)

This self-taught painter lived in Haiti. He was introduced to voodoo ritual during a voyage to Dahomey, and its divinities and ceremonies feature prominently in his work. He used folded-out and patched-up beer packs, and enamel paint, which he spread with a feather or with his fingers.

ISELY,* MARTHE (C. 1900)

At the age of thirty, Marthe Isely left her home in the canton of Jura (Switzerland), where her family were grocers, for Marseilles. Her pictures combine figurative images and writing. She used various media: inks, colored pencils, charcoal, ballpoint pen, oil paints, and gouache.

JACQUELINE* (1928)

Jacquelinewas born in the southern French city of Perpignan. She was maladjusted, withdrawn, and melancholic, and her artistic activity was her only interest. Her family

cared for her until 1964 when she moved into a care home in the region of Grasse. Her gouache paintings and ink and color pencil drawings feature landscapes and human characters.

JAKIC,* VOJISLAV (1932)

Jakic is a Yugoslav Serb, born in Radobiljici in Macedonia, son of an orthodox priest. While he was still a child, he lost first his elder sister and then his younger brother. The family moved in 1935 to the Serbian village of Despotovac, where he lived with his mother. Something of a dropout even as a child, he had trouble fitting in at school. He went to Belgrade in 1952 at the age of twenty, where here he studied drawing and sculpture at night classes, sleeping at the school. Five years later, his exhibitions had come to nothing, and he returned home to his mother. He married, but the union proved short-lived. He began to write a fictionalized autobiography, *Homeless*, and from 1969 devoted himself to producing gigantic drawings using colored pencils, ballpoint pens, gouache, and wax pastels. His works teem with embryonic beings.

JAUFFRET,* OR JAUFRET, CHARLES (LATE NINETEENTH CENTURY)

He was a sign painter in a small village in the southern French region of Haute-Garonne. He was interned in a hospital in the nearby region of Tarn at the beginning of the twentieth century. His work consists of writings and drawings executed in graphite in school notebooks.

JAYET,* AIMABLE (1883–1953)

Originally from Normandy, Jayet worked in Paris as a butcher. He was interned at age fifty after a suicide attempt, and remained in hospital until his death. His compositions combine writing and figurative art, and are mostly in purple ink and colored pencil.

JUVA* (JURITZKY, ALFRED ANTONIN) (1887–1961)

Born a prince in Weissenbach-Neuhaus (Austria), he studied at the University of Vienna until 1910. He and his wife took refuge in France in 1938. Even as a child, he had always collected interesting objects, and in the late 1940s, he began to pick up flints during his walks in and around Paris. He worked on these, highlighting the form suggested by the stone and picking out details in paint. These flints are signed with his pseudonym, Juva.

KERNBEIS,* FRANZ (1935)

Kernbeis was the youngest in a family of seven children. He attended primary school for eight years before leaving to work on the family smallholding. Prey to mental health problems from the age of seventeen, he was hospitalized three years later, in 1955. To begin with, he was extremely passive, staying motionless for hours on end or walking around in a circle with his eyes closed, almost entirely mute. His only pleasure was his artistic activity, which took the form of large compositions with human figures, animals, and vehicles. As the years passed, he began to go

for long walks and to look after a flowerbed at the Gugging House of Artists, where he lives.

KOCZŸ,* ROSEMARIE (1939)

Born in Recklinghausen (Germany), of Hungarian descent, Rosemarie Koczÿ spent her childhood in various orphanages before settling in Switzerland, where she studied at the Ecole des Arts Décoratifs in Geneva from 1961. She graduated in decorative painting and was awarded the Prix de l'Oeuvre de Genève. She explored the possibilities offered by tapestry, and she took part in several competitions and numerous exhibitions. In parallel with this, she secretly painted and drew works that express the tragedy of the human condition. From the 1980s, she started producing large-scale canvases in oil and acrylic, usually using her fingers. She also draws in notebooks with India ink, and uses pastels, watercolor, lithography, sculpture, and collage. All her works suggest existential anguish.

KOPAC, SLAVKO (1913–1995)

Slavko Kopac was born in Vinkovci in northern Croatia. He studied at the School of Fine Arts in Zagreb in 1933, graduating in 1937. After a one-year stay in Paris, he returned home and became a high school art teacher in Mostar, then in Zagreb. In 1943, he traveled to Italy, settling in Florence for five years. His works appeared in several exhibitions there. In 1948, he moved to Paris, where he met Jean Dubuffet, who shared similar artistic concerns. Kopac became curator of Art Brut collections for the first, then the second Compagnie de l'Art Brut. He organized the transfer of the collections to New York in 1951, and to Lausanne twenty-five years after that. He became a member of the consultative committee for the Swiss museum. In parallel with this work, he pursued his own artistic activities, including painting, collage, and sculpture. He also wrote a number of poems and illustrated one of André Breton's texts.

KRIZEK, JAN (1925–?)

Krizek came from a village near Prague. He left for Paris aged twenty-two, taking with him his sculptures, which had not met with success in his homeland. He made statuettes out of rocks and rubble collected on building sites. He subsequently moved south, to Auvergne and Provence, where he worked in a ceramics company.

KRÜSI,* HANS (1920–1995)

Born in the countryside of Appenzell, (Switzerland), Krüsi knew almost nothing about his parents. He was taken in at the age of two by local farmers and placed in an orphanage eight years later. He began work as a farmhand, and then a gardener in Zürich, Bern and the canton of Vaud, as he had always wanted. He settled in the town of Saint-Gall in 1948. For thirty years he earned a living selling flowers on the Bahnhofstraße in Zürich. In 1975, aged fifty-five, he spontaneously took up first drawing, then painting. He used all kinds of materials, from restaurant paper napkins and milk cartons to cardboard boxes. On occasion, he

would offer to sell a painting to his clients for almost nothing. His compositions are typified by their rural iconography, notably animals, in particular cows, alpine landscapes, and *poyas*—the ceremony of transferring the herds to the summer pastures up in the mountains. Krüsi also used various methods of acoustic and optical reproduction, such as tape recorders and photocopiers.

LAMY,* MARC (1939)

Marc Lamy was born in Lyon. After finishing school (run by Jesuits), he went to the École des Beaux-Arts, but then decided to step back from the art world. During this period, he had various jobs, from hospital orderly to restaurant owner. He also worked in a home for juvenile delinquents. In 1988, after suffering some mental health problems, Lamy began to draw, inspired by supernatural voices. Using a Rapidograph pen, he composes protean forms, which, he says, evoke two obsessive memories: his mother's portrait and the human skull, which has been a source of fascination since childhood.

L'ANSELME, JEAN (1921)

L'Anselme was born near Amiens, in northern France. His father left when he was four, and his mother was obliged to work as a chambermaid and cleaner to feed the family. He was called up in 1940 and joined the Resistance the following year. In 1946, he founded the review *Peuple et poésie,* which published the work of self-taught poets, "workers, movers, railroad men, maids, doormen, postmen." It was at this time that he met and began his voluminous correspondence with Jean Dubuffet, who introduced him to Gaston Chaissac. He devoted himself to poetry and chose to "write left-handed" to try and find a style untainted by previous experiences. He also wrote humorous texts ridiculing Parisian intellectual circles.

LATTIER,* GÉRARD (1937)

This painter and "exhibitor of images" was born in Nîmes in the South of France, and spent much of his childhood in the nearby region of Ardèche. An illness left him with paralyzed legs. He took up drawing at the age of six. Later, he entered technical college and took evening lessons at the École des Beaux-Arts in Nîmes. During the Algerian war of independence, he spent several months in a psychiatric hospital, where he spent his time drawing and painting. When he was released from hospital, he took a job at the town hall, while continuing with his artistic pursuits. He endured a period of mental anguish for some time, but then married and had a child. This gave him a new artistic theme: he began to provide ex-voto-style illustrations to all sorts of stories and news items, giving them the flavor of legend. He works on wood panels and accompanies his paintings with stories in French or Provençal written in calligraphy.

LAURE,* (PIGEON) (1882–1965)

Laure Pigeon, a native of Brittany, separated from her husband in 1933 when she discovered his infidelity. She subsequently lived in seclusion in an apartment near Paris. She was interested in spiritualism, and for more than twenty years produced drawings which she believed were dictated to her by spirits. She never spoke about her art and hid her creations from view. After her death, hundreds of drawings were found at her home. She used blue or black ink to trace abstract figures according to a complex system of interlacing loops, with messages and key words. Each piece is dated.

LECOQ* OR LEC OR SYLVOCQ, SYLVAIN (1900–1950)

Lecoq, the son of a shoemaker, was born on the outskirts of Boulogne-sur-Mer in northern France. He felt different from other children and created his own private dream world. He worked in a shop, married, and had three sons. In 1942, he underwent an operation for an ulcer and had to give up work. His wife then fell ill. Lecoq retreated into an imaginary life and started to write, mainly mystical texts on religious and philosophical themes, in an attempt to find some coherence in the universe. Interned in 1947, he escaped on several occasions, traveling hundreds of kilometers to visit his wife or sister, and sending letters of protestation to the director of the hospital everywhere he stopped. He was arrested, locked up, tied to his bed, and guarded as an escape risk. He felt revolted and entrapped by this hospital life. From 1948 to 1950, he worked on a comical text which he accompanied with drawings, poems, love letters, and songs. He saved all sorts of materials: notebooks, brown parcel paper, blotting paper, and cardboard boxes strengthened with iron wire. He drew lines on these with pencil and ruler to write on. The whole surface is covered with neat, sober handwriting, sometimes joined up and sometimes separate, which contrasts sharply with the delirious contents. The texts teems with wordplay, invented phrases, and expressions drawn from some private language. During one period of particularly feverish creative activity, he refused all food and ran away from the hospital. When he was brought back, he drew a self-portrait as a cockerel (*coq* in French) strutting along the road. One day, he was found hanging from his bed.

LÉONTINE* OR CÉLESTINE (C. 1900–?)

Born in the region of Antwerp to a lower-middle-class family, Léontine studied at a school run by nuns. She had a modest lifestyle, living with her deaf sister in Brussels. She drew using pastels and colored pencils. She also produced many texts in Flemish, illustrated in graphite.

LESAGE,* AUGUSTIN (1876–1954)

Born into a family of miners, Lesage in his turn worked in the pits in the *département* of Pas-de-Calais. At the age of thirty-five, he heard a voice telling him "One day, you will be an artist!" but spoke of this to no one. Some months later, during a series of séances, he received several messages that seemed to confirm this vocation, and produced drawings "dictated" by the dead. He then devoted himself to painting: his first canvas, of enormous dimensions, took him two years to complete. He stopped

painting at the outbreak of World War I, but later resumed, finally abandoning the mine in 1923. He devoted himself to painting right up until his death. Part of the spiritualist movement, he painted in public on occasion, notably during an experiment led by Dr. Eugène Osty of the Institut Métaphysique in Paris. At this time, his art lost its inventive, personal character. His oeuvre consists of eight hundred paintings, featuring imaginary architectural constructions in which symmetry plays a vital role.

LIB* (LIBER), STANISLAS (1899–?)

This Polish artist produced oil paintings during one of his stays in a psychiatric hospital. His works often include erotic scenes and the female figure. He framed his own pictures.

LONNÉ,* RAPHAEL (1910–1989)

Lonné began his career as a postman in the village of Montfort-en-Chalosse in southwest France. From 1937, he worked in Bordeaux as a tram conductor, doorman, chauffeur, and hospital orderly. He then returned to his native region to work again as a postman. From his teenage years on, he was particularly interested in poetry and music: he wrote short pieces in alexandrine verse for celebrations and banquets, and played in several jazz bands. He produced his first drawings during experiments in spiritualism, which he took part in around 1950. He felt he had a talent as a medium, drawing the messages he received from the afterlife, and devoted himself to this activity. He felt his hand was directed by the spirit world, and that he was therefore not the artist. His drawings and paintings contain silhouettes, human faces, animals, and landscapes, all with a microscopic attention to detail. He worked in graphite, ballpoint pen, water-based paint, oils, India ink, and felt-tipped pen. Each piece is carefully dated. To begin with, Lonné was happy to give away his works, but by the early 1970s he was selling them. Toward the end of his life, he avoided talking about the spiritualist nature of his work.

LORTET,* MARIE-ROSE (1945)

Marie-Rose Lortet was born in Strasbourg. Among her ancestors were foresters and weavers. During her studies in her hometown, she began to create embroideries. She took the activity up again later, and, breaking free of rules, worked with no initial fixed design, to create delirious knitted pieces, featuring in particular multicolored masks. She then went on to create three-dimensional works which she called "thread architectures," using stiffened cotton or white silk.

MACKINTOSH,* DWIGHT (1906)

Originally from Hayward, California, he was placed in a psychiatric hospital at the age of sixteen. He remained there for over sixty years. In 1978, he left the hospital and began to attend the Creative Growth care center in Oakland. He seemed withdrawn in his own private world, and expressed himself only through his painting. His favorite subject was an apparently female figure sporting an erect penis. He also drew vehicles such as cars and buses, which he depicted as "transparent," showing their machinery.

He drew with a continuous back-and-forth motion of the hand, and his works are accompanied by scriptural elements that introduce an expressive rhythmic element but carry no meaning.

MAISONNEUVE,* PASCAL-DÉSIR (1863–1934)

Trained as a mosaicist, Maisonneuve earned a living as a stallholder in a Bordeaux flea market. When he was sixty-four, he procured a quantity of shells at the market and began making them into masks. The human face was his only subject.

MAR,* JEAN (1831–1911)

Mar spent forty years at the Bel-Air asylum in Geneva, during which time he had no contact at all with the people around him. He spoke to himself in a low voice from morning to night. He was interested only in his drawings and writings, and in the small objects he made with pieces of wire, leaves, and flowers, which he stuck together with breadcrumbs mixed with saliva.

MAYOR,* FRANCIS (1904–1995)

Born in Lausanne to an unwed mother, he spent part of his childhood in Algeria before returning home to Switzerland. It seems his mother tried to kill him on several occasions, attempting to drown him in the Lac de Bret when he was ten. He was placed in a foster family, then in an orphanage, where he was maltreated. He ran away at age fourteen and was taken in by another foster family. In 1923, he joined the merchant navy, and later found a job with the Compagnie Générale de Navigation, which operates boats on Lake Geneva. He started drawing in the 1960s. In 1988 he moved into a retirement home in Payerne, in the canton of Vaud, and was able to devote himself fully to art. His paintings include collages of magazine photographs, foliage, and various junk items. They refer to his life on the lake, to current events and imaginary adventures, and also feature holy figures and portraits of deceased friends.

MEANI,* ANGELO (1906–1977)

Son of a Milanese family of sculptors who owned a small monumental masonry workshop, Meani learned to work in marble and studied at the School of Fine Arts in Brera. He started a career in the family business, carving tombstones, and then held down a number of different jobs. When he was drafted, he sought refuge in Switzerland, where he again had a variety of jobs and lived with friends. He created comical masks using broken crockery, shards of glass from bottles, and other junk. His creations are sometimes decorated with a thick layer of brightly colored paint. They appeared in several exhibitions, notably in a restaurant belonging to a friend of his in Lausanne. He died in Pully, in the canton of Vaud.

METZ,* REINHOLD (1942)

He was born in Karlsruhe-Durlach (Germany) and raised by his great-aunt. He was a lonely child who enjoyed being outdoors. He wanted to become a writer or poet, but

his attempts were rejected by publishers. He found work in a printer's, then a library, and finally in a secondhand bookshop. He experienced a very difficult period during which his best friend committed suicide. At about the age of thirty, he discovered a vocation: to bring back the age of illuminated manuscripts, like those created by monks in the Middle Ages. He chose to produce illuminated versions of Don Quixote in Spanish, German, and French. He dedicated the result to Unicef, then to Jean Dubuffet. Metz has now completed several versions of Cervantes' famous text, using brightly colored inks on highly absorbent paper. Each "bibliophile's book . . . executed entirely by hand," made "in the style of the monks," has two hundred and seventy pages, and he calls them "books from before Gutenberg." The text and the illustrations form a whole, image and word working in harmony.

MONSIEL,* EDMUND (1897–1962)

Monsiel's family came from Poland. He attended primary school, then kept a shop in the small town of Wozuczyn in the province of Lublin. His shop was confiscated by the Germans in 1942 and, fearing arrest, he sought refuge in his brother's attic, even though his life was not under direct threat. He never left the attic, refusing entry to everyone. When he died, twenty years later, some five hundred tiny drawings of exquisite detail were found there. He only drew faces—hundreds, even thousands of them in one drawing. Most of his work shows religious or messianic themes of obscure meaning. His preferred medium was graphite.

MOOG (MEYER), PETER (1872–1930)

Moog was born into a modest family living in the Eifel region of Rheinland-Pfalz (Germany). He was a brilliant pupil and had no difficulties at school. He worked as a waiter, living an easy life and indulging in alcoholic and sexual excesses. He married in 1900, after finishing his military service. At the time he was working in a hotel. The couple had three children, of whom two died young. The marriage was an unhappy one. He ran his own café-restaurant from 1902 to 1907, when he went out of business. A year later, he suffered what the doctors called a "nervous stroke." He wandered from town to town, trying without success to give literary or humorous public lectures. He wanted to be a writer and tried to have his works published. He spent what money he had before returning home to his mother, who still lived in the village where he was born. He was interned, and spent much of his time writing solemn letters to the asylum's directors and love letters to an imaginary fiancée, Amalie de Pisack. His spoken language at this time was also very florid and full of elaborate metaphors. Then he turned his hand to composing masses and to painting. His iconography is chiefly religious. He painted numerous versions of the Last Supper, Judgement Day and the Virgin with Child. His compositions in ink and watercolor feature countless figures with haloes, sometimes mixed with calligraphy. He gave his works away, believing that if he received money for them, his vocation would immediately vanish. His work is analyzed by Dr. Hans Prinzhorn in his book *Bildnerei der Geisteskranken* (1922).

MÜLLER,* HEINRICH ANTON (1865–1930)

Müller is one of the major figures of Art Brut. He was born in Versailles and married a woman from Switzerland in the town of Divonne. The couple settled in Corsier, in the canton of Vaud. Müller was employed in the vineyards, and turned out to be an excellent handyman. He invented a machine for "pruning vines prior to grafting." He obtained a patent for this invention in 1903, but two years later omitted to pay the annual fee for the document. His invention was exploited, and Müller fell into a state of despair. He neglected his family and wandered aimlessly in the vineyards. His conduct worsened and, in 1906, he was interned in the psychiatric wing of Münsingen hospital, near Bern. His condition was never diagnosed. He created huge machines out of branches, rags, and wire that he lubricated with his own excrement. He joined up cogs of different sizes to form a sort of *perpetuum mobile*. He drew on the walls of the asylum and then on pieces of cardboard or sewn-together brown parcel paper. His favored media were pencil and white chalk, which he used to create an imaginary bestiary. Müller can be considered a pioneer of Kinetic Art, but all his sculptures, produced between 1922 and 1930, were destroyed. Only five photographs of four of his machines survive.

NEDJAR,* MICHEL (1947)

Nedjar was born in Soisy-sous-Montmorency (France) to a Jewish family with Sephardic and Ashkenazic roots. His father was from Algiers, but had moved to Paris in 1921; his Polish mother arrived there in 1923, fleeing the pogroms. Many members of his family died in concentration camps. Nedjar was fascinated from a very young age by cloth and fabrics—what the rag collectors called "schmatés." In 1961, he began an apprenticeship as a tailor, but preferred to help his grandmother run her stall at the flea market. A few years later, he traveled to India, Asia, and Mexico, where he discovered magic and voodoo dolls. Back in Paris, he made his first fetish dolls out of cloth and rags, adding feathers, bits of wood, straw, string, and seashells. The result was dyed and then covered in soil and blood. He also drew series of pictures in pencil or wax and made a cycle of statuettes and bas-reliefs in plaster and papier-mâché. His work displays an obsession with burned corpses and mutilated bodies.

OLIVE,* GÉRARD (1946)

Gérard Olive was born in Marseilles to an unmarried mother. He was abandoned a month after his birth and was taken in by foster parents who lived modestly. At the age of six, he was placed in a special school, and two years later was transferred to the juvenile section of the psychiatric hospital of Saint-Alban in the *département* of Lozère. He preferred to be on his own and avoided the other patients. He drew and painted spontaneously, often composing pictures in which several scenes are apparent. He

was fascinated by the technology of optics and, in particular, means of communication that produce an imitation of reality, such as cinema, photography, radio, and television. In 1963, Olive was transferred to the adult section of the hospital. He gave up his artistic activities, working instead in the hospital forge.

OSSORIO,* ALFONSO (1916-1990)

Born in Manilla, he moved to the United States in 1930 and took American citizenship. He took part in exhibitions in New York from 1941, and traveled to Paris on Jackson Pollock's advice to meet Jean Dubuffet. The two men shared a common artistic vision and became good friends. Two years later, Dubuffet wrote a book on Ossorio's initiatory paintings (*Peintures initiatiques d'Alfonso Ossorio*). The American was fascinated by Dubuffet's work and by his Art Brut collection. Dubuffet was at the time looking for a suitable storage place for these works and, in 1951, Ossorio offered to give them a home at his residence in East Hampton, where they remained for eleven years, until 1962. The change in direction in Ossorio's own work from the late 1950s was probably influenced by the presence of the collection. He began to use junk, seashells, shards of glass, broken mirrors, and pieces of metal, incorporating them into pictures he called "congregations."

OZENDA,* FRANÇOIS (1923-1976)

Born in Marseille, Ozenda studied for three months at the École des Beaux-Arts before dropping out. He began work as a framer, but then moved from town to town, taking up various trades. He produced large drawings in ink that combine figurative art and writing, and he also worked in collage.

PALANC,* FRANCIS (1928)

Palanc trained to be a pastry chef and worked in the family business at Vence (France). He invented a system of alphabets made up of combinations of angular graphic elements. These formed the basis for his search for revelations about the vital nature and essence of things. His painstaking works were influenced by his training, and he saw them as cakes. He used a sieve and icing bag, and his "ingredients" were lac, tragacanth, and above all colored "sand" made of eggshells ground to varying degrees of fineness. On occasion, he destroyed his pictures in moments of anger. His creative activity came to a halt after twenty years.

PANKOKS,* MICHAEL (1894–1983)

Pankoks was from Nica, in Latvia. His family owned a farm on the Baltic coast. He went to primary school from 1904 to 1909, then attended evening classes and read medical books. He was probably apprenticed to a carpenter. During World War I, he worked as an auxiliary in a rest home in Mitau, then in a Russian hospital. He spent a lot of time painting and sculpting and was also interested in philosophy. In 1944, he fled west before the advancing Soviet troops. He spent the majority of the next six years in prison, in refugee camps or in air-raid shelters. In 1951, he crossed the border from Austria to Switzerland and was admitted to the psychiatric hospital in Coire. He described himself as a professor of medicine and astronomy, artist, painter, and sculptor. He carried two suitcases filled with small wooden sculptures. He carried out various tasks within the hospital. He took up art again from 1960, working almost anywhere, for example on the stairs. He carved figurines out of bits of wood he saved. The pieces of wood available to him, usually pine or oak, were often too narrow for rounded figures, and the sculptures are somewhere between two- and three-dimensional. He often pierced holes through them, breaking up the form of the silhouette. He believed the pieces had the power to protect him, and often placed them around himself or secreted them in hiding places. He began to lose his sight around 1963, and the sculptures lost some of their fine detail. His health worsened, but Pankoks carried on with his sculpture. In the years following his death, staff found more than eighty pieces hidden in the hospital.

PARGUEY,* XAVIER (1876–1948)

Parguey was born in the village of Vuillafons in eastern France, and lived there all his life. He came from a family of wine-makers, and he owned land and property, but saw his circumstances reduced as a result of the war. He led a humble lifestyle, making baskets, brooms, and stakes, and cheerfully fishing and poaching like a vagabond. He was nicknamed "Zouzou." He carved pieces of wood with a knife, especially tool handles, which he decorated with grotesque motifs.

PODESTÀ,* GIOVANNI BATTISTA (1895–1976)

Born in Torre Pallavicina, a small village in northern Italy, Podestà was the youngest of thirteen, and the only boy, in an extremely poor farming family. After the death of his father, he grew up in an exclusively feminine environment, surrounded by his mother and twelve sisters. He left school at age ten and was hired as a mason's assistant. At the outbreak of World War I, he was twenty. He was called up and sent to the front, where he was wounded and captured by the Austrian army. He found it difficult to readapt to civilian life after his release. His mother's land was not large enough to feed the family, and there was no work to be had in Lombardy. He settled in Laveno, on the banks of Lake Maggiore, where he worked as a police officer. He then worked in a ceramics factory. He married and had two daughters. He spent his free time pursuing his artistic activities, such as decorating the walls and furniture of his apartment, and producing paintings and bas-reliefs. He created three-dimensional pieces using a homemade paste and materials he scavenged, like metal foil and bits of broken mirror. His work is characterized by its bright, shiny colors. It is often accompanied by small notices bearing complaints, protests or moral maxims. Podestà's creations are a symbolic vituperation against the loss of spiritual values in today's society.

He was a familiar figure in his home town, making prophesies, with a long beard and hair down to his shoulders, wearing painted ties and a death's head ring, and carrying a stick carved with episodes from his life. He created the impression of a medieval preacher and was a totally anachronistic figure in the twentieth century.

POLADIAN,* VAHAN (1902 OR 1905–1982)

Vahan Poladian was born in Caesarea to a family of Armenian origin. Before he reached adulthood, his father disappeared during the Armenian genocide and his brother died suddenly. At the age of about twenty, Poladian went into exile, first in Istanbul, then in New York and Cuba, and finally in Paris, where he married and started a family. At the outbreak of World War II, he was conscripted. He was wounded and taken prisoner by the Germans. At the Liberation, his wife left him, taking their daughter with her, and despite multiple attempts, he was unable to trace them. He sought refuge with his mother, but she died shortly after. His despair was at its height. He journeyed to the South of France, where he was taken in by the Armenian hospice in Saint-Raphaël. Here he stayed for the last sixteen years of his life, in an autistic shell, but with a rare creative vigor. He loved hunting in flea markets, a passion that grew. He installed a workshop in the loft of the home and made costumes out of brightly colored cloth, covered in festoons, brooches, and medals. He also made hats, crowns, scepters, canes, sunshades, and handbags. These accessories are made up of unusual bric-a-brac materials, such as Christmas baubles, ping pong balls, light bulbs, and diamanté and costume jewelry. The result symbolized for him the splendor of his distant homeland. Dressed in his own creations, he would walk the streets every day, laughing all the while, as if attending some comical and burlesque funeral. His creative frenzy was characterized by jubilation, and at the same time protestation. In 1982, he decided to stop eating, and let himself die.

LE PRISONNIER DE BALE (THE PRISONER OF BASEL) (GIAVARINI, JOSEPH) (1877–1934)

Of Italian origin, Giavarini worked on a farm as a child. He then became a mason, and moved to Switzerland, settling in Basel at the age of thirty. He was illiterate. He founded a small building firm with the help of his sons. He was condemned to six years in prison in 1928 for the murder of his mistress. During his time in prison, he molded groups of figurines out of breadcrumbs, later using raw earth. He painted the figurines and dipped them in glue to serve as varnish. His principal subjects were acrobats, musicians, and animals. He produced one self-portrait.

PUJOLLE,* GUILLAUME (1893–1951)

Guillaume Pujolle came from the *département* of Haute-Garonne in southwestern France. He began his career as a cabinet-maker. He joined the army in 1913 and was sent to the front. After the war, he worked as a customs officer in the city of Metz on the Franco-Swiss border, and got married in 1924. Prey to mental health problems, he was hospitalized and then interned at the age of thirty-three in the psychiatric hospital in Toulouse, where he remained until his death. His paintings attracted the attention of two doctors, Gaston Ferdière and Jean Dequeker. They were always based on a photograph or illustration, but gave an exaggerated interpretation of it. He used gouache when possible, and also employed pharmaceutical preparations like tincture of iodine or Mercurochrome in wash drawings. He made his brushes from locks of hair, with a roll of paper as handle. He always kept his compasses, set square, and rulers with him wherever he went. With its lines and arabesques, his work resembles pictorial marquetry. He sometimes gave his pictures away, sold them or exchanged them for tobacco. He gave up his art after fourteen years.

RADOVIC,* JEAN (1913–?)

Born in Serbia, Jean Radovic was a shepherd before becoming a soldier. He was taken prisoner in Italy during World War II, but managed to escape and cross into Switzerland. There he was sheltered in a refugee camp before being hospitalized. He was interned for a period of five years, during which time he drew with a quill and with colored pencils. He had one leg amputated. In 1948, he was sent back to Serbia, and nothing further is known of him.

RAMIREZ, MARTIN (1885–1960)

Ramírez was born in Jalisco (Mexico), and worked in a laundry. He emigrated to the United States in the search for a better job. However, the change proved such a racial and cultural shock to him that he lost his bearings and developed serious mental health problems. He found a job as a laborer on the construction of a railroad, but this proved too demanding for his fragile health. He ran away and became a hobo. He was then institutionalized near Los Angeles, before being transferred to an asylum in Auburn, California, where he spent the rest of his days. He never spoke, but instead took up drawing. At that time, the hospital staff would confiscate and burn patients' work at the end of each day, but Ramírez hid his drawings in his clothes or under his mattress. He drew on parcel paper, scrap paper, and pages torn from magazines, in pencil and then in watercolor, charcoals, and paint. His hybrid compositions feature iconography drawn from Mexican culture, such as Virgins, Annunciations, wild animals, cattle-drivers, as well as American images such as skyscrapers, limousines, and Hollywood starlets. He reinterpreted these motifs in his own personal artistic language.

RATIER,* EMILE (1894–1984)

Emile Ratier was born into a farming family in the village of Soturac in the *département* of Lot, in southern France. He lived in the village where he was born all his life, leaving only once when he was sent to the front in 1914. After the war, he sold firewood and then worked as a clog-maker. He led the simple life of a peasant, falling back on his own resources to make what he needed. In the late 1950s, he began to lose his sight. He experienced a period

of depression, and started to carve wooden sculptures with moving parts, mostly in elm. He made models of the Eiffel Tower, carts, merry-go-rounds, animals, and all sorts of unusual vehicles. The grinding noises of the mechanisms helped him control the movement of the object. He established a workshop in a barn at the back of his farm, and ran a wire from the house to the barn as a guideline so he could find his way back and forth.

RAUGEI,* MARCO (1958)

Eldest of four children from a working–class family, Raugei was placed at a very young age in the psychiatric hospital in Florence. He spent much of his childhood and teenage years in various medical establishments. He started attending La Tinafa art therapy center in 1986, where he drew and painted. After two years, he discovered his own personal artistic voice, reproducing the same iconographic motif over and over, with subtle variations.

RENAULT,* CAMILLE (1866–1954)

Camille Renault trained as a chef and caterer, and worked in several towns before returning to his home town of Attigny (Marne, northern France), where he opened a pastry shop and hotel. He was said to be particularly renowned for his tiered cakes. He was of a cheerful, busy disposition. Toward the end of his life, he bought a small house in the countryside near Attigny, and filled the garden with cement statues touched up with paint. The characters are all life-size, decked out in hats and shoes or boots, and are grouped together with animals in a scenery of sculpted trees, which he also created.

RIBET,* HUMBERT (1938)

He spent his childhood in the town of Mâcon, in central France. He fell ill as a teenager with lung disease, and had to spend five or six years in various hospitals and sanatoriums. He occupied himself by drawing in pencil in notebooks. Once his health had improved, he started work in a hotel in the South of France and ceased his artistic activity.

RIPOCHE,* CLÉMENTINE (?-?)

Clémentine Ripoche lived in Bezons, near Paris, and worked in a factory. In 1923, she sent the French meteorological office a series of notebooks filled with her observations of the sky. Her writings were accompanied by illustrations of chariot parades, cortèges, and dramatic scenes. She called these her "visions of the beyond" and considered them to be her "spiritualist work." She did them at night, working solidly for hours at a time. Jean Dubuffet, who was doing his military service at the meteorological office, took an interest in her work and exchanged letters with her for a period of ten months, from September 1923 to June 1924. He retyped all of her letters. This was Dubuffet's first contact with a visionary artist.

ROBILLARD,* ANDRÉ (1932)

André Robillard was interned for mental health problems at age nineteen, and was responsible for several tasks within the hospital. In 1964, he started making symbolic rifles out of tins, old light bulbs, cogs, bits of wood, cloth, nails, and wire, held together with sticky tape. His work space is a chaotic place where he stores all the materials he scavenges for his creations. He has worked like this for over thirty years, creating pretend weapons, spaceships, and animals.

RODIA, SIMON (1875–1965)

Rodia was born in Rome, but emigrated with his family to Los Angeles at the age of nine. In the black ghetto of Watts, he built a series of enormous towers on a triangular plan. Three of them were about thirty meters tall, and the six others were smaller in dimension. Employed as a laborer, he spent all of his free time on his project, which took him thirty-three years to complete, from 1921 to 1954. He was able to salvage long metal rods, which he bent and assembled with cables, then covered with cement. He then encrusted the structures with a mosaic of shells, shards of broken bottles, and fragments of broken ceramics.

RUFFIÉ,* JANE (1887–AFTER 1963)

Jane Ruffié was originally from the village of Lilhac, in the *département* of Haute-Garonne in southwest France. She was fascinated from an early age by the occult, and had her first contact with the spirit world at the age of thirty-two. Her second son died at age fifteen days in 1913. The following year, her husband enlisted, and her anxiety about him drove her to try and contact her dead child who, she claimed, revealed the future to her. From then on, this son was a constant source of comfort and she confided all her concerns to him. These "communications" at first took place in writing, and then, from 1939, as drawings and paintings, an enterprise that spanned more than twenty years. She saw these creations as messages from the beyond and a means of divining the future. Each piece is covered with motifs made up of minute writing.

SALINGARDES,* HENRI (1872–1947)

Henri Salingardes started out as a hairdresser. At the age of fifty, he started running an inn in a village in the southwestern *département* of Tarn. He also dealt in antiques and old furniture. Fourteen years later, with no formal training, he began creating small medallions in cement, which he hung in large numbers around his inn. The medallions were illustrated with reliefs of birds, human figures, and animals with human characteristics. He carried on making these for seven years, from 1936 to 1943, until an accident robbed him of one leg. After this incident, he abandoned his art.

SANFOURCHE,* JEAN-JOSEPH (1929)

Born in Bordeaux, he was taught to draw by his father. He and his family were arrested by the Gestapo during the war, and his father was executed. He studied accounting in Limoges before moving to Paris, where he worked in the industrial sector, then in administration for twenty years.

He tried his hand at many artistic activities, particularly drawing, sculpture, painting, and silk-screen printing. He used various supports for his art, from chips of flint to bone or different types of stone. He attributed a spiritual value to his colorful artistic universe.

SANTORO,* EUGENIO (1920)

Santoro was from Castelmezzano in the Italian region of Mezzogiorno. His family was extremely poor. He attended school for five years and was then apprenticed to a carpenter. He was twenty when war broke out. He was sent to the Albanian front and then to northern Greece. There, he was taken prisoner and transferred to Germany in 1943. He returned home at the end of the war and found work with the local municipality. Later, he set up his own business making coffins in his home village. In 1964, he moved to Switzerland looking for a better life, and settled in Saint-Imier, in the Jura, where he began working in a chocolate factory. He worked there for twenty years, rarely speaking and keeping his distance from his colleagues. In 1979, he painted a commemorative picture on cardboard for the factory's anniversary. This drew praise, and he began to draw and sculpt large-scale human and animal figures using salvaged materials. His three-dimensional wooden pieces are generally painted and varnished.

SARDOU,* VICTORIEN (1831–1908)

This playwright, born in Paris, is remembered principally for his lavishly staged historical plays: *Patrie* (1869), *La Tosca* (1887), and *Madame Sans-Gêne* (1893). He was also interested in spiritualism and believed himself to be in contact with several spirits, including that of Mozart. In 1857, he executed some etchings, notably illustrating the dwelling place of the spirits on Venus and Mars.

SATTLER,* CLAUDIA (1940)

Claudia Sattler worked as a secretary in her home town of Akron, Ohio, and in Sarasota, Florida. She is divorced and has five children. She took up drawing in 1985, using office paper. She often works in series of twelve, drawing figures head to foot in ballpoint pen. The pictures can thus be viewed both ways up. She takes inspiration from literature, in particular Baudelaire, Rimbaud, and certain English poets. Her work features numerous intertwined, embryonic figures.

SCHMIDT, CLARENCE (1897–1978)

Schmidt, a mason by profession, transformed his modest home in Woodstock, New York, into a fantastic architectural extravaganza of thirty-five rooms on seven floors. He built the bedrooms one after the other, with no fixed plan or logic. He would begin by building a rough framework, which he then covered with planks of wood and tar. Each level had a complex system of balconies and walkways leading to the ground or to the roof terrace. The façade was full of windows of differing dimensions and shapes. This was his sanctuary. A tall tree grew through the middle of the structure, and on this Schmidt would hang tin leaves, plastic flowers, bits of broken mirror, and garlands of lights. The structure burned down in 1968. Schmidt immediately started work on a new home, similar to the old one, in a former railway station.

SCHÖPKE,* PHILIPP (1921)

Philipp Schöpke was a native of Lower Austria. He went to school for four years, but failed his exams several times and was obliged to leave. He worked as a laborer until 1941, when he was conscripted into the German army. He was declared unfit for service, however, and was discharged after a few weeks. He spent a short while on a psychiatric ward, after which he found work in a foundry, then on road building projects. His mental health problems grew worse and he returned to hospital. In 1956, aged thirty-five, he was definitively interned at the hospital of Klosterneuburg, near Vienna, staying at the Gugging House of Artists. When he was agitated, he would begin to draw, either spontaneously or at the suggestion of his entourage, and this would calm him. During his periods of depression, he would spend weeks lying in bed, speaking to nobody. His compositions feature human figures with dislocated limbs and transparent bodies so that the innards are visible. The figures have over-large heads and lots of hair. Schöpke drew in pencil and chalks, superimposing vigorous layers of color in the same palette of browns, ochres, and grays.

SCHRÖDER-SONNENSTERN,* FRIEDRICH (1892–1982)

Born in Kucherneese in the German region of Tilsit, he was the second child in a family of thirteen. His father, a postal worker, was an alcoholic, and his mother suffered from a nervous complaint. When he was fourteen, he was sent to a corrective school for vagrancy, theft, and assault. He was unstable and failed in several careers. He was first admitted to a psychiatric clinic at the age of twenty. Later he appears in Berlin at the head of a sect that counted thousands of members. He preached salvation under the name of Eliot I, the Sun King. He then spent some time in prisons and psychiatric institutions. After World War II, although he had no formal training, he began to draw, and was signed up by a Berlin gallery. His works caused a scandal, but he enjoyed a certain measure of public recognition. They were shown at the "Exposition Internationale du Surréalisme" in Paris in 1959. Like his father, he fell prey to alcoholism, and died poor and isolated in West Berlin. His paintings display brightly colored hybrid figures dominated by a maternal idol with accentuated, opulent sexual characteristics.

SCHULTHESS,* ARMAND (1901–1972)

Armand Schulthess was born in Neuchâtel, Switzerland, and raised by adoptive parents. After studying at high school, he worked as an apprentice for an import-export firm. He owned a company making women's clothing in Zurich and then Geneva from 1923 to 1934, but it failed. He decided to travel and spent a while in the Netherlands. Back in Switzerland in 1939, he was employed in an office in the commercial division of the Federal Department of

the Economy. He got married and divorced twice and had one child. In 1951, aged fifty, he decided to step back from the world and retired to a country home he had bought in 1942, at Auressio in the canton of Tessin. He immediately started work on the 18,000-square-meter grounds, laying out a network of paths, bridges, walkways, staircases, and panoramic viewpoints. He used wire to hang hundreds of homemade plaques bearing inscriptions from the trees. He painted on old tins and bits of corrugated iron in oil paint, and then wrote texts on them in five languages, showing his encyclopedic knowledge of diverse subjects such as geology, astrology, mathematics, and psychology. When the plaques became weatherbeaten, he changed them. The labyrinth in the grounds was also laid out according to complex structures: it follows precise routes indicated by signposts with bells or electric wire to imitate telephones. The whole work is a kind of bait destined to attract possible visitors. The garden also represents a sort of cosmogony, an inventory of all the documents Schulthess collected. In the house, he kept a library of seventy volumes that he had written, illustrated, and bound himself, between 1930 and 1940, before his retirement. Schulthess probably died of hypothermia after falling and being unable to get up again. The Tessin authorities and his heirs decided to have his work destroyed. Only a few examples of his writing and a few plaques survive.

SCHWARTZLIN-BERBERAT, CONSTANCE (1845–1911)

Born in Porrentruy (Switzerland), she lost her father before the age of ten. She married and had a son. When she was thirty-five, her mother and husband died one after the other: deeply affected by these bereavements, her life changed irremediably. During the first few years of her widowhood, she spent time in asylums on several occasions, and her mental health declined. She was interned for good in 1885, in the psychiatric hospital at Waldau, near Bern. She was triply isolated, by the nature of the institution, by a linguistic barrier, and by the lack of comprehension of the medical staff for her writing. She spoke little, avoided conversation, and withdrew into a shell. She preferred to communicate with her "voices" and devoted herself to writing her voluminous diary—twenty-four handwritten notebooks, carefully dated and hand-bound—and working on her recipe collection. She worked on these projects assiduously for fifteen years. Individual letters and words sometimes cover the whole of one page. She elongated the downstrokes of the letters and introduced hatching and irregularities. Free from punctuation, this calligraphy teems with neologisms, puns, insults in her *ajoulot* patois, and personal key words and phrases. She created an original cosmic and metaphysical vision.

SETTEMBRINI,* FRANCA (1946)

Franca Settembrini was born in Florence. She was interned in a psychiatric hospital in 1966. Ten years later, she began to attend La Tinaia art therapy center and immediately took to painting, channeling her aggression into her art. Her subject of predilection is the female form, which she endows with lots of hair or long turbans, and with large hands and many fingers.

SIR* (SIRVINS), MARGUERITE (1890–1957)

Marguerite Sirvins was the daughter of a farming family from the *département* of Lozère. She displayed signs of schizophrenia when she was forty-one. Three years later, she started drawing and making embroideries in which she mixed silk, wool, and threads pulled from bits of cloth. Her major piece of work is a white dress made entirely of threads pulled from her bedsheets, which she made into different types of lace using different needles. This highly symbolic garment was perhaps made for a long-imagined wedding day.

SMITH, HÉLÈNE (MÜLLER, CATHERINE-ELISE) (1861–1929 OR 1932)

Hélène Smith was born in Geneva. She was an emotional, anxious child, prey to auditory hallucinations. She began a career as a shop worker. In 1892, she attended a séance, and was supposedly found to have extraordinary powers as a medium. Her spirit guide was an authoritarian yet protective figure called "Léopold," or later "Cagliostro." In 1896, aged thirty-five, she started painting her hallucinatory visions of landscapes, architectural forms, people, and animals from Mars. She explained that this happened "by itself . . . an invisible force directed [her] hand." She also claimed that she had learned to understand Martian and Arabic through her visions. Five years later, she took drawing lessons and finished some paintings, religious in nature, that she said were dictated by "Léopold." She occasionally used her fingers to paint. Her case was studied by Dr. Théodore Flournoy, Dr. Auguste Maitre, and the art historian Waldemar Deonna.

SOMUK* (?–?)

Somuk was from Melanesia and resided in Buka, where he lived by fishing, hunting, and farming his lands. Toward the end of the 1940s, a Father O'Reilly asked him to paint native stories and legends. Somuk spontaneously illustrated scenes of daily life, such as marriages, hunting, dance, play, and mourning. He used old pieces of paper or pages from school notebooks and ink and colored pencil.

SOUTTER,* LOUIS (1871–1942)

Born in Morges (Switzerland), he was a brilliant but very introverted pupil. He began studying architecture in 1892, but soon gave this up in favor of a musical career. He moved to Brussels and joined the Conservatoire, studying the violin under Eugène Ysaÿe. He met his wife, a wealthy and beautiful American, in Brussels. Three years later, he broke off his musical studies and studied drawing and painting in Lausanne, Geneva, and then Paris. The couple moved to the United States in 1897, and the year after, Soutter was in charge of the department of fine arts at Colorado College. His life seemed happy and successful, both socially and professionally. However, everything then changed: he returned to Europe in 1902, ill,

depressed, and lonely. His eccentric and unstable behavior grew more pronounced, and his family had him placed in the Jura de Ballaigues asylum, near Vallorbe, in 1923, when he was fifty-two. He spent the last twenty years of his life there. Despairing and disillusioned, Soutter sought refuge in art. The conventional character of his earlier work gave way to more spontaneous compositions, done in pencil in school notebooks. He then took up the quill to reinterpret the Old Masters, Raphael and Botticelli. From 1937, he decided to do away with all intermediaries between himself and his medium, painting directly with his fingers, using India ink, varnish, or shoe polish. Large, black, human figures predominate in his works, which he would not show to anybody. He would run away from the asylum on a regular basis, walking for miles through the countryside of the cantons of Jura and Vaud, occasionally sleeping in barns or with friends. At the end of his life, he was hardly eating at all, and finally died of exhaustion.

TEUSCHER,* GASTON (1903–1986)

Gaston Teuscher was born into a farming family in Montherod, near Aubonne (Switzerland). He was a primary school teacher by profession. After his retirement, he led a nomadic lifestyle, traveling by train on a daily basis all over the country and talking to all kinds of people. In 1974, when he was seventy-one, he discovered a passion for drawing, which he did on impulse on whatever paper he could get hold of (tablecloths in restaurants, the gold paper in cigarette boxes, etc.). He drew around stains or tears, which inspired him to people his works with silhouettes and faces in ballpoint pen and pencil. He would touch the result up with coffee grounds, tobacco juice or ash, and wine, and then browned them over the flame of a cigarette lighter. He also drew spontaneously, in trains, cafés, or in the street, and in this way amassed an oeuvre of several thousand works. He never thought to profit from his passion, and only rarely gave his creations away: he believed that only a very few people could truly appreciate their significance.

TRAYLOR, BILL (1854–1947)

Bill Traylor was born a slave and worked in a cotton plantation near Benton, Alabama. Even when he was freed, he carried on working until he was eighty-four years old. He was illiterate. In 1938, he left for Montgomery and was hired in a shoe factory before finally retiring. He would spend his nights in the back room of a funeral parlor, and one day, set up a wooden crate on the sidewalk along Monroe Street, a shopping street in the black quarter of town. He sat here and drew and painted on what materials he could find: cardboard cartons, boxes, and old posters. His work features mischievous-looking animals and people in striking, contrasting colors. He used colored pencil, watercolor, gouache, and crayon.

TRILLHAASE, ADALBERT (1859–1936)

Adalbert Trillhaase was born in Erfurt, in the region of Thuringia in eastern Germany. In 1903, he married the daughter of a wealthy industrialist from Hattingen. He tried his hand at different businesses, running a canvas factory at Bielefeld and an iron foundry in Hagen, Westphalia, but his attempts were all unsuccessful. When his father-in-law died, he and his wife moved into his residence in Düsseldorf to manage the family fortune. The couple had three children. Eventually he relinquished his administrative duties and devoted himself to reading and painting. Some well-known artists paid him visits, among them Marc Chagall and Otto Dix. Trillhaase's works were inspired by scenes and characters from the Old Testament, which he mixed with fantastical personal visions. He died in Königswinter-am-Rhein at the age of sixty-seven.

TRIPIER* OR TRI, JEANNE (1869–1944)

Jeanne Tripier was born in Paris and lived for many years in Montmartre with the son of her former husband, an American. She worked in a small shop. At the age of fifty-eight, she became fascinated by spiritualism and divination, and began feverishly to produce drawings, embroideries, and writings, which she took for dictations from the spirit world. She was interned in 1934 in a psychiatric hospital near Paris, where she continued her art for several years.

TRÖSCH,* JOHANN (1924–1985)

Johann Trösch was born with severe malformation of the spine, which left him paralyzed from the waist down. He never went to school, but learned the basics of reading and writing from a private tutor. He spent his entire life in bed, except for the occasional outing in his wheelchair, and was cared for by his parents and sisters. He set up a small folding writing-case next to his bed, surrounded himself with heaps of books, and produced drawings, which he hid from everyone. Several hundred of these drawings were found after his death, on both sides of sheets of squared paper. His lines in pencil were precise, and he filled pages with stereotyped series of miniatures—vehicles, crystallographic structures, machine parts, animals, trees—forming an encyclopedic whole.

TROMELIN,* COMTE DE (1850–1920)

A mathematician, he lived in Marseille, and, at the age of fifty-three, started to produce drawings that he called "semi-spiritualist." In 1903, he signed a pact with the spirit world and gave over all his time to spiritualism. He wrote his memoirs, in which he recounts his experiments with the occult, drawing enigmatic characters and monsters in black pencil.

TSCHIRTNER,* OSWALD (1920)

Tschirtner was born in Vienna, and proved to be a keen and brilliant pupil. His parents sent him to a Catholic school at the age of ten, hoping he would enter the Church. He continued to excel in his studies until he reached the age of majority in 1939. The outbreak of war meant he was unable to continue his studies at the seminary, and instead he was drafted into the German army during the Stalingrad campaign. He was taken prisoner by the French and detained in a camp in the South of France.

His first mental health problems became apparent after his release, and he was interned for a period in 1946 as a schizophrenic. He believed that he had been sentenced to death. His situation worsened: he would swing from excessive piety to extreme violence. He was interned definitively in 1947 and placed in the Gugging House of Artists in 1954. At this time he was secretive and reserved. He took up drawing at the behest of Dr. Leo Navratil, more out of politeness and obedience than through interest. He has a spare graphic syle, in which human figures appear as wiry silhouettes.

URA* (URASCO), BERTHE (1898–?)

Berthe Urasco never married. At the age of thirty-nine, she began to experience some mental health problems that required long-term stays in the Bel-Air asylum in Geneva. She was there for seven years, during which she produced drawings in pencil and colored crayon.

VAN GENK,* WILLEM (1927)

Van Genk was born in Voorburg in the Netherlands, the youngest child and only son in a family of ten. He suffered from severe health and behavioral problems. His mother died when he was five and he was physically abused by his father. He started drawing at home and at school, using art as a substitute for his dreams of travel to distant countries. He was eventually placed in an orphanage, and then in a Christian school specializing in arts and crafts. Here he studied advertising graphics for two years, but proved incapable of adapting to the demands made on him. He was transferred to a home for the mentally handicapped in The Hague, where he received a small salary for his activities in the workshop. With this, he bought himself painting materials. His principal sources of inspiration were tourist guides, the photographs he collected, and in particular his voyages to the Soviet Union, Rome, Paris, Madrid, Copenhagen, Cologne, and Prague. He often portrays the conflict between good and evil, with God, Lenin, and Mao Zhedong facing up to the Devil, Hitler, and Stalin. His work appeared in exhibitions, but he refused to sell to private collectors. He gave up painting in 1988.

VÉREUX, ROBERT (1911–1969)

Robert Véreux was the pseudonym of Dr. Robert Forestier, a phthisiologist based in Paris. He always longed to be a painter, and while at medical school painted several pictures of Surrealist inspiration. In 1947, he visited the Art Brut collection, then run by Michel Tapié, and pretended to be mentally ill. He invented a difficult childhood and claimed to have worked as an errand boy for a hardware store and for a saddler. He also claimed to be self-taught as an artist, and that his paintings reflected his visions. Michel Tapié believed his story and exhibited his works on several occasions, even writing a pamphlet about him. Dr. Forestier continued painting until his death.

VIGNES,* JOSEPH, OR PÉPÉ VIGNES (1920)

Born in Paris, he was an accordionist at public dances and then a singer, before following in his father's footsteps and becoming a cooper. In 1960, at the age of forty, he began to produce drawings in ballpoint pen, colored in with colored pencils, on cardboard or bits of chipboard. His preferred motifs were flowers, boats, cars, airplanes, and trains. He stored all of his work in plastic bags.

LE VOYAGEUR FRANÇAIS*

This artist and decorator was hospitalized for schizophrenia. He signed all of his works with an abstract motif that sometimes took over the whole composition.

WALLA,* AUGUST (1936-2001)

August Walla was born in Klosterneuburg (Austria). He was an only child. After the death of his father, he lived alone with his mother, to whom he was extremely attached. When he was nine, he suffered from serious insomnia, and spent his nights filling his school notebooks with scribblings and doodles. He finished his schooling in a specialized institution and was unable to find a job. At the age of sixteen, he threatened to commit suicide and to burn the house down, as a result of which he was interned. He was a resident of the Gugging House of Artists, near Vienna, where he spent his time painting and writing. His work is a kind of polytheistic parade, uniting gods, demons, saints, prophets, and miracle-workers, as well as imaginary divinities that he called "Satttus," "Kappar," and "Ssararill." He was fascinated by foreign languages and often had recourse to dictionaries, borrowing words from them and inventing his own idioms. His pictures combine word and image. He also worked directly on his surroundings, painting large pictures on the outside of the building, and on roads and trees. The walls of his room were entirely covered by his paintings.

WEY,* ALOIS (1894–1985)

Aloïs Wey was born in Murg (Switzerland), and was the eldest of seven children. He was raised by his grandmother up to the age of nine. When she died in 1903, he returned to live with his parents in Saint-Gall, where he went to primary school. He left the school five years later and worked with his father as a roofer. He changed career several times, working as a mining auxiliary, electrician, and kitchen hand. He retired at age seventy-seven, and moved into a retirement home in Wittenbach, near Saint-Gall. He took up drawing at the age of eighty on the small table in his room, working ten hours a day. He drew imaginary architectural forms, with a clear preference for churches, arranging areas of bright color surrounded by black on the same page. He paid particular attention to his windows, doors, and roofs, ornamenting them with spires, cupolas, and many other decorative motifs. He used colored pencil, ink and gold-, silver-, or copper-toned varnishes.

WILSON,* SCOTTIE (FREEMANN, LOUIS) (1888–1972)

Scottie Wilson was the son of a Russian Jew, who had emigrated to Scotland and settled in Glasgow. He never went to school and was illiterate. He joined the army at the age of sixteen, and then worked on fairgrounds and in circuses before setting up a mobile stall which he took round London's old markets. In around 1928, after a period of forced exile in Ireland, he left for Toronto, where he worked as a dealer in secondhand goods. At the age of forty, he suddenly decided to take up drawing in the back room of his shop. He moved to Vancouver and devoted himself entirely to his pictures, which he drew in black and then touched up with colored inks, often using hatching. Birds, fish, trees, and human figures proliferate in his work. To begin with, he preferred to give his work away. When he returned to England after World War II, he sold his pictures cheaply at markets or in exhibitions, which he would arrange himself in unusual locations such as a cinema foyer, a closed-down shop or a caravan. These events would be accompanied by music. When he saw his work exhibited in a London gallery, he was scandalized by the prices. He went home and fetched a series of drawings, and began selling them in front of the gallery for practically nothing. He started painting plates in the 1960s. Wedgwood commissioned a design for a dinner service from him. His work eventually lost its passion, becoming merely decorative.

WITTLICH,* JOSEPH (1903–1982)

Joseph Wittlich was born in Gladbach, near Neuwied, in Rheinland-Pfalz (Germany). His mother died when he was two. He had problems fitting in at school and was unhappy when his father remarried; he ran away, and buried himself in his drawing. When he was seventeen, he traveled to France to join the Foreign Legion, but he was turned down. He returned to Germany, and was hired as a farmhand in 1923. He spent his nights painting, but made no attempt to protect or store his works safely. He was conscripted into the German army during World War II. He suffered a bullet wound, was taken prisoner by the Russians, and later, when he got back to Germany, was buried under rubble during a bombardment. At the end of the war, he worked in a ceramics factory in Höhr-Grenzhausen. He lived in two small attic rooms, where he began painting again. He preferred to give his works away than sell them; some were featured in exhibitions in German museums during the 1970s as naïve art. His favorite subjects were battle scenes, portraits of generals, female figures, and royal couples. His works are dominated by large areas of bright colors.

WÖLFLI,* ADOLF (1864–1930)

Adolf Wölfli is one of the major figures of Art Brut. He was born to an extremely poor family living in the region of Bern. He was brought up alone by his mother after his alcoholic father left (he died a few years later of *delirium tremens*). Wölfli attended school sporadically up to the age of nine, when he started working as a goatherd. His mother then died, and he was looked after by different families. He earned a living as a farmhand, woodcutter, and laborer. He suffered several serious setbacks during his youth, including an unhappy love affair which affected him deeply. He was arrested in 1889 for indecent assault and spent two years in prison. On his release, he committed another offense and was interned, at age thirty-one, in Waldau hospital, near Bern. Here he remained until his death in 1930. He took up drawing, writing, and composing in 1899, working from morning till night for thirty years. His work attracted the interest of Dr. Walter Morgenthaler, who wrote a monograph about him, entitled *Ein Geisteskranker als Künstler* (1921). His oeuvre is huge, consisting of twenty-five thousand pages of graphic compositions, musical scores, and literary works.

ZAGAJEWSKI,* STANISLAW (C. 1929)

Zagajewski was abandoned at birth: he was found in the church of Saint Barbara in Warsaw. He was placed in an orphanage, where he was given a name, and was transferred between orphanages several times during his childhood. He never speaks about his schooling. He became a mason and helped on several stucco projects. In addition, he creates altars out of hundreds of pieces of delicately carved clay. He has lived in Wloclawek, Poland, for over twenty years.

ZEMANKOVA,* ANNA (1908–1986)

Anna Zemankova was born the daughter of a hairdresser in Olomuc (Moravia). She worked as a dental technician before marrying an army officer in 1933. She had three children. The family lived in Brno, and then moved to Prague in 1948. Twelve years later, aged fifty-two, she experienced a period of severe depression, and sought refuge in painting. She was convinced that she could "tap into magnetic forces that are normally invisible." She would work every day between the hours of four and seven in the morning, in a kind of ecstasy, before her day as a housewife and mother began. She used pastels and quills, and in 1969 began to perforate sheets of paper. Three years later, she invented a new technique of embossed drawings that resembled embroidery. She began to paint on silk and satin, which she sometimes decorated with beads and sequins, and sometimes with cutout patterns and collages. At the end of her life she was paralyzed and lost her legs to diabetes, but carried on with her artistic creations until the very end.

BIBLIOGRAPHY

MANUSCRIPT SOURCES

Archives of the Compagnie de l'Art Brut and the Collection de l'Art Brut
"Art Brut Almanac." 1945-48.
– January: DUBUFFET, Jean, "Le vent tourne;" *Peinturez hardi:* "Sur quoi peindre;" *Petit Courrier:* "Nouvelles de Giordano Falzoni," "Nouvelles de Slavko Kopac," "Nouvelles du Limousin," "Opérations de végétalisation," "Statue d'écorce de bouleau," "La Main gauche," "Nouvelles de la revue 'Peuple et Poésie';" CHAISSAC, Gaston, "Commentaires de Chaissac sur les dessins de Jean l'Anselme."
– February: DUBUFFET, Jean, *Peinturez hardi:* "Pigments blancs." BRETON, André, "Joseph Crépin." TRILLHAASE, Felicitas, dame Haller, "Trillhaase." DUBUFFET, Jean, *Petit Courrier:* "Empreintes d'épluchures," "Statues de charbon," "Nains de forêts," "Pierres peintes: coquilles d'huîtres," "Géants de murailles."
– March: DUBUFFET, Jean, *Peinturez hardi:* "Pigments de couleur." JACK-SENNÉ, A.E., "Maisonneuve." DUBUFFET, Jean, "Gironella."
– April: DUBUFFET, Jean, *Peinturez hardi:* "Peinture à l'eau." BRETON, André, "L'art des fous, la clé des champs." MORGENTHALER, Walter, "Wölfli." DUBUFFET, Jean, Petit Courrier: "Nouvelles d'Aristide Caillaud," "Nouvelles de Duquet," "Nouvelles de Saad El Khadem."
– May: DUBUFFET, Jean, *Peinturez hardi:* "Peinture à l'huile," "Capderoque." TAPIÉ, Michel, "Le zouzou."
– June: DUBUFFET, Jean, *Peinturez hardi:* "Siccatifs." MESENS, E.L.T., "Scottie." Trans. Marie Canavaggia. DEHARME, Lise, "J.-D. Benquet." DUBUFFET, Jean, Petit courrier: "Nouvelles de Vandersteen," "Nouvelles de Robert Véreux" (lettre de Robert Véreux à Michel Tapié, February 16, 1948), "Nouvelles de Louis Cattiaux."
– July: DUBUFFET, Jean, *Peinturez hardi:* "Aspect brillant." FOREL, Jacqueline and Jean GAGNEBIN, "Aloyse." PITTARD, Eugène, "Masques suisses."
– August: DUBUFFET, Jean, *Peinturez hardi:* "Vernis." BRETON, André, "Hector Hyppolite." DUBUFFET, Jean, Petit Courrier: "Mort de Georges Roger," "Nouvelles de Oskar Schmid," "Brindilles et racinettes," "Tapisseries et marionettes."
– September: DUBUFFET, Jean, *Peinturez hardi:* "Aspect mat." LADAME, Charles, "Berthe U." WYRSCH, "Heinrich Anton."
– October: DUBUFFET, Jean, *Peinturez hardi:* "Émulsions;" "Miguel Hernandez." PÉRET, Benjamin, "Robert Tatin."
– November: DUBUFFET, Jean, *Peinturez hardi:* "Mastics." CAZARD, Jean-Paul, "Salingardes." DUBUFFET, Jean, *Petit Courrier:* "Nouvelles de Garcia Tella," "Nouvelles de

Marigaly," "Collaboration fraternelle," "Nouvelles de Clotilde Patard," "Nouvelles de Madeleine Kemeny-Szemere."
– December: DUBUFFET, Jean, *Peinturez hardi:* "Recettes." LADAME, Charles, "Le Cabinet du professeur Ladame."

Compagnie de l'Art Brut address list. n.d. [c. 1948-49].
Compagnie de l'Art Brut address list. n.d. [c. 1960-75].
Library catalogue. [c. 1960].
Dubuffet, Jean. "Voyage en suisse, juillet 1945." 1945.
Library card file. [c. 1948-49].
Inventory of works gathered together in Vence 1959-62 and subsequently sent from Vence to Paris in 1962.
Logbook of the Compagnie de l'Art Brut. 1948-49.
Logbook of the Compagnie de l'Art Brut. 1961-75.
Record of proposals and undertakings (current and future). 1962-63.
Logbook. Registry assembled April 29, 1963 "for the purpose of recording useful details." April 1963-October 1975.
Logbook of the Compagnie de l'Art Brut. 1948-50.
Record of active and inactive members. Compagnie de l'Art Brut. 1948.
Register of collections. Art Brut. 1949.
Register of acquisitions. vols. 1-2. 1949-51.
[Record of] arrival[s] and departure[s] of objects. 1949.
Record of deliberations of the Compagnie de l'Art Brut administrative council (including minutes of meetings). 1948-51.
Register of collections and associated documents of the Compagnie de l'Art Brut. 1951.
[Registry of] Acquisitions (Vence) as of June 1959. Logbook of arrivals (collections sent from Vence to Paris).
Record of collections assembled in Vence in 1959 and subsequent years.
[Record of] collections assembled in Vence at the home of J. Dubuffet. June 1959-August 1960.
Record of arrivals and acquisitions. vol. 1-5. [c. 1960-75].
Record of acquisitions. 1967-69.
List of issues in numerical order. [c. 1960-70].
Various files, correspondence, and unpublished documents.

Archives of Public Institutions
Bern, Psychiatrische Universitätsklinik Waldau.
Geneva, Musée d'Art et d'Histoire.
Geneva, Musée Barbier-Müller.
Geneva, Musée d'Ethnographie.
Geneva, Albert Skira.
Lausanne, Centre de Recherches sur les Lettres Romandes [Center for the Study of Swiss Francophone Arts].

Paris, Bibliothèque Jacques Doucet (correspondence file "Breton").

Paris, Fondation Jean Dubuffet.

Paris, Service de Documentation de l'Hôtel Drouot.

Southampton, NY, Ossorio Foundation.

Washington, D.C., American Art, Smithsonian Institution.

Zurich, Office Suisse de Tourisme.

Private Archives in Switzerland

Lausanne, Esther González Martínez.

Saint-Pierre-de-Clages, Bernard Wyder.

Santander, Ignacio Carles-Tolrà.

Villeurbanne, Philippe Dereux.

Archives of the Author

– Interviews (tape-recorded and manuscript): Michel Thévoz, Lausanne, various interviews; Geneviève Roulin, Lausanne, various interviews; Slavko Kopac, Paris, June 22, 1988; Robert Dauchez, Paris, June 23, 1988; François Mathey, Paris, June 24, 1988; Philippe Dereux, Villeurbanne, July 8,1988; Michèle Edelmann, Paris, December 7, 1988; Pierre Bettencourt, Stigny-par-Ancy-le-Franc, January 12, 1989; Laurent Danchin, Paris, March 15, 1989; Jacqueline Voulet, Paris, March 16, 1989; Slavko Kopac, Paris, March 17, 1989; Rosemarie Koczÿ, Lausanne, March 1989; Pierre Chave, Vence, April 5, 1989; Roger Cardinal, Paris, August 9, 1989; Laurent Danchin, Paris, September 27, 1989; Jacqueline Porret-Forel, Chigny, August 17, 1990; Eva Steck, Lausanne, September 13, 1990; Jean-Paul Ledeur, Paris, October 13, 1990; Robert Doisneau, Paris, November 1, 1990; Pierre Maunoury, Paris, November 1, 1990; Gérard Ladame, Lausanne, June 26, 1991; Paul and Gérard Ladame, Lausanne, July 4, 1991; Alfred Bader, Le Mont-sur-Lausanne, July 5, 1991; Françoise Fauconnet-Buzelin, September 12, 1995 (telephone interview); Daniel Spoerri, Paris, May 10, 1996; Armin Heusser, Paris, May 11, 1996; Peter Schaufelberger, June 21, 1996 (telephone interview); Annette Messager, July 20, 1996 (telephone interview); Michel Thévoz, Jean-Christophe de Tavel, Laurent Danchin, Lausanne, doctoral dissertation colloquium, September 5, 1996; Pierre Louy, October 24, 1996 (telephone interview); Michael Baumgartner, November 8, 1996 (telephone interview).

– Correspondence: Jacques Berne, Le Havre, March 6, 1989; Claude Lévi-Strauss, Paris, March 7, 1989; Jean-Claude Drouin, Rochecorbon, May 8, 1989; Jacques Dauchez, Paris, March 28, 1990; Slavko Kopac, Paris, November 23, 1990; Pierre Maunoury, Paris [c. November 1990]; Jacques Dauchez, Paris, September 22, 1995; Roger Gentis, Bizac, November 24, 1995; Laurent Schweizer, Lausanne, November 24, 1995; Johann Feilacher, Maria Gugging, May 22, 1996; Ursula Diedam, London, June 18, 1996; Leon Golub, New York, April 1, 1996; Walter Navratil, Vienne, March 16, 1996; Georg Baselitz, Holle, March 26, 1996; Roger Brown, La Conchita, April 5, 1996; Harald Szeemann, Tegna, May 19, 1996; Eberhard W. Kornfeld, Berne, June 15, 1996; Regina Irman, Winterthur, June 25, 1996.

WRITINGS AND PUBLICATIONS BY JEAN DUBUFFET

Prospectus aux amateurs de tout genre. Paris: Gallimard. Collection "Métamorphoses," 1946.

Les Barbus Müller et autres pièces de la statuaire provinciale. Part I. Unpub. 1947; reprint, Geneva: Musée Barbier-Müller, 1979.

"Notice sur la Compagnie de l'Art Brut." Paris, 1948.

Les Statues de silex de M. Juva. Paris: René Drouin, 1948.

"L'Art Brut préféré aux arts culturels." Paris: René Drouin, 1949.

"Ler dla canpane." Paris, 1949.

"Honneur aux valeurs sauvages." *Cinq petits inventeurs de la peinture.* Lille: Librairie Marcel Évrard, 1951.

Peintures initiatiques d'Alfonso Ossorio. Paris: La Pierre Volante, 1951.

"L'Art Brut." *L'Art Brut.* Vence: Galerie Les Mages, 1959.

"La Compagnie de l'Art Brut." Unpub. Paris, 1963.

"Place à l'incivisme." *L'Art Brut.* Paris: Musée des Arts Décoratifs, 1967.

Prospectus et tous écrits suivants. Paris: Gallimard, vols. 1-2, 1967; vols. 3-4, 1995.

Asphyxiante Culture. Paris: Jean-Jacques Pauvert, 1968; reprint, Paris: Éditions de Minuit, 1986.

Bâtons rompus. Paris: Éditions de Minuit, 1986.

Poirer le papillon: Lettres de Jean Dubuffet à Pierre Bettencourt 1949-85. Paris: Lettres Vives, 1987.

Lettres à J.B. 1946-85. Paris: Hermann, 1991.

Lettres à un animateur de combats de densités liquides: correspondance de Jean Dubuffet avec Pierre Carbonel. Paris: Hesse, 1992.

Correspondance: Jean Dubuffet and Witold Gombrowicz. Paris: Gallimard, 1995.

DANCHIN, Laurent and André ROUMIEUX, eds. *La Ponte de la langouste: Lettres à Alain Pauzié.* "Les Inattendus" series. Paris: Le Castor Astral., 1995.

WORKS ON JEAN DUBUFFET

Publications and Exhibition Catalogues

Cahiers de l'Herne 14 (devoted to the correspondence between Jean Dubuffet and Witold Gombrowicz). Paris: L'Herne, 1971.

Cahiers de l'Herne 22 (devoted to Jean Dubuffet). Paris: L'Herne, 1973.

Catalogue des travaux de Jean Dubuffet, assembled by Max Loreau and Armande de Trentinian, parts I-XXXVII, Paris: Jean-Jacques Pauvert, 1966-68; Paris: Weber, 1972-76; Paris: Éditions de Minuit, 1979-84.

DANCHIN, Laurent. *Jean Dubuffet: Peintre-philosophe.* Lyon: La Manufacture, 1988.

ABADIE, Daniel, Noël ARNAUD, Jacques BERNE et al. *Dubuffet.* Paris: Éditions du Jeu de Paume, 1992.

Dubuffet. Martigny: Fondation Gianadda, 1993.

Jean Dubuffet, "La période de Vence." Exh. cat. Galerie Alphonse Chave, Vence, 1995.

LIMBOUR, Georges. *L'Art Brut de Jean Dubuffet: Tableau bon levain à vous de cuire la pâte.* New York: Pierre

Matisse; Paris: René Drouin, 1953.
LOREAU, Max. *Dubuffet et le voyage au centre de la perception*. Paris: La Jeune Parque, 1966.
PICON, Gaëtan. *Le Travail de Jean Dubuffet*. Geneva: Skira, 1973.
RAGON, Michel. *Dubuffet*. Paris: Le Musée de poche and Georges Fall, 1958; 2nd ed., revised and expanded, 1995.
Salut à Jean Dubuffet. Exh. cat. Vence: Galerie Alphonse Chave, 1985.
THÉVOZ, Michel. *Dubuffet*. Geneva: Skira, 1986.

Articles
Anonymous. "Under the Mattress." *News Week*, February 1962.
CANADAY, John. "Art: Dubuffet at the Modern Museum." *The New York Times*, February 21, 1962.
"Jean Dubuffet." *The New York Times*, February 25, 1962.
PACQUEMENT, Alfred. "Jean Dubuffet à New York, Américains à Paris dans les années 50." *Paris-New York*. Exh. cat. Paris: Centre Georges Pompidou, 2nd ed. 1977; new ed. Paris: Gallimard, 1991.
SANDLER, Irving. "In the Art Galleries." *New York Post*, March 4, 1962.

PUBLICATIONS ON ART BRUT AND OUTSIDER ART
(before 1976)

Revue L'Art Brut. Paris: Compagnie de l'Art Brut.
– No. 1, 1964: DUBUFFET, Jean and Louis LAMBELET, "Le Prisonnier de Bâle." DUBUFFET, Jean, "Palanc l'écrituriste," "Les dessins médiumniques du facteur Lonné," "Miguel Hernandez," "Le lambris de Clément." OURY, Jean, "Benjamin Arneval." DUBUFFET, Jean, "Heinrich Anton M.," "Humbert Ribet."
– No. 2, 1964: MORGENTHALER, Walter, "Adolf Wölfli." Trans. Henri-Pol Bouché; new ed., Lausanne: Collection de l'Art Brut, 1979.
– No. 3, 1965: DUBUFFET, Jean, "Le mineur Lesage," "Salingardes l'aubergiste," "Le cabinet du professeur Ladame" (Robert Gie., Julie Bar., Jean Mar., Joseph Heu., Berthe U.), "Les télégrammes de Charles Jaufret." OURY, Jean and Edelmann, Claude, "Jayet le boucher." EDELMANN, Michèle, "Les coquilles de Maisonneuve." PUEL, Gaston, "Filaquier le simplet."
– No. 4, 1965: MUSGRAVE, Victor and de MAINE, Andrew, "Scottie Wilson." MAUNOURY, Pierre, "Emmanuel le Calligraphe." DUBUFFET, Jean and Dequeker, Jean,"Guillaume." DUBUFFET, Jean, "Paul End," "Moindre l'Égyptologue," "Florent," "L'écrit du Comte du Bon Sauveur," "Jacqueline."
– No. 5, 1965: DUBUFFET, Jean, "Le Philatéliste," "Broderies d'Élisa," "Joseph Crépin," "Rose Aubert," "Gaston le Zoologue." EDELMANN, Claude, "Sylvain." EDELMANN, Michèle, "Xavier Parguey."
– No. 6, 1966: ANDREOLI, Vittorino, Cherubino TRABUCCHI and Arturo PASA, "Carlo," Trans. Henriette Valot. DUBUFFET, Jean, "La double vie de Laure," "Simone Marye," "Anaïs," "Robe nuptiale et tableaux brodés de Marguerite."
– No. 7, 1966, DUBUFFET, Jean, "Haut art d'Aloïse." POR-
RET-FOREL, Jacqueline, "Aloïse et son théâtre;" new ed. Lausanne: Collection de l'Art Brut, 1989.
– No. 8, 1966: DUBUFFET, Jean, "Messages et clichés de Jeanne Tripier la Planétaire," "La fabrique d'Auguste," "Gustav le Démoniste." MAUNOURY, Pierre, "François." EDELMANN, Claude, " Olive." Dubuffet, Jean, "Pièces d'arbres historiées de Bogosav Zivkovic."
– No. 9, 1973: CARDINAL, Roger, "Madge Gill." Ludovic MASSÉ and A. WOLFF, "Nataska." Edelmann, Michèle, " Jane Ruffié." STOCCHI, Gabriele and A. Wolff, "Bentivegna." WOLFF, A., "Les manivelles d'Émile Ratier." EDELMANN, Michèle and A. WOLFF, "Collection du Dr A. Marie" (Xavier Cotton, Émile Josome Hodinos, F. Kouw, Jules Léopold, Édouard L., Auguste Merle, Ravallet, Victor-François, Gaston Vil., le Voyageur Français, and the "semi-spiritualist" drawings of the Comte de Tromelin).

Published Works
BADER, Alfred. *L'Histoire d'une pétition concernant la Collection de l'Art Brut*. Lausanne, 1971.
BADER, Alfred, ed. *Insania-Pingens: Petits maîtres de la folie (Textes d'Alfred Bader, Jean Cocteau, Georg Schmidt et al.)*. Basle: Ciba, 1961.
BRETON, André. *Manifeste du surréalisme*. Paris: Gallimard, 1924.
——— *Les Pas perdus*. Unpub. 1924; new ed. Paris: Gallimard, 1949.
BRETON, André, and Paul ELUARD. *L'Immaculée Conception*. Paris: José Corti, 1930.
Les Cahiers de la Pléiade, no. 6. Paris: Gallimard, fall 1948-winter 1949.
CARDINAL, Roger. *Outsider Art*. London: Studio Vista, 1972.
CHAISSAC, Gaston. *Hippobosque au bocage*. Paris: Gallimard, 1951.
EHRMANN, Gilles. *Les Inspirés et leurs demeures*. Paris: Le Temps, 1962.
FOUCAULT, Michel. *Histoire de la folie à l'âge classique*. Paris: Plon, 1961.
FRIEDMAN, Bernard H. *Alfonso Ossorio*. New York: Harry N. Adams, 1972.
HERNANDEZ, Miguel. Evolución [Paris], l'Art Brut [Compagnie de l'Art Brut], 1949.
JANIS, Sidney. *They Taught Themselves*. New York: Dial Press New York, 1942.
KANDINSKY, Wassily, and Franz MARC. *Der Blaue Reiter*. Munich and Zurich: R. Piper & Co Verlag, 1912.
KARDEC, Allan. *Le Livre des Esprits*. 1857; new ed. Paris: Dervy-Livres, 1977.
———. *Le Livre des Médiums*. 1861; new ed. Paris: Dervy-Livres, 1976.
KOPAC, Slavko. *Tir à cible*. Paris: Compagnie de l'Art Brut, 1949.
L'ANSELME, Jean. *Histoire de l'aveugle*. Paris: Compagnie de l'Art Brut, 1949.
LUQUET, Georges-Henri. *Les Dessins d'un enfant*. Paris: Alcan, 1913.
Le Dessin enfantin. Neuchâtel, 1927; Paris: Delachaux & Niestlé, 1967.

MICHAUD, Dominique Allan. *Gaston Chaissac: puzzle pour un homme seul*. Paris: Gallimard, 1974; revised and expanded ed. 1992.

PAULHAN, Jean. *Guide d'un petit voyage en Suisse*. Paris: Gallimard, 1947.

RAGON, Michel. *Vingt-cinq ans d'art vivant: chronique vécue de l'art contemporain, de l'abstraction au pop art, 1944-69*. Tournai: Casterman, 1969.

TAPIÉ, Michel. *Miguel H.* [HERNANDEZ]: *L'Art Brut*. Paris: René Drouin, [c. 1948].

———. *Robert Véreux: L'Art Brut*. Paris: René Drouin, n.d. [c. 1948].

———. *Sculptures de Krizek. L'Art Brut*. Paris: René Drouin, n.d. [c. 1948].

THÉVOZ, Michel. *Louis Soutter ou l'Écriture du désir*. Lausanne: L'Âge d'Homme, 1974, vol. 1-2.

———. *L'Art Brut*. Geneva: Skira, 1975; new ed. 1980 and 1995. Trans. in English (Geneva: Skira, 1976).

TÖPFFER, Rodolphe. *Essai de physiognomonie*. Geneva: Schmidt, 1845.

———. *Réflexions et menus propos d'un peintre genevois ou Essai sur le Beau dans les arts*. 1848; Paris: Hachette, 1865.

Exhibition Catalogues

Aloyse. Lausanne: Musée Cantonal des Beaux-Arts, 1963.

L'Art Brut. Paris: Pavillon Gallimard and Compagnie de l'Art Brut, 1948.

L'Art Brut préféré aux arts culturels. Paris: Galerie René Drouin, 1949.

L'Art Brut. Vence: Galerie Les Mages, 1959.

L'Art Brut. Paris: Musée des Arts Décoratifs, 1967.

Les Barbus Müller et autres pièces de la statuaire provinciale: L'Art Brut. Part 1. Paris: Gallimard, 1947.

Bildnerei der Geisteskranken, Art Brut, Insania Pingens. Berne: Kunsthalle, 1963.

Bulletin D. Cologne, 1919.

Catalogue de la collection de l'Art Brut. Paris: Compagnie de l'Art Brut, 1971.

Cinq petits inventeurs de la peinture. Lille: Librairie Marcel Évrard, 1951.

Entartete Kunst: Ausstellungsführer. Berlin, 1938.

Miguel H. [HERNANDEZ], *L'Art Brut*. [Paris, basement of the Galerie René Drouin, 1948.]

Robert Véreux: L'Art Brut. [Paris, basement of the Galerie René Drouin, 1948.]

Sculptures de Krizek. L'Art Brut. [Paris, basement of the Galerie René Drouin, 1948.]

Simon Rodia's Towers in Watts. Los Angeles: County Museum, 1962.

Les Statues de silex de M. Juva. [Paris, basement of the Galerie René Drouin, 1948.]

Articles

Anonymous. "Les expositions." *Paru*, January 1948.

———. "Un nouveau musée." *Combat*, September 6, 1948.

———. "Quoi de neuf." *Franc-Tireur*, September 11, 1948.

———. "À l'exposition de l'Art Brut un plombier-zingueur peint en entendant des voix." *Point de vue*, September 16, 1948.

———. "À la galerie Drouin: Crépin, Antinéa et quelques autres bruts." *Combat*, October 13, 1949.

———. "Un autre procès: celui de l'art 'culturel.'" *Gazette de Lausanne*, October 23, 1949.

———. Untitled. *Nouvelles littéraires*, October 27, 1949.

———. "Des primitifs aux anarchistes." *Elle*, April 21, 1966.

———. "Les Cahiers de l'Art Brut." *Bulletin de Jean-Jacques Pauvert*, no. 6, July-August 1966.

———. "Pèlerinage aux sources." *Paris-Match*, May 20, 1967.

———. "Théâtre brut." *Le Nouvel Observateur*, March 13-March 19, 1968.

———. Untitled. *Journal du Nord*, December 1972.

———. "L'Art Brut bientôt visible au château de Beaulieu." *24 Heures*, November 25, 1975.

A. J. and M. X. "Parlons de tout." *La Tribune*, February 4, 1930.

ADLOW, Dorothy. "Dubuffet's L'Art Brut." *Christian Science Monitor*, February 24, 1962.

AUBERJONOIS, René. "Souvenir de Louis Soutter." *Werk*, no. 10, October 10, 1948; article reprinted in Thévoz, Michel. *Louis Soutter ou l'Écriture du désir*. Lausanne: L'Âge d'Homme, 1974, pp. 238–39.

———. "Au hasard d'une correspondance: Lettres de René Auberjonois à son fils Fernand." *Études de lettres*, no. 4, Lausanne: Université de Lausanne, 1972.

BARRAUD, Philippe. "L'Art Brut a offert à la Ville de Lausanne un don d'une valeur inestimable." *24 Heures*, June 7, 1971.

———. "Le château de Beaulieu deviendra l'"Institut de l'Art Brut.'" *Nouvelle Revue de Lausanne*, September 1, 1972.

BERTHERAT, Yves. "L'Art Brut." *L'information psychiatrique*, no. 9, November 1966.

BLASDEL, Gerg. "The Grassroots Artist." *Art in America*, no. 56, September-October 1968.

BONNEFOI, Geneviève. "L'envers et l'endroit. L'Art Brut." *Les Lettres nouvelles*, sections 1-2, March-April 1965.

———. "L'Art Brut." *La Quinzaine littéraire*, June 1-15, 1966.

BOURET, Jean. "Racines de bruyères et cailloux ou la fumisterie de l'"Art Brut.'" *Ce soir*, September 10, 1948.

———. "L'Art Brut." *Arts*, September 17, 1948.

———. "L'Art Brut." *Arts*, October 14, 1949.

BRETON, André. "Le message automatique." *Minotaure*, no. 3-4, 1933.

———. "L'art des fous, la clé des champs." Unpub. La Clé des champs, 1948; Paris: Sagittaire, 1953.

BURNET, Paul. "L'antimuseo di Dubuffet 'Art Brut.'" *Centroarte Orbassano*, February 1967.

C. D., "Krizek." *Arts*, February 20, 1948.

CALONI, Philippe. "L'art comme un diamant brut." *Pariscope*, no. 5-11, April 1967.

CANADAY, John. "Jean Dubuffet." *The New York Times*, February 25, 1962.

CAREMAL, C. Untitled. *Empédocle*, December 1949.

CHERONNET, Louis. "De l'Art Brut à l'Art naïf." *Opéra*,

September 29, 1948.

CHABRUN, Jean-François. "L'art des consciences perdues." *Nouveau Candide*, May 1, 1967.

CHONEZ, Claudine. "L'Art Brut." *Une semaine dans le monde*, September 11, 1948.

———. "L'Art Brut à l'honneur." *La Nef*, October 1948.

Collection de l'Art Brut. Restauration partielle du château de Bealieu, "Aménagement partiel du château de Beaulieu pour l'installation de la collection." Notice from the city of Lausanne, no. 177, July 14, 1972.

CRESPELLE, Jean-Pierre. "Expositions: à nouveau public, nouvelle présentation." *France Soir*, May 6, 1967.

DAMISCH, Hubert. "L'Art Brut." *Encyclopædia Universalis*, vol. 1, 1968.

DHAINAUT, Philippe. "L'Art Brut." *Cahiers du Sud*, no. 383-384, October 8, 1965.

DIEHL, Gaston. Untitled. *La Gazette des Lettres*, October 1949.

DOMERGUE, René. "L'Art Brut (l'art fou) qui n'effraie plus personne gîte place Vendôme." *L'Aube*, October 20, 1949.

EDELMANN, Claude. "Art Brut." *Connaissance des Arts*, no. 173, July 1966.

ELGAR, Frank. "L'Art Brut et l'art de faire de l'Art Brut." Carrefour, November 8, 1949.

ELUARD, Paul. "Le génie sans miroir." *Les Feuilles libres*, no. 35, 1924.

ERNST, Max. "Au-delà de la peinture." *Cahiers d'art*, no. 6-7, 1936.

ESTEBAN, Claude. "L'art dépossédé." *Nouvelle Revue française*, no. 174, June 1, 1967.

ESTIENNE, Charles. "Les Arts." *Combat*, December 27, 1947.

———. "Lyrisme ou délire." *Combat*, June 1949.

F. D. "Art Brut." *Journal de Genève*, November 6, 1949.

FERDIERE, Gaston. "Point de vue d'un psychopathologue." *Nouvelle Revue française*, no. 174, June 1, 1967.

FLORENTIN, L. "L'art des possédés." *La Suisse*, January 28, 1930.

FOUCHÉ, J.-J. "La brutalité des 'œuvres.'" *Réforme*, April 22, 1967.

GREENBERG, Clement. "Jean Dubuffet and 'Art Brut.'" *Partisan Review*, March 1949.

GUEGEN, Pierre. "Brutes ou pas brutes." *L'Architecture d'aujourd'hui*, Decemmber 1949.

GUILLY, René. "M. le Zouzou (du Doubs) représentant de "L'Art Brut." *Combat*, December 16, 1947.

HÉRAUT, Henri. "Heinrich Anton, Auguste et Jeanne." *Le Rayonnement des Beaux-Arts*, June 1, 1948.

JOLY, G. "L'Art Brut: l'art roublard plutôt." *L'Aurore*, October 18, 1949.

KLERX, Alexandre. "L'Art Brut." *Le Phare*, May 14, 1948.

KUBIN, Alfred. "Die Kunst der Irren." *Das Kunstblatt*, no. 5-6, May 1922.

KUENZI, André. "La ville des occasions manquées?" *Gazette littéraire*, May 29-30, 1971.

LAUGIER, Robert. "L'Art Brut." *À mon point de vue*, October 1948.

LASCAULT, Gilbert. "L'Art Brut." *Paris-Normandie*, April 14, 1967.

———. "Situation de l'Art Brut." *Les Temps modernes*, May 1967.

LE CORBUSIER. "Louis Soutter, l'inconnu de la soixantaine." *Minotaure*, no. 9, 1936.

LENNON, Peter. "L'Art Brut." *The Guardian*, April 21, 1967.

LÉPINE, M. "L'Art Brut (Compagnie de)," Paris: Encyclopédie Larousse, 1970.

LERRANT, Jean-Jacques. "L''Art Brut'"au musée des Arts Décoratifs." *Le Progrès*, April 23, 1967.

MATHEY, François. "L'Art Brut." *La Quinzaine littéraire*, April 15-30, 1967.

MÉOT, Anya. "Le génie commun de Jean Dubuffet." *Valeurs actuelles*, April 13, 1967.

MICHEL, Jacques. "Jean Dubuffet parle de sa donation d'Art Brut à Lausanne." *Le Monde*, September 15, 1971.

Minotaure, 1 / 12-13. Paris: Albert Skira, 1933-39.

MOUSSEAU, Jacques. "L'Art Brut échappe-t-il à la culture?" *Planète*, September-October 1967.

NAKOV, André. "L'Art Brut à Paris." *Gazette de Lausanne*, April 15, 1967.

PARET, Pierre. "L'Art Brut."*Sud-Ouest*, June 7, 1967.

PICARD, Lil. "Die Masse Mensch im Dickicht der Städte." *Die Welt*, February 1962.

PICHARD, Joseph. "L'Art Brut ou la peinture onirique." *La Croix*, April 24, 1967.

PIERRE, José. "Raphaël Lonné et le retour des médiums." *L'Œil*, no. 216, December 1972.

PIEYRE DE MANDIARGUES, André. "Un acte d'amour." *Nouvelle Revue française*, no. 174, June 1, 1967.

PLUCHART, François. "L'Art Brut remet en question notre conception de l'histoire." *Combat*, April 10, 1967.

RAGON, Michel. "Promenades à travers le monde." *Arts*, January 30, 1948.

ROUSSELOT, Jean. "La peinture à Paris." *L'Écho d'Oran*, November 12, 1949.

SCHWARTZ, Paul Waldo. "The Art of The Insane: A Pertinent Message." *New York Times*, April 11, 1967.

SEUPHOR, Michel. "L'Art Brut' est maintenant domicilié chez M. Gallimard." *L'Aube*, September 11, 1948.

SPIES, Werner. "Genie und Irrtum." *Frankfurter Allgemeine Zeitung*, May 16, 1967.

———. "L'Art Brut avant 1967." *Revue de l'art*, no. 12, 1968.

SPOERRI, Elka. "Adolf Wölfli." in *Künstler Lexikon der Schweiz XX. Jahrhundert*, Eduard Plüss and Hans Christoph von Tavel, eds. Frauenfeld: Huber, 1958-67, vol. 2.

SZEEMANN, Harald. *Chronique de l'art vivant*. April 10, 1970.

THÉVOZ, Michel. "Variations physiognomoniques." *Les Temps modernes*, no. 258, Paris, November 1967.

TRUCCHI, Lorenza. in *L'Europa letteraria*, March-April 1965.

WALDBERG, Patrick "L'Art Brut." *Paru*, November 1949.

PUBLICATIONS ON ART BRUT AND OUTSIDER ART
(after 1976)

Revue L'Art Brut,
Published by the Collection de l'Art Brut, Lausanne
– No. 10, 1977: Dubuffet, Jean, "L'Art Brut à Lausanne." STECK, Hans, "Jules Doudin." CELEBONOVIC, Aleksa, "Vojislav Jakic." Trans. Claudine Orlic. THÉVOZ, Michel, "Les sédimentations mentales de Jakic." "Gaston Teuscher." MAUNOURY, Pierre and Renée MAUNOURY, "Pierre Jain." THÉVOZ, Michel, "Albino Braz." ROULIN, Geneviève, "Samuel Failloubaz."THÉVOZ, Michel, "Katharina." CHEVASSU, Bernard, "Louise Fischer." THÉVOZ, Michel, "Solange Lantier," "Louise Tournay."
– No. 11, 1982: DASNOY, Albert, "Léontine." REQUET, André, "Sylvain Fusco." FILIPPA, Guy, "Aloïs Wey," Trans. Vincent Kaufmann. THÉVOZ, Michel, "Edmund Monsiel." GENTIS, Roger, "André Robillard." ANDREOLI, Vittorino, "Les dernières années de Carlo." MASSÉ, Claude, "Joseph Vignes dit "Pépé." STROOBANT, Dominique, "Italo Perugi." CHEVASSU, Bernard, "François Portrat." THÉVOZ, Michel, "Les missives de Samuel Daiber," "Thérèse Bonnelalbay."
– No. 12, Gugging, 1983: THÉVOZ, Michel, "Johann Hauser." NAVRATIL, Leo, "Philipp Schöpke." BREYMANN, Thomas, "August Walla." THÉVOZ, Michel, "Oswald Tschirtner." NAVRATIL, Leo, "Johann Garber," "Fritz Opitz." THÉVOZ, Michel, "Rudolf Horacek." NAVRATIL, Leo, "Franz Kernbeis," "Johann Korec," "Josef Bachler," "Johann Scheiböck," "Otto Prinz."THÉVOZ, Michel, "Max."NAVRATIL, Leo, "Franz Gableck," "Johann B."
– No. 13, 1985: THÉVOZ, Michel, "Reinhold Metz."
– No. 14, 1986: THÉVOZ, Michel, "Josef Wittlich." BROMET, Joop and Nico VAN DER ENDT, , "Willem Van Genk," Trans. Désirée van Reek. GOFFART, Valérie, "Angelo Meani." BREYMANN, Thomas, "Hans Krüsi." DUBUFFET, Jean, "Notes au sujet d'Henriette Zéphir." BADER, Alfred, "Jean Radovic." JOUSSEMET, Guy, "Yvonne Robert." POHRIGNY, Arsén, "Anna Zemànkovà," trans. Milena Braud. SCHLUMPF, Hans-Ulrich, "La seconde vie d'Armand Schulthess." SIGODA, Pascal, "Camille Renault et le jardin des surprises."
– No. 15, 1987: PEIRY, Lucienne, "Giovanni Battista Podestà."
– No. 16, 1990: FITTING, Zora, "Yanco Domsic." DEBRAINE, Luc, "Eugène Gabritschevsky." MACGREGOR, John M., "Ted Gordon." Trans. Geneviève Roulin. CAMERIN, Daniela, "Benjamin Bonjour." CARDINAL, Roger, "Michel Nedjar." RAAFLAUB-SIMON, Élisabeth, "Édouard Boschey." BORN, Maurice, "Eugenio Santoro." IN DER BEECK, Manfred, "Helmut." Trans. Rébecca Mex. GARCIA, Enrique Alfonso, "Pepe de Valence," trans. Gabriel Uribe. MAUNOURY, Pierre, "René le bedeau."
– No. 17, 1992: MACGREGOR, John M., "Dwight Mackintosh," trans. Geneviève Roulin. PEIRY, Lucienne and Joseph PODDA, " Vahan Poladian ou l'Arménie retrouvée." THÉVOZ, Michel, "Johann." STREBL, Michaela, "Johann Fischer," trans. Catherine Lepdor. THÉVOZ, Michel, "Marcomi." KUEPPERS, Robert, "Théo," Trans. Marie-Odile

Vaudou. BAUKUS, Peter, "Erika Orysik," Trans. Catherine Lepdor. MENSI, Massimo, "La Tinaia," trans. Anic Zanzi. THÉVOZ, Michel, "Michael Pankoks."
– No. 18, 1994: MAURER, Lise, "Émile Josome Hodinos."
– No. 19, 1995: CHOQUARD RAMELLA, Florence, "Constance Schwartzlin-Berberat."

Published Works
L'Art Brut et après . . ., expériences et réflexions (Suisse, France, États-Unis, Grande-Bretagne, Belgique). Texts gathered by Gérard Preszow, edited by Françoise Henrion. Brussels: Art en Marge, 1988.
Art Brut, Madness and Marginalia. Edited by S. Weiss. Art & Text 27, Sydney and Melbourne, Art & Text Pty. Ltd. December-February 1988.
ARZ, Claude. *Guide de la France insolite.* Paris: Hachette, 1990.
———. *La France insolite.* Paris: Hachette, 1995.
AZZOLA INAUDI, Maria Ausilia. *Carlo.* Università degli studi di Siena, facoltà di lettere e filosofia, 1990-91, forthcoming.
CHAISSAC, Gaston. *Le Laisser-aller des éliminés: Lettres à l'abbé Coutant.* Paris: Plein Chant, 1979.
COLLINS, Georges R. Schuyt, Michael ELFFERS and Joost ELFFERS. *Les Bâtisseurs du rêve.* Paris, 1980.
DANCHIN, Laurent. *Chomo.* Jean-Claude Simoën, 1978.
———. *Art Brut et Compagnie: La face cachée de l'art contemporain.* Paris: La Différence, 1995.
DELACAMPAGNE, Christian. *Outsiders, fous, naïfs et voyants dans la peinture moderne (1880-60).* Paris: Mengès, 1989.
DOPFFER, Anne. *Organisation et fonctionnement de la Collection de l'Art Brut, Paris.* Mémoire de muséologie. École du Louvre. 1990-91.
FEILACHER, Johann. *Gugging.* Vienna and Helsinki, 1993.
JOUVE, Jean-Pierre, Claude Prévost and Clovis Prévost. *Le Palais idéal du Facteur Cheval: Quand le songe devient la réalité.* Paris: Le Moniteur, 1981.
GONZALEZ MARTINEZ, Esther. *Le Visiteur à l'œuvre: Analyse de la réception du Musée de l'Art Brut par le public.* Master's thesis in sociology and anthropology, Université de Lausanne, March 1994.
KILLER, Peter, and Peter E. SCHAUFELBERGER. *Hans Krüsi.* Urnäsch: Säntis Verlag, 1991.
LAFARGUE, Guy and Angelo MADYALES. *Travesti couloir des songes.* Monteton: Cahiers de l'Art Cru, 1989.
LASSUS, Bernard. *Jardins imaginaries: Les habitants paysagistes.* Paris: Presses de la Connaissance, 1977.
MACGREGOR, John M. *Henry J. Darger: dans les Royaumes de l'Irréel.* Trans. Geneviève Roulin. Lausanne: Collection de l'Art Brut; Lugano, Galerie Gottardo, 1996.
*MAIZELS, John. *Raw Creation: Outsider Art and Beyond.* London: Phaidon, 1996.
*MELLY, George. *It's all writ out for you: The Life and Work of Scottie Wilson.* London: Thames & Hudson, 1986.
La Mesure des irréguliers: Symptôme et creation. Edited by Fabienne Hulak. Nice: Z'éditions, 1990.
NAVRATIL, Leo. *August Walla: Sein Leben und seine Kunst.* Nördlinden: Greno, 1988.
PEIRY, Lucienne. *Charles Ladame ou le Cabinet fou d'un psychiatre.* Lausanne: Collection de l'Art Brut, 1991.

————. *Hans Steck ou le Parti pris de la folie.* Lausanne: Collection de l'Art Brut, 1991.

————. *L'Art Brut.* Geneva: La Joie de Lire, 1995.

————. *De la clandestinité à la consecration: Histoire de la collection de l'Art Brut, 1945-96.* Doctoral thesis, Université de Lausanne, 1996.

PORRET-FOREL, Jacqueline. *Aloïse ou le Théâtre de l'univers.* Geneva: Skira, 1993.

Ragon, Michel. *Du côté de l'Art Brut.* Paris: Albin Michel, 1996.

ROSENAK, Chuck and Jan. *Encyclopedia of Twentieth-Century American Folk Art and Artists.* New York: Abbeville Press, 1990.

RUDOFSKY, Bernard. *The Prodigious Builders.* New York: Harcourt Brace Jovanovich, 1977; French ed. Paris: Jules Tallandier, 1979.

THÉVOZ, Michel. *Le Langage de la rupture.* "Perspectives critiques" series. Paris: PUF, 1978.

————. *Les Écrits bruts.* "Perspectives critiques" series. Paris: PUF, 1979..

————. *Gaston Teuscher.* Lausanne: Collection de l'Art Brut, 1981.

————. *Art, Folie, LSD, Graffiti, etc.* Lausanne: L'Aire, 1985.

————. Art Brut. *Kunst jenseits der Kunst.* Aarau: AT Verlag, 1990.

————. *Art Brut, psychose et médiumnité.* Paris: La Différence, 1990.

————. *Requiem pour la folie.* Paris: La Différence, 1995.

VERROUST, Jacques et Jacques LACARRIERE. *Les Inspirés du bord des routes.* Paris: Le Seuil, 1978.

WEISS, Allen S. *Shattered Forms, Art Brut, Phantasms, Modernism.* New York: State University of New York Press, 1992.

Exhibition Catalogues and Reviews

L'Aracine. Paris: Musée d'Art Brut, 1988.

Artension. D'autres regards sur l'art actuel, 1-25, 1987-91.

La Beauté insensée: Collection Prinzhorn-Université de Heidelberg, 1890-20. Exh. cat. Charleroi: Palais des Beaux-Arts, 1995-96.

Dada: Première revue d'art pour enfants, special issue, September 1994, issue dedicated to Art Brut, no. 23, October-November 1995.

Jean Dubuffet & Art Brut. Exh. cat. Coll. Vicenza: Coll. Peggy Guggenheim; Venice: Arnoldo Mondadori, 1986-87.

La Fabuloserie, Art hors-les-normes. Paris: La Fabuloserie, 1983; new ed. 1993.

Les Jardiniers de la mémoire, nos. 1-8, Bègles: Site de la Création Franche, 1989-96.

Augustin Lesage 1876-54, Paris: Philippe Sers, 1988.

Livre d'or de la collection de l'Art Brut. Lausanne, no. 1-3, 1976-96.

Le Monde d'Alphonse Chave ou la Vision d'un amateur d'art. Lyon: Elac, 1981.

Heinrich Anton Müller 1869-30: Katalog der Maschinen, Zeichnungen und Schriften. Berne: Kunstmuseum; Bâle and Francfort-sur-le-Main: Strœmfeld, 1994.

Neuve Invention. Lausanne: Collection de l'Art Brut, 1988.

L'Œuf sauvage: L'art existe à l'état pur, nos. 1-9, 1991-94.

Open Mind. Exh. cat., Gent: Van Hedendaagse Kunst, 1989.

Outsiders: An Art without Precedent or Tradition. Exh. cat. London: Hayward Gallery, Arts Council of Great Britain, 1979.

Parallel Visions, Modern Artists and Outsider Art. Exh. cat. County Museum of Art, Los Angeles; Museo Nacional Reina Sofia, Madrid; Kunsthalle, Basel; Setagaya Art Museum, Tokyo. Los Angeles: County Museum of Art and Princeton University Press, 1992-93.

Portraits from the Outside: Figurative Expression in Outsider Art. Exh. cat. New York: Parsons School of Design Gallery, Grœgfeax, 1990.

Raw Vision: International Journal of Intuitive & Visionary Art, nos. 1-16, 1989-96.

Les Singuliers de l'art: Des inspirés aux habitants paysagistes. Exh. cat. Paris: Musée d'Art moderne de la ville de Paris, ARC 2, 1978.

Von einer Wellt zu'r Andern. Exh. cat. Cologne: Kunsthalle, 1990.

Wölfli: dessinateur-compositeur. Lausanne: L'Âge d'Homme-collection de l'Art Brut; Berne: Fondation Adolf Wölfli, 1991.

Collection de l'Art Brut exhibition cards. Lausanne, 1976-96.

Articles

Anonymous. "L'Art Brut; capitale: Lausanne." *La Galerie,* February 1976.

————. "L'Art Brut." *L'Œil,* May 1976.

————. "La collection de l'Art Brut: un succès réjouissant." *Nouvelle Revue de Lausanne,* May 1, 1976.

————. "Musée de l'Art Brut, Château de Beaulieu, 1004 Lausanne / VD." *Architecture Suisse,* no. 26, April 26, 1977.

————. "Autour de l'Art Brut." *Tout va bien,* October 19, 1977.

————. "Ça va pas la tête?" *Libération,* August 7, 1982.

AESCHLIMANN, Jean-Christophe. "Musée de l'Art Brut." *Construire,* no. 16, April 16, 1986.

————. "L'art d'inventer." *Construire,* no. 11, March 11, 1987.

ALAMIR-PAILLARD, Marie. "Töpffer: l'art de la naïveté." *La Revue du musée d'Orsay,* no. 3, September 1996, pp. 46-57.

AUDÉTAT, Michel. "La folie a cessé d'être créatrice." Interview with Michel Thévoz. *L'Hebdo,* Lausanne, no. 45, November 9, 1995.

AUTRAND, Dominique. "Au-delà des murs de l'asile." *La Quinzaine littéraire,* no. 297, March 1-15, 1979.

B. P.-O. "Une heure avec Michel Thévoz." *Nouvelle Revue de Lausanne,* October 21, 1985.

BORRINI, Catherine-France. "À la brocante de l'âme." *L'Hebdo,* February 6, 1986.

BOURBONNAIS, Caroline. "La Fabuloserie." *L'Œuf sauvage,* no. 2, December 1991-January 1992.

BREERETTE, Geneviève. "Les enfants de l'Art Brut." *Le Monde,* March 14, 1977.

CARDINAL, Roger. "Art Brut in context." *Raw Vision,* no. 1,

Spring 1989.

Caffari, C. "Le langage des marginalisés." *Feuille d'avis de Vevey*, March 15, 1979.

CHARRIERE, Edmond. "Inauguration d'un nouveau musée à Lausanne: Qu'est-ce que l'Art Brut?" *Tribune de Geneva*, March 3, 1976.

"Château de Beaulieu: Collection de l'Art Brut." *Préavis de la Ville de Lausanne*, no. 116, March 23, 1976.

COUSSEAU, Henri-Claude. "L'origine et l'écart: d'un art l'autre." *Paris-Paris: créations en France 1937-57*. Exh. cat. Paris: Centre Georges Pompidou, 1981; new ed. Paris: Gallimard, 1992.

CRUCHET, B.-P. "Entre la prétention et l'imbécillité." *Gazette de Lausanne*, November 4, 1980.

DANCHIN, Laurent. "Dicy, Alain Bourbonnais (1925-88)." *Artension*, no. 5, August 1988.

———. "Autour de l'Art Brut." *Raw Vision*, no. 1, spring 1989.

———. "Quelques considérations brutales sur l'Art Brut." *Art et thérapie*, no. 30-31 (special issue entitled "L'Art fou: De l'art des fous à la folie de l'art"), August 1989.

———. "Y a-t-il un marché pour l'Art Brut?" *Artension*, no. 29, November 1991.

DESCOMBES, Mireille. "Collection de l'Art Brut: Les lignes de vie de Bill Traylor." *L'Hebdo*, February 18, 1993.

DUCHEIN, Paul. "Eugène Gabritschevsky." *Pharmacien de France*, October 15, 1987.

ENKELL, Pierre. "Je ne parviens pointement à m'exprimer." *Nouvelles littéraires*, March 29, 1979.

GARZAROLLI, Richard. "Voyages autour de la folie." *Tribune de Lausanne* and *Le Matin*, February 26, 1979.

GATEAU, Jean-Charles. "Après l'Art Brut, Michel Thévoz analyse les écrits bruts." *Journal de Genève*, December 25, 1978.

GISIGER, Hansjörg. "Was ist elitäre Kunst?" *Basler Nachrichten*. March 10, 1976.

H. P. "Scottie à l'Art Brut." *Gazette de Lausanne*, December 28, 1977.

HAENGGI, Jeanmarie. "Du Pacifique au Léman." *Le Démocrate*. October 22, 1990.

HEINRICH, N. "Un événement culturel." *Les Immatériaux*. Exh. cat. Paris: Centre Georges Pompidou, Expo Média, 1986.

JACCARD, Roland. "L'Art Brut à Gugging." *Le Monde*, January 27, 1984.

JAUNIN, Françoise. "Art Brut en question." *Tribune de Genève*, March 7, 1976.

———. "Laure au musée de l'Art Brut. Spiritisme et poésie." *Tribune de Lausanne* and *Le Matin*, May 17, 1978.

KUENZI, André. "Jean Dubuffet: La petite fille n'a plus de confiture au nez!" *24 Heures*, February 26, 1976.

———. "Collection de l'Art Brut: Ouverture 26 February au château de Beaulieu." *24 Heures*, November 5, 1976.

———. "Vernissage à la collection de l'Art Brut: L'œuvre dessiné de Laure." *24 Heures*, March 22, 1978.

LAING, Joyce. "L'Art extraordinaire: Collection écossaise d'art outsider." *Raw Vision*, no. 16, fall 1996.

LÉVEQUE, Jean-Jacques. "L'imagination au pouvoir: La raison du plus fou." *Le Quotidien de Paris*, March 8, 1976.

LUBOW, Arthur. "The Creeks." *Vanity Fair*, August 1992.

M. P., "Les Suisses au sommet de la capitale." *Le Figaro*, March 5, 1977.

MACGREGOR, John M. "Art Brut chez Dubuffet: An Interview with the Artist, August 21, 1976." *Raw Vision*, no. 7, summer 1993.

MAURON, Véronique. "Hans Krüsi: une étrange gaieté." *Gazette de Lausanne*, June 29, 1990.

MERMOD, Jean-David. "L'Art Brut au pays de l'art contemporain." *L'Éveil culturel*, no. 11, March 1996.

MICHEL, Jacques. "Les derniers 'peintres maudits' à Lausanne." *Le Monde*, February 24, 1976.

PAJAK, Frédéric. "Brut de brut." *Passeport pour l'Art Brut*, 1986.

PEIRY, Lucienne. "Podestà: Le Moyen Âge au xxe siècle." *Voir*, no. 37, March 1987.

———. "Le royaume d'Aloïse." *Voir*, no. 37, March 1987.

———. "Le hasard fait bien les choses." *Voir*, no. June 40, 1987.

———. "Les éclats de la contestation." *Construire*, no. 8, February 24, 1988.

———. "Un univers sans frontières." *Construire*, no. 36, September 7, 1988.

———. "La dictée des défunts." *Construire*, no. 8, February 22, 1989.

———. "L'énigme vagabonde." *Construire*, no. 28, July 12, 1989.

———. "Le mystère parfait." *Construire*, no. 36, September 6, 1989.

———. "Eugenio Santoro." *Construire*, no. 5, January 31, 1990.

———. "Benno Kaiser: sculptures de sable." *Scoop*, February 1990.

———. "Louis Soutter." *Scoop*, no. 144, March 1990.

———. "L'homme a perdu l'animal. Une exposition fait revenir la bête au galop." *Le Nouveau Quotidien*, March 13, 1993.

———. "Bill Traylor, esclave, clochard, artiste." *Le Nouveau Quotidien*, April 15, 1993.

———. "L'aventure de l'Art Brut: une histoire de diamants et de crapauds..." *L'Éveil culturel*, no. 7, March 1995.

———. "Chemins de contrebande." *La Quinzaine littéraire*, July 1996.

POULIN, Jean-Claude. "Asphyxiante éducation?" *Journal de Genève and Gazette de Lausanne*, March 14, 1976.

PRESZOW, Gérard. "Art Brut et Compagnie. Une visite guidée." *La Revue nouvelle*, no. 10, 1987.

REBETEZ, Jean-Louis. "Un événement artistique à Lausanne. Les sortilèges de l'Art Brut." *Feuille d'avis de Vevey*, March 6, 1976.

RENKO, J.-P. "Les visions du facteur Lonné." *Tribune de Genève*, July 10, 1980.

ROFFAT, Claude. "De l'œil à l'œuf. L'œil existe à l'état sauvage." *L'Œuf sauvage*, no. 1, October-November 1991.

SEMIN, Didier. "Chaissac et Dubuffet: Les Années 50." Exh. cat. Paris: Centre Georges Pompidou, 1988; revised and expanded version in *Dubuffet*. Paris: Éditions du Jeu de Paume, 1992.

SOUCHAUD, Pierre. "La cafetière anti-impérialiste." *Artension*, no. 5-6, November-December 1982.

TAUXE, Henri-Charles. "Les écrits bruts." *24 Heures*, February 16, 1979.

TEYSSEDRE, Bernard. "L'art des innocents massacrés." *Le Nouvel Observateur*, March 8, 1976.

THÉVOZ, Michel. "Le débile n'est pas toujours celui qu'on croit." Museum, Paris: Unesco, vol. 34, no. 3, 1982.

———. "Le sémioticien ventriloque: Analyser le musée." Proceedings of the international conference of the Association Suisse de Sémiotique, Centre de Recherches Sémiologiques, 1996.

VERHOMME, Hugo. "Non-musée pour non-art." *Nouvelles littéraires,* March 4, 1976.

WELLS, Ken. "'Outsider Art' Is Suddenly the Rage Among Art Insiders." *The Wall Street Journal*, February 25, 1992.

PSYCHIATRIC STUDIES

BADER, Alfred and Leo NAVRATIL. *Zwischen Wahn und Wirklichkeit: Luzern.* Frankfurt-am-Main: Bucher, 1976.

DANCHIN, Laurent. "Hommage à Gaston Ferdière." *Artension*, no. 22, March 1991.

DEQUEKER, Jean. *Monographie d'un psychopathe dessinateur: étude de son style, thèse de médecine présentée à l'université de Toulouse.* Rodez: Georges Subervie, n.d. [c. 1948].

FLOURNOY, Théodore. *Des Indes à la planète March: Études sur le cas de somnambulisme avec glossolalie (1900).* Paris: Le Seuil, 1983.

GRASSET, "Les faits du spiritisme et nos connaissances sur l'au-delà." *Æsculape*, no. 1, 1911.

JANET, Pierre. *L'Automatisme psychologique: Essai de psychologie expérimentale sur les formes inférieures de l'activité huMaine (1889).* Paris: Félix Alcan, 1989.

MACGREGOR, John M. *The Discovery of the Art of the Insane.* New Jersey: Princeton University Press, 1989.

MARIE, Auguste. "Le musée de la folie." *Je sais tout,* vol. IX, October 15, 1905.

MORGENTHALER, Walter. *Ein Geisteskranken als Künstler, 1921.* Partial French ed. "Adolf Wölfli." *L'Art Brut*, no. 2, trans. Henri-Pol Bouché. Paris: Compagnie de l'Art Brut, 1964; new ed. 1979.

MORSIER, Georges de. *Art et Hallucination: Marguerite Burnat-Provins.* Neuchâtel: La Baconnière, "Langages et documents" series, 1969.

NAVRATIL, Leo. *Schizophrenie und Kunst.* Munich: Deutscher Taschenbuch Verlag, 1965.

OSTY, Eugène. "M. Augustin Lesage, peintre sans avoir appris: Aux confins de la psychologie classique et de la psychologie métapsychique." *Revue métapsychique,* January-February 1928.

PORRET-FOREL, Jacqueline. *Aloyse ou la Peinture magique d'une schizophrène.* Lausanne, Jaunin. Doctorate thesis presented to the medical faculty of the Université de Lausanne, 1953.

PRINZHORN, Hans. *Bildnerei der Geisteskranken.* Berlin: Springer, 1922; French ed. *Expressions de la folie.* Trans. Marielène Weber. Paris: Gallimard, 1984.

———. *Psychopathologie und Bildnerischer Ausdruck.* Bâle: Sandoz, no. 3-24, 1963-77.

RÉJA, Marcel. "L'art malade: dessins de fous." *La Revue universelle*, I, vol. 2, 1901.

———. *L'Art chez les fous.* Paris: Mercure de France, 1907; new ed. with foreword by Fabienne Hulak, Nice: Z'éditions, 1994.

ROGUES DE FURSAC, Joseph. Les Écrits et les dessins dans les maladies mentales et nerveuses. Paris: Masson, 1905.

SCHWEIZER, Laurent. *De la Production et de l'exploitation des beaux-arts du patient soigné en établissement psychiatrique.* Undergraduate (*licence*) and doctoral thesis presented to the Law Faculty of the University of Lausanne, Zurich: Schulthess Polygraphischer Verlag AG, 1995.

SIMON, Max. "L'imagination dans la folie. Étude sur les dessins, plans, descriptions et costumes des aliénés." *Annales médico-psychologiques*, no. 16, 1876.

———. "Les dessins et les écrits d'aliénés." *Archives de l'anthropologie criminelle et des sciences pénales*, III, 1888.

Thèse-Métaphore-Chimère. Interdisciplinary francophone symposium on the dynamic esthetic in art, madness and science, presented by Alfred Bader and Gérard Salem. Bern, Frankfurt-am-Main, and New York: Peter Lang, 1986.

THÉVOZ, Michel. "Marcel Réja, découvreur de 'l'art des fous.'" *Gazette des Beaux-Arts*, no. 1408-1409, May-June 1986.

VINCHON, Jean. *L'Art et la folie.* Paris: Stock, 1924; new ed. 1950.

VOLMAT, Robert. *L'Art psychopathologique.* Paris: PUF, 1956.

WILL-LEVAILLANT, Françoise. "L'analyse des dessins d'aliénés et de médiums en France avant le surréalisme: Contribution à l'étude des sources de 'l'automatisme' dans l'esthétique du xxe siècle" (1980), in *La Mesure des irréguliers.* Edited by Fabienne Hulak. Nice: Z'éditions, 1990.

STUDIES ON ART

Published Works and Articles

BAUDRILLARD, Jean. *La Transparence du mal.* Paris: Galilée, 1990.

CHARPIN, Catherine. *Les Arts incohérents.* 1882-1893; Paris: Syros Alternatives, 1990.

DACHY, Marc. *Journal du mouvement Dada.* Geneva: Skira, 1989.

DANCHIN, Laurent and Philippe RIVIERE. *La Métamorphose des medias: Sens et non-sens de l'art contemporain.* Lyon: La Manufacture, 1990.

Donations Daniel Cordier: Le regard d'un amateur. Exh. cat. Paris: Centre Georges Pomipdou, 1989.

DUBORGEL, Bruno. *Imaginaires à l'œuvre.* Paris: Greco, 1989.

ERNST, Max. *Écritures: Notes pour une biographie.* Paris: Le Point du Jour, 1979.

ETERSTEIN, Claude. *Le Bon Sauvage.* Paris: Gallimard, 1993.

GOLDWATER, Robert. *Le Primitivisme dans l'art moderne.* 1938; French trans. Denise Paulme, Paris: PUF, 1988.

GROTE, Ludwig. "Expressionismus und Volkskunst." *Zeitschrift für Volkskunde*, no. 2, Stuttgart: W. Kohlham-

mer Verlag, 1959.

JOUFFROY, Alain. "La collection André Breton." *L'Œil*, no. 10, October 1995.

Kinderzeichnung und die Kunst des 20. Jahrhunderts. Texts collected by Jonathan Fineberg. Ostfildern-Rui bei Stuttgart: Hatje, 1995.

MÉRÉDIEU, Florence de. *Le Dessin d'enfant.* Paris: Blusson, 1990.

RAUZY, Alain, "L'Immaculée Conception en 1930." *Folie et psychanalyse dans l'expérience surréaliste.* Edited by Fabienne Hulak, Nice: Z'éditions, 1992.

SZEEMANN, Harald. *Individuelle Mythologien.* Berlin: Merve Verlag, 1985.

Thévoz, Michel. *L'Académisme et ses fantasmes.* Paris: Éditions de Minuit, "Critique" series, 1980.

THILMANY, Robert. *Critériologie de l'art naïf.* Paris: Vilo, 1984.

WERCKMEISTER, Otto Karl. "The Issue of Childhood in the Art of Paul Klee." *Arts Magazine*, 1977.

Exhibition Catalogues

Le Cavalier bleu. Berne: Kunstmuseum, 1986-87.

Comédie-Tragédie. Castres: Centre d'Art contemporain, 1988.

La Différence. Neuchâtel: Musée d'Ethnographie, 1995.

Kinderzeichnung und die Kunst des 20. Jahrhunderts. Texts gathered by Jonathan Fineberg with the Lenbachhaus, Munich, and the Kunstmuseum, Berne. Stuttgart: Gerd Hatje, 1995.

Paul Klee. New York: Museum of Modern Art, 1949-50.

Annette Messager: Comédie tragédie 1971-89. Musée des Beaux-Arts, Grenoble; Bonner Kunstverein, Bonn; Musée Municipal, La Roche-sur-Yon; Kunst-verein für die Rheinlande und Westfalen, Düsseldorf, 1989-90.

Mit dem Auge des Kindes. Kinderzeichnung und moderne Kunst, Munich, Lenbachhaus. Berne: Kunstmuseum, 1995.

Niki de Saint-Phalle. Bonn: Kunst und Ausstellungshalle der Bundesrepublik Deutschland; Glasgow: McLellan Galleries; Paris: Musée d'Art Moderne de la Ville de Paris, 1992-93.

Paris-Paris 1937-57, Paris: Centre Georges Pompidou, 1981; new ed. Paris: Gallimard and Centre Georges Pompidou, 1992.

Arnulf Rainer, Louis Soutter: Les doigts qui peignent. Musée Cantonal des Beaux-Arts, Lausanne; Shirn Kunsthalle, Frankfurt; Neue Galerie der Stadt Linz and The Wolfgang Museum, Linz, 1986-87.

Arnulf Rainer: Art Brut Hommagen. Cologne: Galerie Susanne Zander, 1991.

Arnulf Rainer und die Künstler aus Gugging: Miteinander-Gegeneinander. Cologne: Susanne Zander gallery, 1995.

Regards sur Minotaure: La revue à tête de bête. Geneva: Musée Rath; Paris: Musée d'Art Moderne de la Ville de Paris, 1987-88.

Julian Schnabel: Reconocimentos, pinturas del Carmen. Basel: Kunsthalle, 1989.

Visionäre Schweiz. Kunstmuseum, Zurich; Museo Nacional Reina Sofía, Madrid; Städtische Kunsthalle und Kunstverein für die Rheinlande und Westfalen, Düsseldorf, 1991-92.

FILMS AND VIDEO
(selected sources)

FLORIAN CAMPICHE. *Le Miroir magique d'Aloyse.* 1967, 26'.

KERMADEC, Liliane de. *Aloïse.* 1975.

BADER, Alfred. *Aloïse*, 1978, 9' (abridged version of the film by Florian Campiche).

LÉNIER, Christiane. *L'Art Brut.* Service de la Recherche de l'ORTF, 1971, 60'.

PLACE, Claude, and Bernard d'ABRIGEON. *Attention Art Brut: Chomo, Paranthoën, Bourbonnais*.1981, 52'.

OZIL, Didier. *La Battue (Gérard Lattier).* 1991, 7'.

IMBERT, Henri-François. *Benjamin Bonjour: là-haut sur la montagne.* 1996, 6'.

BOURBONNAIS, Alain. *Simone Le Carré-Galimard.* 1988, 14'.

MASSICOT, Pascale, Stéphane JEAN-BAPTISTE and Éric POTTE. *Simone Le Carré-Galimard: les surprises de l'insolite.* 1993, 15'.

VOLLERIN, Alain. *Chichorro.* 1993, 50'.

MAXIMY, Antoine de. *Chomo.* 1985, 26'.

JAKAB, Irène, Kurt BEHRENDS and Gaston FERDIERE. *Les Demeures imaginaires (La Folie Réthoré, Picassiette, Watts Towers, E. Juncker).* 1977, 30'.

ZELE, Michel van. *Philippe Dereux: la peau des choses.* 1990, 28'.

CHOLBI, Pierre. *La Fabuloserie.* 1991, 12'.

PRÉVOST, Claude and Clovis. *Le Facteur Cheval.* 1981, 13'.

IMBERT, Henri-François. *Auguste Forestier: Constructions.* 1996, 18'.

BÜTTLER,Heinz. *Gugging: Zur Besserung der Person.* 1984, 90'.

BÜTTLER, Johann Hauser. *Der Zeichner bin ich de Heinz.* 1987, 50'.

EDELSTEIN, Simon. *Hans Krüsi: l'Homme aux Fleurs d'Appenzell.* 1983, 54'.

RAGON, Michel. *Histoire de l'Art Brut et de l'Art hors-les-normes I-II.* 1994, 31' et 31'.

DANCHIN, Laurent and Bernard GAZET. *Raphaël Lonné, dessinateur médiumnique.* 1989, 13'.

MASSICOT, Pascale, Stéphane JEAN-BAPTISTE and Éric POTTE. *Marie-Rose Lortet: Histoires racontées de toutes pièces.* 1993, 9'.

BASTID, Geneviève. *Francis Marchhall.* 1976, 23'.

MASSICOT, Pascale, Stéphane JEAN-BAPTISTE and Éric POTTE. *Francis Marchhall: Objets naufrages.* 1993, 14'.

CASTEILLA, Nathalie. *Fernand Michel, artiste zingueur.* 1989, 10'.

BOS, Josette, Odile CHOPARD and Bernard GUHUR. *Œuvres en souffrance.* 1986, 26'.

MASSICOT, Pascale, Stéphane JEAN-BAPTISTE and Éric POTTE. *Jano Pesset: Portrait d'un homme humble.* 1993, 7'.

Giovanni Battista Podestà. Burckhardt Production, 1990, 10'.

CRISTIANI, Jean-Noël. *Monsieur Poladian: En habits de ville.* [c. 1981], 13'.

PLACE, Claude, and Bernard D'ABRIGEON. *Pour un art populaire* (Petit Pierre, Gérard Lattier, Lena Vandrey, Châtelain, Pecqueur, Candide). 1981, 52'.

BOURBONNAIS, Alain. *Émile Ratier.* 1976, 13'.

MASSICOT, Pascale, Stéphane JEAN-BAPTISTE and Éric POTTE. *Raymond Reynaud: Le troisième cerveau.* 1993, 14'.

IMBERT, Henri-François. *André Robillard, À coup de fusils!* 1993, 25'.

BADER, Alfred. *Friedrich Schröder-Sonnenstern.* 1964.

SCHLUMPF, Hans-Ulrich. *Das zweite Leben des Armand Schultess.* 1974.

SCHLUMPF, Hans-Ulrich. *Armand Schulthess: J'ai le téléphone.* 1976, 53'.

BORY, Michel, Jean MAIERAT and Guy-Jules RENAUD, *Gaston Teuscher.* Collection Plans-Fixes, 1978, 32'.

MASSICOT, Pascale, Stéphane JEAN-BAPTISTE and Éric POTTE. *Turbulence: Alain Bourbonnais sous le vent de l'Art Brut (La Fabuloserie).* 1993, 15'.

MASSICOT, Pascale, Stéphane JEAN-BAPTISTE and Éric POTTE. *Pascal Verbena dit le Chérubin Charbonnier.* 1993, 11'.

VICENS, Louis-Michel. *Joaquim Vicens Gironella: le liège et la mémoire.* 1994, 20'.

BOURBONNAIS, Alain. *Pepe Vignes.* 1987, 24'.

KORALNIK, Pierre. *La Passion d'Adolf Wölfli.* 1984.

EXHIBITIONS OF THE COMPAGNIE DE L'ART BRUT

Basement of the Galerie René Drouin Gallery, Paris:
"Les Barbus Müller, Henri Salingardes, Xavier Parguey." November-December 1947.
"Robert Véreux and Lamy." Winter, 1947.
"Miguel H. [Hernandez]." Winter, 1947.
"Joseph Crépin." Winter-spring, 1947.
"Auguste Forestier, Jeanne Tripier, Heinrich Anton Müller." N.d. May-June 1948.
"Les Statues de silex de M. Juva." June 17-July 17, 1948.
Group exhibition: Aloïse, Miguel Hernandez, Henri Salingardes, Joaquim Vicens Gironella, Jan Krizek, Joseph Crépin, Maurice Baskine, Gaston Chaissac, Pierre Giraud. July 17-August 31, 1948.

Pavilion of Gaston Gallimard, Paris:
Group exhibition (around 40 participants, including Adolf Wölfli, Aloïse, Joaquim Vicens Gironella, Miguel Hernandez, Robert Tatin, African artists, children, and anonymous artists). September 7-October 1948.
"Adolf Wölfli." October 12-November 5, 1948.
"Joaquim Vicens Gironella." November 9-December 3,1948.
"Aloïse." December 7, 1948-January 11, 1949.
Group exhibition: Paul End, Heinrich Anton Müller, Aloïse, Wölfli, Auguste Forestier, Jeanne Tripier, Marie-Louise B., Gaston Chaissac, Miguel Hernandez, Jean l'Anselme and others. January 15-February 20, 1949.
Group exhibition: Jeanne Tripier, Auguste Forestier, Heinrich Anton Müller. February 22-March 19 (or April 1?), 1949.
"Wölfli et d'autres: Jean Stas, Salingardes, Juliette-Élisa Bataille, Paul End, Stanislas Liber, Jospeh Crépin, Gaston Chaissac, Marguerite Sir Berthomier, Jean l'Anselme." April 1949.
"Miguel Hernandez." May 17-June 10, 1949.

Other locations
"L'Art Brut." Sixty-three participants, including Aloïse, Adolf Wölfli, Gaston Chaissac, Auguste Forestier, Antinéa. Galerie René Drouin, October-November 1949.
"Cinq petits inventeurs de la peinture"(Paul End, Alcide, Stanislas Liber, Gaston Dufour, Sylvain Lecoq). Librairie Marcel Évrard, Lille, January 10, 1951-January 25, 1952.
"L'Art Brut." Galerie Les Mages, Vence, August 18-early October 1959.
"Art Brut." Galerie Daniel Cordier & Michel Warren, New York, February 20-March 3, 1962.
"L'Art Brut." Musée des Arts Décoratifs, April 7-June 5, 1967.

Additional Sources in English

BOURDIEU, Pierre. *The Rules of Art: Genesis and Structure of the Literary Field.* Stanford University Press, 1995; Cambridge Polity Press, 1966.

KLEE, Felix. *Paul Klee.* Trans. Richard and Clara Wilson. New York: George Braziller, 1962.

KLEE, Paul. *The Diaries of Paul Klee, 1898-1918.* Berkeley, CA: University of California Press, 1968.

MORGENTHALER, Walter. *Madness and Art: The Life and Works of Adolf Wolfli.* Lincoln, NB: University of Nebraska Press, 1992.

PRINZHORN, Hans. *Artistry of the Mentally Ill.* New York: Springer-Verlag, 1995.

RUBIN, William S. *Dada and Surrealist Art.* London: Thames and Hudson, 1969.

———. *Primitivism in 2oth Century Art: Affinity of the Tribal and Modern.* 2 vols. New York: Museum of Modern Art, 1984.

SHATTUCK, Roger. *The Banquet Years: The Origins of the Avant-Garde in France.* New York: Vintage Books: 1968.

INDEX

Numbers in italics refer to illustrations.

Alcide *80*, 87, 92
Alex, Kosta 215
Aloïse or Aloyse (Corbaz, Aloïse) 7, 9, *34*, 39, *40*, 42, 49, *51*, 53-54, 57, *63*, 71, 75, *75*, 77-78, *78*, 79, 82-83, 85, 92-93, 96, 98-99, *109*, 114, 121, 136, 139, *147*, 150-151-152, 155-156, *157*, 158, 171-172, 178, 183, 192, *193*, 195, 210, 215, 222, 225, 233, 244, 248, 253, 255, 257, 259, 263-264
Appel, Karel 107
Arcimboldo, Giuseppe 12, 168
Arnaud, Noël (Müller, Raymond) 128
Arp, Jean 31, 63
Arrabal, Fernando 171
Artaud, Antonin 41, 51, *52*, 248
Auberjonois, Maurice 85-86
Auberjonois, René 41, 44, 49, 86
Aubert, Rose 116-117, 123

Bacon, Francis 257
Bader, Dr. Alfred 9, 171, 186, 196
Bailly, Carol *217*
Barr, Alfred 107
Baselitz, Georg 236, 244, 253, 259
Baskine, Maurice 71, 98, *99*
Bataille, Juliette-Élisa 137, *139*, *181*, 241
Baudrillard, Jean 263
Baya *129*
Bazaine, Jean 66, 166
Bedeau, le 217
Berger, René 172
Bernard, Dr. Paul 87, 147
Berne, Jacques 9, 86, 101
Bertelé, René 85
Bettencourt, Pierre 9, 126
Biner, Pierre 261
Birnbacher, Georg 253
Blin, Roger 171
Bluhm, Ursula 117
Boissonnas, Édith *73*
Bojnev, Boris 117
Boltanski, Christian 253
Bomsel, Edmond 74
Bonjour, Benjamin 202, *203*, 213, 215
Bonnafé, Lucien 52
Bonnard, Pierre 35
Bonnefoi, Geneviève 156
Bonnelalbay, Thérèse 162, 164
Borgeaud, Georges 81, 83

Born, Maurice 211
Borofsky, Jonathan 243
Bosch, Hieronymus 12, 155
Bouché, Henri-Pol 128
Bourbonnais, Alain 172, 225-227, 232
Bourdieu, Pierre 7-8, 11-12
Bouret, Jean 82
Bousquet, Joë 85
Bowie, David 251
Braque, Georges 14, 117
Brassaï (Halasz, Jules) 60, *60*
Brauner, Victor 81
Brendel (Genzel), Karl 7, 22, *23*, 30, 42, 225, 253
Breton, André 7, 19-20, *20*, 31-33, 38, 51, 67, 72, 74-75, 81, 85, 87-88, 94, *94*, 95-97, 248
Brown, Roger 236, 251
Browne, A. F. 25
Brueghel, Pieter, 155
Budry, Paul 41, *41*, 42-43
Burland, François *214*, 215
Burnat-Provins, Marguerite 45, *46*, 62, 143

Cardinal, Roger 9, 171, 226, 233
Carles-Tolrà, Ignacio 9, *160*, 162, *162*, 163, 215, *215*
Carlo (Zinelli) 134, 136-137, 137, 141, *143*, *146*, *154*, 155, 183, 192, *193*, 194, 210, 231, *231*, 244, *244*
Castelli, Léo 68
Celebonovic, Aleska 145
Cendrars (Sauser, Frédéric, known as Blaise) 41
Chabrun, Jean-François 168
Chagall, Marc 7, 33, 166, 259
Chaissac, Gaston *70*, 72, *72*, 77, 78, 82, *84*, 85, 88, 90, *90*, *97*, 98-99, 101, 121, *161*, 163, *164*, 215, 233, 257
Chave, Alphonse 112, 113-114, 116-117, 118-121
Chave, Pierre 186
Cheval, Ferdinand or Le Facteur 19, 83, 225, 233, 236-237, *238*, 239, 241
Chevallaz, André 172
Chonez, Claudine 83
Choquard Ramella, Florence 221
Cingria, Charles-Albert 35, *36*, 41
Cocteau, Jean 79, 171
Cordier, Daniel 109-110, 128, 133
Crépin, Joseph-Fleury 20, 71, *71*, 82-83, 85, 96, 125, 231, 257

Dado 109, 121
Danchin, Laurent 9, 233
Darger, Henry 196, *224*, 225, *225*, *226*, *256*, 257
Dauchez, Jacques 9

Dauchez, Robert 9, 72, 86
David, Jacques Louis 12
Degas, Edgar 257
Delacroix, Eugène 13, *13*, 20, 36, 62
De Kooning, Willem 106
Delaunay, Robert 63
Delaunay, Sonia 63
Demkin, Georges 117, *120*, *121*, 123
Deonna, Waldemar 41
Dequeker, Dr. Jean 153
Derain, André 117
Dereux, Philippe 9, 113, 117, *160*, 162-163, 215
Desnos, Robert 33
Doisneau, Robert 9, 90, *90*, *104*, *132*, *152*, *233*, *238*
Dominguez, Oscar *30*
Domsic, Yanko *233*
Doudin, Jules *170*, 171-172, 183, *183*, 196, 210, 222
Drouin, Jean-Claude 67
Drouin, René 41, *65*, 66, *67*, 68, 71-72, 74-75, 77, *80*, 81-83, 87, 114
Dubillard, Roland 171
Dubuffet, Jean 7-9, 11, *11*, 12, 28, 31, 35, *35*, 36, *36*, 37, *37*, 38, *38*, 39-46, *46*, 49, 51-54, 57, 60, 62-63, 66-68, *68*, 71-72, *73*, 74-75, 78-79, *79*, 80-83, 85-89, 91-97, *97*, 98, *98*, 99, *99*, 100-103, *104*, 105, *105*, 106, 108-109, *109*, 110-111, *111*, 112, *112*, 113-114, 116-119, *119*, 120-121, 123, *124*, 125-126, 128, *128*, 129, 132-134, 139, 141, 143, 145, 147, 150, 152-160, 162-168, 171-175, 182, *182*, 183, 190-192, 196-198, 214-216, 223, 225-227, 230, 232, 245, 252-253, 255, 257, 260-264
Dubuffet, Lili *79*, 103, 105, 112
Duchamp, Marcel 51, 106-107, 253
Duf (Dufour), Gaston *80*, *81*, 82, 87, 114, 134, *134*, 155, 192, 225
Dürer, Albrecht 255

Eckenberger, Reinaldo *231*
Edelmann, Claude 156
Edelmann, Michèle 9, 129, 156
Ehrmann, Gilles 233
Eluard, Paul 31-33, 52, 248
End, Paul *80*, 87, *88*, 92, 114, 123
Engels, Friedrich 7
Enkell, Pierre 222-223
Eno, Brian 251
Ernst, Max *29*, *30*, 31-32, *42*
Esteban, Claude 169
Estève, Maurice 66
Évrard, Marcel *80*, 81

Fautrier, Jean 68, 106
Feilacher, Dr. Johann 255
Ferdière, Dr. Gaston 9, 25, 51-52, 52, 145
Filaquier, Henri 155
Fischer, Johann *201*, 252
Fischer, Louise 202
Florent 155
Flournoy, Théodore 19

Forel, Dr. Oscar 139
Forestier (For), Auguste 52-54, *54*, *55*, 75, 78, 78, 82-83, 93, *93*, 96, *108*, 109, *110*, 125, 141, *151*, 154, 157, 213, *230*, 231
Fouéré or Fouré, Adolphe-Julien 233
Fraisse, Clément *145*, 147
Freud, Sigmund 8
Fusco, Sylvain *148*, *149*, 150, *150*, 236

Gabritchevsky, Eugène 109, *115*, 116-117, 121, 122, 123, 215
Gagnaire, Aline 71
Gallimard, Gaston 43, 54, 60, 66, 74-75, 85, 101
Gaudí, Antonio 237
Gauguin, Paul 13, 36, 62
Gelli, Giordano 202
Genet, Jean 252
Gentis, Roger 217
Giacometti, Alberto 253
Gie, Robert 49, *50*
Gill, Madge 20, 134, *135*, 136, *136*, 137, 139, 141, 145, 155, 162, 171, *180*, 182, 208, 210, 257, 259, 264
Giraud, Pierre 72, 82
Giraud, Robert 71, 100
Gironella, Joaquim Vicens *64*, *65*, 66, 71, 77-79, 88, 93
Gisbourne, Mark 244
Goebbels, Joseph 7
Goesch, Paul 7, 244, 253
Golub, Leon 248
Gordon, Theodore H. 183, *186*, *187*, 213, 215, 260
Goya y Lucientes, Francisco de 12
Gris, Juan 257

Hartung, Hans 71
Hauser, Johann 183, 190, 202, *202*, 217, 236, 248, *251*, *254*, 255
Héraut, Henri 85
Hernandez, Miguel *70*, 71, 77-80, 88-90, *90*, 92, 96, 98-99, 125, 136, 141, *152*, 153, 156
Herrera, Magali 162, *163*, 164
Heu (Heuer), Joseph 49
Hill, Carl Fredrik 215, 244, 253
Hodinos, Émile Josome (Ménétrier, Joseph Ernest) 25, *25*, *26*, 217, *220*, 221, *221*
Hugo, Victor 17, *17*, 18-19, 32
Hulak, Fabienne 233
Hulten, Pontus 236, 253
Hyppolite, Hector 33, 85, 87, *87*

Irman, Regina 249, *249*
Isely, Marthe 114, 117, 123
Itten, Johannes 79

Jacob, Max 35
Jakic, Vojislav 139, *140*, 141, 145, *159*, 182-183, 210
Jakovski, Anatole 71
Janet, Pierre 18
Jauffret, Charles *132*, 133
Jawlensky, Alexej von 22

Jayet, Aimable 155, 71
Jorn, Asger 121, 128, *128*, 133
Josephon, Ernst 244
Juva (Juritzky, Alfred Antonin) *64*, 66, 71, 77, 85, 88, 114

Kandinsky, Wassily 7, 13-14, 22, 33, 35, 63, 68, 85, 253
Kardec, Allan 16
Kernbeis, Franz 202, *202*
Kind, Phyllis 257
Kirchner, Ernst Ludwig 7, 14, 33
Klee, Felix 15, 16
Klee, Paul 14, *14,* 15, 30-31, 33, 35, 168, 253, 257
Knopf, Johann *44*
Koczÿ, Rosemarie 215
Kokoschka, Oskar 7, 33, 253
Kopac, Slavko 9, 78-79, 87, 102, 113, 126, 128, 128, 129, 156, 182, *182*
Krasner, Lee 106
Krizec, Jan 69, *70*, 71, 82, *82*, *100*
Krüsi, Hans 183, *189*, 190, *190*, 202, *204*, 217, 233, *235*, 260, *260*, *261*, 262
Kubin, Alfred 22
Kuevelec *76*

Lacan, Jacques 221
Ladame, Dr. Charles 25, 27, 27, 28, 45, 46, *49*, 172, 183
L'Anselme, Jean 85
Lascault, Gilbert 168
Lattier, Gérard 215
Laure (Pigeon, known as) 20, 133, 136, 150, 162, 171, 208, *208*, *209*, *259*
Lebensztejn, Claude 167
Le Carré-Gallimard, Simone *232*
Lecoq or Lec or Sylvocq, Sylvain *80*, 87, 92, 171
Le Corbusier (Jeanneret, Charles Édouard, known as) 42, 44, 166
Ledeur, Jean-Paul 9, 125
Legendre, Henriette 121
Léger, Fernand 166
Legoff 168
Lehman, Wilhem 76
Léonard de Vinci 100
Léontine ou Célestine 183, *185*
Lerner, Nathan 196
Lesage, Augustin 7, 16, *16*, 19, *19*, 20, *131*, 133, 136, 139, 141, 144-145, 155-156, 171, 208, 210, 213, 215, 257, 262
Lévi-Strauss, Claude 79, 81, 86, 88, 168
Lévy, Jules 12
Lib (Liber), Stanislas *80*, 87
Limbour, Georges 67, 113
Lombroso, Cesare 25, 183
Lommel, Madeleine 226
Lonné, Raphaël 137, 141, *142*, 145, 147, 153, 155, 162, 164, *169*, 183, 236
Lortet, Marie-Rose *216*

Maar, Dora 52
MacGregor, John M. 196, 233, 260

Mackintosh, Dwight 183, 190, 196, 215
Maizels, John 9
Maisonneuve, Pascal-Désir *83*, 85, 87-88, *89*, 96, 109, *110*, 141, 155, 168, 179, 179
Malraux, André 7, 81, 86
Manessier, Alfred 66, 166
Manet, Édouard 83
Mar, Jean 49, *49*
Marc, Franz 14, 85
Marie, Dr Auguste 25, *25*, 27-28
Martini, Jean de 178
Marx, Karl 8
Massé, Ludovic 156
Masson, André 32
Mathey, François 9, 166, 169, 172
Matisse, Henri 35, 117, 195, 253
Matisse, Pierre 79, 101, 103, 105, 107
Maurer, Lise 221
Mayor, Francis 198, *198*, 202, 262
Meani, Angelo 196, *196*, 198
Meienberg, Niklaus 251
Mermod, Henry-Louis 41
Messager, Annette *240*, 241, 242, *242*, 253
Messerschmidt, Franz Xaver 248
Messens 87
Metz, Reinhold 183, *186*, *188*, 217, 218, 264
Michaux, Henri 68, 81, 86, 109, 113
Michelangelo 100, 255
Miró, Joan 81, 168, 255
Mnouchkine, Ariane 171
Modigliani, Amedeo 35
Mondrian, Piet 63
Monsiel, Edmund *206*, 206
Moog (Meyer), Peter 22, *23*
Morgenthaler, Dr. Walter 20, *22*, 24, 30, 44, 79, 81, 91, 151, 253
Morsier, Dr. Georges de 44
Müller, Heinrich Anton 9, 39, 44, *47*, 53, 57, *61*, 78, *78*, 79, 82-83, 85, *91*, 98, *98*, 99-100, *101*, *148*, 150, 155, 157, 166, *168*, 172, 180, 195, 233, 236-237, *237*, 252, 264
Müller, Joseph-Oscar 68
Munch, Edvard 168
Münter, Gabriele 14
Musgrave, Victor 152, 155, 226

Nakov, André 168
Namuth, Hans *105*, *106*
Natterer, August *28*, *45*
Navratil, Dr. Leo 251, 253
Navratil, Walter 251, 256
Nedjar, Michel 206, *208*, 215, 226, *229*, 255
Neuwirth, Gösta 251
Newman, Barnett 107
Nietzsche, Friedrich 7, 8
Nilsson, Gladys 236, 251
Nolde (Hansen, Emil, known as) 7, 33, 62
Nørgard, Per 248
Nutt, Jim 236, 251

INDEX

Obaldia, René de 171
Oddo, Marius 117
Odincourt 166
Oldenburg, Claes 248
Olive, Gérard 147, 155
Olof, Per 239
O'Neil, Robert 157
Ossorio, Alfonso *102*, 103, *103*, 105, *105*, 106, *106*, 107-109, *109*, 110-111, 125, 245, *245*
Osty, Eugène 19
Oury, Dr. Jean 154
Ozenda, François 114, *114*, 117

Pagé, Suzanne 225
Palanc, Francis *113*, 114, *114*, 117, *117*, 121, 123, 150, 155-156, 263
Pankoks, Michael 190
Parguey, Xavier 69
Parsons, Betty 108
Paulhan, Jean 39, 42, 54, 67, *73*, 74-75, 80-81, 85, 87, 95
Peillet, Emmanuel 128
Penck, A. R. 245, *246*
Péret, Benjamin 87
Pesset, Jano *232*
Picassiette 236
Picasso, Pablo 13, *13*, 14, 35, 52, *67*, 99, 166, 253, 255, 257
Pittard, Eugène 45
Planque, Jean 107
Podestà, Giovanni Battista 9, 136, *138*, *204*, *205*, *206*, 206, 208, 213, 215, 217, *218*, *219*, *252*, 262, 264
Pohl, Franz 7
Poladian, Vahan *213*, 262
Pollock, Jackson 102, 106-107, 109
Ponge, Francis 81, 113
Porada, Cathy von 117
Porret-Forel, Dr Jacqueline 9, 49, 79-80, 141, 150-152
Portrat, François *177*
Potter, Fuller 107
Preszow, Gérard 231
Prinzhorn, Dr. Hans 7, 20, 22, 22, 23-24, 30-33, 43, 51, 88, 91, 157, 183, 236, 248
Prisonnier de Bâle (Giavarini, Joseph), le 39, 49, *52*, *53*, 57, 88, 92, 150, 155, 172, 262
Pujolle, Guillaume 7, 52-53, *55*, *56*, *130*, *136*, 139, 145, 153, 156-157, 162, 180, 213, *230*, *252*

Queneau, Raymond 53, 128, *128*

Radovic, Jean 136, *138*, 171, 213
Ragon, Michel 63, 71, 81, 225
Rainer, Arnulf 236, 245-246, *247*, 248, *248*
Ramírez, Martín 213, 251-252, 257
Ratier, Émile 134, *134*, 141, 144, *166*, 179, 262
Ratton, Charles 68, 74, *74*, 86, 94
Raugei, Marco 202
Réja, Marcel (pseudonym of Paul Meunier) 7, 24, *24*, 25, 90
Renault, Camille *132*, 217, *226*

Renoir, Auguste 255
Requet, Dr. André 151
Ribet, Humbert 117, 123, 155
Richter, Agnès *24*
Ries, Dr. Julius von 139
Rihm, Wolfgang 251
Rilke, Rainer Maria 248
Ripoche, Clémentine 38
Rivière, Georges-Henri 86
Robillard, André 134, *146*, 147, 210-211, *212*, 217, 231, 236
Roché, Henri-Pierre 68, 74, 94
Rodia, Simon 225, 233, *233*, 236, 238-239, 241
Rogues de Fursac, Dr. Joseph 24
Rooman 107
Rosen, Seymour 233
Rouault, Georges 35, 68
Roulin, Geneviève 183-184, 190, 192, 216, 222
Rousseau (Henri, known as Le Douanier) 33
Rubin, William 236
Ruffié, Jane 136, 147

Saint-Phalle, Niki de 237-239, *239*, 241
Salingardes, Henri 68-69, *69*, 71, 75, 77, 89, 93, 155, 262
Santoro, Eugenio 183, *197*, 198, 202, *210*, 211
Sardou, Victorien 17, *18*, 19
Sattler, Claudia 215
Schenk, Werner 88
Schiele, Egon 257
Schmidt, Clarence 225, 233, *234*, 236
Schmidt, Georg 171
Schnabel, Julian *241*, 242-243, *243*
Schöpke, Philipp 190, 202, 255
Schröder-Sonnenstern, Friedrich *116*, 117, 143, 248
Schulthess, Armand 206, 225, 242, *242*, 253, 263
Schwartzlin-Berberat, Constance 217, *221*, *222*
Sendrey, Gérard 226
Settembrini, Franca 190, *200*, 201
Seuphor, Michel 75, 81
Simon, Dr. Max 24
Sir (Sirvins), Marguerite 134, 137
Skira, Albert 41, 156
Smith, Hélène *18*, 19, 41
Soby 107
Solier, René de 81
Somuk *58*
Soupault, Philippe 32
Soutter, Louis 42, 44, *46*, 62, 88, *90*, 143, 171-172, *173*, 215, 245-246, *246*, *247*, 248, 253, 255, *255*, 257
Spoerri, Daniel 236, 251
Starobinski, Jean 42
Steck, Dr. Hans 25, 28, 49, 80, 171, 183
Still, Clyfford 106-107, 109
Stuss, Otto 7
Supervielle, Jules 86
Szeemann, Harald 171, 253, 255, 256

Tal Coat, Pierre 66
Tapié, Michel 67-69, 71-72, 74, 85, 107

Tàpies, Antoni 255
Taueber, Sophie 31, 63
Tauxe, Henri-Charles 223
Teller, Claire 226
Teuscher, Gaston 183, 184, 196, 211, *211*, 217, 262
Thévoz, Michel 9, 156, 172, 174, *176*, 177-180, 182, *182*, 183-184, 190, 192, 195-198, 201-202, 210, 211, 214-218, 221-223, 226, 233, 255-255, 259-261, 263
Tinguely, Jean 186, 236-237, *237*, 238, *238*, 239, 241, 253, 257
Titeca, Dr. Jean 87
Tobey, Mark 166
Töpfer, Rodolphe 14
Traylor, Bill 183, *184*, 257
Trentinian, Armande de 9
Tripier or Tri, Jeanne 20, *77*, 78, 82-83, *89*, 92, 99, 109, *110*, 137, 171, 222, *222*, *240*, 242, 262
Tromelin, Comte de *17*, *25*, 25
Trucchi, Lorenza 133
Tschirtner, Oswald 201, 231, 255, 257
Tuchman, Maurice 253
Tzara, Tristan 52, 81

Ura (Urasco), Berthe 49, 85
Urs 107

Valadon, Suzanne 35
Van Genk, Willem 183, *195*, 196, 215, 217, *257*, *258*, 259
Véreux, Robert 85
Vialatte, Alexandre 113
Vian, Boris 7
Vignes, Joseph *212*, 213
Vinchon, Jacques 91
Virgili, Josué *227*
Voll, Oskar *43*

Vouga, Bernard 178
Voyageur Français, le 25, *27*
Vulliamy, Gérard *151*

Waldberg, Patrick 83
Walla, August 183, *199*, *200*, 201, *207*, 206, 217, 233, *234*, 236, *241*, 242-243, *243*, 248, 255, 263
Ward, Eleanor 108
Warren, Michel 109
Weiss, Allen S. 233
Wey, Aloïs 183, 184, 202, 218
Wilson, Scottie (Freemann, Louis) 33, *79*, *86*, 87-88, *96*, 96, 141, *141*, 152-153, *153*, 155, *167*, 195, 210, 231, 257, 261, 264
Wittlich, Joseph 184, *190*, *191*, 196, 198, *198*, 215, 217, *228*, 231, 259
Wolff, A. (pseudonym of Dumarçais, Philippe) 156
Wölfli, Adolf 7, 9, *20*, *21*, 22, 30, *38*, 39, 41, 42, 44, *45*, 53-54, 57, *57*, *62*, 75, 77, *77*, 78-79, 81, 83, 85, 92, *95*, 96, 99, 100, *107*, 125, *127*, 139, *141*, 147, 151-152, 155, *155*, 156, 158, *158*, 171-172, 180, *180*, 186, 195, 215, *227*, 236, 243-244, 248-249, *249*, *250*, 251, 253, 255, 257, 259, *259*, 262-264
Wols (Wolfgang Schultze, known as) 68, 106
Wyrsch, Jacob 44, 79-80

Yoakum, Joseph 225, 251
Yoshida, Ray 236

Zagajewski, Stanislaw *10*
Zander, Susanne 257
Zemankova, Anna 182
Zéphir 217
Zivkovic, Bogosav 168, *168*

Translated from the French by James Frank
Biographical notices translated by Susan Pickford
Additional research by Ellen Booker
Copy-editing: Bernard Wooding
Color separation: Euresys
Typesetting: Studio X-Act, Paris

Originally published as *L'Art Brut*
© Flammarion, Paris, 1997
English-language edition © Flammarion, 2001

ISBN: 2-08010-584-1 FA0584-01-VIII
Dépôt légal: September 2001
Printed in Italy